Women in
Doctor Who
Damsels, Feminists and Monsters

VALERIE ESTELLE FRANKEL

McFarland & Company, Inc., Publishers
Jefferson, North Carolina

LIBRARY OF CONGRESS CATALOGUING-IN-PUBLICATION DATA

Names: Frankel, Valerie Estelle, 1980– author.
Title: Women in Doctor Who : damsels, feminists and monsters /
 Valerie Estelle Frankel.
Description: Jefferson, North Carolina : McFarland & Company, Inc.,
 Publishers, 2018 | Includes bibliographical references and index.
Identifiers: LCCN 2018002477 | ISBN 9781476672229 (softcover : alk.
 paper) ∞
Subjects: LCSH: Doctor Who (Television program : 1963–1989) |
 Doctor Who (Television program : 2005–) | Women on television. |
 Feminism on television.
Classification: LCC PN1992.77.D6273 F73 2014 | DDC 791.45/72—dc23
LC record available at https://lccn.loc.gov/2018002477

BRITISH LIBRARY CATALOGUING DATA ARE AVAILABLE

ISBN (print) 978-1-4766-7222-9
ISBN (ebook) 978-1-4766-3154-7

Front cover images © 2018 iStock

Printed in the United States of America

McFarland & Company, Inc., Publishers
 Box 611, Jefferson, North Carolina 28640
 www.mcfarlandpub.com

ACKNOWLEDGMENTS

A big thanks to Kathrin Franke, Yochanan Urias and Risa Romano for their editing and to Chrissie at chakoteya.net for all her background work. And, of course, to the creators, producers, and actors who filled *Doctor Who* with such fascinating women.

TABLE OF CONTENTS

Acknowledgments 00

Introduction 1

Sweet Girls

The Innocent: Susan and Friends 5

Kid Power: Maria, Rani and Jorjie 19

Loyal Assistant: Jo Grant 26

The Disciple: Martha Jones 35

Sexy Damsel: Peri and Mel 43

The Heart: Rose and Charley 48

Sacrifices and Fridgings: One-Off Companions 56

Childlike Wonder: Amy Pond 64

Experts

Warrior Babe: Leela 70

The Scientist: Zoe and Liz 73

Seasoned Professional: Barbara Wright 79

Wisewoman: Evelyn Smythe 81

Bad Ladies

Collaborator: Sara Kingdom 88

Margaret Thatcher: Helen A 97

Evil Ice Queen: The Rani 104

The Fool: Missy 106

The Monster: Miss Quill 110

Tough Girls

Galactic Orphan: Ace and Lady Me 118
Brash Equal: Donna Noble 123
Feminist: Sarah Jane Smith 127
Hero Mom: *The Sarah Jane Adventures* 132
Adventuress: Bernice Summerfield 137
Soldier: Roz Forrester 141
Sovereign: Erimem 149

Outsiders

The Alien: Destrii and Izzy 156
Cyborg: Compassion and Feyde 162
Perceptive Minority: Bill and Anji 168
The Shadow-Self: Gwen, Suzie and the Mara 176

Relationships

Companions' Mothers: Jackie, Francine, Sylvia 182
Family Unit: Nyssa and Tegan 188
Controlling Caregiver: Clara Oswald 191
Time Lady: Romana 199
Trickster-Seductress: River, Trix and Iris 209
Love Interests: Grace and the Tardis 219

Conclusion: The Female Doctor Question 226
Appendix: Doctors and Companions 229
Works Cited 231
Index 239

INTRODUCTION

Back in 1963, the producers of *Doctor Who* envisioned their new television show as a way to "enlighten children about various historical time periods" as the characters explored space and time (Muir 9). Despite the modest aim, the show ran for 26 years. For most of the series, the male Doctor was the hero on the hero-quest; his mostly female companions were sidekicks.

Producer Graham Williams comments, "The function of the companion I'm sad to say, is and always has been, a stereotype ... the companion is a storytelling device ... it is a very cardboard figure" (Tulloch and Alvarado 209). For the First through Third Doctors, men leap into action and women (or rather, submissive twenty-year-old girls) wear short skirts and scream for rescue. The Fourth Doctor's era tried to move away from this stereotype—the beloved Brigadier was more well-rounded, and writers created female companions with different personalities. However, each personality appeared a one-note archetype.... Williams noted that after scientist, ditz, feminist, and jungle girl, the only "stereotype" he could think of was Romana the "ice queen" (Tulloch and Alvarado 213). These characters were strong, clever, independent, and funny, but lacked much depth (though Sarah Jane triumphed when her actress rewrote the lines). Next, Five got Nyssa the young science genius and brash, argumentative Tegan—new characters in a female team-up, but ones who cleaved heavily to their roles. (Male Turlough the traitor and Adric the teen genius were admittedly no better.) Six reverted to screaming damsels Peri and Mel, this time with extra sex appeal. The women they (rarely) encountered tended to be just as one-note: soldiers, queens, monsters, wisewomen, and collaborators. Many had positions of power, but few used them wisely or well.

A change finally came when Seven paired with Ace, a teen explosives expert who finally got depth, family, and backstory—about half her episodes dealt with her fears and memories. Sadly, this was the era of the show's can-

1

celation in 1989. In the continuing novels and audio adventures and in New Who (2005 to present), the female characters are much more developed, but still derive from one-line concepts—Egyptian princess, futuristic archeologist, charming shopgirl. Their personalities are brackets, not goals or conflicts. Thus the show fits well into archetypal studies, considering how each group rather than individual character is presented. There's much to discover in terms of agency and feminism, but also how much characters manage to transcend their tired roles.

Of course, women besides companions appear through the show—the Rani and the Inquisitor, soldiers and princesses, scientists and leaders. Tackling every woman in the Whoniverse (admittedly likely missing a few) was quite a chore. Needing to draw the line somewhere, I included minor characters from the show of fifty-plus years, but for the spinoff shows, audio adventures, books, and comics, I only included major companions. In fact, there's an extraordinary amount of extended universe: shows include *The Sarah Jane Adventures, Torchwood, K9,* and the current *Class,* along with a few solitary pilots and specials. (These modern shows are identified by "series," while Classic Who is analyzed with its 26 "seasons," matching British terminology of the two time periods. Serials appear in italics, with single episodes in quotes.) The books continued as New Adventures (1991–97, Virgin Books) and Missing Adventures (1994–97, Virgin Books), Eighth Doctor Adventures (1997–2005, BBC Books), and novellas (2001–04, Telos Publishing), along with audio plays (1998–, Big Finish Productions), comic strips in *Doctor Who Magazine,* and original comic books and graphic novels. These were a place for minority companions and more experimental plotlines, where many female creators like series editor Rebecca Levene, authors Kate Orman and Claire Lister, and audio scriptwriters Caroline Symcox, Barbara Clegg, Jenny T. Colgan, Catherine Harvey, Una McCormack, Jacqueline Rayner, Emma Beeby, and Alison Lawson found a chance to shine.

Verity Lambert, who launched the show, became the great heroine of the Whoniverse. "Verity Lambert was *Doctor Who*'s first producer, who helped develop the basic concept of the show. *Doctor Who* was a show that could literally do anything and go anywhere, because it would" (Riggo). She left after two years, but the program bore her stamp, especially in the capable companion Barbara. As a producer, Lambert's Bechdel test (whether women speak to each other onscreen about something other than men) has the most success—of nineteen stories, 85 percent pass (Simon).

Many women helped shape the show, like original Cybermen designer Alexandra Tynan. Also notable is Delia Derbyshire, the pioneer of electronic music and sampling, who created the first arrangement of the *Doctor Who* theme in 1963. Further, nearly fifty years later, while Russell T. Davies is credited with reviving the show, a salute goes to producer Julie Gardner and also

Jane Tranter, Controller of Drama Commissioning at the BBC, who battled fiercely for it.

Individual writers and directors have also shone through the show. Julia Smith was the second woman to direct *Doctor Who* (specifically *The Smugglers* and *The Underwater Menace*), following Paddy Russell's direction of *The Massacre of St Bartholomew's Eve*. Fiona Cumming, an assistant floor manager and production assistant in the sixties, later directed *Castrovalva, Snakedance, Enlightenment,* and *Planet of Fire* during Peter Davison's years. Writers Lesley Scott (*The Ark*), Barbara Clegg (*Enlightenment*), Paula Woolsey (*Attack of the Cybermen*) and Rona Munro (*Survival*) join them, even before the many female writers and producers under the recent Davies and Moffat regimes. All these women presented the female companions and guest characters as dynamic and varied, though often trapped within the patterns of their archetypes.

SWEET GIRLS

The Innocent: Susan and Friends

"There we have her: the ideal wife and mother as seen in the first six or seven decades of the twentieth century. A pubertal girl, whisked away from home before she discovers her sexuality (What boy wants to compete with his father for the attention of a full blown sexual woman?)" explains Joan Gould in her work on fairytale archetypes (30). Carol Pearson in her own archetypes study suggests "the Innocent" for this category. Innocents "assume they will be cared for by the universe and other people, because they are so special and so good" (78).

The Doctor's fifteen-year-old granddaughter Susan Foreman (Carole Ann Ford) is living with him on earth and attending school when the first episode begins in 1963. She's an anachronism, understanding advanced physics and chemistry beyond the abilities of earth humans at the time, yet not British coinage.

In the original pilot, Susan was a traveler from the forty-ninth century in futuristic clothes unrelated to the Doctor—the final script writer, James Anthony Coburn, suggested Susan be the Doctor's granddaughter for children to have an easier time relating to the relationship (Haining 19–21). Thus, the story changed from an ancient intergalactic time traveler shepherding around a young woman in his spaceship to a grandfather teaching and protecting his last descendent.

The show offers no details on Susan's parentage, leaving it possible that her use of "grandfather" is merely a sign of respect for an elder. Certainly, nothing establishes that she's *not* his biological granddaughter (though her Gallifreyan name is clearly not Susan). The Tenth Doctor says he was a father and grandfather once, and Clara's journey through the Doctor's lives in "The Name of the Doctor" shows Susan willingly boarding the Tardis (before its

police box camouflage). The novels and radio plays have done more to fill in her story.

Cold Fusion has a murky flashback in which the Doctor comes to his wife and reassures her he will protect Susan. "She will be taken away from here, away from this madness. I will take her far from this world of vampires and valeyards" (96). According to *Time's Crucible,* the Pythia, former matriarchal rulers of Gallifrey, curse the people with sterility, so the patriarch Rassilon invents the looms, genetic factories. After this, "the Pythia threw herself into the Crevasse of Memories That Will Be" (Platt, *Lungbarrow* 275). In response, a presidential decree is issued, on the day of Susan's birth that "only the Loom-born shall inherit the Legacy of Rassilon. There shall be no more children born of woman" (174). This puts the genders in opposition as the president snatches the power of reproduction from womankind (the followers of Pythia become the Sisterhood of Karn, continuing a gender battle on the show). Susan notes, "I never saw my mother. But I know that she died when I was born, at the very same moment the Pythia cursed the world" (Platt, *Lungbarrow* 268). The Doctor's sons are killed, but he saves Susan, who accompanies him on his adventures.

It should be noted that the novels are uniquely positioned to all fit together, however much they contradict, thanks to the quirks of time travel. *Sometime Never...* by Justin Richards, has her named Zezanne, the daughter of a futuristic empress, granddaughter of a world-conquering tyrant Doctor. Meanwhile, Lady Larn appears in Eric Saward's *Birth of a Renegade* as the only surviving descendent of Rassilon. Renegade students want to make her president, and unsuccessfully try recruiting the Doctor to their cause. After the coup is defeated, the Doctor's mind is selectively wiped and the pair escape to earth. While a character, she is also a beacon of hope for the Doctor, encouraging him to take her to a better life. "The Innocent is the part of us that trusts life, ourselves, and other people. It is the part that has faith and hope, even when on the surface things look impossible" (Pearson 71).

She appears a teenager and generally fills this role in their little family. Susan herself tells Ping-Cho that she's "in [her] sixteenth year" (*The Roof of the World*). Of course, this might be cover, and there's no guarantee that Susan is on her first regeneration. As one of the original companions, and the only underage member of the team, her helpless state sets the scene for all the companions who follow. Carole Ann Ford, who played Susan, says, "Susan was originally going to be quite a tough little girl—a bit like the *Avengers* lady, using judo and karate—but having telepathic communication with the Doctor. Then they decided they wanted me to be a normal teenage girl so that other teenage girls could easily identify with me" (Tulloch and Alvarado 210). Her role thus became far more conventional. She adds, "I think they

chose me because they wanted a good screamer. I did an awful lot of that" (Haining 81).

When asked why he has companions in the new series, the Doctor repeatedly stresses the wide-eyed delight they bring to adventures. Laura Geuy Akers suggests that the companions' reactions impact their relationship with the Doctor. Though the Doctor has experienced the universe many times, the very act of "re-experiencing time is source of wonder, and this wonder infuses [the companion's] relationship with the Doctor" (177). He also emphasizes their childlike insistence on right and wrong, in comparison with his often-jaded expediency. According to Courtney Lewis and Paula Smithka, editors of *Doctor Who and Philosophy,* "It's a sign that [the Doctor] thinks you're capable of considering the abstract, being adventurous, daring, as well as understanding and compassionate toward strange aliens." Of course, the Companions are his sidekicks—sounding boards he can show off for as they admire his cleverness. They subordinate their wishes and personalities to his and provide emotional support, usually platonically. "The companions have functioned as generic viewer identification figures. They exist to ask questions, get captured, and befriend whatever beleaguered populations they may find," Aaron John Gulyas explains in his essay on companions on the printed page. For the audience, they give the Doctor someone to talk to, and most often, lots of sex appeal.

The second episode introduced the Daleks and cemented *Doctor Who*'s popularity for all time. It should be noted that its writer, Terry Nation, has about a 50 percent Bechdel rate (Simon). He offers many strong roles for women in his stories, and had planned to produce a Dalek spin off show starring a woman. Later, he produced the first British genre show to star a woman, *Survivors*. In the episode, however, the Doctor dismisses Susan's concerns as fancy, adding to the older teacher companion Barbara, "You know, sometimes I find the gulf between Susan's age and mine makes difficult understanding between us" (*The Daleks*). When Barbara intervenes, she discovers Susan is most frustrated at being ignored:

BARBARA: Well, Ian said you were terrified. Well, something must have frightened you.
SUSAN: It's not that so much. It's just that I'm, I'm fed up no one believes me.
BARBARA: Believes what?
SUSAN: Oh, I don't know.
BARBARA: That there was someone out there and they touched you on the shoulder?
SUSAN: There was someone there.
BARBARA: But you didn't see who it was
SUSAN: No. It was like that. A light touch on the shoulder. I couldn't have been mistaken.
BARBARA: Well, I believe you.

SUSAN: But Grandfather says that it's impossible for anyone to live out there.
BARBARA: Oh, Susan, it isn't that he doesn't believe you. It's just that he finds it difficult to go against his scientific facts.
SUSAN: I know.
BARBARA: Oh, look. Why don't you just try and forget it for the moment?
SUSAN: For the moment.

Barbara's description of the Doctor as fixed in the realm of science emphasizes Susan as the childlike voice of faith and inexperience—the classic feminine role. In the same episode, Susan coos, "You always think of something, Grandfather," and he happily acknowledges that her faith is "something that he prize[s] very highly."

"Susan's character arc through the first ten episodes of *Doctor Who* takes her from homelessness and immaturity to self-discovery and, at last, a place that can be her home," comments John Kenneth Muir in *A Critical History of Doctor Who on Television* (99). However, *The Dalek Invasion of Earth* brings all to an end. At his most condescending, the Doctor tells Susan, "Yes, you little monkey. You know, since you've been away from that school, you seem to have got yourself thoroughly disorganized, haven't you? Yes, you need taking in hand." He even offers to spank her. As this arc reaches a new level of condescension, their adventure breaks up the little family. In earth's future, the human resistance is battling the Dalek invaders, and Susan falls for the attractive human rebel David. At the end of their adventure, Susan feels sad at the prospect of leaving him, and the Doctor appears to sense this. While Susan tells David goodbye, and he pleads with her to stay, the Doctor slips into the Tardis and locks her out. He tells her: "You're still my grandchild and always will be, but now, you're a woman too. I want you to belong somewhere, to have roots of your own. With David, you'll be able to find those roots and live normally like any woman should do." He adds, "One day, I shall come back," and flies away (*The Dalek Invasion of Earth*).

The Damsel in Distress may be the oldest female archetype—only when her prince abandons her or she abandons him, as in Susan's farewell, does she learn to take care of herself in the world. Of course, Susan trades grandfather for husband, keeping a prince who will continue to care for her. In this scene, Susan becomes the first companion (of many!) to suddenly leave the Doctor to marry someone she's just met. "On *Doctor Who*, the women who stay behind to marry inevitably act not as if they have succumbed to passion, lust or love. On the contrary, they act as though they have contracted a strange disease that has drained all traces of personality from them" (Muir 64).

The problem here is Susan's lack of agency. She can't bear to make the decision, so the Doctor makes it for her, brutally locking the door then abandoning her on an alien planet with no one she trusts aside from David. David tells her, "He knew. He knew you could never leave him." Certainly, he has

made the decision in her best interest. But he has the Tardis, giving him access to all of time and space, while she must remain on earth, waiting pointlessly for his promised return.

She appears to have died before or during the Time War: The Doctor reports that he is the last of the Time Lords and that his entire family has died. Later adaptations gave Susan different fates: In the novel *Legacy of the Daleks*, Susan and David adopt three war orphans and name them Ian, Barbara and David Junior; in 2199, she is captured by the Master, but succeeds in stealing his Tardis and presumably going on adventures. In the Eighth Doctor audio drama ironically called *An Earthly Child*, she has a human son with David named Alex (played by Paul McGann's son), and becomes a leader of the Earth Council. The sequel, *Lucie Miller*, shows Susan, a survivor of the first invasion, reaching out to the Doctor through blind faith in him, even while struggling through hopelessness. Of course, he returns for her.

With Susan trading travel for a traditional human marriage, a string of replacement companions arrive—Vicki, Katarina, Dodo, Polly, Victoria, and Zoe. All are female teenagers whose main job appears to be screaming for rescue, though the last is also a clever scientist. The Doctor in turn lumps them and tends to call them all "dear child." On occasion, he appears their babysitter, chasing after high-spirited Ben and Polly and noting, "Oh dear, I suppose I'd better follow them. See that they don't get into any harm" (*The Smugglers*). Most often, the Doctor loses the young lady near episode's end and an (apparently) single-appearance character from that same episode is elevated to companion status. Meanwhile, Steven and Jamie stay on longer, watching with bemusement as their counterparts phase in and out. This attitude of disposable companions all playing the same role emphasizes their unimportance—when the Doctor loses his Susan substitute, he needs only invite another onto the Tardis.

This also emphasizes their status as "girls who waited," decades before Amy Pond. They all have uninteresting lives they can leave at a hat drop to go adventuring with the male hero. "The culture we live in also conditions girls to equate femininity with passive, dependent behavior. They are encouraged to act like Cinderellas waiting for a prince to come, Sleeping Beauties waiting to be awakened," explains Jean Shinoda Bolen in her archetypes book *Goddesses in Everywoman* (200). As a shared archetype, the Innocent is "the 'nameless maiden'; she represents the young girl who does not know 'who she is' and is as yet unaware of her desires or strengths" (Bolen 199). As such, she's on a quest for identity. Before marriage many young women exist in a similar state. She is the "child woman," attractive yet unaware of her own attraction. While Polly in particular comes aboard with her boyfriend, the companions all display a lack of sexual awakening, sailing chastely through the stars and only marrying after they have left the Tardis as Susan and even

Barbara does. Not until Amy Pond in 2010 will a companion travel with her husband.

The teen companions' helpless status is exacerbated by their lack of agency. Jessica Burke in her "*Doctor Who* and the Valkyrie Tradition" describes "Jo, Dodo, and Susan, whiners, shriekers, and mini-skirted little girls with no apparent individual willpower, no recognizable backbone, and no Valkyrie Reflex" (Burke 176). Individually, these women have interesting qualities, but soon enough, they're all left shrieking. Vicki is the first companion the Doctor asks to travel with him on the show. About sixteen, she's lost both her parents, leaving her adrift on an alien planet in the twenty-fifth century. The Doctor, in turn, has just lost his granddaughter. When Vicki plaintively mentions that she has "nobody," in *The Rescue*, Barbara and Ian are as eager to adopt her as the Doctor is. She stays on with them all, outlasting Barbara and Ian's departure. Critic Peter Haining describes her as "far more child-like and naive" than Susan (83).

She's created as a futuristic genius—by the age of ten she had obtained certificates in medicine, physics, computers, chemistry, and other sciences. However, Vicki is just as feminized and helpless as Susan: Her actress, Maureen O'Brien, notes: "I found the role limiting to say the least … to look frightened and scream a lot is not very demanding to an actor" (Tulloch and Alvarado 210). While Ian and the Doctor scale cliffs and dodge spikes in *The Rescue*, Barbara is stuck on a crashed spaceship, comforting a distraught Vicki. They care for a crippled passenger and are menaced by an alien warrior. When they face the Daleks, Ian calls Vicki "little fool." The Doctor calls her "child" as he did Susan. She uses her tech skills to reprogram the Morok armory's computer in *The Space Museum*, but is terrified of heights and must be blindfolded and lowered on a rope in *The Chase*. She gushes with a youthful enthusiasm on meeting Nero and watching Rome burn in *The Romans*. She's a teen with whom fellow teens and children can empathize, not a sex object: While comparing Vicki to Helen of Troy, King Priam says, "If only he'd met a nice, sensible girl like you. I always say it's character that counts, not good looks" (*The Myth Makers*).

In *The Myth Makers,* story of the Trojan War, she falls in love with Troilus, and chooses to stay behind with him as Cressida. Even with his entire society destroyed by the Greeks, she prefers him to the Tardis or her twenty-fifth century home. They presumably sail off with Troilus's cousin Aeneas to found Rome. Like Susan, Vicki gives up everything she's known to live in the distant past, rebuilding a destroyed civilization amid great hardship for the love of a young man (in fact, Vicki leaves the Doctor before Troilus declares his love or agrees to stay with her, leaving her painfully dependent). Her and Susan's identical exits make them conventional and even interchangeable heroines, while setting a heavy precedent.

The Doctor releases Vicki but takes the priestess Katarina (Adrienne Hill) in her place. Katarina is another pushover, as a humble servant to the demanding Princess Cassandra. She calls the Doctor "Great God"—this is an exaggeration of the companion's relationship to the Doctor, but not so far off, as he is the arbiter of their fate with unheard-of technology. She has a quaintly naïve way of speaking ("poisoning of the blood" rather than blood poisoning, "temple" instead of Tardis). Katarina's first job is to nurse companion Steven Taylor while the Doctor hunts for medicines outside the Tardis, but even in this, she pleads helplessness. "She doesn't really understand," Steven says to excuse her, and he's right (*The Daleks' Master Plan*). All Katarina says is "What's happening, Doctor?" leaving her an exaggerated version of helpless companion. "She was really a very simple girl, lost once she was taken out of her ancient world into the high technology of the Tardis," Adrienne Hill reports (Haining 85).

The Doctor by contrast seems to appreciate her ignorant, worshipful attitude: "Oh my dear young man, you ask so many questions. Look at Katarina over there. She doesn't ask questions, she just looks and learns. Now, why don't you try the same thing?" he tells Steven (*The Daleks' Master Plan*). "Katarina! Come over here, my child. Now, have a look at another wonder."

During her first story as companion, she's taken hostage. While the men fumble to save her, and Katarina screams incessantly, she frees herself enough to hit the outer door controls. This hurls her into space. There's a stunned silence as Katarina is the first companion ever to die. After, Steven and the Doctor speculate whether she deliberately sacrificed herself or just "pressed the wrong button." Her epitaph is as the "companion who didn't understand"—one traveling through space while unaware that outer space or machinery could exist, who was swept out into the void without ever truly comprehending that she was in the presence of an alien, not a god deserving of worship. While her sacrifice was brave, it came from incomprehension, and is not even unequivocally presented as deliberate. Further, as a companion from an impossibly primitive time, whom the viewers had met less than a full episode before, she was far less sympathetic than her fellows. The awkwardness of a companion understanding so little certainly motivated her exit. Her episodes have been lost, so her only appearances remain in the audio recording and script, along with a handful of novelized adventures (most of which depict her as a ghost or otherwise experiencing an afterlife).

After this experiment, the show scrapped their plan to pick up Anne Chaplet (Jackie Lane), a Huguenot servant from *The Massacre of St Bartholomew's Eve*. In the episode, Steven Taylor aids the terrified girl. However, they leave her behind and instead pick up her contemporary descendent, Dodo Chaplet, who's played by the same actress but is more relatable. "Dodo was to be a close replacement of Susan, a surrogate granddaughter for the

Doctor" (Tulloch and Alvarado 210). She not only resembled the previous actress—she'd originally auditioned for Susan's role! (Haining 87). With endearing cockney accent and waiflike appeal, she offered a connection for young viewers. Her name Dorothea may have been shortened to "Dodo" by cruel classmates, who thought she was stupid because of her north-of-London accent, at least according to the novel *Salvation*. She's incredibly youthful, especially in personality. Connie Zweig explains in her archetypes essay:

> Women are made, not born. Without enduring the fires of individuation, some remain girls. Carefree and perhaps careless, remain wed to the ideals of childhood, the promise of perfection, the dream of human potential without limits. They remain at without contact with the depths, full of optimistic smiles but unable to bear the burdens of responsibility, the tensions of compromise, the sobering reality of adulthood [183].

From her arrival, Dodo's almost as naive as Katarina. She runs into what she believes is a police box, and the Tardis dematerializes with her inside. Her treatment in her first adventure (*The Ark*), displays Steven's and the Doctor's attitudes towards her. As she tries going out "for some fresh air," Steven stops her, insisting she needs to ask permission: "Look, Dodo, you don't know what you might have found out here. No gravity, poisoned atmosphere, all sorts of things. Look, stop prancing around over there. What happens if you get lost?" She retorts that she could catch a bus, clearly missing the concept of outer space and alien worlds. Meanwhile, she wears a crusader's tabard for no discernible reason, apparently playing dress-up. In all her conversations, she's the child:

> DODO: Achoo!
> DOCTOR: Oh, bless you my dear.
> DODO: Oh, thanks.
> DOCTOR: You have a handkerchief, I hope?
> DODO: Of course I have.
> DOCTOR: Well then, use it, my child! We must do something about that cold of yours. That reminds me, why are you dressed in these stupid clothes? Have you been footling about in my wardrobe? Is that what it is? What do you think you're playing at, crusades?
> DODO: I'm not playing at anything. Is it all right to wear, or do I have to ask permission for that as well?
> DOCTOR: Yes, you do my dear. Now you take care of them because you never know when we might use them. Now, I suggest we take a last look round and we'll get you off to bed [*The Ark*].

Here, the Doctor is at his most patronizing. Later, he tells her to "stop sniveling" and criticizes her use of slang. He also warns Steven not to "frighten the child." The children's games and dolls they encounter in *The Celestial Toymaker* emphasize this image. At episode end, Dodo unwisely takes candy from the Toymaker, which propels them on their next adventure. Steven calls

her a fool in several episodes, noting, "If it wasn't allowed, Dodo would be first in line!" (*The Savages*). In the end, she only has about four-and-a-half stories on television, better than Katarina, but worse than most other companions.

In *The War Machines,* Dodo is taken over by the computer WOTAN. The Doctor fixes her by hypnosis, making her recite, "My name is Dodo Chaplet. I resist all attempts to change me into somebody else" (in contrast with the more mentally forceful Doctor, who resists the takeover on his own). He carts her off to sleep in a friend's house for 48 hours, thus removing her from the action. She parts from the Doctor off-screen as her new friend (and the Doctor's next companion) Polly Wright (Anneke Wills) explains briefly, "She says she's feeling much better and she'd like to stay here in London, and she sends you her love." The Doctor dismisses her with an annoyed, "Her love? Oh, there's gratitude for you. Take her all the way around the world, through space and time, and then..." Her arrival and departure are both treated with little fanfare.

In the Doctor's next scene, Ben announces Polly has vanished, and she smoothly transitions into the next girl-in-distress. Producer Innes Lloyd invests little in Dodo (whom he inherited), and spends more time on Ben and Polly, though he soon replaces them with childlike Victoria. His Bechdel score is 50 percent (Simon). With long, elaborately pinned blonde hair and a splendid figure, Polly was the it girl, played by a popular actress. More conventionally pretty than the waif-like Susan or Dodo, she brings a love interest along. When she first sees Ben in the nightclub, she sets out on a self-appointed "rescue mission" to pick him up. However, an aggressive man starts flirting forcefully with Polly, and as she screams, Ben grabs him in an armlock and literally rescues Polly. These roles continue defining their relationship. He generally calls her "Duchess," evoking the male fantasy of the gorgeous, high class girl who falls for the lowly sailor.

Before meeting the Doctor, Polly is Professor Brett's personal assistant in Chelsea. She meets Ben Jackson and the First Doctor in her favorite nightclub, and is soon entangled in the battle against WOTAN. This early artificial intelligence begins by outcompeting her at her secretarial job and proceeds to try conquering earth through thought control and war machines. It takes over her mind (though not Ben's). Nonetheless, she manages to resist, at least enough to let Ben escape (with her emotions overpowering alien control, as frequently occurs for the companions). It's the men of the story who defeat WOTAN, with Ben physically dragging Polly from its clutches. At the adventure's end, she sneaks into the Tardis with Ben and both sail away.

Polly Wright is very much the embodiment of the then-contemporary 1960's, and the Doctor's gateway to modern times. Even a miniskirt in the sixties meant self-liberation. "While the curmudgeonly Doctor was an incon-

gruous figure in Swinging London, his new companions Ben (Michael Craze) and Polly (Anneke Wills) seemed refreshingly authentic" (Hearn 34).

Ben calls her "our little dolly-rocker Duchess" (*The Smugglers*). She's upbeat, noting, "Anytime you want a bit of brightness in your life, come to Pol" (*The War Machines*). As the first companion to encounter the Cybermen (along with Ben), she gives long speeches on the value of human life and emotion, as the traditional companion's role. She cries, "Millions and millions of people are going to suffer and die horribly! ... But I can't make you understand, you're condemning us all to die. Have you no heart?" (*The Tenth Planet*).

As traditional companion, she's also the shrieking rescuee. Her actress notes that she wanted to play her "scatter-brained" and "kooky," adding, "I thought it would be a very good idea to play a total coward. Television was full of brave ladies in those days. I wanted to play a sort of feminine anti-hero, a weedy, frightened lady who screamed and kicked and shouted 'Doctor' at the least sign of danger" (Haining 87–88). She's condemned to be converted to a fish person in Atlantis. In *The Tenth Planet,* she's stuck making the coffee. She actually attacks Cybermen with nail polish remover in *The Moonbase.*

Like several other companions, Polly longs to return home: Her thoughts are audible in *The Underwater Menace* as she nonverbally chants, "Please let it be Chelsea, 1966." Like her predecessors Barbara and Dodo, she departs the Tardis when it just happens to return to her own time. The Doctor's goodbye to her is traditionally gender-coded as he says, "Off you go. Now go on, Ben can catch his ship and become an Admiral, and you Polly, you can look after Ben" (*The Faceless Ones*). It's implied this is exactly what happens. Spin-off stories see the pair marrying, divorcing, and reconciling, as well as meeting various later Doctors. In 2010, Sarah Jane Smith mentions that Ben and Polly are running an orphanage together in India (*Death of the Doctor*).

With the First Doctor regenerated into the Second and Highlander companion Jamie onboard, the pair find another surrogate daughter type. With her wide curls and high voice, Victoria Waterfield (Deborah Watling) is a hostage for her more important Victorian father. Dressed in an elaborate ballgown, she innocently feeds the birds. However, the Daleks force her onto an evil-looking metal scale, where she sobs and covers her ears in pain. Even the Daleks appear to sympathize with her as (uncharacteristically) they tell her "Do not be afraid. You are not to be exterminated." She's probably the youngest of all the companions, first introduced as terrified and sobbing in despair. Inspired by a painting that resembles her, Jamie sets out on a desperate rescue mission and the men carry her away.

Watling notes: "I was first seen in *Doctor Who* screaming at the Daleks, and I think I continued screaming for the next year. I screamed myself hoarse at every monster that came in sight" (Haining 90). In her last episode, *Fury*

from the Deep, Victoria's constant screaming finally has a practical use, destroying the monsters. Of course, giving her screaming power is more parody than a blow for feminism.

Screaming companions come straight from horror or similar genres that sensationalize the story and give the women little agency. Violence against women is frequent onscreen, as it provokes a visceral terror in both genders.

> As slasher director Dario Argento puts it, "I like women, especially beautiful ones. If they have a good face and figure, I would much prefer to watch them being murdered than an ugly girl or a man." Brian De Palma elaborates: "Women in peril work better in the suspense genre. It all goes back to the *Perils of Pauline*.... If you have a haunted house and you have a woman walking around with a candelabrum, you fear more for her than you would for a husky man." Or Hitchcock, during the filming of *The Birds*: "I always believe in following the advice of the playwright Sardou. He said 'Torture the women!' The trouble today is that we don't torture women enough" [Clover 234].

Film analyst Carol J. Clover adds: "Angry displays of force may belong to the male, but crying, cowering, screaming, fainting, trembling, begging for mercy belong to the female. Abject terror, in short, is gendered feminine, and the more concerned a given film with that condition ... the more likely the femaleness of the victim" (240). Taking on this lesson, all the young women are hyper-feminized, sobbing and shrieking for rescue. Rage and power are rare.

Soon enough, Victoria's dress gets shortened. Her actress candidly notes, "Over the episodes the hemline crept up and it became a mini-pelmet. The show used to go out after the football on Saturday, so it had to appeal to Dads as well" (Hutchinson). When the character protests, the Doctor quips, "A bit short? Oh, I shouldn't worry about that. Look at Jamie's" (*Tomb of the Cybermen*). Jamie, in fact, soon joins in.

> JAMIE: Did you see how those lassies were dressed?
> VICTORIA: Yes, I did. And trust you to think of something like that.
> JAMIE: Well, I couldn't help thinking about it.
> VICTORIA: Well, I think it's disgusting, wearing that kind of ... thing.
> JAMIE: Oh, aye, so it is, so it is. You, eh, you don't see yourself dressed like that then?
> VICTORIA: Jamie!
> JAMIE: Oh, I'm sorry. It was, eh, just an idea [*The Ice Warriors*].

Peter Bryant produced and script-edited the show from the Second Doctor's *The Web of Fear* to *The Space Pirates* and cast Jon Pertwee before leaving. The only character to leave under his reign, Victoria, makes an assertive departure without an instant marriage, insisting (rather like Tegan) that the adventures have been too harrowing. Of Bryant's ten stories, 80 percent pass the Bechdel test, an impressive score (Simon).

Of course, damsels in danger continued appearing, in the background

if not in the Tardis. In *The Daleks*, Dyoni, the only named female Thal, is a significantly unempowered young woman with dialogue like "I have no opinions in the matter" and "It would have been better if you had given it to a man instead of a girl." She's accustomed to being overlooked (especially since her comrades have known her since her girlhood) and to her gender going second.

Sixteen-year-old Ping-Cho travels with Marco Polo to Peking, so she can marry a member of Kublai Khan's court. She and Susan become friends and Ping-Cho smuggles Susan the lost Tardis key. During the trip, she falls for Ling-Tau, one of Khan's messengers. When her intended husband dies before her arrival, she wins the chance to wed her love, though through no action of her own. This gentle love plot lacks agency and thus casts Ping-Cho as another weak damsel.

The Crusade also offers an arranged marriage as Maimuna's father refuses to give her to the emir El Akir. Consequently, the emir simply takes her and convinces her he has killed her family. Though she's powerlessly shut up in a harem, she hides Barbara there and faces down the guards, insisting, "What do you want in here? Are you both drunk? Or mad?" She seamlessly lies that no one has come, protecting her friend. Clearly, she's determined, clinging to life despite the dictates of her culture. As she tells Barbara, "At first, I tried to kill myself to spare my father's honor. But when I believed him dead, I did not even have the will to die." Just as El Ekir draws his sword to kill her for protecting Barbara, Maimuna's father saves her and she returns to her family. The story is more than a little sexist and racist, as the Muslims use Maimuna as a helpless prize, but she stands out for her generosity and loyalty.

Sabetha, a young woman in *The Keys of Marinus*, teams up with Susan. The pair advance the plot and solve puzzles as a team. Still, when she first appears, Sabetha's a hypnotized pawn that Barbara struggles to break out of her programming. In *The Dalek Invasion of Earth*, Jenny likewise provides a young sweet-faced girl for Susan to pair with. In a more assertive revision of the damsel, she's a capable freedom fighter, in charge of assigning jobs.

Kirsty, daughter of the laird of Clan McLaren in *The Highlanders*, tends her father's wounds. Having just seen her people lose the battle, she seems rather hopeless, responding to the prisoner slaughter with "We can but mourn," while Polly insists they arrange a diversion. (Polly also calls her a "stupid peasant.") When they fall in a pit, Kirsty despairs yet again, even as Polly helps her climb out. "Didn't the women of your age do anything but cry?" she asks. The two women team up for large chunks of the story and have many lively conversations, despite Kirsty's wobbly emotions. They also take a soldier prisoner and mock him. "So, I bet the Colonel would be highly interested to hear how his Lieutenant Finch was captured by two girls," Polly gloats. She gets to shine, contrasted against the weaker damsel.

Many generic girls become stand-ins with no personality at all, even in a short list of characters. Ara, the serving girl in *The Underwater Menace*, delivers messages, though she does save Polly in a display of sisterhood. Likewise, Kando, a bright-eyed teen, is part of an academic field trip. However, she spends most of her time held prisoner by the Dominators, until Jamie helps rescue her. Elizabeth, a young woman in Restoration England, sees the sky filled with light and alerts her father (*The Visitation*). When an alien android attacks, her brother hands her a musket so she can fight, but the entire family is killed nonetheless, just to drive forward the plot.

In *Fury from the Deep*, Mrs. Maggie Harris, whose husband is second in command to Chief Robson, spends most of the story isolated and possessed by the seaweed. She also lets possessed assassins in through the front door when they knock. The story presents her as a fluff-head and victim.

Vana joins the Krotons in the episode of that name, an act described as "a great honor," but which is clearly exploitative—in fact, her mind is so excellent that the Krotons wish to sap her energy. The Doctor saves her by placing her in a coma for half the episode—making her a wimpy Sleeping Beauty figure to be rescued.

In *Black Orchid*, Ann Talbot, Nyssa's lookalike, has transferred her engagement from one lord (presumed dead) to his brother. Clearly, she's something of a ninny. When she's attacked, she accuses the Fifth Doctor because she recognizes his costume. The Doctor's reasoned arguments—that someone else must be mimicking his costume and that he has no motive— are no match for her hysteria. Nyssa is taken hostage in her place, but Ann continues to be a damsel, misled by ex-fiancé and mother-in-law in this creepy family dynamic.

There are other good-hearted screamers in the series. Anita (Carmen Gómez) rushes to help the crew of the Tardis when she encounters them in the countryside. However, her help leads to aliens killing her boyfriend at her Spanish restaurant (*The Two Doctors*).

Sweet Flowerchild tries escaping the circus of *The Greatest Show in the Galaxy* in a lacy floral dress with her boyfriend. "Oh, Bellboy, please. You promised. You know it's down to us now. We're the only ones left to fight. Come on," she pleads. She kisses him, gives him an earring, and insists, "One of us must get there." Though Bellboy tries to draw fire, the creatures controlling the circus find and strangle her. Aram, a fine-boned blonde, begins *Timelash* running away with two young men. Within a minute or two, the enemy catches and vaporizes her, setting the scene with her pathetic death. Both women tear the audience heartstrings with their death but thus become props, not people.

In her long, purple gown, the young noblewoman Vena (also of *Timelash*) goes along with the government. She insists, "The Borad has promised

all of us a better place in which to live. We must trust him." She comes across as naïve, unwilling to make a fuss. However, she defies her father and fiancé to save her lover—stealing a time traveling amulet and heading off on a great adventure all the way to earth, where she meets H.G. Wells. The Sixth Doctor persuades her to give him the amulet, but she insists on coming along, adding, "Doctor, it is my planet, and they are my people. Either you take me back with you now, or the amulet stays here." She returns with him and aids in a rebellion, emphasizing how some ingenues are still willing to take a stand.

Jenny, played by the real-life daughter of the Fifth Doctor, Peter Davison, demands a relationship with the Tenth Doctor, greeting him as her dad on her arrival. "I have a body, I have a mind, I have independent thought. How am I not real?" she asks ("The Doctor's Daughter"). Jenny is a soldier, but as she notes, the Doctor is one as well—he lacks moral superiority. The two sides of her character battle: programmed soldier and young Time Lord as she decides who she will become. Her struggle echoes the Doctor's conflict: his rage at the Daleks versus his morality, as Jenny, like so many antagonists, reminds him he is a killer as well. "The Virgin is a symbol of that Innocent in each one of us that is totally undefiled and pure no matter what we have done or what has been done to us" (Pearson 76). Thus, she becomes a symbol of his lost innocence, even as he charges into war.

She's a determined, spunky character who displays a Time Lord's intelligence and creativity. She acts as a companion, and the Doctor invites her to travel with him. Eventually, she sacrifices herself for him, then regenerates, proving by the first act as much as the second that she's a true Time Lord. However, Jenny kisses the guard to escape their cell—a weakening example of clichéd feminine wiles. When the Doctor distracts a guard with a clockwork mouse, Jenny clobbers him to the Doctor's dismay.

> It is the Doctor's moral honesty that prompts his own daughter—born of an alien cloning machine in Davies's final season—to abandon her ideological fundamentalism and turn from warrior to healer. As Martin Amis argues in an essay on nuclearism, progress can only be made when we confess to our own children the moral horrors for which we are responsible: "we will have to take deep breaths, wipe our eyes and stare into theirs, and tell them what we've done" (33). Unknown to the Doctor, his daughter survives somewhere out there in the universe [Charles, "War" 462].

Moffat's "Blink" introduces Sally Sparrow, a kindly shop girl who communicates with the Doctor through Easter eggs on her DVDs to stop the terrible Weeping Angels. As she follows his directions, she becomes a stand-in for the viewers. There are many jokes about her lack of DVDs and up-to-date technology. It's also notable how much she's being watched—by the angels, especially. This trend reflects how men always watch her too—Billy asks her on a date right away, and mentions several times that she is "hot"

and "gorgeous." This ties in with the male gaze—on too many shows, men watch the women, and women watch themselves being looked at. They are framed as the object, there to be admired. Nonetheless, she's resourceful and clever, determined to help the endangered Doctor.

Sophie is Craig Owens' love interest in "The Lodger." She hangs around waiting pointlessly for Craig to notice her, until the Doctor pushes her into going out and exploring the world. This he does, emphasizing that she can do anything she wants. The Doctor also matchmakes her and Craig together. It's a sweet moment in a story framed as the Doctor's adventure in becoming normal—thus Sophie and Owen are some of the most normal people on the show. However, she displays a lack of agency without the Doctor's pushing her.

On the show *Class*, April is cheerfully arranging the prom no one's asked her to, in a sky-blue dress covered with clouds. She's the epitome of the nice girl, though only in the first episode. At prom, April breaks out of her comfort zone. When she tells the students to run because the aliens are invading and they dismiss her, she springs to the stage and screams at them all. "Will none of you people listen to niceness ever?" she demands. "You'd listen to me if I was some A-hole telling you how fat you looked on Instagram!" ("For Tonight We Might Die"). In this moment, she claims the power of anger and assertiveness. In fact, this prepares her for a great trial. During the episode, the alien invader invades her heart. Though the teens banish him, April and the alien king remain linked.

Through the course of the show, the girl with half a heart and Ram, the cool kid with half a leg, start dating. More importantly, April grows immensely. With a sword in each hand, dirt-smeared, April has become an apocalyptic warrior by year's end. She tells Ram that she doesn't "need a knight in shining armor" (though this is undercut when she faints in his arms an instant later). She duels the king, defeats him, and becomes the shadows' new king. This is absolutely the Innocent's journey to total strength. However, as her father and Ram try persuading her to show mercy, they're clearly disturbed by the tough warrior she's become and miss her lost innocent side. She does show mercy, but adds, "I get the last word." On her order, the Shadow Kin lock their former king away and battle her enemies—the murderous pink blossoms that herald an alien invasion. Clearly pink and pretty need not be equated with goodness—shadows in the now-fierce April's service can redeem the world.

Kid Power: Maria, Rani and Jorjie

The Sarah Jane Adventures, specifically a children's show, begins with teen Maria Jackson moving to a new town. The first night in her new home,

Maria sees her mysterious neighbor, Sarah Jane Smith, talking with a glowing, winged alien. Instantly she realizes there's a world beyond what she knows. Despite her youth, irrepressible Maria shows initiative and heroism. When they're evacuated from the sinister Bubbleshock factory, Maria goes back for her new friend Kelsey. There she saves the artificially-created boy Luke and becomes his friend. Throughout the episode, she insists on being part of Sarah Jane's adventures despite the danger. The older woman finally gives in.

> SARAH JANE: I suppose you've seen too much now. It's not as if anyone's going to believe you. Aliens are falling to Earth all the time. It's not just those stories you hear on the news. All sorts of creatures. Some have got lost, like the one you saw me sending home last night. Some of them crash-land, and some of them want to invade. You still believe me?
> MARIA: Yes.
> SARAH JANE: Really? How come?
> MARIA: Because you're bonkers, but I don't think you're a liar [*Invasion of the Bane*].

"Sarah Jane recognizes Maria's inner strength and sees her as a kindred spirit," Jennifer Stuller explains in her book on mighty heroines (125). Though Maria asks, "Don't you wish you had found someone special to share it with?" Sarah Jane hugs her and says, "Oh I think I have. For the second time."

Sarah Jane adopts Luke and becomes team leader to Maria and the other neighborhood kids. Like the final teammate, Clyde, Maria is the normal one of the group, but she's also a younger version of the clever investigator. "What's wonderful to see are the scenes between Sarah Jane and Maria; they brainstorm and problem solve, they comfort and support one another, and they mirror each other" (Stuller 126). While she's less trendy than Clyde, she appears braver and fiercer. The three kids make up most of the hero team, empowering young viewers with their cleverness.

Of course, Maria's the white female best friend in the typical children's show split of white male hero, white female best friend, black male best friend. The balance shifts when she moves away, allowing a new little girl to take her place.

Rani Chandra is television's first Indian-British companion. She's independent, confident and loyal, a gifted young teen who relies on her friends and inspires trust. She's interested in history and journalism, like Sarah Jane and other past companions. While she appears romantically interested in Clyde, she doesn't turn soft or pathetic because of it. Like a few other companions, she must contend with general racism when she time travels, as she does, several times, alone. Still, she handles it with confidence and humor. "Yes, hello. Ethnic person in the Fifties. Hi. Listen, please. It's important," she babbles (*The Temptation of Sarah Jane Smith*).

When her mother is kidnapped by the villainous Mrs. Wormwood, Rani and Sarah manage to rescue her together. Rani helps defeat the Slitheen and Blathereen, the Mona Lisa, and Erasmus Darkening and helps Captain Tybo catch Androvax, the Judoon's most wanted criminal. She steals a peek into the Tenth Doctor's Tardis when he arrives for Sarah's wedding. At last, she's elevated to Lady Rani by an alien robot, fulfilling a children's power fantasy. Like the other kids, she rules the show, emphasizing that young people can save the day. Rani finally becomes a mentor for Sky on how to be a teenage girl.

Sky, born in the fifth series, is another magical child. Sarah Jane opens her door to discover a baby in a basket. "Oh, why would anyone leave you on a stranger's doorstep?" she asks. The baby cries and all the light bulbs explode, giving her a startling answer. She frets, "A teenager I can handle. But a baby? An alien baby? I need help." This of course marks a new life stage for Sarah Jane. "Having a daughter becomes a metaphor for mothering the self—the magical child within. Sarah Jane names her Sky, evoking the magic of the heavens and joy of space travel—a magical name for a magical child. She is the Divine Child as River is, a girl partly human and partly magical, with an alien mother and an earth mother, gifted with supernatural abilities and a destiny" (Frankel, *Doctor Who and the Hero's Journey*).

The villain of this story is Miss Myers, who has cloned Sky to use as a living bomb. She explains that her child "has a destiny. A destiny to change worlds, and that some will do anything to destroy" (*Sky*). At the end of her first episode, Sky suddenly grows up into a twelve-year-old, primed to go on adventures while Luke is at college. The moment Sarah Jane tries leaving her behind, she runs into danger, claiming the chosen one's path. As she tells her foster mother, "You've been kind to me, Sarah Jane. You've tried to keep me safe, but this is what I was created for.... Maybe this is why I was brought here. To save Earth" (*Sky*). Filled with wonder, admiring the "beautiful, noisy, smelly" world, Sky is primed to become the next generation of hero, though she doesn't get many episodes. The show suddenly ended with Elisabeth Sladen's terminal cancer.

The Sarah Jane Adventures emphasize how dependent fictional children are on their parents and the family rules, as well as their lack of power in an adult-run society. The other children's spinoff makes the same points. *K-9* (2009–2010) is set in near-future London, with the teens battling an Orwellian dystopia in the year 2050. The show, aimed at young teens, is co-funded by Disney & Park Entertainment, and filmed in Australia with no overt Whovian references for copyright reasons. It stars fourteen-year-old Starkey (the brave rebel), Jorjie (the girl hacker), and Darius (the messenger boy) alongside Professor Gryffen, and an updated K-9 Mark II (voiced by original K9 John Leeson).

In episode one, as Starkey heroically posts rebellious messages, Jorjie Turner (Philippa Coulthard), bursts in and insists on working with him. When he refuses, she keeps following him like an irritating kid sister. Asked what she wants, she replies, "Same as you. To make a difference.... I admire your work. I want to help." She's also hacked him to discover his identity, the better to present her case. In episode three, she tracks him down in the forest to bring him a picnic, blushing prettily. As she tells him, "You said you had three hiding spots. I've already checked two" ("The Korven"). Wearing her cheerful red and purple, she's a force of brightness as well as determination. Later, when he's locked in a VR prison, she hacks in to show him images of aliens locked up and experimented on in a secret facility ("Regeneration"). As she insists over and over that he use his skills to help, she's the hero-enabler, like a companion. It's a feminine role but not a terribly progressive one. She also finds herself in a love triangle with her two friends, another gender cliché.

In episode two, Starkey and Darius break into the prison and are penned up with an alien ingloriously nicknamed Mr. Wiffy. Poised and self-confident, Jorjie smiles, "You boys can't do without me, can you?" and breaks them out ("Liberation"). However, the prison governor corners the boys and gloats, only to be undercut by June Turner (Robyn Moore), a poised middle-aged inspector for the nebulous "Department" in charge of alien threats. Repelled, Darius retorts, "Mr. Wiffy might be stinky, farty and gross, but, lady, you're a monster." To the charge of "imprisoning innocent aliens," she coolly replies that she's doing this for the future and humanity's children. Just then, Jorjie bursts in to announce she's appalled by her mother's secret job. As the freedom-fighting youth and agent of totalitarianism, they're set at odds through the show. While June is a loving mother, she believes in rule of law and cannot accept the children's actions. Jorjie's rebellion is revealed as an adolescence metaphor, fighting with her parent as well as struggling to repair the world.

Class introduced a specifically teen spinoff in 2016. It's quite self-aware: At episode beginning, the student Tanya tells April that by asking about her prom date they've failed the Bechdel test then and there. They also know many tropes of science fiction and heroism.

Tanya (fourteen to the other kids' seventeen) harnesses her genius by trading homework help for cash in her online game. She's frustrated because being skipped two years ahead means she feels like a kid sister. Her mother, denying her prom, calls her a "little girl." (To go, Tanya must write an essay about how missing it would stunt her interpersonal development.) As the show continues, she struggles with the hero-teens' lack of acceptance: "You only tolerate me. You look at me like a little sister or a baby," she protests ("Detained"). Nonetheless, in the same episode, she uses an alien prison

device to engineer an escape for them all. She makes herself part of the team though she's the only one of the five not romantically connected, and indeed, feels too young for it. In the final episode, her mother is devastatingly killed, and then the Shadow Kin come after her brothers. As she succumbs to grief, Miss Quill, the evil alien teacher, warns her, "You have a choice, then, don't you? Let it consume you and die yourself, or face your future with spite, with defiance" ("The Lost"). Tanya demands a warrior's training and fights beside Quill, saving her brothers and responsibly hustling them out of town even as she deals with the earth-shattering loss. While Quill is pregnant, it's Tanya who's becoming mother-protector to her family.

Back on the main show, Bill befriends Kitty, the street urchin and thief of "Thin Ice." The Twelfth Doctor smiles, "Oh, I see! I get it. You lure people to the fair and then you rob them. Very good. Very enterprising." He treats Kitty as the children's leader, negotiating with her as he warns her little family of their danger. Meanwhile, when he meets Lord Sutcliffe, who's been sacrificing them all, the Doctor lectures him, using the children as a prop: "Human progress isn't measured by industry, it's measured by the value you place on a life. An unimportant life. A life without privilege. The boy who died on the river, that boy's value is your value. That's what defines an age. That's what defines a species." The story emphasizes the value of the most disposable people—the street kids. The Doctor leaves Sutcliffe's house to them, reversing their fortunes and giving them a happy ending.

Sharon Davies, created for the *Doctor Who Weekly* comic strip by writer Pat Mills and artist Dave Gibbons, is the first recurring companion of color. "Just as with Izzy Sinclair in the Nineties, comics showed themselves far more willing to embrace a bit of diversity than the TV executives of the day" (Ingram). From a steel mill town, the "gobby, streetwise schoolgirl" is poor but smart (Ingram). She's also young and lively, stowing away with the Doctor and refusing to go home since she's having fun. She's "that rarest of things, a kid sidekick who was actually believable to kids" (Ingram). On their adventures, she grows up enough that she never does return home, instead finding marriage and happiness on an alien planet. Thus, she becomes a truly conventional companion in the end.

Before Governess Clara's young charges, children appear in a few *Doctor Who* adventures. Stellar, a six-year-old girl in a poofy princess gown shopping with her mother, actually befriends the dragon in *Dragonfire*. She seems to add a moment of whimsical cuteness, but little more. Meanwhile, *Survival* introduces a frightened little girl in overalls, called the silly nickname "Squeak." She tells Ace that the "bad cat" killed her own pet. With an arm around the little girl, Ace comments, "Her gran's the next floor up. I'll take her." As Ace's eyes flare with the wild side she's picked up, she defends her community and its most helpless inhabitants.

In *Survival*, Ace meets a childhood friend, Ange, and reveals she's come home to "catch up a bit." However, Ange tells her most of her friends have vanished. Yanked into a wilderness, Ace discovers the other teens are being preyed on by cheetah creatures. The teen boys sit haplessly in the woods, while Ace and her Indian friend Shreela construct snares and fight with torches. Only the third female writer of the show, Rona Munro cleverly constructs a mix of female characters here, with the girls notably more heroic.

There's CAL, Charlotte Abigail Lux, who loved libraries so much she is given a library to watch over forever as a computer program after her death. Despite her fear and confusion, she saves every visitor to the library, preserving them in her memory banks and then restoring them. In "Fear Her," Chloe Webber is possessed by an Isolus alien. She's the child of abuse, filled with nightmares. When her mother refuses to talk about her father, she draws endlessly, and the possessing alien lets her capture people and keep them trapped in drawings. However, the nightmare of her father comes to life and intimidates her. Her mother and Rose figure out how to free this most vulnerable of children and allow her to heal. She, like Squeak, needs protecting, casting little girls as the emotionally fragile rescuees. Sometimes, like CAL, they're more than children, and must step up and save the world.

"The Doctor, the Widow and the Wardrobe" features rowdy companion kids Lily and Cyril, who journey to an alien planet, making the Doctor come after them. With them, he gets to play uncle, creating a house of delights and treats, which he revels in as much as his young friends. With Young Amy Pond too, he's goofy and childish, giving her a one-night adventure she always remembers.

"The Doctor Falls" introduces a house full of children, including Alit (played by 11-year-old Briana Shann). With her poofy hair, she appears she's going to be young Bill. Instead, she befriends the companion, as the only kid not frightened of Bill-as-Cyberman. As such, she gives Bill a touchstone and someone for whom to fight. Alit deserves a bonus for accepting a jelly baby from the Twelfth Doctor. Finally, she actually blows up an entire squad of Cybermen by throwing "humanity's first weapon," an apple. It's actually an exploding one, which Nardole terms "the ultimate apple upgrade." She stands out from the other children for her compassion and for defending her home as a warrior. After, she heads up her friends, leading them all to a new land.

A Twelfth Doctor comic series has him move in with the Collins family in 1972 after he sacrifices his Tardis (temporarily) to cure their father of an alien infection (*The Pestilent Heart*). Lloyd Collins is British, while his wife Devina is Jamaican. Their children, Jess and Maxwell, enjoy the Doctor's creative adventures, while the parents find him a hilariously troublesome and sometimes irritating houseguest. Once again, the Doctor proves a fun play-

mate for the children, as the adults wish he'd take things seriously. After five comics together, the Doctor finally departs.

Fans of esoteric *Who* may recall John and Gillian, the Doctor's bubbly grandchildren from the early First Doctor comic strips. "The Doctor's first wholly original comics companions were introduced in his debut strip adventure, back in *TV Comic* #674 (1964)" (Ingram). However, these irritatingly precocious grandchildren "were really more plot devices than characters, serving only to give the Doctor someone to explain things to during the course of his deeply odd adventures" (Ingram). When *TV Comic* licensed Jamie McCrimmon in 1967, the kids were hastily sent to college. Though they make continuity problematic, the novel *Conundrum* by Steve Lyons takes the Doctor into the Land of Fiction, where he encounters the incredibly perky characters.

> "We thought you were gone forever!" shrieked Gillian delightedly.
> "You're regenerated again," enthused John, pulling at the Doctor's jacket with fascination as he sized up the Time Lord's unfamiliar appearance.
> "I..."
> "Never mind that," Gillian interrupted. "Grandfather, you've got to help us. The Kleptons are here..."
> "...and the Trods!" put in John [195].

Digby and Franny, Governess Clara's children in "The Snowmen," are frightened and vulnerable yet perceptive as they share Clara's secret life. Fictional children are confidantes and aids, helping the heroine by noticing things she can't. Hero children return with modern Clara's wards, Angie and Artie Maitland. As she travels with the Doctor, the kids find themselves coming along in "Nightmare in Silver," only to discover the promised amusement park has been taken over by Cybermen. Jaded adolescent Angie enjoys testing the limits of her independence, a classic trait in a companion, as she wanders off defiantly. Though she's held as a hostage (like early companions), Angie nonchalantly contributes a solution, adding, "Am I the only one paying attention to anything around here?" She offers the voice of reason and simple observation. Meanwhile, in "The Rings of Akhaten," Clara uses her nannying power to reassure a frightened girl, chosen to sing a special song to a god. The small, fantastically-dressed alien girl is quite relatable as she suffers from stage fright and summons her courage to do the right thing. Like many children, she adds a vulnerable sympathy to the episode.

While *Doctor Who* began as a children's show starring teen Susan, it's the Coal Hill episodes that make this feel like a children's show in truth. After Clara becomes a teacher there, Courtney Woods, an African-British student in Clara's class, takes pride in her reputation as a "disruptive influence" ("The Caretaker"). She's clever but bored in school, finding plenty of excuses for why she can't do her work. She discovers the Tardis and the Doctor takes her

for a ride (making her vomit). Clara is appalled when the Doctor says Courtney isn't special, so he takes them on a trip to the moon, where Courtney insists they not kill the creature hatching there—an insight that turns out to be right. The Doctor says she'll be President of the U.S. someday, emphasizing how her disruption can channel itself as courage and strength ("Kill the Moon").

Meanwhile, "In the Forest of the Night" emphasizes the predicament of the students—the Doctor proposes settling them all on a planet somewhere when the Earth is doomed, and Clara must protest how badly that would work. They are her responsibility, her burden, or so it appears. At last, the children prove able companions, broadcasting a message to mankind that they must allow the wiser trees to save them. Like many stories, this one emphasizes the adults' foolhardiness and children's wisdom.

Loyal Assistant: Jo Grant

In 26 years of original show, the Doctor had thirty companions, twenty-one of whom were female. Only four episodes have just a male companion (*The Massacre, The Evil of the Daleks, The Keeper of Traken, and Planet of Fire*) and in all, he picks up a female. The stereotypical gender behaviors often found in the show should also be noted: Women are seen empathizing, admiring, fawning, screaming, crying, complaining, pleading, and being rescued. They're clumsy, naïve, frightened, and uneducated. Often they fall in love and marry or get left behind for other reasons.

The Doctor by contrast drives (especially the Tardis) and selects the destinations. Arrogant and adventurous, he knows all the scientific facts, wields the screwdriver, saves the day. He's the one to negotiate with or threaten aliens (who revenge themselves on *him*, but treat the companions as pawns). As he lectures, explains, and orders, the show comes across as significantly patriarchal, a pattern that mostly remains through New Who. "Patriarchal thinking—Western rational linear thought—tends to reduce our existence to one extreme: order and control. When we succumb to this reduction of our lives, we lose contact with the reality of our greater human mystery as well as that of the entire cosmos" (Leonard 16).

"Someday there will be girls and women whose names will no longer signify merely an opposite of the masculine, but something in itself something that makes one think not of any complement and limit, but only of life and existence: the feminine human being," hopes poet Rainer Maria Rilke (qtd. in Zweig 183). However, this assertive companion is not to be found in the show's many obedient assistants.

In season eight (1971), the educated Liz Shaw was replaced by "a more

traditional female lead," the "daffy, helpless damsel type" (Muir 21). After the many interchangeable girl companions (plus a few stand-out scientists), producer Barry Letts wanted Jo Grant (Katy Manning) to be different. He explained: "The last thing that I want is just a pretty doll or somebody who can just stand there and scream. We have got to have somebody who has got a strong personality in their own right" (Tulloch and Alvarado 211). As it turned out, about 50 percent of the episodes he produced passed the Bechdel test (Simon). However, the new character was quirky but unassertive.

Jo Grant appeared in sixties-style miniskirt, boots, and wispy blonde hair, representing "Chelsea Road 1960's" (Tulloch and Alvarado 211). She was "very small, very cute, and as it happened, very short-sighted," script editor Terrance Dicks explains (Haining 155). When Jo started running in her first adventure, she crashed into a tree. Later, she did a roll from a moving car and "strained all the ligaments" ("Days Gone By").

The character seems incompetent at both science and the spy game. In her first appearance, she sprays the Doctor's new project with a fire extinguisher (it's smoking!) and costs him three months' work. He calls her a "ham-fisted bungler" and greets her announcement that she's his new assistant with a plaintive, "Oh no!" In their first conversation, she reveals she's never heard of steady state micro-welding and is puzzled by a mention of opposable digits. (In contrast with her predecessor the Cambridge professor, Jo notes that she took "general science at A-Level"). In the episode, the Master hypnotizes her into bringing a bomb into UNIT, and she seems pure liability.

Dicks also describes Katy Manning being "late, desperately nervous, short-sighted" and with a "hacking cough" but also "just so lovable" (Tulloch and Alvarado 211). Dicks, script editor of 28 stories, is at about a fifty percent Bechdel rate, and the six scripts he wrote all pass (Simon). Despite this, he famously ditched the capable Liz in a step backwards in progressivism. Further, two of his edited scripts, *The Time Monster* and *The Time Warrior,* specifically mock feminism. Christine Cornea explains on her essay about Second Wave: "While Jo could be described as more free-spirited than Liz, her central purpose was to ask numerous questions that allowed for expository speeches from the Doctor and to act as counterpoint to his heroic exploits. In this, she was a reactionary figure and any adjustments made in the name of feminism with her characterization were purely cosmetic." Jon Pertwee's era had the worst ratio of male to female characters, and given the other statistics, this is unsurprising.

Though UNIT is a professional organization, far from the family unit of the Tardis, Jo is another naïve teen who sees the Doctor as a surrogate parent. In disguise in one episode, she calls him her "uncle." In traditional gender behavior, she's held hostage to coerce the Doctor. Caring for him in his illness, she gets labeled "A proper little Miss Nightingale." In *The Claws of Axos,* she

screams constantly in an extremely short skirt that reveals the color of her underwear. When she wears a fancy evening gown for a date with Mike Yates, the Doctor sweeps her off to Pelladon, where she has one of the few romantic scenes in the original show.

Jo's childishness inspires the arrogant Third Doctor's compassion, making her a good foil, if a weak companion. Her high-pitched voice, puffed sleeves, and short dresses code her as young as much as her naiveté. The Doctor in turn is condescending as well as protective. When she's gagged, the Doctor notes, "You know, I've got a good mind to let you stay like that. So much more peaceful. In any case, even if I released you, you'd probably ask me a lot of fool questions" (*Day of the Daleks*).

In the same episode, Anat, the icy dark haired military woman with her stilted speech contrasts with emotional, childlike Jo. Anat is ruthless: she says, "We are soldiers, not murderers" but nearly executes the Doctor through mistaken identity. She's coldly controlled and calls Jo "child," adding "don't be silly!" and finally noting, "Stupid child! You do not know what you are doing." Meanwhile, naive Jo blithely has supper with the controller, not realizing he's a slave of the Daleks. While the Doctor debates morality with him, Jo protests that the Doctor shouldn't be rude.

Jo was like "the hip and independent young woman of the 1970's, but she was still scatterbrained and emotional" (Layton 105). For instance, in *The Daemons,* Jo professes her belief in magic, the supernatural, and the Age of Aquarius, while the Doctor winces at her unscientific outlook. In "The Green Death," she shows her environmentalist side, crying inarticulately: "No! No, look it's time to call a halt! It's time that the world awoke to the alarm bell of pollution instead of sliding down the slippery slopes of, of, of, whatever it is."

Jo's role throughout this series can look oddly uneven from both perspectives. In *Day of the Daleks,* she fetches and carries for the Doctor and for UNIT, is fearful of ghosts and seems naively trusting when the twenty-second century Controller tells her how wonderful life is. She arrives on Peladon in a posh frock and hairdo, ready for her date with Mike Yates. She spends a great deal of time in *The Mutants* being captured, rescued, captured again, swept up in the arms of a good-looking hero. In *The Time Monster,* she mostly tags along after the Doctor, to Cambridge and to Atlantis, where she's promptly sent off for another groovy frock and glam hairdo. It's so in keeping with 1972's expectations, and so alien to a modern viewer [Nichols].

Nonetheless, she has a sneakily clever and self-sufficient side despite her first appearance: She's the one to explain to the Brigadier that "superluminal" means faster than light. She also saves the Doctor on their first adventure. She eventually learns to resist the Master's hypnotism by reciting nursery rhymes, a juvenile but assertive act (*Frontier in Space*). She knows karate and can pilot a helicopter (proving that UNIT has some entrance criteria). Though

Jo screams at monsters in *Frontier*, she quickly reorients and charges off to the sailing ship because "they must have rope somewhere." She flings grenades on *Planet of the Daleks* (without her famed clumsiness) and karate chops their jailors in *The Mind of Evil*. The Doctor even acknowledges she's better with a gun. A talented escape artist, she excels at lockpicking. "She's forever escaping from one cell or another (*Carnival of Monsters*, as with *Terror of the Autons* before it, reveals that she carries a skeleton key everywhere) to the point that by *Frontier in Space*, the Master's plans hinge on his belief that if left to her own devices in a prison cell, Jo can be relied upon to dig her way out with a spoon. Which she does" (Nichols).

Still, her final appearance emphasizes the weakness in her character arc. "Since she was conceived in a sexist light as a screaming, helpless woman, it is only natural that the character would be sent off on equally degrading terms" (Muir 213). In the environmentally-minded *The Green Death*, she turns from activist to activist's wife as she falls for the episode's professor. His condescension is a running joke between them, yet still disturbing, as it seems an exaggeration of the ongoing dynamic. He actually tells Jo, "My dear good child, I've got work to do."

Further, he seems to be a substitute Doctor, not only a scientist, but also a condescending authority figure. With his comments like, "I suppose you can't help being a bit cloth-headed. You're only a kid, after all" he echoes the Doctor's "dear child." Jo even ruins his experiments as she does the Doctor's. Since Jo falls in love, and consequently retires from UNIT, Jo appears to consider it more pastime than career (common in her era, but hardly feminist). Her final goodbye once again highlights Jo as airhead and the men in her life as condescending:

> Jo: You don't mind, do you?
> Doctor: Mind? He might even be able to turn you into a scientist.
> …
> Jones: Hey, Jo, come and drink a toast to the happy couple.
> Jo: But that's us.
> Jones: Aye, so it is. Don't worry, Doctor. I'll look after her.

As they celebrate, the Doctor sneaks off, returning to his lonely adventures.

Many years later, Jo attends the Doctor's funeral on *The Sarah Jane Adventures* in a delightful fan moment. In the future, Jo is still interested in new age trends like exotic herbal teas. She's also a world traveler who "spent her life going from country to country." Her grandson notes she's been protesting, chaining herself to railings as she protects the environment. She has seven children and thirteen grandchildren whom she brought up around the world (*Death of the Doctor*). Jo reflects on how different things are now— the Doctor travels with a married couple (the Ponds), while Jo believed she would have to give up adventures when she got married (in fact, many female

companions did exactly that, trading in the Tardis for a human man). She complains to the Doctor, "So I waited and waited, because you said you'd see me again. You did, I asked you and you said yes. You promised. So I thought, one day, I'd hear that sound, Deep in the jungle, I'd hear that funny wheezing noise, and a big blue box right in the middle of the rainforest. You see, he wouldn't just leave. Not forever. Not me. I've waited my whole silly life" (*Death of the Doctor*). Though he assures her he kept watching over her and is very proud, Jo never achieves equality.

The "loyal assistant," more support system than fellow scientist, appears in many adventures. Astrid Ferrier, helping her boss take down the evil Ramón Salamander in *The Enemy of the World*, is dramatically realized, with a striking amount of screen time. After rescuing the Second Doctor, Jamie, and Victoria, she helps them infiltrate Dalek headquarters. When told to take a back seat, she grabs a guard's gun: "And I do things my way. Really, as Head of Security, you should have more reliable guards." With this, she emphasizes that sidekicks can't be discounted.

The villain's helper in *The Enemy of the World*, Fariah, is a food taster. Played by a rare minority for the sixties, Carmen Munroe, she's captured while escaping, and when interrogated, answers bravely that she can only die once, and someone has beaten her tormentor to it. Meanwhile, the Atlantean servant girl Ara of *The Underwater Menace* helps the Second Doctor oppose Professor Zaroff. She carries messages and bravely saves companion Polly, then hides her.

Shirna, a faded showgirl in a pale green catsuit covered in bobbles, arrives in *Carnival of Monsters*. Able to tap dance and play the alien tambourine, she has a delightfully snappy exasperated attitude, telling her partner, "Dim witted yokels, you said they were. Twist them round your finger, you said. Have them eating off of your hand, you said. Well, a fine mess we're in now, aren't we." Despite this, she's eager to help the lifeforms carried inside her miniscope ... including the Third Doctor and Jo. She's a positive character who breaks out of the traditional Whoniverse categories. Meanwhile, stereotypical twenties flapper Claire Daly in *Carnival of Monsters* is a lively young woman full of pop culture references, and friend for Jo. However, her role in the story only covers delivering lines like "Oh, Daddy, there's something dreadful out there!"

Other helpers are defined by their lack of personalities or lines, leaving them generic helpers indeed. Officer Jane Blythe is Captain Hart's personality-free secretary in *The Sea Devils*. A human with immense frizzy hair, Kari is a space pirate in *Terminus*. However, teamed up with the Doctor, she fulfils the role of questioning companion rather than fierce warrior. Janet of *Terror of the Vervoids* has lots of screen time but only discusses her steward duties, with nothing personal to share. In the same episode, lab assistant Ruth is

quickly infected by the Vervoid seeds and erupts with leaves, before the audience can get to know her.

With coiffed hair and a purple sequined dress, secretary Adelaide, in *Horror of Fang Rock,* protests, "It's like some terrible dream!" When Leela insists they must fight, she faints. Leela rolls her eyes. While a wimp, Adelaide's appropriate for her time and contrasts the fierce Leela. "In our culture, women are usually rewarded if they live the roles of mother, wife, and helpmate, or even mistress and the passively inspiring Muse. While many women find these roles meaningful, to others they can be limiting and debilitating" (Leonard 4).

In *Nightmare of Eden,* Romana meets Della, who's been playing her boss's Continuous Event Transmuter machine; it's more than the video projector it appears, as it actually preserves living specimens. As Della reveals touchingly, "Eden brings back such unpleasant memories for me. That was where we lost the other crewmember." Romana realizes this person was more than a friend. Della frequently stands wordless, hands clasped, in a black vest and white shirt identical to her employer's. Her tied-back curls emphasize her girlish marginalization. Loyally, Della continues keeping her boss's secrets. Her boss callously responds by framing her for drug-smuggling. Della is vindicated and finds her love interest once more, but only after the real criminals injure her.

Considering how the show is set up, obedient assistants inevitably parallel the Doctor and his companions. For instance, when Martha, Jack, and Ten find the Master at the end of time, his assistant is Chantho, a charming alien lady who has served the Master for seventeen years. Martha jokes with her and they get in a little Bechdel-friendly conversation about Chantho's language patterns. Her unrequited love for him echoes Martha's for Ten. Despite Chantho's good-hearted submissiveness, the Master suddenly kills her, enraged as he is that she never detected the secret identity he'd hidden from himself ("Utopia"). This is often the pattern, with cruel geniuses ignoring the loyal women who back them up, or scapegoating them. This counterpoints Martha, who ought to receive much more respect.

The modern show has few generic girl assistants, preferring more nuanced characters. Nonetheless, Emma Grayling, a psychic, works for a ghost-hunting professor. The Eleventh Doctor calls her "the assistant and non-objective equipment," dehumanizing her a bit (*Hide*). He also strikes a parallel between her and his own companion relationships. Clara in turn discovers Emma loves her professor. While the story suggests she'll be a damsel, Emma finds love, then provides a lifeline to bravely save her descendent, a trapped hero-explorer. The professor tells her, "I was as lost as her, but being with you, you gave me a reason to be, Emma. You brought me back from the dead." She subverts the pattern and proves she's no pushover but a savior.

In season seven, with Liz and the Third Doctor, the scientist Miss Dawson keeps bossy Dr. Quinn's contact with the Silurians secret because she desperately loves him. He in turn is largely indifferent. Her protests that he must tell the Brigadier or the Doctor "before someone else gets killed" go ignored as well (*Doctor Who and the Silurians*). When he is killed, she demands their destruction as she succumbs to hysteria. The Doctor directly asks her about their intentions but she lies, saying only "We must destroy them, before they destroy us." She thus comes across as foolhardy and vindictive, in contrast with logical Liz.

Loveable blonde Petra Williams at the Inferno project is also devoted to her obsessive, irritable superior. As a loyal "personal assistant," she sticks up for herself in front of a newcomer whose interference she resents, telling him, "Mister Sutton, I am Professor Stahlman's personal assistant, not a typist, and I'm not available for borrowing" (*Inferno*). However, she soon falls in love with him and transfers her loyalty away from her corrupt boss. Thus, her assertive statement comes across as part of their romantic tension. He condescends to her too, telling her, "You're not brave, you're just plain stupid."

Meanwhile, the Third Doctor is thrust into a parallel universe, in which Great Britain is a Republic under a Fascist regime. Alt-world Liz is "Section Leader Shaw," an officer in a brown RSF uniform, who points a gun at the Doctor. "I am not concerned with saving your skin, only in carrying out the correct procedure," she tells him, with her coolness pushed to its extreme. Gentle Petra is flipped into a tougher version of herself who barks at Sutton, "Must I remind you once again that I am Assistant Director of this project? You will address me in the correct manner." Clearly, both helpful women can be authoritative, but only in an alternate world. The contrast stresses the sweet nature of their real-world counterparts and the Doctor's relief at being among them.

Dr. Ruth Ingram, the Master's assistant in *The Time Monster*, is a feminist, irking the men around her:

> MASTER: Now look, my dear, there is no need for you to worry your pretty little head.
> RUTH: And there's no need for you to be so patronizing, Professor. Look, just because I'm a woman, there's no need to treat me like—
> HYDE: Here we go.

She makes mistakes and the Master expresses his irritation, compounded by the fact that Ruth's brother refuses to take responsibility for her. Not far away, Jo is protesting, "You know, Doctor, you're quite the most infuriating man I've ever met," emphasizing the parallel between Time Lords and their assistants. Both, while frustrated by patriarchal bosses, are far less clever than Doctor and Master.

In *City of Death,* Count and Countess Scarlioni are an odd power couple. "Here, just as Russell T. Davies would do with the Master and Lucy Saxon in 2007, we have a couple who invert the whole concept of the Doctor and his companion: an ancient, brilliant alien and his beautiful and glamorous female partner. The Scarlionis' marriage even shares the curious asexuality of the Doctor-companion," critic Liz Barr says of the season's dynamics. In her elaborate skirts and jewelry, she has unknowingly married an alien—shortly after he reveals his origin, he kills her. Thus, much like a companion, she has failed to earn her husband's respect.

Seth and Teka, big-eyed teens in unisex jumpsuits, are doomed as sacrifices to a false god in *The Horns of Nimon.* He's a runaway, while she is an upper-class girl with total faith in him. "Like the Scarlionis, they follow the pattern of the standard Doctor-female companion duo. Seth himself comes to act as a sort of sub-assistant to both Romana and the Doctor, standing behind Romana and looking pretty while she drives off the villains, and feeding her straight lines for jokes" (Barr). Teka tries to defend herself with a blaster, but when she's unsuccessful at shooting it, she finds herself unconscious in the creature's larder. There she lies, completely passive, awaiting death. After the Doctor saves them all, he describes Seth as a hero.... Teka doesn't get a mention.

In *Shada,* Professor Chronotis, a Time Lord hiding on earth, hypnotizes a young Cambridge student, Clare Keightley, to be his assistant. Though she and her friend Chris help the Professor, the story has a sexist current. As he fills her with technical knowledge, he suggests she's a waiting blank slate. His treatment reflects the Doctor's with his companions—respecting them as people yet using them as sounding boards for his own cleverness.

In her rainbow nurselike cap, Tasambeker is introduced with the line "You're wasting your time there. He's not interested in you." Throughout *Revelation of the Daleks,* she continues mooning after her boss Jobel, even as he condescends to her. Davros summons Tasambeker and shows that Jobel loves someone else, and then challenges her to prove her loyalty by killing Jobel: "Serve me with your total being and I shall allow you to become a Dalek." Thus poor, weak-willed Tasambeker goes from giving over her life to one man to offering it to a worse one. She takes Jobel aside and confesses her feelings. However, he tells her, "Do you honestly think I could possibly be interested in you? I have the pick of the women. I would rather run away with my mother than own a fawning little creep like you." With that, she kills him, then instantly regrets it. Befitting her treachery, the Daleks kill her in turn.

In a gleaming white suit, Belazs is the employee and former lover of Kane, the villain of *Dragonfire.* She tries to kill him, but she fails and Kane kills her. Meanwhile, Xana is another former lover, who killed herself long

ago to avoid being persecuted for her crimes, and was memorialized as a statue. The villain's shallowly characterized women may become literal trophies, but they clearly lack loyalty to him in the flesh.

Remembrance of the Daleks features Professor Rachel Jensen, scientific advisor for the Intrusion Countermeasures Group. A controlled older woman in a traditional skirt, she's clearly in her element. This role, for decades, would have been given to a man, with the pretty young woman as assistant. The fact that Jensen keeps the female assistant—Allison Williams, an admiring damsel in a school tie who's also a physicist—places women at the center of this adventure instead of just assisting. The two debate and even argue. Thus in the original show's final year, it makes a nice update on the classic relationship.

Shou Yang, an Asian student at Exeter University, fights beside Ace in *Battlefield*. They have a fight (in which Ace actually starts to get racist) before the girls realize they're both being controlled by Morgaine. The feminism is problematic here, as an older woman forces two girls to quarrel and they nearly go along with it. This reinforces the concept that women must always be jealous adversaries. At the sillier end of the episode, the girls team up with the Brigadier's wife Doris, who previously just seemed the force of domesticity keeping him at home. Subverting their usual story roles as sidekicks, Ace, Doris, and Shou drive off in Bessy, pointedly leaving the men behind. This makes a fun gender flip and joke for the audience.

> BRIGADIER: What about supper?
> DORIS: Oh, that's a good idea. Have something really delicious ready for us when we get home, okay? (They drive off) Oh, wicked!
> ANCELYN: Ah, are they not magnificent?
> BRIGADIER: Yeah. Are you any good with a lawn mower, Ancelyn?
> DOCTOR: I'll cook supper.

A week after the 1996 movie, *Radio Times* began publishing a sixty-part Eighth Doctor comics series written by Gary Russell and drawn by veteran Who artist Lee Sullivan. When the American show wasn't picked up, they cut the strip short after 42 segments (four ten-part stories and a concluding two-parter), ending in March 1997. The *Radio Times* companion was Stacy Townsend, a young blonde cargo hauler from the future.

Cybermen attack her, so the Doctor steps in. The comic narrates "She's not a trained warrior. She's a trained mover of crates from A to B. Stacy's friends are now Cybernised. Except one. He's called the Doctor." She's a trained helper from the start. Despite this traumatic storyline, her lines are quite generic. "Poor Bill. He didn't deserve this. None of the Dreadnaught's crew did," she notes calmly. She appeals to Bill (now a Cyberman) equally emotionlessly, noting, "A couple of hours ago, we were friends, remember?" Since she adds that they were planning marriage, this emotional appeal is

seriously watered-down. Bill dies tragically, fighting his programming. Thus, Stacey joins as a companion who should be reeling from loss and seeking a new life. However, she never rises above generic perky companion.

In the next story, they pick up Ssard, a young Ice Warrior, and the pair assist the Doctor through small amounts of growth. After the comic was canceled abruptly, Gary Russell wrapped up the Stacy and Ssard friendship in the BBC Eighth Doctor book *Placebo Effect*. Apparently, Stacy and Ssard eventually leave the Tardis and decide to live in Ssard's time period. They invite the Doctor to their wedding, on Micawber's World in 3999, and the Doctor generously smuggles Stacy's parents over to attend, despite the paradoxes this will cause. Ssard also reveals that Stacey can't have children, from a "side-effect of something that happened while we were travelling" (20). Again, this is a serious topic, though only touched on as a brief throwaway. The Church of the Way Forward, which opposes interspecies marriage, arrives to protest the wedding, but the pair manage all the same, and presumably live happily ever after. Neither Stacy nor her comic ever really take off.

Heather McCrimmon (born 1990) is a comics companion of the Tenth Doctor, and, of course, a descendent of Jamie. Ghost hunting in Edinburgh, she meets Ten, who takes her back in time to help her (*The Chromosome Connection*). After, Ten agrees they should travel together to help with her history essay and the pair share fifty individual stories. Though a sweet-faced student, she has her cruel side, to the point of letting a group of Nazis die. In the end, she's contaminated by radiation that will kill her if she time travels, so she stays back in her own time (a tragic ending, but not a marriage plot, at least). She becomes an archeologist and freelance alien hunter, discovering assertive power in the end.

The Disciple: Martha Jones

Martha Jones (played by Freema Agyeman) became the first Black female companion, which unfortunately became her greatest legacy. In this interview with *The Guardian*, before she debuted, all the magazine appears able to ask is how the actress feels about being Black. She's being disturbingly exoticized rather than asked anything about herself and her acting.

Q: Are you doing her as a stereotypically "feisty black woman"?
A: Stereotypically feisty how? It's a coveted lead female role. There are no stipulations. The BBC has chosen to cast it black. I'm proud to be an actor, I'm proud to be black, but in this case the two are not synonymous.
...
Q: Do they make references to your being black or is it politely ignored?
A: It's not politely ignored but it's not the whole point of the character, so of

course it's acknowledged and rightfully so. But at what point do you get the balance? Because the flip side is a continuous labeling "black companion," "black, black, black, black"

...

Q: So does it do your head in that you are always referred to as the first black companion?

A: No, not at this point, because it's correct, we've got to acknowledge it. But if we're still talking about it in 50 years' time then there's a problem; then we're not advancing because soon it's got to just be "actor." Martha's outspoken, she's educated, she's academic, she's independent. She's older than Rose, she's more challenging of the Doctor as well, and family is very much more a factor [Pool].

Each time she insists there's more to herself, the interviewer relentlessly drags the conversation back to race.

Nearly as famous as her race is her relationship with the Tenth Doctor—in fact, he treats Martha quite badly. She's famously the "rebound" companion of New Who, acquired just after the Doctor has tragically lost Rose. On every trip, he mentions her, emphasizing his preference for his former companion. Meanwhile, though everyone mistakes his glamorous escort Rose for his love interest, no such assumption goes to lovely, intelligent Martha. When he first whisks Martha away, he promises her only a single trip, then two, and refuses to commit. Martha's look of devastation when the Doctor takes her home in "The Lazarus Experiment" says everything. At this point, nearly halfway through the year, she insists on a real partnership, and he gives her a Tardis key.

Further, on New Earth, the Doctor takes Martha to the ugly, degraded part of the world ... he took Rose to the nicer section. Martha cringes at hearing he brought her "to the slums," and on hearing that he came with Rose, she has to ask, "Ever heard the word rebound?" ("Gridlock"). Not only is he offering Martha secondhand adventures, he's giving her the worse part. According to Laura Geuy Akers in her essay on New Who, Martha "doesn't need wonder to inspire her to act. The Doctor values Martha's enthusiasm, skills, and dedication, but he can't make the empathic connection with her that he had with Rose, probably in part because Martha doesn't find wonder energizing in the way that Rose did" (178). She's a colleague, not a force of pure empathy. Unfortunately, he can't stop making comparisons.

On their first trip, to Shakespearean London, he leaves Martha in jeans rather than offering her a sumptuous gown as his more accepted companions sometimes wear. Perhaps this adds to her fears about her status. When she brings up that she's "Not exactly white, in case you haven't noticed," and wonders if there's a risk she'll be carted off as a slave, he retorts, "I'm not even human. Just walk about like you own the place. Works for me." With this, he shows a surprising lack of understanding. Courtney Stoker explains in her essay on power dynamics "Maids and Masters":

Martha recognizes that history is not necessarily a safe place for her, since she doesn't have the same privilege and power there that she does in her present. And the Doctor assures her that he has less power and privilege ("I'm not even human!"), which is a blatant misrepresentation of what is happening here. The Doctor has white privilege (and, more relevantly in Elizabethan England, male privilege), even if he isn't actually a human.

In the "future," Martha's race is not an issue. However, the Doctor doesn't choose their excursions on this basis. In the past, Shakespeare waxes poetic about it, 1900s students make nasty comments, the Doctor presents her as his maid. In the present, under the Master's reign, her family are demeaned as maids and a janitor. Her role tending a shop counter in "Blink" is also a lower-class job. In "42," Martha even hauls the computer for a technician, noting that she might as well make herself useful. Though she begins as a clever medical student, this role is subverted and discarded in nearly every episode. As the Doctor volunteers himself and Martha for work in the sewers during the Great Depression in "The Daleks take Manhattan," he's giving Martha the nastiest possible adventures.

Worst of course is her treatment in "Human Nature." For *three months,* Martha the doctor must scrub floors, listen to racist insults, nod and smile. Why? Because the Doctor takes her to a time of prejudice in England. They could have hidden in 2007 where Martha would have been the most comfortable, or in the future, where her race and gender wouldn't be an issue. However, as she scrubs, her place in the Doctor's dynamic becomes clear. Students come by and snap out insults like "With hands like those, how can you tell when something's clean?" Meanwhile, the attractive, white Nurse Redfern comes first in the Doctor's life and in medical certification, while Martha is left to helplessly tidy up. As he falls for the nurse and shares his journal of hopes and dreams with her, Martha watches in dismay. As she notes sadly, "You had to go and fall in love with a human, and it wasn't me." Meanwhile, he's oblivious to Martha's presence, much like he is on the Tardis. This story emphasizes how he needs her to comfort him, to keep him from being lonely and ground him emotionally. "Martha as John Smith's housemaid is not that different from Martha as the Doctor's companion. When we see Martha in a maid uniform, it's a visual amplification of her relationship to the Doctor, not a deviation from it" (Stoker).

As she retreats into the Tardis or tells the other maid she longs to head for the stars, she shows her clear unhappiness. Nonetheless, Martha responds with support for the Doctor and even admiration, saying, "I've only just met him. It wasn't even that long ago. But he is everything. He's just everything to me and he doesn't even look at me, but I don't care, because I love him to bits. And I hope to God he won't remember me saying this." Thus, she casts herself as a total pushover. At episode end, after inviting Nurse Redfern along

so they can try to start over (ignoring how Martha would feel as a third wheel!) the Doctor accepts the easy way out and agrees that Martha clearly didn't mean her declaration of love.

During their travels, he screams at her ("Utopia"), lies ("Gridlock"), and conceals vital information ("The Sound of Drums"). In return, she finishes the year by walking the entire earth to tell stories of the Doctor's wonder and goodness, like a disciple. As Martha explains as early as "Gridlock": "You've got your faith. You've got your songs and your hymns. And I've got the Doctor." At Series Three's end, "Martha acts as a disciple of the Doctor, venturing out into a world to spread his word—a word that will be able to save all of humanity. She is the apostle who takes the word to the gentiles, the believer who draws the fish in the sand despite the penalties for her religious belief," Karma Waltonen notes in "Religion in Doctor Who: Cult Ethics" (154). This of course is a courageous and perilous quest, though largely unseen on the show. A novelization tackles her story but falls significantly short of heroism:

> The Story of Martha (BBC books; Abnett, Roden, Lockley, et al.), detrimentally relays Martha's year-long journey. The authors diminish Martha's importance—making her into a sniveling girl who wears heeled shoes and focuses on her own stupidity instead of her mission (Abnett et al, 37). The story is divided between Martha and the misogynistic tales of her being hunted. Here Martha becomes a slave in Japan, anticlimactically overrun by the Drast, never actually travels the world because other people pose as Martha Jones to tell the stories instead, and spends a deal of time remembering unconnected tales about the Doctor. Abnett and his colleagues devalue an otherwise complex valkyrie [Burke 181].

After her adventure, undertaken on behalf of the Doctor, all while her family is abused because of their relation to her, she's finally had enough. "She eventually leaves him because she fears subsuming her personality in the light of the Doctor's vast experience and intellect and living a life of unrequited love," Lynnette Porter adds, in an essay on New Who companions (257). She says an amicable goodbye, with a great deal of self-awareness. "Spent all these years training to be a doctor. Now I've got people to look after. They saw half the planet slaughtered and they're devastated. I can't leave them."

She starts to leave, then pops back and tells him the story of her friend Vicky, who desperately loved her roommate but "he never looked at her twice. I mean, he liked her, but that was it. And she wasted years pining after him. Years of her life." Martha compares their situations and emphasizes that she's ready to move on. In a moment of delightful assertiveness, she throws her mobile phone to Ten. "If that rings, when that rings, you'd better come running. Got it?" Only here, having quit as sidekick, does she give orders.

Unlike most companions, Martha's time in the show hasn't finished when

she leaves the Tardis. The following year, she's a capable soldier for UNIT. Clearly her travels with him were cutting off her full potential—an issue she's wise enough to realize. In "The Sontaran Stratagem"/"The Poison Sky," Donna and Martha smoothly become friends (unlike the rocky start to the Sarah Jane and Rose dynamic, or Martha's competition with Rose's memory). Donna congratulates her on her marriage and soon the women are cheerfully insulting the Doctor's skinniness. "Oh, I'd rather you were fighting," he concludes. Martha has (mostly) moved on with the doctor she met in the year that never was. She's happy with her new career, and has made a place for herself.

At episode end, the Doctor invites Martha to rejoin them. She refuses, emphasizing her agency and self-awareness. However, the Tardis carries her off abruptly, taking her to the adventure of "The Doctor's Daughter." There her medical training (appearing so rarely in her own companion arc) proves invaluable, as she saves an enemy soldier and helps build a treaty. At episode end, at her insistence, she gets home to resume her career.

The Series Four finale brings her back to the show, along with Rose and the casts of *Torchwood* and *The Sarah Jane Adventures*. When Daleks attack her UNIT base, General Sanchez orders Martha, as the most valuable team member, to escape with Project Indigo and contact the Doctor. Sanchez also gives her the Osterhagen Key, and with it, the power to destroy the entire planet. After Martha works with the Doctor and all his companions to save earth, Captain Jack offers her a place on his Torchwood team. She visits *Torchwood* as a respected UNIT doctor in a three-episode arc, and would have stayed if Freema Agyeman's new job on *Law & Order: UK* hadn't prevented it. Davies also had intended her to appear on *Enemy of the Bane*, the Series Two finale of *The Sarah Jane Adventures*, and thus span all the shows (*The Writer's Tale*).

Her final show appearance a year and a half later in "The End of Time, part 2" has her suddenly wed to Mickey Smith. This seemed dismissive for some fans as the two Black companions, the ones rejected for the Doctor-Rose perfect partnership, end up together. Certainly, few others of earth understand their shared history of adventures. But they also share a history of being second-string. Thus Martha's final salute is awfully problematic once again.

A companion with a similar relationship to her Doctor is the novels' Sam Jones. Sam, a teen student at Coal Hill, meets the Eighth Doctor in *The Eight Doctors* (1997) while running from a group of drug dealers. The Doctor rescues her, but she also defends her peers, retorting, "Not at Coal Hill. Not if I've got anything to do with it." She's later revealed to be the "snitch," telling on the kids to the cops. She's squeaky clean, almost too good, though also a vulnerable teen in need of rescue. She's a vegetarian so opposed to drugs she won't even drink Coca-Cola, a PC supporter of Greenpeace and gay rights.

Continuing her contradictions, she's remarkably practical and self-possessed, even after bursting into the Tardis.

> "Look, I expect you're feeling a bit confused and frightened," said the Doctor. "Don't worry. Everything's all right. You're quite safe. Let me try and explain—"
> Sam cut him off. "Don't bother. This is the control room of a space ship, right.... Bigger on the inside than the outside," said Sam impatiently. "I can see that for myself. What did you say it was called?" [Dicks, *The Eight Doctors*]

She accepts he's an alien with the words, "Well, as aliens go you're an improvement on the little green guys with pointy heads." Promptly, she demands a ride somewhere interesting and logically points out the Doctor can return her to her own time later. Off they go.

Later books reveal Sam Jones is a paradox as well as companion. In one timeline, appearing in *Unnatural History* by Jonathan Blum and Kate Orman, she's a heroin user who smokes, tries to seduce the Doctor, and sleeps with companion Fitz. She runs into a time scar over San Francisco and alters her timeline including her first meeting with the Doctor. Metaphorically, she is rebelling against her role as perfect companion and doing everything possible to destroy her good girl image. "The 'Dark Sam' character, introduced by Jonathan Blum and Kate Orman in *Unnatural History*, can be read as an attempt to make the quite bland Sam something more interesting. Like many characters in the Virgin New Adventures, Sam's alternative self is suffused with sex, IV drug use, and angst. She is everything the wholesome Sam Jones is not" (Gulyas).

Sam quips, "Think about it. If the old guy in the tomb didn't want any hanky-panky on Gallifrey, don't you think he'd want to make sure you were paired up with a good little girl, who'd never dare to screw you?" (*Unnatural History* 171). Dark Sam spends the book trying to reconcile the two sides of herself. "I can fake it if you want. Dye my hair, put her clothes on," she offers (60). She also visits blonde Sam's room, filled with all her stuff. Everywhere she goes, including visiting her earth family, she feels the disconnect as she struggles with identity. Eventually, the Doctor sacrifices the dark version to restore the light one. However, he soon discovers that Blonde Sam is a paradox he has created—building this woman into the perfect companion has actually compromised her existence. Once again, the harm the Doctor does to idealistic companions takes center stage.

After adventures together, Sam settles on earth in 1996 but agrees to aid Sarah Jane for a year before returning to her parents, six years older than she should be. "I'm hoping there'll be a Nobel Prize in this somewhere," Sarah says. "Either that or we'll end up bringing down Western civilization," Sam adds (Miles, *Interference part 2*, 172).

Her girl power agenda makes many consider her flimsy. Worse yet, Sam is one of the companions who falls in love with the Doctor, a love he cannot

return. She's instantly jealous when other women get close. She soon goes from thinking, "What should I do?" when she's in a tricky situation to, "What would the Doctor do?" a concept that marks her, like Martha, as a gooey-eyed disciple. When they part, she says "I love you."

> The Doctor looked up at the ceiling again. "Do you know, I know exactly what you mean by that," he said. So Sam let go of him, and took a few steps back. They quite deliberately and carefully didn't kiss. Not even in a friendly sort of way [Miles, *Interference part 2*, 173].

Finally, Sam's idealism in following the Doctor's path leads her to become a political activist. She's shot and killed in the novel *Sometime Never...* by Justin Richards, because a group called the Council of Eight is eliminating all the companions. Although the Doctor vanquishes them, he discovers Sam's grave during the last Eighth Doctor Adventures novel, *The Gallifrey Chronicles*. Clearly, she is ambiguously sacrificed because of her devotion to the Doctor.

He has many other companions, some of whom share this devotion. After the Eighth Doctor's single television movie, he adventured through the extended canon with the eight-year novel series, as well as a nine-year tenure in the *Doctor Who Magazine* comic strip, and many audio book adventures from Big Finish Productions. His first audio adventure, *Storm Warning*, teases traveling with the historical Mary Shelley. "Mary's Story" finally explains this as part of the 2009 omnibus *The Company of Friends*. As occurred historically, Mary and Percy Shelley, Lord Byron, Mary's stepsister Claire Clairmont, and Byron's physician John Polidori are vacationing at Villa Diodati near Lake Geneva in June 1816. They begin writing ghost stories. However, the Eighth Doctor, hideously infected with vitreous time, bangs on their door and introduces himself as Doctor Frankenstein. With this, he drops dead (apparently), only for Percy Shelley to propose making his corpse twitch with electricity.

Shelley shocks the dead body, and the Doctor returns to life and runs out into the rain. Quips like "It's alive" and "We need villagers with pitchforks" add to the humor. Mary bravely follows and discovers a bestial creature in the Tardis, though the monstrous "Doctor Frankenstein" babbles that he recalls traveling with her. He sends out a signal for aid, summoning a younger version of the Eighth Doctor, who saves him. The younger version, having healed his older self, invites Mary along. As the Doctor concludes as the adventure wraps up, "You have to remember, it's very important. Frankenstein is the name of the monster and not the name of the Doctor."

After this, three Mary adventures follow. She's notably *not* spunky, but reserved and uncertain whether she even wants to be a companion. Her pragmatic intelligence shines through the era of her upbringing, giving her a nice balance and touch of religious philosophy. At the start of *Army of Death*, this

otherwise educated, groundbreaking woman reveals she's developing roman-
tic feelings for the Doctor, finding his exuberance appealing (though confus-
ingly, this last adventure is the only one to show such feelings). This is her
last episode before she returns home, leaving her another dreamy-eyed com-
panion left to resume her normal life and write her classic novel.

Petronella Osgood (Ingrid Oliver) stars as a UNIT scientist in "The Day
of the Doctor." With her Fourth Doctor scarf and trivia knowledge (later fol-
lowed by a bow tie), she's a fan stand-in. She also appears to be a descendent
of Sargent Osgood, UNIT's Technical Adviser in *The Dæmons* (1971). Along
with her knowledge, she has endless faith, pleading, "Please, Doctor. Please
save us. Please save us. Please save us" when the Zygons attack. The Doctor
singles her out, and Osgood gazes adoringly at her idol.

Her own Zygon duplicate reveals much about her vulnerable, insecure
personality, taunting her with "I so hate it when I get one with a defect" and
"Ooo, you've got some perfectly horrible memories in here, haven't you? So
jealous of your pretty sister. I don't blame you. I wish I'd copied her." Osgood
actually uses the scarf to escape in a delightful fannish moment and nod to
geek power. At episode end, the UNIT staff must negotiate with their Zygon
counterparts, bound because neither side knows who is human or alien. The
Osgoods suddenly realize only one has their inhaler, but they keep quiet,
carefully maintaining the peace. "Osgood and her Zygon duplicate demon-
strate that unity can be achieved … [and] that alternative solutions are worth
seeking" (Nathanael 89).

Osgood returns for "Death in Heaven," wearing an Eleventh Doctor
bowtie (which Twelve immediately compliments). She's a smart and compe-
tent UNIT employee who uses her OCD and fannish knowledge to give clever
answers. She realizes Missy is the reborn Master and adds that the Cybermen
are reviving the dead from the graveyards. The Doctor is immediately
impressed and makes her an offer of "All of time and space." Osgood takes a
breath from her asthma inhaler, eyes sparkling. At this moment, she could
become the first disabled companion (who in fact might have had serious
trouble running, adding complexity to the role). Thus it's a shock when Missy
suddenly kills her. "I promise, I'm much more useful to you alive," Osgood
reasons, but logic means nothing to the insane Missy.

She returns, as surprise for the audience in "The Zygon Invasion"/"The
Zygon Inversion"—her "sister" is dead, but the other lives on. The episode,
fixated on doubles, emphasizes Osgood's power to maintain the peace by not
revealing who is human and who Zygon—thus they must be treated the same.
Throughout the adventure, she prizes peace above an "us versus them" phi-
losophy. Osgood protects a pair of boxes that ensure peace—allegedly, one
can strip the disguise from every Zygon, and the other can kill them. Kate
Lethbridge-Stewart and Bonnie, the Zygon leader, open the boxes to discover

they're empty, letting them play out their conflicts. Though Kate doesn't learn, Bonnie comes to understand the Doctor's philosophy and becomes the new Zygon-Osgood. "What are we going to do?" says the first Osgood. "Same old. Same old. Defending the Earth," smiles the other. When Osgood turns down traveling, the Doctor touchingly repeats her own words back to her, saluting the geeky audience by saying, "You should know: I'm a really big fan." At last, one disciple has earned the adoration of her Doctor.

Sexy Damsel: Peri and Mel

The Doctor, of a species called the Time Lords, can be quite patriarchal. He picks up young women, starting with those who resemble his granddaughter, and flies them around the galaxy, showing off places of his choosing as he teaches and condescends to them. His power "is often taken for granted and only occasionally questioned" (Nathanael 85). Meanwhile, companion criteria appears to include being a twenty-year-old girl in a short skirt with a sense of naïve wonder and no family ties.

Sometimes he even carries them off without asking, as they've been seeking an actual police box. On occasion, he hypnotizes the girls or uses other types of mind control. When he returns them home, often against their will, they sometimes find themselves in the wrong place or time, leaving Rose's mother, for instance, fearful she has died. Many companions live on, frustrated that he never returns as he promised. His excuse in "School Reunion" that he hates seeing companions age and die seems remarkably self-centered, even sexist (or perhaps racist in this case).

He tends to insist he's in charge, though some companions like Donna defy him. However, since he's far more experienced and educated about alien life (even more so than the few aliens he picks up) and since they're flying in *his* Tardis, even Romana finds herself assisting and taking orders. This dynamic comes to a head with Six and Peri, a badly balanced pair that lets the Doctor dominate the relationship until he betrays and abandons Peri in an ambiguous yet highly uncomfortable sequence.

"The audience's first view of Perpugilliam Brown in "Planet of Fire" was in a wet bikini. Later costume choices were decidedly tight and short" (Leitch). Peri wears short skirts and tight plunging tops that emphasize her hourglass figure. "The voluptuous Peri (Nicola Bryant) is regarded as a sex symbol among male fans more than any other companion" (Layton 110). John Nathan-Turner said of Peri, "She'll often be wearing leotards and bikinis. A lot of dads watch *Doctor Who* and I'm sure they will like Nicola" (244). She thus is presented as the ultimate gift to the male gaze and thus a disturbing character. "No 1980s guest character never mentions that Nicola Bryant's Peri

is dressed like a porn star, though even giant earthworms and barbarian chiefs express an interest in having sex with her" (Newman 121). While an American college student, specializing in botany, Peri continues to be a prize for the male characters. Peri cringes in *The Caves of Androzani* when the alien says he wants her beauty. She's kidnapped by the Borad and Sharaz Jek, both of whom wish to possess her.

"Some fans love her for her sassy persona, and others despise her because they do not like Bryant's voice, which many call 'whiny' or 'nasal'" (Muir 341). The Doctor and Peri squabble a great deal. When he's asked what they do in the Tardis, the Doctor responds, "Argue, mainly" (*Mark of the Rani*). In that episode, Peri asks foolish questions in a poofy pastel dress and pink high heels while the Doctor insults her and corrects her grammar. In the first episode of *Mindwarp,* according to Tansy Rayner Roberts in her essay "The Ultimate Sixth": "Colin Baker and Nicola Bryant do their best to mitigate a regressive script which has them once again bickering with each other. They deliberately undercut several bitchy lines to each other with wry smiles and understanding looks." Still, it remains problematic.

Colin Baker's Doctor slaps and tries to strangle Peri in *The Twin Dilemma*. Though he's filled with remorse and even considers retirement, the Doctor-companion relationship is harmed. He's excused because he's off-balance and has just regenerated, but most fans reacted with revulsion—to them the Doctor just "wouldn't do that" (Muir 346).

In *Mindwarp,* she's actually frightened of the Doctor—cringing, sobbing, and hollering as he interrogates her. Normally, companions go along with the Doctor's ploys, trusting him implicitly. But as Peri shrieks, she makes it clear the new violent Doctor scares her.

> PERI: What? No, stop this!
> (The Doctor kneels by her and they whisper.)
> DOCTOR: It's all right, we're alone now. We can talk.
> PERI: Oh, Doctor, I thought that brain transference pulse had made you crazy.
> DOCTOR: I'm your friend, you know that.
> PERI: I was beginning to wonder.

He tells her, "You are expendable. You have no value…. If that means sacrificing you in my place, then that is the way it must be." Though a ruse, the words seem a natural extension of his harshness and disregard. As the real Doctor comments during trial, "There have been many companions but only one me" (*Mindwarp*). Though his fifth incarnation sacrifices himself to save Peri, it's believable this one would abandon a companion to save his own more important existence. Compared with his own everlasting life and threatened with madness, this sequence seems just believable to the audience and finally to the Doctor himself.

The Doctor is (probably) pretending to be evil to save Peri's life—but the net effect is that he has to behave appallingly to her when she is unexpectedly turned into a harem girl, and then by tying her to some rocks on the pink beach and interrogating her viciously. We see evidence that he is performing for the cameras, but we also see him going much further with emotional cruelty (pretending to be his real self and then pulling the rug out from under her) than is necessary [Roberts, "Ultimate Sixth"].

In the same episode, Peri is made a slave with a wispy harem veil, ostensibly identical to all the others, as if emphasizing the Doctor's words—she's interchangeable and forgettable. The Doctor is on trial for his life—Peri's fate is merely incidental evidence to that story. He in turn calls her "savage" and "stupid girl," making it clear she's not worth his time. He fails to rescue her. Finally, she has her head shaved and a new personality implanted (with a long pan up her body, just to complete the degradation). With this, the Time Lords send an assassin to destroy her body, as nothing of her remains.

As the Trial of a Time Lord sequence wraps up, the Doctor reveals that this was a fake, altered history. As it turns out, Peri is well and has neatly wed the barbarian king of the planet. But as all this takes place offscreen, compared with the horrific onscreen version, it feels like a tacked-on fairytale. The Doctor's kidnapping *could* have killed Peri—it's almost incidental that it didn't. In the end, Peri is abandoned on a far-off alien world with pink oceans and ringed planets in the sky, where horrific mindswap technology rules, to be queen to a barbarian warrior king. She does not choose to leave—she is left, and the Doctor never returns to check on her. A sense of closure never comes as the characters don't get to forgive each other and reconcile.

Prior to this ending, Peri and the Doctor have audio adventures from Big Finish, many with a third companion. Erimem, the feisty Pharaoh, is a good match, enabling a pairing with plenty of girl talk and friendship, not just the Doctor-assistant relationship.

Perky Melanie Bush (Bonnie Langford) promptly took Peri's role. Both "brought back some of the old dependent female stereotypes. Mel in particular screamed her way through many episodes" (Layton 105). Melanie Bush, a fitness fanatic, was best remembered for trying to get the Doctor to ride an exercise bike and drink carrot juice in her opening scene. Allegedly a computer programmer, she is never seen using this skill. The energetic Langford brought her celebrity status to the show—years later, she's more often remembered as the actress, not the character.

Oddly, Mel never actually meets the Doctor—she's first shown as his companion in an event he shows during his trial … that occurs during his future! When he and Mel join up, they paradoxically both seem familiar with the events. As such, her motives, reason for traveling with the Doctor, and backstory are nonexistent.

Soon enough, he regenerates into Seven and he and Mel begin a traditional partnership ... too traditional. During the trial episodes, she shows initiative and appears capable. However, beside the Seventh Doctor in *Time and the Rani,* an alien leads her about on a leash and "she runs and screams her way through the entire serial" (Muir 369). Throwing up her hands and shrieking like a cliché, she's difficult to take seriously. She's either delightfully optimistic or disturbingly naïve with a squeaky cutesy voice: "Traveling with the Doctor challenges Mel's trusting nature. Every time she wanders off to do something that sounds fun (Holiday camp! A lovely cool swim in a pool! Milkshakes at the mall!), bad things happen. She's kidnapped and threatened with a toasting fork (*Paradise Towers*), suspended upside down (*Time and the Rani*) and threatened by soldiers (*Dragonfire*)" (Thomas).

At the same time, she adds sweetness to counter the Sixth Doctor's acerbity. Lynne M. Thomas, in her essay on the season, calls her "the most relentlessly chipper, trustworthy companion in *Doctor Who* history." Colin Baker comments, "She has red hair, petite, an enormous amount of energy, always on the go. So, when we arrive, unlike Peri who says, 'Doctor, I don't want to go out there, it might be dangerous' Melanie says, 'Hey! Let's go out there and look!!!' She's kind of up-and-at-'em" (Airey).

Pairing her with the kindly whimsical Seven helped as well. This is a partnership, in which both genuinely want to help others. Thomas adds: "She cares about Pex, the Kangs, Ace, Delta, Mr Burton and Sabalom Glitz, but not just them. The nameless ordinary people on the fringes of the story matter to Mel: the Lakertyans in *Time and the Rani;* the holiday camp-goers in *Delta and the Bannermen;* the residents of *Paradise Towers;* everyone in the mall on Iceworld in *Dragonfire.*"

"It's refreshing to have a companion who is cheerful, goes off on her own to investigate things and seems to actually like the Doctor" (Roberts, "Ultimate Sixth"). In the story *Dragonfire,* there's a rare overlap from old companion to new, since most of the story has Mel and Ace working together as a team while Seven goes solo. At the end, it's Mel who nudges the Doctor to take Ace along on his adventures.

Meanwhile, Mel goes off with Sabalom Glitz, the most conniving trader in the galaxy. This seems like a more heartless companion handoff than usual. However, Thomas sees significance here. "Perhaps she decided that Glitz needs her, in a way that the Doctor doesn't. After all, if Glitz wouldn't know trustworthy if it bit him on the nose, isn't she exactly the person to demonstrate how it ought to work?"

Many women in the classic show are secretaries, wives, daughters, and maids: they scream, are held helpless, and occasionally die. Count Grendel of Gracht is delighted to meet Romana, as she's an exact match for another woman. Grendel describes "the Princess Strella. First Lady of Tara, a descen-

dant of the Royal House, Mistress of the domains of Thorvald, Mortgarde and Freya. In fact, Tara's most eligible spinster, shortly to become, in rapid succession, my fiancée, my bride, and then deceased." Since he covets her claim to the throne and her estates, he clearly sees her as just a prize. Showing disinterest in anything that makes the princess individual, he proposes Romana take her place and adds, "Aren't I a lucky man to have two such beautiful women as my bride?" Meanwhile, Strella loves another, so all the women's actions are defined by the controlling men in their lives, as Romana still travels with the Doctor. Switching the princess with an android only emphasizes all the women's status as pawns (*The Androids of Tara*).

Princess Astra of Atrios is not just helpless princess but human puzzle piece that heroes and villains both conspire to sacrifice. As she quarrels with her marshal, they display conflicting perspectives along classic gender lines. She insists, "Atrios is being destroyed around us. We must negotiate before it's too late. We must have peace."

He retorts, "I understand only my duty. And my duty as Marshal of Atrios is to prosecute this war to a successful conclusion. Yours is to uphold the people's morale and give them comfort" (*The Armageddon Factor*). If Astra's role is to comfort, not to lead or even remain confident under pressure, she's been demoted from royalty to damsel.

She's also completely in love. She and her secret lover, Surgeon Merak, are trying to sneak around their own military and negotiate a peace. The marshal considers her a piece as well, using her for her popularity and noting, "She's beginning to panic, becoming a thorn in my flesh, an irritant. She could be useful to my enemies. Something tells me her value to me may be at an end." As he prepares to execute her, the Doctor and Romana arrive, seeking the Key to Time. However, Astra vanishes, and after quite some time offscreen (in which everyone hunts for the prize of a princess), she appears in a public message in which she reveals the enemy Zeons have captured her—apparently they want her too. It's finally revealed that a shadowy figure has kidnapped her, seeking the same Key to Time the Doctor wants. Making her the goal of every character's treasure hunt while she's chained to the wall significantly weakens her as a person.

At last, she willingly sacrifices herself, allowing the forces of evil to dictate her destiny as a piece in the Key to Time. "She was a living being, and now what is she? A component," Romana protests (*The Armageddon Factor*). Worse yet, Romana's taking her form an episode later links her with the damsel archetype in viewers' minds.

"The Next Doctor" introduces Jackson Lake—not a Victorian Doctor, but a Victorian man who hallucinates himself to be one after his wife and son are taken. Of course, he resolves that he needs a companion. "He understands that an essential part of being the Doctor is having companions, to

make people around you do brave and extraordinary things" (Sharma). His choice is a dark-skinned prostitute he rescues at the docks—the villainous Miss Hartigan even nastily notes, "I doubt he paid you to talk." Nonetheless, he doesn't hesitate to make Rosita (Velile Tshabalala) an equal partner. In her brightly-patterned skirt, with poofy hair, she's a nonconformist. She's also heroic, actively aiding Jackson and the genuine Doctor to vanquish the Cybermen.

> In *The Next Doctor* (2008), Rosita fought Cybermen side-by-side with the Tenth Doctor, and she saves him and her Doctor from a potentially fatal fall. Yet her ultimate fate is a condensed replay of all the problems with the way companions of color are treated in New Who: her future, and the only compliment she will receive, is discussed between two white men just out of her earshot. What she wants, what she hopes, doesn't matter; she's going to be the nanny [Dodson 33].

Indeed, Jackson opens his home to her and continues their partnership once he regains his memories, but hiring her to watch his son seems rather a power disconnect. One critic calls her "an alternative universe copy of Martha," adding, "The fact that Rosita loves Jackson's Doctor and he's oblivious to her love makes her much more like Martha (above and beyond the fact that she is of African descent). Her possibly winning Jackson's heart in the end satisfies the romantics who were sad that Martha would never win her Doctor" (Welch 69–70). Indeed, after she's saved them all from a Cybershade, the Doctor tells Jackson, "Take care of that one. She's marvelous," hinting at a future relationship.

In "The Vampires of Venice," Signora Calvierri has opened a finishing school. The girls who join become hypnotized waifs, then fanged sea monsters. They are being prepared to be perfect inhuman brides. As the Signora tells them, "Then there are ten thousand husbands waiting for you in the water." When they attack the Doctor, he notes, "There's nothing left of them. They've been fully converted. Blimey, fish from space have never been so buxom." Of course, this objectifies the women while giving them up as a lost cause—they're permanent monsters now. Most accept these changes willingly—however, one heroine, Isabella, fights her fate. For her independent thought, the Signora calls her a traitor and actually makes her walk the plank, as a true virgin sacrifice to her sons. Clearly, only obedient, mindless brides are desired. Eleven and Amy's failure to save Isabella casts her as the helpless damsel in truth.

The Heart: Rose and Charley

The gateway character for New Who is a modern teen from London. "She's positive, ambitious and full of conviction and confidence," said Billie

Piper, the pop star chosen for the role. "She's ballsy and goes with her gut instinct. She's a good character to relate to or aspire to" (Belam). "Pop star at 15, anorexic at 16, has-been at 17, teen bride at 18, Hollywood wife at 19, drama student at 20, single woman at 21, born-again star at 22 … it's hard to believe that Billie Piper is still only 24" (Hattenstone). She came from a singing career with her first single as a girl-power song. "In public, she was the ingénue, feigning know-how, while the real Billie was far more streetwise than she let on" (Hattenstone). From the beginning of "Rose," her character "demonstrates curiosity, grace under pressure, logical and intelligent thought processes, and bravery" (Larsen 122). Though she's a shopgirl in government-subsidized housing with no higher education, she's clever and intuitive. Over and over, she saves the day. With her valor, she became a new kind of companion for a new era of Who.

Antoinette F. Winstead, in her essay on Davies companions' self-discovery, describes the perfect heroine's journey arcs for Rose, Martha, and Donna. She adds, "It is important to note that as originally conceived, the *Doctor Who* series mirrored the typical monomyth, wherein the hero battled and won against evil and saved the damsel in distress. It was not until its new, post–9/11 incarnation in 2005 that the heroine's journey took center stage in the *Doctor Who* series, reflecting a 21st century sensibility toward the role women play in not only science fiction, but also the horror and action-adventure genres" (229). It's nice to see the companions get a plot arc and a chance to dominate the scene as godlike beings and saviors in each year's finale. For Christopher Eccleston, the Ninth Doctor, the best thing is that Davies has feminized a male genre. "He's thought: how can I get girls into it? And he's given them a proper heroine. The Doctor is quite sidelined in the first episode and it's like revenge for 40 years of domination" (Belam).

Davies' era was also known for female creators. Julie Gardner, Davies' most constant collaborator, helped him launch not only *Doctor Who* but also *Torchwood* and *Sarah Jane Adventures*. She has more above the line credits than any other woman in *Doctor Who* history. Alice Troughton (no relation to Patrick Troughton), directed "Midnight," "The Doctor's Daughter," five two-part *Sarah Jane Adventures*, and two *Torchwood*s. Helen Raynor wrote "Daleks in Manhattan"/"Evolution of the Daleks" and "The Sontaran Stratagem"/"Poison Sky," along with *Torchwood*'s "Ghost Machine" and "To the Last Man."

The Bechdel test likewise does well in the Davies era. "More than 70 percent of the episodes that aired between 2005 and 2009 did pass the test outright, and every one had at least two named female characters" (McMahon-Coleman). Rose episodes scored 74 percent and Martha episodes, 78 percent. All Donna's episodes passed, possibly because she took a lively interest in exploration and didn't bother mooning about the Doctor.

Davies also brought in interracial couples, beginning with Mickey and Rose. Martha is engaged to Tom Milligan, and both Donna's first fiancé and her husband, Lance and Shaun, are Black. Other mixed-race couples include Foon and Morvin from "Voyage of the Damned," Milo and Cheen in "Gridlock," Sally Sparrow and Billy Shipton, the programmers in "The Parting of the Ways" and Martha's father's girlfriend and also her cousin Adeola's relationship.

> Russell T. Davies excelled at bringing all backgrounds, ages and lifestyles together on *Doctor Who*. His era seemed to be marked by a pervasive insistence, embedded in the characters he created and all they accomplished together, that these things should no longer be shocking to us. That there is no need to make a fuss over the color of two people who love each other, because that love is worthy of recounting all on its own [Asher-Perrin, "No Room" 66].

Davies also introduces the first omnisexual companion, Jack Harkness, who gets his own spinoff on *Torchwood* and a steady boyfriend. *Torchwood* also stars a rare Asian character, in tech genius Tosh. Other Asians of the time include the fortuneteller in "Turn Left" and geologist in "The Waters of Mars," creating a little inclusivity across the board.

New Who companions each "competently match the Doctor's wit and intellect with her own brand of streetwise common sense" (Winstead 230). At the same time, the younger Doctors are shown as being attractive to the companions but unable to reciprocate. In the books with Sam Jones and the audio serials with Charley Pollard, the Eighth Doctor has this relationship, before he meets Rose or Martha. Rose, Martha, and later Amy develop love for the Doctor, as do single-time guests like Astrid Peth and Madame de Pompadour. The female companions are thus "placed at an emotional as well as an intellectual disadvantage to the Doctor" (Britton 117). He remains aloof, kind and polite, but neglectful. The women are guests on his Tardis, able to be invited or dis-invited as he wishes. A sexist tinge thus appears through all these heroines' stories. "Rose and Martha reinforce the unspoken heterosexual myth that women will always relate to powerful men in romantic ways and that in a deeply fundamental way women will be defined in relation to men: their growth and movements, including appearances and disappearances across parallel worlds" (Kang 42).

Meanwhile, the new era brings with it new cultural norms. "*Doctor Who's* heroines are "Cosmo Girls," shapely and fashionable, who embrace both their femaleness and the commodity culture" (Winstead 229). Third-wave feminism, letting women save the day in pink miniskirts or minivans full of kids if they wish, has led to the "girl power" stories of the nineties and beyond. Like Buffy and Cher, Rose saves the day with pretty blonde hair and lots of makeup, seeking paths to power other than conventional fighting (and, in fact, she saves the day more than the Doctor does). "She's a heroine," adds

Eccleston. "She teaches him huge emotional lessons. They love each other. I think it's love at first sight, but it's not a conventional love affair, it's far more mysterious than that" (Belam). Rose protects the universe's last Dalek and even protests having the Tardis alter her mind (for translation) without asking. She thus provides a conscience on the show. "The tenth Doctor believes that he has learned from Rose to question his own motives, to interrogate his use of power" (Nathanael 87).

"Psychologist Carol Gilligan's studies of ethical values point to a feminine focus on the network of relationship, responsibility, and caring in contrast with a masculine focus on separation, autonomy, principles, and rights, and hierarchy" (Leonard 17). Between Rose's arrival and the new emphasis on relationships and even romance, the show reached out to females and modern teens. They invaded the formerly heavily male fandom. Nonetheless, many women criticize it on this basis: they don't want to be given a romantic show because that's "what women want." They also don't want to be given young fangirls Amy and Rose to identify with, rather than the capable Doctor. As Captain Jack stares at Rose's rear end through binoculars in "The Empty Child," the male gaze gets a hit in as well.

Of course, the Ninth Doctor is notably damaged. "Both benevolent and volatile, the Doctor is a war veteran suffering from posttraumatic stress disorder. Because of his trauma, he harbors many secrets, the biggest of which is his name. Unable to share neither his name nor past, he is also incapable of sustaining a long-term relationship" (Winstead 233). The Doctor's damage after the Time War appears particularly in "Dalek," in which he confronts the other final survivor. However, as he reacts with cruelty and rage, Rose literally reaches out, allowing the Dalek to absorb her human sympathy. She continues to act as the Doctor's advisor and conscience. "Her value to the Doctor is as his emotional core, the reminder of his humanity, the embodied force of compassion that keeps him from tipping over into homicidal lunacy" (Magnet 155). As his conscience, she takes an active role in changing him. "In echoes of *Pygmalion,* the balance of power shifts between the two. In an inversion of the old formula, the Doctor ends up leaning from his more emotionally literate companion. (Hearn 65).

In the first episode, while he stands helpless, she swings down and kicks the Auton into the Nestene Consciousness, saving the world. In "The Unquiet Dead," the Doctor causes the problem, which Rose and the local Gwyneth warn him against. In "The Satan Pit," the Tenth Doctor presents her as his savior, rejecting her role as a useless hostage. As he tells a devil-like monster: "I don't know. But if I kill you, I kill her. Except that implies in this big grand scheme of Gods and Devils that she's just a victim. But I've seen a lot of this universe ... if I believe in one thing, just one thing, I believe in her" ("The Satan Pit").

Davies "presents a 21st century version of women who are capable of not only thinking for themselves, but also of rescuing themselves and others, and, when necessary, the Doctor" (Winstead 230). Since Rose saves the world, it's her on-again, off-again boyfriend who must wait in the car, as he complains in "School Reunion." Winstead calls Mickey the "daffy, damsel in distress figure," a title he often earns (239).

In the Series One finale, Rose becomes Bad Wolf, a glowing goddess filled with the very heart of the Tardis, like love and the feminine presence embodied. This force is so powerful she can disintegrate Daleks with just a thought. The Ninth Doctor gazes at her worshipfully as she stares through time and space, saving her friends (even granting Captain Jack immortality!) and destroying her enemies. After, however, the Doctor must channel the force from her (destroying himself in the process) so she can survive. This gives her ultimate goddess power, but then shows a man protectively removing it from her in contradictory messages.

At last Rose departs, though as her character hangs on desperately between realities, she clingingly chooses the Doctor over her own mother, alt-reality father, and Mickey. The Doctor warns, "Once the breach collapses, that's it. You will never be able to see her again. Your own mother!"

Rose only replies, "I made my choice a long time ago, and I'm never going to leave you. So what can I do to help?" ("Doomsday"). However, she is swept into that other reality, leaving her and the Tenth Doctor parting sadly, even as he burns up a star just to say goodbye. Still, her adventure has given her a sense of purpose. In Bad Wolf Bay, Rose tells the Doctor she'll no longer work in a shop, adding, "There's still a Torchwood on this planet. It's open for business. I think I know a thing or two about aliens." The Doctor dubs her "Rose Tyler, Defender of the Earth." Though she's been cheated of adventures in time and space, he praises her for "living a life day after day. The one adventure I can never have" ("Doomsday"). She says she loves him and he's cut off before (presumably) he can say it back. Emphasizing how important she is to him, he sheds visible tears for the loss of his beloved companion. Of course, all these are palliative salutes to the companion who's written off the show.

Two years later, he gives her a clone of himself to bring up, telling her, "He destroyed the Daleks. He committed genocide. He's too dangerous to be left on his own.... That's me, when we first met. And you made me better. Now you can do the same for him" ("Journey's End"). In the end, Rose gets a fairytale—actually settling down and growing old with the Doctor.

When he's dying a year later, the Tenth Doctor bids Rose goodbye last, suggesting she's the most important to him. It's early enough in her life that Rose is the only companion not to recognize him—objectifying her, the Doctor wants to see her more than have an exchange with her. Despite or perhaps

because of Ten and Rose's many painful partings, she remains one of the most popular companions—specifically the one to reboot the franchise and make certain New Who could succeed.

Throughout her adventures, she functions as a beacon of sweetness and hope for the Doctor. "Women in touch with Muse energy tend to be mysterious and spiritual; their inspiration comes from love. They enjoy others' creativity and genuinely encourage it. Generous, they tend to give without expecting in return. Often they are trusting, fresh, receptive, and caring, and their simplicity opens the way for new images and ideas to develop" (Leonard 105).

However, this role is inherently limiting. "The difficulty for these women is that often they inspire others at their own expense. When a man wants a woman to inspire him but not to create herself, he can make her mad. Living the role of a Muse of femme inspiratrice can be difficult and frustrating or a way to remain passive" (Leonard 105). Rose is free to operate, but as the Doctor's assistant and touchstone. In her final series moments, she's given the task of rehabilitating the new Doctor, but as a housewife, not an adventuress.

In the audio adventures, a sweet, spunky character echoes Rose's personality. Charlotte Pollard, a very cheerful "Edwardian adventuress" in the Big Finish audio dramas, rebels against her soft upbringing and seeks a life of adventure. Born the day the Titanic sank, the eighteen-year-old offers the Eighth Doctor a lively back and forth with banter and occasional practical jokes. Russell T. Davies told India Fisher, her actress, that he truly enjoyed the Eighth Doctor and Charley dynamic, which contributed a great deal to his creation of Rose (52).

In 1930, His Majesty's Airship, the *R101*, sets off on her maiden voyage to Karachi, secretly transporting an alien delegate. Charley has stowed away onboard in boy's clothes, seeking excitement. She's on a terribly romantic trip to meet a young man named Alex Grayle in the Singapore Hilton. Of course, the Eighth Doctor lands. They rendezvous with a flying saucer and the alien, Engineer Prime of the Triskele, bonds with Charlotte, valuing her extraordinary empathy. Meeting Engineer Prime, whose grey face revolts the men, Charley breaks down in tears and decides, "She's beautiful" (*Storm Warning*). The engineer alien reaches out to Charley noting, "Charley ... you are kind." Since the engineer has a quavering feminine voice, this moment evokes sisterhood and sensitivity, the human "heart" the Doctor often lacks.

At the episode end, Charley brightly announces she's coming with the Doctor. "It's all right, Doctor, I know. And I'd love to come with you. See the galaxy, mix with the Martians, and visit the Venusians," she decides. Though he fears she's an aberration in time since she should have crashed, he brings her along anyway.

Charley's gushing enthusiasm matches the Eighth Doctor's energy well.

She embraces the wonders of the universe though she eventually develops feelings for the Doctor himself. Charley creates scandal by expressing this love, long before Rose or Martha arrive. "He became literally everything to her—her family, her best and only friend, a father figure, and yes, to some extent, a crush," explains Fisher (53). In turn, the Doctor tells her he loves her, but his words suggest a more platonic relationship. A kiss they share is motivated by a body merge rather than emotion.

By rescuing Charley from her preordained death, the Doctor causes a temporal paradox. The Web of Time begins to crumble and President Romana gives orders to arrest Charley and the Doctor. Displaying her valiant love, Charley tries sacrificing herself to save the universe, but the Doctor refuses, absorbing the forces of anti-time into himself instead. Thus contaminated, he must exile himself into a parallel universe where time does not exist. Once again, loving Charley stows away and joins him until he can recover. At last they return to the normal universe, with new companion C'rizz.

After various adventures, C'rizz sacrifices himself, and a horrified Charley tells the Doctor that she wants to go home. Accordingly, in the audio drama *The Girl Who Never Was*, he takes her to Singapore where she angrily walks away and leaves the Doctor a goodbye note, insisting she'll disappear and make a new start for herself. "I can go anywhere. Be anything I want—just like a Time Lord really." Before she can leave, the pair are swept away on an adventure together, complete with various memory wipes. The Doctor also encounters the eighty-five-year-old version of Charley, whom he abandoned, and loyally invites her along: "Charley, it's such a big universe. And now I get to show it to you all over again." Despite his generosity, this ends up being someone different than he expected. The twist-filled story ends with the Doctor reading Charley's original note and letting her go, while Charley is stranded on a desert island, only to be quite shocked when the Tardis shows up piloted by Doctor Number Six. Charley joins him but refuses to reveal her secret. This final dynamic is interesting because Charley, like River Song, has all the power in the relationship with her knowledge of the Doctor's future. "Because she was in control, it created a shift in their power balance, and she was no longer a little girl utterly in awe of the Doctor," Fisher adds (53). Later, she gets her own spin-off.

Another strange flip occurs when Mila, a non-corporeal Dalek experiment, stows away on the Tardis and eventually takes over Charley's form. Afterwards, Mila travels with Six, all the while pretending to be his companion, while Charley is left behind with an alien virus (*Patient Zero*). The local aliens cure her and keep her in cryogenic storage for several millennia, bringing her out to aid them with projects. Mila finally sacrifices herself to save the Doctor, while Charley and her new friends alter the Doctor's memories so he only recalls Mila, not the companion that he will travel with a few life-

times in his future (*Blue Forgotten Planet*). Thus Charley, like River, meets her Doctors in reverse order but keeps herself distant to preserve their time-lines. In altering his memories, she goes a step further, emphasizing her power over his life, all for the good of the universe.

Alice Obiefune, an African-British library assistant in her thirties, travels with Eleven in the comics. Filled with grief over the recent loss of her mother, she begins the comic painted all in grey, tiny and crushed-looking within the panels as she's laid off and evicted and even her friends move away. Nonetheless, she bears it all stoically. Suddenly, she meets Eleven as he runs past her, chasing an alien "rainbow dog." Alice manages to catch the creature, which feeds on negative emotion. This companion travels with the Doctor to deal with her loss, asking to first go somewhere her mother would have enjoyed (*After Life*). As they travel, she continues recalling her mother's advice and solving alien mysteries with her deep empathy. Thus she too is a beacon for the Doctor.

In "Planet of the Dead," the Tenth Doctor emphasizes the importance of ordinary bus riders from London, all of whom have been carried to an alien planet. He fixates on a single sweet woman, Angela Whittaker, to make his point:

> DOCTOR: All right now, stop it. Everyone, stop it! Angela, look at me. Angela? Angela? Answer me one question, Angela. That's it. At me, at me. There we go. Angela, just answer me one thing. When you got on this bus, where were you going?
> ANGELA: Doesn't matter now, does it?
> DOCTOR: Answer the question.
> ANGELA: Just home.
> DOCTOR: And what's home?
> ANGELA: Me and Mike. And Suzanne. That's my daughter. She's eighteen.
> DOCTOR: Suzanne. Good. What about you?
> BARCLAY: Don't know. Going round Tina's.
> DOCTOR: Who's Tina? Your girlfriend?
> BARCLAY: Not yet.
> DOCTOR: Good boy.

He hears about the others' plans for chops and gravy or watching television, and replies, "Just think of them. Because that planet out there, all three suns, wormholes and alien sand, that planet is nothing. You hear me? Nothing, compared to all those things waiting for you. Food and home and people. Hold on to that, because we're going to get there. I promise. I'm going to get you home." Angela begins the episode crying into her hands, but soon proves helpful, using ordinary knowledge to break through UNIT's phone tree. The others too all aid in the solution. Working together, the Doctor gets all his passengers home, emphasizing the power of everyday humanity. True magic, he suggests, can be found in Rose, Alice, and Charley, in all those filled with love and empathy.

Sacrifices and Fridgings: One-Off Companions

Reinette is the first person the Tenth Doctor specifically asks into the Tardis. The 18th-century aristocrat intuitively reads the Doctor's mind and understands the many doorways to eras of her life all allow the Doctor to step through, like the pages of a book. She and the Doctor connect intensely, making her and Astrid Peth from "Voyage of the Damned" into "examples of this illusive type of companion who is not able to accept the Doctor's invitation to 'see those stars a little closer'" (Achenbach). "Voyage of the Damned" takes place on the space Titanic, a snobby cruise ship where Astrid waits tables. She tells him: "I just wanted to try it, just once. I used to watch the ships heading out to the stars and I always dreamt of … it sounds daft." However, her dreams of exploration strike the Doctor, a sentiment that signals he'll soon be adopting a companion.

The Doctor smuggles her to earth, where she is all agush: "But it's a different planet. I'm standing on a different planet. There's concrete and shops. Alien shops. Real alien shops! Look, no stars in the sky. And it smells. It stinks! Oh, this is amazing. Thank you!" she cries. Her very human delight thrills the Doctor of course. "She sees beauty where the Doctor only sees the mundane. And Astrid never expects anything more; for her, that one tiny journey was the highlight of her life. But, of course, the Doctor offers her the entire universe" (Achenbach).

When the Titanic predictably crashes, a small party including the Doctor and Astrid, crawl through the ship. However, they die one by one, emphasizing the many sacrifices the Doctor inspires. Bannakaffalatta, the stigmatized cyborg, explodes himself to stop the Host—waitstaff robots turned killer. Rickston Slade, the cruel CEO climbing through the ship with them, names Foon and her husband Morvin "Mister and Mrs. Fatso," while the rich guests mock them for winning their tickets on a gameshow. However, their real-life skills prove useful, since they work with robotics. As Foon fears death, she makes her all-too-relatable confession, in a delightful moment: "I dialed the competition line five thousand times. That's five thousand credits. I might as well have paid for the tickets. I've been hiding the phone bill for months now."

Her husband laughs at the absurdity of ever paying off such a bill, but adds, "Does it matter? Look at us. You drive me barmy. I don't half love you, Mrs. Van Hoff. Come here." Slade, called upon to help the couple, runs and saves himself, leaving the Doctor to shove the overweight pair through the gap in the rubble and save them. At the next trap, Morvin falls to his death and Foon despairs. When one of the ship's Host robots attacks the Doctor, she hurls it and herself into the pit, joining her husband in death. "No more," the Doctor pronounces fiercely. Each death in this episode of doom hits him

hard, emphasizing that the characters, however loveable, only exist to push his emotional story forward.

Through their adventure, Astrid offers cheerful help, even flirting with Bannakaffalatta to emphasize her acceptance of him. When the Doctor heads for the bridge alone, he tells them: "Mister Copper, look after her. Astrid, look after him. Rickston, er, look after yourself. And I'll see you again, I promise."

Astrid calls for the Doctor to wait for an "old tradition." She pulls out a box to stand on and gives the flustered Doctor a huge kiss. After he leaves, she insists on teleporting after him, adding, "He's gone down there on his own, and I, I can't just leave him. He's done everything he can to save us. It's time we did something to help him." While the Doctor confronts Max Capricorn, the evil CEO crashing the ship, Astrid heroically grabs him and hurtles them both into the engines. After saving the ship, the Doctor realizes he can bring her back with her emergency bracelet. However, he fails. "She's just atoms, Doctor. An echo with the ghost of consciousness. She's stardust," a last survivor tells him. Sadly, the Doctor kisses her goodbye and poignantly lets her go. "Astrid's fate is similar to that of the Tardis: forever flying through the stars" (Achenbach). Her death, more than all the others, hits him painfully, once again making the story all about him.

When Davros asks "how many more have died in your name?" in "Journey's End," Astrid appears. She's joined by Jabe ("The End of the World"), the Game Station Controller ("Bad Wolf"), Lynda Moss ("The Parting of the Ways"), Sir Robert MacLeish ("Tooth and Claw"), Mrs. Moore ("Age of Steel"), Mr. Skinner ("Love and Monsters"), Ursula Blake ("Love and Monsters"), Bridget ("Love and Monsters"), The Face of Boe ("Gridlock"), Chantho ("Utopia"), Luke Rattigan ("The Poison Sky"), Jenny ("The Doctor's Daughter"), River Song ("Forest of the Dead"), the unnamed Hostess ("Midnight"), and Harriet Jones, who has died during the episode. More than half are sweet young women of the sort he takes as companions. Of course, Classic Who could have added many more including Adric, Sara, and Katarina. River joins the sacrificed companions in "Forest of the Dead" and Clara in "Face the Raven." Donna loses her memory, and Bill, her humanity, while Rose and Amy tumble permanently into distant times and realities.

Granted, a sacrifice can be noble and beautiful—surrendering the self to save others. Almost every Doctor has given his life for this. However, far too many on the "Journey's End" list have no agency, destroyed by aliens as a brutal message to the Doctor, making it a fight between him and them. The problem is the concept that women are damsels, to be rescued by the men or fought over—prizes not people. As Anita Sarkeesian describes in "Damsel in Distress (Part 1) Tropes vs Women":

Let's compare the damsel to the archetypal Hero Myth, in which the typically male character may occasionally also be harmed, incapacitated or briefly imprisoned at some point during their journey. In these situations, the character relies on their intelligence, cunning, and skill to engineer their own escape—or, you know, just punching a hole in the prison wall works too. The point is they are ultimately able to gain back their own freedom. In fact, that process of overcoming the ordeal is an important step in the protagonist's transformation into a hero figure. A Damsel'ed woman on the other hand is shown to be incapable of escaping the predicament on her own and then must wait for a savior to come and do it for her.

This casts someone like Astrid as the story's lost prize instead of a savior in her own right. As Sarkeesian adds, "At its heart the damsel trope is not really about women at all, she simply becomes the central object of a competition between men (at least in the traditional incarnations). I've heard it said that 'In the game of patriarchy women are not the opposing team, they are the ball.'"

When veteran comic-book writer Gail Simone became sensitive to this issue, she coined the term "Women in Refrigerators" for a website dealing with this problem. The title refers to the death of Alexandra DeWitt, Green Lantern Kyle Rayner's girl-friend during issue #54 from the third volume of Green Lantern. In this issue, Kyle comes home to his apartment to find Alex's corpse infamously stuffed inside his refrigerator by his nemesis, Major Force, a deplorable act that had inspired the title of Simone's website, which, through professional and fan participation, has amassed a damning list of women in comics who have been raped, killed, mutilated, or have lost their powers [Powers].

Specifically, fridged women are killed to affect the central hero, or in this case the Doctor.

Jabe, a beautiful tree lady, is one of the first aliens Rose Tyler meets in "The End of the World." Sweet and respectful, she tells the Ninth Doctor, "All the same, we respect the Earth as family. So many species evolved from that planet. Mankind is only one. I'm another. My ancestors were transplanted from the planet down below, and I'm a direct descendant of the tropical rain-forest." She also has discerned his true species, and spends a moment com-miserating over the loss of his people. She aids the Doctor, even as the room heats to levels her human body can't withstand. Her eyes blaze. She calls him "Time Lord" and urges him to action ... then moments later, she bursts into flame. This is the quintessential "damsel" moment, urging on the hero as she perishes.

In the same episode, Rose (newly elevated to high society) sympathizes with a worker in overalls, chatting about her job as plumber. Significantly, the worker, Raffalo, is silenced, unable to even speak to guests without per-mission. She dies moments later—this humanizes Rose but adds Raffalo to the list. For the second episode, too many women die, all suggesting Rose's precarious position.

The next episode follows the pattern. Gwyneth, a servant in 1869 Cardiff in "The Unquiet Dead," has the sight, and it keeps growing stronger. Once again, Rose bonds with her, crossing boundaries to help her do the dishes. They hold a séance and the alien species of the Gelth speak through her, demanding Gwyneth: "Take the girl to the rift. Make the bridge," they plead. Gwyneth, their channel, faints. Rose cares for her and also defends her, urging Gwyneth to sleep and telling the Doctor Gwyneth shouldn't have to fight his battles. As Rose takes her agency, the other woman reclaims it and retorts, "You would say that, Miss, because that's very clear inside your head, that you think I'm stupid.... Things might be very different where you're from, but here and now, I know my own mind, and the angels need me. Doctor, what do I have to do?"

Gwyneth channels the Gelth, but they take advantage, seeking to kill mankind and take their bodies. The Doctor tells her they aren't the angels she thought but liars. She heroically replies, "I can't send them back. But I can hold them. Hold them in this place, hold them here. Get out." In a room filled with gas, Gwyneth takes a box of matches from her apron pocket. They run, she dies. "She saved the world. A servant girl. No one will ever know," Rose remarks sadly.

Series One ends in the futuristic Big Brother House of "Bad Wolf." There, the Ninth Doctor gets to save an actual damsel in the person of hopeful television star Lynda-with-a-y. He calls her "sweet" and she looks the part with blonde poofy ponytails. She's perky but also desperate for love, asking, "Am I popular?" and adding, "Oh, but does that mean I'm nothing? Some people get this far just because they're insignificant. Doesn't anybody notice me?"

When the Doctor breaks out, he tells her, "Stay in there, you've got a fifty-fifty chance of disintegration. Stay with me, I promise I'll get you out alive. Come on!" When she hesitates and her companion refuses, he adds, "Lynda, you're sweet. From what I've seen of your world, do you think anyone votes for sweet?" They flee together and when she proposes going with him, he smiles and agrees it would not be a bad idea. As usual, this exchange dooms her shortly after. In the following episode, she acts as a coordinator by tracking Dalek movement. However, the Daleks locate her and cut through the door with a torch as Lynda watches in terror. They finally shoot the glass, hurling her into space as the Doctor listens over the communication system ("The Parting of the Ways"). Of course, she trusts in the Doctor, acts heroically, and is killed for it. The Doctor remembers her among all the others who sacrificed in "Journey's End."

In the following year's "Age of Steel," the alt-world Jackie Tyler becomes a Cyberman, along with much of the country. Of course, Rose is distraught, while her alt-world father Pete angrily join the resistance. In the same episode, another converted woman breaks the Doctor's hearts when he breaks the

cyber control over her: as she repeats how cold she is, and adds that she's getting married in the morning, all the Doctor can do is shut her back down.

She's one more sacrifice, fashioned into a tool. The episode also features the brave getaway driver and resistance fighter Mrs. Moore. She supplies the team with her ID badge, knockout drugs, and even bombs as they infiltrate Cybermen headquarters. As she explains modestly, "Oh, I used to be ordinary. Worked at Cybus Industries, nine to five, till one day, I find something I'm not supposed to. A file on the mainframe. All I did was read it. Then suddenly I've got men with guns knocking in the middle of the night. Life on the run. Then I found the Preachers. They needed a techie, so I, I just sat down and taught myself everything." Despite her heroism, a Cyberman suddenly, instantly kills her.

"Love and Monsters" introduces a fan community including Ursula, Bliss, and Bridget. The alien Abzorbaloff that infiltrates their group absorbs the members into its body one by one, creating a merged mess of flesh. At last only Elton is left, with his vulnerable love interest Ursula gazing at him from the beast's stomach and urging him to run. With this, he takes a stand, backed by the Doctor and Rose. All the victims die with the creature, except for Ursula, whom the Doctor manages to preserve in a chunk of paving slab. However, the young couple seem resigned: "At least I'll never age. And it really is quite peaceful, you'd be surprised," Ursula says, and they hint at a thriving love life as well.

The neutral character Trinity Wells is an American newsreader for the network "AMNN." On the show (or rather, shows) she reports important incidents such as the Slitheen crisis from "Aliens of London" and the Sycorax invasion. Though a background character, she appears in all of the first four series of New *Doctor Who*. She does additional reporting in *Torchwood: Children of Earth, The Sarah Jane Adventures,* and some novels and comics. She's a competent woman of color who does her job, though she doesn't have much personality. Nonetheless, Wells is briefly taken over by fake astrologer Martin Trueman in *The Sarah Jane Adventure* "Secrets of the Stars." Since she's lost to the Master's worldwide takeover, she has her victim moments.

Fridged women continue through Martha and Donna's eras. The Sibylline Sisterhood in "The Fires of Pompeii" are human prophets. However, an earthquake in Pompeii awakens the dormant Pyrovile, an alien who takes over the women. It expands their psychic powers but converts them into stone. Later, Miss Evangelista is a running joke. As she shouts that she's found something important, everyone ignores her. "Couldn't tell the difference between the escape pod and the bathroom. We had to go back for her. Twice," her coworker notes ("Silence in the Library"). The first to die, she bursts into a skeleton and then keeps talking in a creepy manner. She's the useless assistant, who does nothing to aid the characters until after her death.

In "42" the captain sacrifices herself to save her crew and stop her husband

from murdering them all. She's atoning for the illegal and immoral crime that endangered them all and killed her husband. Likewise, the hostess on the planet Midnight saves them all by dragging herself and the assistant Sky into the deadly sunlight. The Doctor realizes after that no one even knew her name.

In "Midnight," this stage of Girard's scapegoating function begins after the people on the shuttle encounter something that knocks on the outside of the small ship that is keeping them alive. It appears that somehow the creature has entered the shuttle and has taken over the body of one person who had been, until this moment, just another member of the community. The woman named Sky is now marked as being different from the others, and so she, or the creature that is possessing her, is blamed for the deaths of the driver and the mechanic as well as damage to the shuttle. The crime that this creature, and/or Sky herself, is accused of is more than mere murder; it is a double murder that tears apart their community because without a mechanic, a driver, and a working shuttle, this crime could lead to the total destruction of their own community [Green 108–109].

Abigail in "A Christmas Carol" is being kept as collateral against a loan, in the ultimate objectification. The patriarch of her world thus emphasizes his power over her life and family. Even after the Doctor wakes her, she's consistently othered: Young Kazran asks, "When girls are crying, are you supposed to talk to them?" only for the Doctor to respond that he has no idea. Clearly, girls are mysterious, unknowable creatures. The Doctor visits each year to reform young Kazran, and they treat Abigail like a toy they rarely take from its box. She in turn fulfils her role in the story and falls in love with Kazran, then uses her magical singing on command. She is sweet, innocent, and tragically dying, with no personality beyond this. These damsels who only exist (and die) to affect the men of the story are a particularly common trope.

Jenny, the Doctor's daughter, is created to be a soldier, and the Doctor spends the episode complaining about how he resents fatherhood being thrust on him. An appalled Donna insists he take responsibility for the living girl before them. The eternal war finally ends when Jenny throws herself between her father and a gun, saving his life at the cost of her own. Of course, the Doctor was just coming around to accepting her and inviting her along. "The Doctor, in being the only person present who clearly speaks out against violence, is once again marked as a scapegoat. Jenny's death, however, is something different. A child of the machine herself, her innocent death again reveals the violence in the two conflicting communities for what it is" (Green 111). In her name, the Doctor insists on an end to conflict, immortalizing her as a static symbol. However, he's oblivious to the real girl's survival.

Lady Clemency Eddison, the fragile-looking hostess of the murder mystery "The Unicorn and the Wasp," is trapped by a husband who pretends to be handicapped: He tells her that this was the only way he could be certain of keeping her. This isn't her first time being used by men, as in India she had an affair with a handsome man only to have him reveal "his true shape," a

giant wasp. She was left pregnant and gave away the baby. In the episode, he finally returns and begins killing her guests, the third man to betray her. All these events demonstrate how thoroughly she, and by extension all women, are playthings for the 1920's men.

In Bill's first episode, she falls for a student who shares her powers of observation. Heather's eager for adventure, and Bill offers to run away with her. Meanwhile, Heather observes a strange puddle with reversed reflections. Transforming into a puddle-person, she follows an increasingly-frightened Bill. The Twelfth Doctor explains that her craving for adventure motivated the puddle creature: "It found a pilot, so it ate her" ("The Pilot"). The Doctor resents the death but prepares to forgive the alien, telling it, "You've already taken one person from the Earth. I'm going to let that pass, because I have to, but I will not let you take another. Go. Just go now. Fly away. Why won't you just go?" As it turns out, it promised to travel with Bill, so she must sadly release her love interest, letting her sail away. This encounter appears to only exist to put Bill through the emotional wringer, though Heather startlingly returns to give her a happy ending in Bill's farewell episode.

Even the feminist *Sarah Jane Adventures* had these moments. Historically, the sixteen-year-old Lady Jane Grey was crowned Queen of England in 1553. After only nine days, she was executed to make way for Queen Mary. Though she sat the throne, she remained a pawn of her father and the British lords, and went down in history as a pointless, tragic sacrifice. In *Lost in Time*, Rani travels back and meets her. She finds a sweet-faced young woman married at fifteen to an unwashed boor. The queen adores Rani, whom she takes as a lady in waiting. In turn, Rani speaks to the queen as a friend, something Jane Grey appreciates. Rani tries to comfort her with knowledge of her future fame, and the queen decides she's an angel. Though sacrificed to history, Lady Jane departs with a new confidence and reassurance.

Likewise, as *Class* Series One ends, Shadow Kin suddenly kill Ram's dad and Tanya's mom, then go after Tanya's brothers and April's mother until April and Quill stop them. This brutal list of fridgings terrorizes the teens, enforcing that none of them will be safe until April returns with the shadows. The evil Corakinus smirks: "Look at you, in your little circle. Pretending to be heroes and never expecting to pay a price.... I have killed two. Come with me or I will kill more" ("The Lost"). He then takes every human on the planet hostage, escalating the stakes. They fight him off and save the world, but remain devastated by the losses.

Cass in "Night of the Doctor" proves yet one more addition to the list. In his fiftieth anniversary special, the Eighth Doctor tries to save her, but when she discovers he's a Time Lord, she panics and locks a bulkhead between them. "Go back to your battlefield. You haven't finished yet. Some of the universe is still standing," she spits. She dies in the crash, and her sacrifice

impels the Doctor to end the war as the Sisterhood of Karn lay out her dead body. Ohila insists, "If she could speak, what would she say? ... She would beg your help, as we beg your help now." With a final salute of "Cass, I apologize," he drinks the sisterhood's elixir and transforms.

Rita in "The God Complex" is quite compelling. A nurse in scrubs, she bursts into the room threatening the Eleventh Doctor with only a chair leg. Instantly, she takes charge—traditionally the Doctor's job. She assesses him and his companions cleverly and scientifically, announcing, "Their pupils are dilated. They're as surprised as we are. Besides which, if it's a trick, it'll tell us something." The Doctor quips in response, "Oh, she's good. Amy, with regret, you're fired." Rita is Muslim—and her religion becomes a plot point as they're all trapped by their faith. She's also quite humorously self-aware about it, snarking "Don't be frightened," to the Doctor's amusement. In British tradition, she also prepares tea instead of panicking. As Rita continues proving brave and competent in the hotel of horrors, the Doctor offers his customary invitation. However, Rita senses his bossiness and control, retorting, "Why is it up to you to save us? That's quite a God complex you have there." She thus takes the skeptical companion role, challenging his superiority as Donna does. Despite her skill, she too perishes, though dignified and proud to the end. In the same episode, a lone policewoman (and thus a profession associated with bravery) launches the episode announcing, "My name is Lucy Hayward, and I'm the last one left." Even dying of terror, she steadfastly records her experiences in a diary to save the next victims. She too deserves a salute.

"The Asylum of the Daleks" introduces humans who have been turned into Daleks, with eyestalks suddenly, disturbingly jutting from their foreheads. The first is Darla von Karlsen, introduced with the words, "Her daughter is in danger, and only you can save her."

However, the Eleventh Doctor tells her, "It's a trap.... You are, and you don't even know it." Suddenly, an eyepiece bursts from her forehead and she captures him. In the next scene, Amy's makeup artist Cassandra reveals herself as another. Later in the episode, a male officer transforms, and finally the mysterious Oswin herself. Thus, the women are a sympathy snare, hiding their hybrid Dalek nature. A layer of original personality remains, but the first victim has only what's needed to entrap the male hero. As the Doctor pleads with Darla to remember her daughter, she retorts that her memories only activate to preserve her cover.

Flirty, mad Tasha Lem transforms the same way a few years later. The women trap the Doctor with compassion—and usually succeed. However, Oswin and Tasha's personalities overcome the technology, emphasizing the power of individual will. Still, as other women like Osgood are killed to enrage the Doctor, the tragic cycle continues. Too many are damseled, de-powered and sacrificed to create an emotional blow for others.

Childlike Wonder: Amy Pond

When Amy first appears, she's a little girl with red rubber boots and a jacket over her nightgown—a fantasy heroine ready for her big adventure. "Ohh, that's a brilliant name. Amelia Pond. Like a name in a fairytale," the Eleventh Doctor says ("The Eleventh Hour"). Her creator, Steven Moffat, explains: "The basis of the relationship between the Doctor and the companion really is a magic man from space and a child…. It's not boyfriend and girlfriend, it's not husband and wife, God knows, it's actually a magic man from space who can take you away, means you never have to go back to school, and a child. And that remains their relationship even when they're growed up a bit" (qtd. in Hoskin 133).

The Doctor offers to make the seven-year-old his companion—his youngest ever. As he bonds with the fellow orphan alien (since she's Scottish), he notices how brave she is: "You're not scared of anything. Box falls out of the sky, man falls out of the box, man eats fish custard. And look at you! Just sitting there."

At the same time, the Doctor orders young Amy to cook him treats, complaining, "Why can't you give me any decent food? You're Scottish, fry something" ("The Eleventh Hour"). With this, he's turning her into his classic assistant and sidekick. He absent-mindedly ditches her for twelve years then two more without apology. He earns a child's trust, discovers she's in danger, and then abandons her until literally the eleventh hour.

> DOCTOR: Not safe in here, not yet. Five minutes. Give me five minutes! I'll be right back.
> YOUNG AMY: … People always say that.
> DOCTOR: Am I people? Do I even look like people? Trust me. I'm the Doctor.

Young Amy (played by a cousin of Karen Gillan's) returns over and over, capping her first year and her time on the show, as well as appearing as a talisman for the dying Doctor in "Let's Kill Hitler." As an alien disguised as Young Amy notes, "Poor Amy Pond. Still such a child inside. Dreaming of the magic Doctor she knows will return to save her. What a disappointment you've been" ("Amy's Choice"). The Doctor beats the alien by manipulating Amy's dreaming mind, a disturbing image for viewers.

Even older Amy galvanizes Eleven's childishness. In the minisodes "Bad Night" and "Good Night," the Doctor shouts for Rory when Amy's "having an emotion," then dismissively counsels her to deal with it by buying her past self an ice cream. They go off to the fair with him prattling, "Do you get scared on Ghost Trains? I get a bit scared, so is it okay if I hold your hand?" In "The Impossible Astronaut," he hates wine and insists on his special curly straw. "We're encouraged to see Amelia and the Eleventh Doctor as the

same—adventurous and childlike—rather than what they actually are: a small and vulnerable child and a powerful alien" (Stoker).

Their fantasy adventure is goofy, with the Doctor's fish fingers and custard, emphasizing how truly ridiculous he is. As Amy grows up, she makes cartoons and dolls of her imaginary best friend. He's very tactile, licking and tasting everything including the shed. Even when he returns for an older Amy, he drives a big fire truck, taunts the prisoner and gets taunted in turn and otherwise acts like a big kid. He's oblivious to changing clothes in public (though Amy is not). In fact, he and Amy both play dress up in the episode. "To hell with the raggedy—time to put on a show!" he cries. He's more a childhood companion than a mentor [Frankel, *Doctor Who and the Hero's Journey*].

Amy becomes a true believer companion, heightened by beginning the relationship as a trusting child. Moffat adds, "She's a little girl who believes that men can fall from the sky … and she's the girl who grows up to believe you should never believe in that sort of thing because they're liars and they don't turn up when they say they will. And the rest of the story is the doc trying to make her the girl he first met again" ("Out of Time"). By the time of her wedding, she can stand up and believe in her raggedy man strongly enough to return him to existence.

When he meets her adult self, Eleven discovers a short-skirted kissogram girl. Her very first shot pans slowly up her legs (a feature that continue being mentioned through the show). Many fans objected, considering this "too sexy" for a family show, or a regression in the world of feminism. Gillan insisted her character was showing confidence, while executive producer Piers Wenger said, "The whole kissogram thing played into Steven's desire for the companion to be feisty and outspoken and a bit of a number. Amy is probably the wildest companion that the Doctor has travelled with, but she isn't promiscuous" ("Viewers Think"). However, the job has no effect on her character and is based solely on attractiveness, not training. Then there's the minisode in which Rory makes a mistake because Amy is wearing a short skirt over the Tardis's mirrored floor. Teresa Jusino protests in her essay "Moffat's Women":

My problem is with the too-easy, dated, sexist humor they employ, especially in the second part. First, there's the issue of Amy being a bad driver and Rory being allowed to "have a go" at driving the Tardis. Bad woman driver, ha ha…. Less forgivable, however, is the final message at the end. Once the crisis is resolved, The Doctor says that they should be safe, but to prevent it from happening again, he says "Pond, put some trousers on." So, let me get this straight: Rory gets distracted, Rory drops the coupling … and it's Amy's job to put some pants on.

Amy and Rory joke about how Amy passed her driving test specifically by wearing a short skirt. As Jusino adds, "It bothered me that Moffat went with humor that dates back to a time when people laughed at bosses chasing

their secretaries around a desk, and it was totally okay." As she adds, "'punishing' Amy for what she wears, even in jest, sends the message that men and boys don't ever have to be responsible for their actions. That women cause trouble, or that women are 'asking for it.'" This, she emphasizes, is a major problem in storytelling.

Amy appears in trendy clothes with short skirts, foregoing more casual, practical, or frumpy outfits, as does Clara after her. Only after her love triangle concludes do the miniskirts make way for trousers, sweaters and jackets, while River becomes the new lust object. While they, like Leela and Peri, absolutely dress to captivate the male gaze, it should be noted that the female gaze has also gotten some attention through the show. From Ian's arrival in episode one, the show tries to offer all viewers macho men to admire. Undercutting this cliché, youthful kilted Jamie is the one to make a splash as one of the most endearing, beloved (and underdressed) companions.

As New Who begins, the young sexy Doctor follows Jamie's example. Eccleston is actually stripped and tortured in "Dalek," allowing female viewers to gaze at his body in a way quite unusual for the Doctor. Following him comes flirty, fun David Tennant. He gives a wink and a grin to many female characters, though he rarely undresses or wears silly costumes. Overlapping them both, Captain Jack lets female robots strip him in "Bad Wolf," and destroys all sorts of barriers at *Torchwood*. Though he presents himself as ill-fitting in society, Eleven carries on Ten's flirtations, mostly aiming them at River, rather than various alien women and his own companions. The producers play this up, having Eleven actually strip in a 2011 Children in Need minisode. This of course is a gift to the female gaze, emphasizing a new era of Who.

Amy's era (Series Five–Seven) was notable for its lack of female creators. Helen Raynor's "The Sontaran Stratagem"/"Poison Sky" in Series Four were the last two episodes of *Doctor Who* to be written by a woman until Series Nine. In 2010, "Amy's Choice" and "The Lodger," both directed by Catherine Morshead, were the only lady-directed episodes in the first three years of Steven Moffat's tenure as showrunner. With Amy, the Bechdel test also fell into peril. "Only half the episodes passed the test, and that the average speaking time of the female companion per episode (which peaked with Donna) also dropped by the more than a minute per episode, to its lowest level ever" (McMahon-Coleman). Along with criticism for his lack of female staff, many complained of a certain similarity to Moffat's characters.

His episodes revolve around women waiting, from River in her cell to Liz Ten stuck in her forgetting cycle. At last Amy (who has already waited plenty) spends millennia trapped in a box, then waits decades for the Doctor and Rory to find her in "The Girl Who Waited." Moffat's women: River, Amy, Clara, Missy, are all sexy, all damaged, all in need of the Doctor to stabilize and care for them.

Amy waits her entire life for the Doctor; River is bred to kill him. Clara has sliced herself in pieces through all of space-time to save him. Missy/The Master never appears onscreen without focusing every moment on an obsession with the Doctor. Thus their lives really do revolve around the Doctor … and without him they blink out of existence (in contrast to the Davies companions, who continue active lives, especially Martha).

Notably, the Doctor must solve their mysteries, depicting the women as puzzles rather than people. While River teases him with her secrets, Amy and Clara don't know the answers to their pasts, depriving them of agency. Clara is of course the "Impossible Girl," scattered across the universe. In Eleven's first year, he discovers the base code of the universe comes from Amy's origin time. He tells her, "It's you. It's all about you. Everything. It's about you…. Mad, impossible Amy Pond. I don't know why, I have no idea, but quite possibly the single most important thing in the history of the universe is that I get you sorted out right now" ("Flesh and Stone").

She certainly has her tough side, suggesting the androgyny of childhood. As a teen, she even tells her friends "I count as a boy" for her rough-and-tumble troublemaking ("Let's Kill Hitler"). Presumably, she's referring to her aggression and independence. She wields a sword in "The Curse of the Black Spot" and "The Girl Who Waited." When Riddell of "Dinosaurs on a Spaceship" introduces a "two man job," Amy tells him, "I'm easily worth two men. You can help too, if you like."

The Doctor means to fly off with young Amy, but miscalculates and leaves her waiting patiently for an entire *twelve years*. Upon the Doctor's return, she whacks him with a cricket bat, but also displays a terrible foolhardiness as twice she ties up the Doctor, endangering her life in the process.

In his absence, Amy never quite grows up. She goes through the motions of becoming an adult—when the Doctor reappears she's got a job as a kiss-a-gram, has been through therapy and is soon to be married. But as we get to know her better, we also discover that Amy never forgot the "raggedy Doctor"; we see that she's still got copious drawings, dolls and puppets of her "imaginary friend." When the Doctor finally does make good on his invitation to adventure, it's significant that Amy runs away with him with barely a second thought [Hoskin 133].

He's very condescending as he invites her to come, responding to her protest of "I grew up" with "Don't worry. I'll soon fix that." He insists she'll come "Cause you're the Scottish girl, in the English village, and I know how that feels." Indeed, as she hurries off in her nightgown, she seems like Wendy in Peter Pan, desperate to avoid growing up and plunging into the next life stage. As they fly off, her wedding dress is revealed, hanging in the closet. Unlike many companions, she's leaving vital plans behind.

Like Rose, Amy ditches her boyfriend to run off on the Doctor's adventures, then eventually brings the boyfriend, pitting him against the Doctor

for her attention. When she finally tells him she's engaged, while coming onto him, he protests, leaving behind the Doctor who loved Rose and Reinette to insist he's "space Gandalf" or "the little green one in Star Wars," both asexual characters who never have romances and are never desired by the women.

Amy counters with "Every room you walk into you laugh at all the men and show off for all the girls ... you are a bloke and you don't know it" ("Meanwhile in the Tardis"). While her fiancé is a feminized, empathetic nurse who's more than a little afraid of her, the Doctor is dashing and cool. "Rory, like Mickey, is dedicated to his beloved, endearingly desperately in love with a woman who does not love him with the same intensity. Like Mickey, Rory is something of a clown figure, charmingly inept at the heroics displayed around him and repeatedly in need of rescuing as though he were the female companion" (Layton 109).

The conversation finally ends with the Doctor perceiving she's in love with Rory not him, and that they need to go on a marriage counseling adventure together and work things out. He remains condescending as he warns her that being a time traveler can mask the importance of the everyday world: "Oh! The life out there, it dazzles. I mean, it blinds you to the things that are important. I've seen it devour relationships and plans ... because for one person to have seen all that, to taste the glory and then go back, it will tear you apart. So.... I'm sending you somewhere. Together" ("Vampires of Venice"). The enforced date to solidify her feelings is also controlling and paternalistic.

As she still struggles with commitment on their adventures, an evil dream-version of the Doctor chides her to choose between the dashing hero and bumbling nurse in "Amy's Choice." She ends the episode, however, killing herself so she'll either be dead or in a world with Rory, having decided he's worth her life. The Doctor lets her make the choice for both of them, giving her the agency here.

Even so, Amy is arguably willing to do anything to postpone her wedding including end the universe itself and get preserved in a box for two millennia, with Rory as automaton waiting outside in total single-minded devotion. Gillan describes Rory's vigil for Amy as the "ultimate romantic gesture" ("Out of Time"). Having reclaimed her normal life (parents, wedding, and no Doctor at all), her memories slowly return and she interrupts her wedding reception to demand the Doctor return to existence. Moffat describes this as the story of how Amy has been changed by the Doctor and the Doctor's success at restoring her imagination and youthful faith. With this, she abandons her adult cynicism and returns to the fun and adventure of childhood, with Rory by her side ("Out of Time").

Barbara, Susan, Victoria, Polly, Jo, Leela and Peri leave to marry and settle down. Amy is the first to marry but bring her husband along, emphasizing that she can have it all—a husband and the Doctor. However, this too

appears a type of avoiding real life, as Amy and Rory explore in their last few episodes—they can't commit to attend a wedding or hold down jobs because another adventure will always pop up.

As they travel, there's a plot arc of Amy's ambiguous pregnancy—the scans alternate between pregnant and not, to the Doctor's puzzlement. Pregnant Amy is kidnapped; they retrieve her in "A Good Man Goes to War," and then the baby herself is kidnapped. "The lack of bodily autonomy and agency here is palpable—she is held captive, unaware of her pregnancy, and wakes in pain with no time to adjust to the idea of being a mother" (McMahon-Coleman). Thus, Amy is robbed of the pregnancy and the raising of her child, finally discovering that she can't have any others. Her body is co-opted by a religious order that uses her to harvest a Time Lord child. When her child returns, she's a murderous psychopath and the Doctor must push Amy to intervene. "Just stop them. She's your daughter. Just stop them," he orders, and after the goading, Amy threatens to kill everyone on their ship to save her ("Let's Kill Hitler").

Changing status is meant to be tumultuous, even epic. "The gaps from housewife to career woman; from wife to widow; from widow to lover; from lover to single woman again: all involve pain and ungainliness and a change of consciousness," explains fairytale scholar Joan Gould (41). For this reason, Amy's wedding, childbirth episode, and her daughter's wedding all see the universe itself on the brink of war or annihilation.

However, skipping the pregnancy and the baby years (with her daughter replaced as a childhood friend, then an adult time traveler) leaves Amy adventuring in the Tardis with few ties to normal life. She even tries divorcing Rory in "Asylum of the Daleks," insisting that he should get to be a dad, even if she can't be a mom. She still appears Young Amy, fighting commitment. "Arguably even more disappointing, then, than Amy's characterization being based largely on her role as a wife, is her apparent belief that her worth is tied to her reproductive capacities" (McMahon-Coleman).

Even when Rory and Amy finally settle at home, they miss traveling, with Amy fussing to Eleven, "I just worry there'll come a time when you never turn up. That something will have happened to you and I'll still be waiting, never knowing" ("A Town Called Mercy"). Through it all, waiting is a painful issue for her, beginning with her decade-long delay as a child.

The Doctor insists that he has left many companions but "not you" ("A Town Called Mercy"). Because they are literally his in-laws or because the Doctor has grown up at last, he considers these companions permanent. Even his own granddaughter didn't receive this devotion. When they leave, they vanish to a timeline when the Doctor can't follow. Amy joins her husband rather than staying with the Doctor and River, choosing a normal life and human love over her imaginary pal.

EXPERTS

Warrior Babe: Leela

Harry Sullivan and the Brigadier, like Ian, Steven Taylor, Ben Jackson, and Turlough, are the action heroes. Captain Jack takes this role in the Davies years as do the women to new extents. The standout action heroine of the classic show is Leela. "Issues surrounding women's changing roles within society were often at the forefront of science fiction television at this time, evident in the many 'battle of the sexes' scenarios adopted by the genre" (Cornea). Warrior women showed that women could be strong, authoritative leaders. Some women "shape themselves to become independent, strong-willed, and productive. Properly called 'father's daughters' they discard their mothers' ways and identify more with the masculine world" (Zweig 184). As Leela follows in her fictional father's footsteps (as in fact the only female shown in her tribe), she's a classic warrior woman, defined through her masculine deeds. Archetypes scholar Victoria Schmidt explains:

> The Amazon is a feminist. She cares more about the female cause than her own safety. She wouldn't hesitate to come to the rescue of another woman or child no matter what the risk is to herself. Her friendships with women are the most important relationships she has, but these are few and far between due to her androgynous attitudes. Her masculine side is just as strong as her feminine side, which often leaves her confused about where she fits in with others.

She adds; "She places value on being self-sufficient and looks down on others who are dependent and needy, even though she comes to their aid." Reputedly, Leela was the first companion little girls pretended to be while playing (Tulloch and Alvarado 213). She offered a new model of strength and independence. Bolen notes that the Amazon is filled with contradictions. "On the one hand, she rescues women and feminist values from the patriarchy, which devalues or oppresses both. On the other, with her intense focus

on goals she can also require that a woman sacrifice and devalue what has traditionally been considered feminine" (71). In fact, the "savage pin-up-girl outfit" detracts from her seriousness—her entire bare back is often visible. Her provocatively cut hunting leathers and cleavage are offered to the male gaze in every episode.

The actress, Louise Jameson, notes they "should've used someone of mixed race or at least darker than me" since the producers sent her to a tanning booth ("Louise Jameson Interview"). In fact, she's coded as nonwhite with her foreign-sounding lack of contractions. Adding to this, she was named after Palestinian freedom fighter Leila Khaled and she wore uncomfortable brown contact lenses over her blue eyes until a plot device changed her eye color in *Horror of Fang Rock*.

> So, there is a sense in which Leela may well have stood for feminist militant activity as much as she might be allied to contemporary depictions of the armed and dangerous, female revolutionary or soldier. Taken this way, it seems that the portrayal of Leela does offer some kind of challenge to the masculine authority of the Doctor, but it is also pertinent to note that her approach to the world is repeatedly interpreted as uncivilized, misguided and childish within the narrative world of *Doctor Who* [Cornea].

This woman can function on her own without needing a man's approval. Jameson comments, "Because she grew up in the jungle, her senses would have been heightened. So I wanted her to have that kind of animal visceral reaction." She based her character on her highly sensitive dog and on a curious three-year-old, whom she saw as sharing Leela's untutored quality ("Louise Jameson Interview"). These were logical choices but not terribly strong ones.

The Doctor calls her "primitive, wild, warlike, aggressive and tempestuous, and bad tempered too" but in the next breath adds "courageous, indomitable, implacable, impossible" (*Underworld*). She's a doer of deeds, someone who acts and often saves the Doctor's life rather than worrying and scheming. When she's captured and almost boiled in *The Sun Makers,* she accepts her impending death stoically instead of screeching to be saved. Thanks to her armed violence, some joke that he's taking a serial killer around the galaxy. In fact, she's quite single-minded. When the Doctor tells Leela she must stop attacking people or they'll get into trouble, she retorts, "Do not worry, Doctor. I shall protect you" (*Image of the Fendahl*).

She offers more contradictions—fierce yet naïve, masculine and feminine at once. Leela's an outsider, but she lacks the angst of Spock. Instead, she blithely strips off her sailor suit in front of men, or mentions the need for a "tesh-nition" (*Horror of Fang Rock*). In many ways, she's a running joke. Moreover, she's Eliza Doolittle.

> Throughout the season, the Doctor's relationship with Leela is broadly based on a professor and pupil footing, with the Doctor seeking to "tame her savage heart" (in

the opening episode of *The Invisible Enemy,* she is pictured carefully writing her name on the blackboard). This paternalistic aspect is made slightly more palatable by the fact that Leela is aware of the Doctor's attempts at "civilizing" her, and uses or loses what she deems valuable—she acknowledges the benefits of science, but balances this with her instinct. That said, there's a tetchiness to their relationship, replete with wince-inducing moments when he ridicules her for being "primitive," "savage" or just plain stupid [Lotz].

"She's in no way the Doctor's equal, explicitly having less education and knowledge than not just the Time Lord she travels with but almost everyone she encounters" (Magnet 159). *The Invisible Enemy* has the Doctor's body invaded by an intellect-craving virus—it notably rejects Leela as a host, since she is "all instinct and intuition." In *The Robots of Death,* Leela plays with a yo-yo, which she thinks is "part of the magic" that keeps the Tardis running. In the male-female dichotomy of Four and Leela, he is male and rational while she is instinctual and naïve … and as solo companion, a problematic representation of all women.

Leela goes about blissfully clobbering and killing villains in *The Talons of Wang-Chiang,* though she protests wearing a restrictive Victorian blouse. She devours a haunch of meat off a cold spread, and her bemused host copies her. Meanwhile, the police chief hesitates to discuss murder before a "lady of refinement"

> LEELA: Does he mean me?
> DOCTOR: I don't think so [*Talons of Weng Chiang*].

Later in the episode, Leela dresses in a pastel Victorian gown with her hair piled on her head. The Doctor is struck speechless, then calls her look charming and adds condescending comments like "I should be proud to take you to the theater looking like that" and "If you're very good I shall buy you an orange." Since the men manage to grab and chloroform her, it seems clothes do make the woman. She's also stripped down to Victorian underwear and screaming in terror as she's menaced by a giant rat. The Doctor rescues her with a gun. Over and over, many strong moments are undercut with weaker ones.

In *The Invasion of Time,* Leela organizes a Time Lord resistance movement, grouping the allegedly older, wiser beings into a fighting force. At episode end, she decides to stay on Gallifrey with the rather uninteresting Commander Andred, leader of the Chancellory Guards, though they haven't had much onscreen interaction. This unconventional companion has fallen for a sudden conventional marriage, like so many of her weaker sisters. Jameson notes her exit is quiet because the showrunners were still hoping she'd stay. The night before, the producers were offering to rewrite the final scene to keep her onboard, but she had other projects. "I would've much preferred to have died saving his life," Jameson added later. She was actually asked back

for a season when Four transformed into Five, but she turned it down ("Louise Jameson Interview").

In the novels, Leela remarks assertively, "I chose Andred. He had very little say in the matter" (Platt, *Lungbarrow* 289). Their child's birth heralds a new era on Gallifrey, ending the curse of sterility. She also returns in some of the audio adventures, in which she teams up with Romana. Later, Leela says of her life, "There was a man. They said he was my tamer but it was not like that. We were both lions happy mated in our cave. Then came the day when he did not return … one lion alone does not make a pride" (*Gallifrey Series One: Weapon of Choice*).

A few other savages appear—*The Sun Makers* has Veet as a young growling warrior woman obsessed with Leela's skin outfit (and thus something of a second Leela), though she displays a surprising skill at counterfeiting. Tala, a bland soldier in *Underworld*, may be named for Atalanta in this Theseus retelling. She and Leela often share scenes, but in a Bechdel failure, never address each other. Finally, the one-shot comic *Terror of the Cabinet Noir* has Twelve team up with the seventeenth-century swordswoman Julie d'Aubigny, a girl educated as a boy, who accounts well for herself and her archetype.

Paradise Towers introduces gangs of teen girls calling themselves the Red, Blue and Yellow Kangs swarming the streets and warring on each other. They've built a primitive society out of the ruins, even drawing their names from ordinary objects like "Bin Liner" and "Fire Escape." Chanting slogans while menacing visitors with crossbows, they're primitive with wild hair and broken sentences. There are no men apparent—with them leaving for war and elderly women actually capturing and eating them, the street girls must rely on themselves. However, they worship a computer, much as Leela first does—this, along with their ritualized greetings and heavy gestures mark them as unschooled primitives. "Mature Warriors, especially those confident of their skills, do not have to fight about everything. They choose their battles carefully" (Pearson 103). None of the show's primitive young women have achieved this status.

The Scientist: Zoe and Liz

Zoe Heriot (Wendy Padbury), a final Second Doctor companion, makes a clear role model for young women. Spunky and likable, unlike austere Romana or professional Liz Shaw, she's beloved among companions, as is her partner Jamie McCrimmon. "A genius astrophysicist in a silver catsuit from a 21st century space-station, Zoe has class and sass combined, Dr. Who's closest equivalent to the Avengers' Emma Peel" (Martin).

Zoe is young but she "can handle herself in a mature responsible fashion"

(Muir 158). Her actress called her "a computerized type of lady without many human emotions" (Tulloch and Alvarado 211). With a scientific training equal to the Doctor's and a lively curiosity, she meshes perfectly with Jamie—heart and physical energy. In *The Mind Robber*, the Doctor stands helplessly while Zoe successfully wrestles her world's comic strip creation the Karkus, who finally shrieks for help and promises to be her slave. In *The Dominators,* she changes into "inefficient" girly clothes with a gauzy skirt but still leads a slave rebellion. With computers, she proves the Doctor's equal or sometimes superior.

> ZOE: Oh. Doctor, you've got it all wrong.
> DOCTOR: Oh dear, I've been working in square roots. Can I have that again,
> please?
> ZOE: Well they don't give you a second shot. Well, press the button again.
> SELRIS: This is the most advanced machine. Perhaps he can't answer the questions.
> ZOE : Of course he can. The Doctor's almost as clever as I am [*The Krotons*].

While the Doctor frequently tutors his intellectual companions in real life practicality, Zoe's abstract knowledge proves highly useful. Scientists are rational, processing the evidence instead of just listening to it. Thus, Zoe quickly becomes independent of the Doctor. She has a photographic memory too. With her logic and mathematics, Zoe computes the attack pattern to destroy the incoming Cyberships. "Zoe is something of a genius. Of course, it can be very irritating at times," the Doctor notes (*The Krotons*). In *The Invasion*, Zoe outwits stubborn computers using ALGOL, and mentions she's enjoying herself. She forces them to blow up, demonstrating her clear superiority over the "stupid primitive machine."

Zoe spends a chunk of *The Invasion* unconscious in a crate, dangled about for the men to rescue. Nonetheless, she and her momentary partner, Isobel the camera expert, fight for feminism. When the Brigadier insists he'll use his army photographic unit, because it isn't a job for a young woman, Isobel blusters, "Well, of all the bigoted, anti-feminist, cretinous remarks…" When Jamie pops up and suggests he's superior, Zoe wonders if they should even let him come along, and Isobel pipes up, "Oh, I don't know. Men aren't much good in situations like this." With identical short haircut and short skirts, Zoe and Isobel demonstrate progressivism, a stand for independence. The other girl evokes Zoe's fun side, helping her try on feather boas in a rare lighthearted moment. As Zoe blows up the computer with her conflicting instructions (still wearing the boa), the two friends laugh together gleefully.

She was one of the strongest companions. However, Tulloch and Alvarado retort, "Zoe was able to appear as a scientific equal to the Doctor— not so much because of her 'computer' lines, but because Troughton's Doctor, like Zoe, tended to get frightened and run" (211). With his flute-playing and strange coat, it's true he's more odd than stalwart.

Unfortunately, her end rivals Donna Noble's for its tragedy and wastefulness. When the Second Doctor is arrested by the Time Lords and exiled to Earth, they return her and Jamie home with their memories of the Doctor wiped.

When the show resumed in color the following year, there was a new Doctor (Jon Pertwee), new companions, and a new setting as he was stranded on Earth and worked for the United Nations Intelligence Taskforce, or UNIT. The Third Doctor was possibly the most pompous with the largest sense of superiority. His first match was envisioned as his equal, "an intellectual Cambridge scientist" who was "more than a match for the Doctor's wit and brain" (Muir 21). This was Liz Shaw (Caroline John), the 1970 companion. Brigadier Lethbridge-Stewart (founder of UNIT and a fellow companion) describes her as "an expert in meteorites, degrees in medicine, physics and a dozen other subjects" (*Spearhead from Space*). He recruits her over her protests, so she remains somewhat sullen through the first episode. Robert Holmes was the one who minted many new companions—Liz Shaw, Jo Grant, Sarah Jane, Romana (Murray 219). As the writer of *Spearhead from Space*, he introduced a new era with realism and dynamic characters, sparkling with literal and metaphoric color.

Meanwhile, Liz is a born skeptic about alien invasions, the Doctor, time travel and everything else. Quite tough, she jabs the Doctor when he fusses over shots, explains science to other characters, and escapes from bondage without needing help. When told she can't go to the caves in *Doctor Who and the Silurians,* she archly asks the Brigadier, "Have you never heard of female emancipation?" After an order to man the Brigadier's phones, she retorts, "I am a scientist, not an office boy." And when the Brigadier tells her to fetch medical treatment in *Inferno,* she drily asks if he remembers that she "happens to be a doctor." Before Sarah Jane arrives, she's the voice of female power.

An adult career woman, she's the equal to everyone, even her male military boss: When the Brigadier tells her he doesn't care for her tone, she retorts, "I don't much care for yours either. No wonder the Doctor cleared off" (*Inferno*). For Liz's first appearance, her hair is elaborately braided. Her top is high-necked and long-sleeved, though she also has a short skirt and false eyelashes. Her actress notes, "They would insist on dressing me in miniskirts and not a lot else. I used to point out that these sorts of clothes would hardly have been Liz Shaw, Cambridge scientist's kind of wardrobe, but I think they were a bit too scared there would be trouble if the traditional *Doctor Who* glamour girl was dispensed with" ("Caroline John"). Though she's a PhD, she's always called "Miss Shaw," "Liz" or "m'dear," diminutizing her. Further, the Doctor's first assignment for her is that she "persuade" the Brigadier to part with the TARDIS key—feminine wiles rather than scientific expertise.

For their first adventure, she's the one to throw the switch and destroy the Nestene Consciousness and save the Doctor. In *Inferno,* she saves the earth while the Doctor remains in his coma. However, her strength was her downfall. Producer Barry Letts notes that having a brilliant Cambridge scientist didn't work, since "we didn't have anybody who could say, 'Doctor, what's all this about?'" (Tulloch and Alvarado 212). In fact, Liz's character complained that all the Doctor needed was "someone to pass him his test tubes and tell him how brilliant he was" (*Terror of the Autons*). Her actress adds:

> I think it was fairly clear quite early on that my character didn't really fit into the pre-scribed *Doctor Who* format of action, action, action. I felt they weren't really giving me enough reason to stay on, although I might have done a bit more if they had wanted me to. However, there was a new producer in the form of Barry Letts and he clearly wanted to take things in his own direction to make something of his own with the show's limited character format. On top of all this, I had never established the best kind of rapport with Jon Pertwee, who I think basically saw the show in a very traditional light and didn't want a companion who in any way matched up to him in terms of intelligence ["Caroline John"].

"Unfortunately, the writers seemingly did not know how to develop a believable relationship between the Doctor and a female companion who did not require rescue," Muir adds (177). Thus, Liz vanishes after just four episodes with the Brigadier casually mentioning she's gone back to academia at Cambridge.

There are other female scientists, though the ones in the original show can be rather "damseled." Jan Garrett, a computer specialist in *The Ice Warriors,* is brave and professional, arguably better at running the Britannicus Base than her boss Clent. Likewise, assistant Gia Kelly in *The Seeds of Death,* actually a highly-qualified physics specialist, drives the plot. However, most of her lines involve reporting scientific facts with as little personality as possible and serving her boss in a model of perfect efficiency. Clearly, she's a strong intellectual but a one-note character.

Anne Travers from *The Web of Fear* is another skilled woman who out-thinks many of the men. She dominates the dialogue through the entire episode and, moreover, has a biting, sarcastic confidence that doesn't automatically submit to male authority:

> ANNE: You have a reputation for distorting the truth. You take reality and you
> make it into a comic strip. In short, Mister Chorley, you are a sensationalizer.
> CHORLEY: You smug little redbrick university.
> ANNE: Don't say it, Mister Chorley. I have a very quick temper and very long
> claws.

Other stories don't even differentiate gender. *Colony in Space* features full families of colonists and plenty of female representation, with Mary Ashe,

Jane Leeson, and Mrs. Martin besides Jo Grant. The women fight for their survival as much as the men do. In *Logopolis,* male and female Logopolitans sit and use abaci, with identical dress. Thus scientists are presented as unisex, clear-minded and devoted to equality. There are no screaming assistants here. Similarly, in *Meglos,* Caris has the same pageboy cut and uniform as the other scientists, counterbalancing the society of superstitious priestesses. Her presence suggests rationality … that women can side with science, not just mumbo jumbo. "The source of all our energy, the heart of our civilization, a device we've become totally dependent upon, and all we know about its internal structure are a few vague theories," Caris protests. When a copy of the Doctor finds her, she gasps but notably doesn't scream. Later she charges on to save the real Doctor, rationally insisting he has a double.

Likewise, the sweet-looking Tanya Lernov, Astrogater, Second Class, works on Space Station W3 as token female on their Russian team. She is presented as more instinctual than scientific, as she protests a small drop in air pressure levels because, as she says "I didn't like it" and adds that her nose is "like a barometer. It never lets me down." Thus she parodies data gathering. With this, *The Wheel in Space* (1968) gets points for a female scientist, but she's clearly flimsier than the male ones.

In *Image of the Fendahl,* anthropologist Thea Ransome capably carries out tests. In a clichéd scene, however, her partner Max takes her prisoner, and, crouching over her in a position of power, explains how he will use her to enact his master plan. He leaves her bound and she looks close to tears. After a pentagram ritual, Thea is transformed into the Fendahl core and begins killing the coven members. She thus goes from scientist to damsel to a Medusalike monster, problematic roles for a strong woman.

Some are a bit tougher. Professor Sarah Lasky of *Terror of the Vervoids* bosses around men and women alike. She enters the show complaining, "Am I expected to trust my life for millions of miles to a bunch of incompetents who can't even get my luggage aboard without losing it?" She goes on to label people "dunderheads" with "thick academic skulls." She even calls the Sixth Doctor a fool. She's invented "Demeter seeds," which can grow anywhere with an extraordinary yield. Flipping the show's classic gender roles, she condescends to her male assistant, whom she labels a "bit of a romantic, highly strung." She arrogantly tells him he's wrong to criticize the monster they've created, adding, "I should think that when man first discovered fire there were those who were equally appalled and wanted it suppressed. If they'd prevailed, the human race would still be cowering in caves." Only toward episode end does she repent, adding, "I must have been blinded by professional vanity." She hopefully negotiates with her plant creations, but they stab her to death for trying.

Dr. Nasreen Chaudhry of "The Hungry Earth"/"Cold Blood" is another

scientist, a geologist in the year 2020, though the new show bothers to make her Indian and female. She and her team dig so deep that they awaken the Silurians. Beside Amy Pond, she acts as a human ambassador and tries to forge a peace. When the Silurians return to hibernation, Nasreen and the other scientist, Tony, stay with them. Since he's her love interest, she exits companion-style, but gains some respect for seizing the adventure of a lifetime.

Shona McCullough begins her story dancing goofily across a North Polar science station, for the audience's amusement. Her teammates back her up, but it's soon revealed they're all in a dream (within a dream within a dream), manipulated by Dream Crabs. When the Twelfth Doctor arrives, he calls her the "gobby one." Her team are Ashley the "uptight boss one" and the older Professor Rona Bellows, the "sexy one." As they solve the mystery and begin to wake, they realize they aren't actually scientists: lighthearted Shona works in a shop, Ashley is an account manager for perfume, and Rona is a grandmother. This suggests that, since they're not scientists but geeks (Shona even plans a *Game of Thrones* marathon), they're audience stand-ins, ordinary British folk able to travel with the Doctor for the Christmas special. While this is charming, they lose intellectual respect.

Erica and her partner Doug actually destroy the earth in "The Pyramid at the End of the World." It's presented as a series of tiny misfortunes—her reading glasses break so he, who is hungover, must do the bacterial calculations. While they're both responsible, he is shown bearing more of the fault as he naps under his desk and leaves an airlock open. After he disintegrates before Erica's eyes, the Twelfth Doctor arrives to work with her, and she proves competent and capable. When she comes up with a brilliant idea, the impressed Doctor asks, "Seriously, what are you doing when this is all over?" In a nice example of representation, she's a little person but this goes unmentioned and is irrelevant to her job.

Toshiko Sato of *Torchwood* is beautiful and mysterious—a problematic role for an Asian woman, as it means conforming to stereotypes. She's also a computer genius who's insecure in her personal life, another stereotype. "As a technology expert, she is a cliché of the hardworking, scientific genius. There is no need for any further Othering—she is already an outsider, and she doesn't need to be invaded by aliens because as a woman of the Orient her body is already colonized" (Dunn 118). Her actress, Naoko Mori, comments, "Russell wasn't thinking ethnic or anything, it was just a great part." She adds, "I love Tosh … she's a late bloomer with issues and quirks" ("Making Torchwood").

Tosh is not the most realized of characters, though she's likeable: She's shown having a Japanese heritage, a mother she loves, and a love of reading, but not much else. "Technical expert Toshiko Sato is a different kind of cyber-

woman, a genius with machines who never goes anywhere where without her laptop; but her adeptness with technology is matched only by her ineptness at personal relationships" (Cheyne 44). The technology she's been borrowing in the first episode allows her to transfer text to her computer and absorb it faster—even her personal, hidden greed is for knowledge.

Tosh's tragic personal life is limited to a frozen World War I soldier as boyfriend and a lesbian affair with the alien Mary. She finally falls for her teammate Owen—an issue complicated by his death and resurrection. All of her romances are doomed, in contrast with her teammate Gwen's happy marriage.

In Series Two, Tosh's sudden death shocked everyone. Her actress noted that killing characters off is unusual in American television. In fact, Mori looked sad and disturbed when she was told by the writer Scott Handcock that she and Owen were deliberately given a Romeo and Juliet death with the thought of "Maybe he should just take Tosh with him" ("Making Torchwood"). Unfortunately, her character's tragedy stemmed from her romance more than her individuality and cleverness.

Seasoned Professional: Barbara Wright

Barbara Wright (Jacqueline Hill), one of the Doctor's first companions, is a history teacher, in contrast with Susan the perpetual student. In 1963, Barbara takes a penetrating interest in her odd pupil, so she and her colleague Ian Chesterton follow Susan into the Tardis. The Doctor kidnaps them and they all fly away.

"Barbara Wright seems to have been named for her knack of making 'right' guesses. Of course, as a teacher, she is also 'Miss Right'" (Newman 120). She's a history teacher, and thus the first professional woman to accompany the Doctor as well as model for future companions. "There's a strong feminist current to *Doctor Who*, thanks to the character of Barbara, the Doctor's central foil and sparring partner" (Riggo). Her ethics counter the Doctor's occasional short-sightedness, while she's a capable expert. "Jacqueline Hill established from her first moment onscreen in *An Unearthly Child* that Barbara Wright was a self-confident, intelligent woman" (Muir 81).

Like Elisabeth Sladen would as Sarah Jane, Jacqueline Hill rewrote her lines to make herself stronger. She notes, "Everything else I had to put in myself, and this meant taking it up with either Verity or the director concerned. I think there were times when I said 'Barbara wouldn't say this or she wouldn't do this,' and they were usually very good and listened to me on those points because I knew the character better than anybody else" ("Jacqueline Hill"). Thus creator Verity Lambert along with various directors helped Barbara break out.

In her mid-thirties, she was the oldest female companion until Sarah Jane's return in the new show. The actress notes, "The good thing about Barbara was that because she was older than most of the girls since, the writers were more hesitant about making her look silly, or scream too much. That side of things was largely left to Carole Ann Ford, which is why she left earlier than Bill Russell and myself" ("Jacqueline Hill").

"Although my temperament often meant I came into conflict with the Doctor who gave the impression that he knew *everything*," she adds (Haining 83). Barbara argues constantly, making her more opinionated than almost any other companion. Despite her training that the past is static, Barbara constantly demands interference for the greater good. In fact, her seeking out what is "best left alone" carries her onto the Tardis in the first episode. She insists on healing the caveman Za and criticizes the Doctor, saying, "You treat everybody and everything as something less important than yourself!" In *The Daleks,* she continues arguing for action: Ian and Susan resist recruiting the Thals because they are pacifists, while Barbara refuses to "simply run away." She chides both the Doctor and Ian for "wasting time with small talk … all you're doing is playing with words." However, when the Doctor accuses her and Ian of sabotaging the ship, she explodes with overdue anger, emphasizing how she's no pushover: "How dare you! Do you realize, you stupid old man, that you'd have died in the Cave of Skulls if Ian hadn't made fire for you? And what about what we went through with the Daleks … because you tricked us into going down to the city! Accuse us? You ought to go down on your hands and knees and thank us! But gratitude's the last thing you'll ever have, or any sort of common sense either!" (*The Edge of Destruction*).

Various of the adventures can be seen as a gender clash: In the first episode, the cavepeoples' "Old Mother" doesn't want the Doctor to bring fire to her tribe. However, Ian does so finally, changing their lives forever. In *The Edge of Destruction,* Barbara suggests "another intelligence" has invaded the ship, but the Doctor calls this "not very logical," and Ian laughs aloud. Further, the Doctor and Ian conceal from her and Susan, "the girls," that the Tardis has only five minutes' viable time left, assuming they can't handle the knowledge. At the story's end, the Doctor explains that gender roles were in play: "It was your instincts and intuition against my logic, and you succeeded." While chasing the keys of Marinus, Ian insists both women stay in safety. Barbara retorts, "I do wish Ian wouldn't treat us like Dresden china," while Susan responds naively, "I think it's nice the way he looks after us," offering two competing views of gender relations. Barbara manages to free the slaves of Morphoton, once again advocating interference to end human suffering. In both this and *The Keys of Marinus,* Barbara impersonates royalty, and finally embraces her role as Aztec goddess.

Barbara takes a central role in *The Aztecs,* as all the characters act along

gender conventions. The Doctor finds himself engaged to a pushy lady, and Ian battles Aztec warriors. Unfortunately, Barbara's modern morality and sensibility make her situation worse with every attempt—she is named a false goddess, and the honorable Autloc suffers for her intervention. As the Doctor protests that the Aztec sacrifice must take place and that history can't be altered, she retorts, "Well, they've made me a goddess. And I forbid it!" By the end of their conversation, she's insisting on being called Yetaxa now—she's begun to believe in her own divinity. With idealism pitted against the Doctor's knowledge of time, she casts aside her experience as academic. Proven wrong, she ends the story running frantically for the Tardis, an Aztec mob in chase.

When Barbara sees how her well-meaning actions have only allowed more killing, she removes her goddess's regalia, a mortal once more. Now that she's been stripped of authority, the Doctor comforts her, saying, "You failed to save a civilization, but at least you helped one man." In comparison with the Doctor, however, she has accomplished very little.

Wisewoman: Evelyn Smythe

The Marian Conspiracy audio adventure by Jacqueline Rayne features Colin Baker in a solid historical adventure. The celebrated episode is best known for introducing the history professor companion Dr. Evelyn Smythe (Maggie Stables). As she lectures a university class, the Sixth Doctor's beeping scanner gradually interrupts. When she orders him to stop, he protests, "The safety of the entire universe could be at stake!"

"Mmmm," she says skeptically and calls him on the carpet. As he continues to insist she's a nexus point whose history is being erased, she's unimpressed, "You are asking a favor of me and might want to keep on my good side," she criticizes. Evelyn is tough and uncompromising, with no time for the Doctor's ego. She even offers to make him her special chocolate cake "if you're good." The doughty lady comments that at 55 there's no chance she'll retire. In fact, in a reversal of traditional gendering, she has left her husband who wanted her to put their anniversary over her career.

As he sets off to fix time, Evelyn insists on going along to meet her hero Queen Elizabeth rather than waiting quietly to fade away ... and brings her beloved cocoa. On their journey, she lectures the Doctor on history without pause, emphasizing her expertise and deconstructing his ego-trips. She doesn't bother costuming, as she decides her anachronistic orange cardigan and overstuffed handbag are good enough for history. At the end of the adventure (with the threat to her life fixed), she announces she'll travel with the Doctor and see history ... she even dictates their next trip. "I do hope I don't regret this," the Doctor murmurs.

Evelyn is celebrated among fans for being a skeptical older companion, more vulnerable than the tweens thanks to her heart condition. While producing innumerable gadgets from her handbag, she guides them to attend an interstellar time/space conference and meet historic figures, not just tour vacation planets. She's ruled by reason and can be ruthlessly pragmatic when needed. While the wimpy Peri lets Six dominate her, Evelyn is more experienced than basically any companion ever seen and used to dealing with arrogant male colleagues and cantankerous frat boys. Evelyn doesn't complain about his pomposity, but actively trains him out of such behavior. With her, Six becomes more willing to listen and compromise. He also respects her, as he tells her on their first adventure, after she produces hairpins for lockpicking, "You are without a doubt one of the most useful and well-prepared companions with whom I have ever traveled."

Evelyn finally falls in love on an alien planet and leaves him, but the Doctor significantly goes back to visit. In *Thicker than Water,* when he takes Mel to meet Evelyn, he credits her with having substantially improved his manners and temperament. She dies heroically far in the past, but continues to appear in audio and novel adventures set before this date, so dearly is she admired.

Evelyn Smythe, then Wilfred Mott, are the only companions not a "normatively nubile age" (Britton 121). Caryn E. Neumann notes in "Babes and Crones: Women Growing Old in Comics": "Comics have long denied the existence of highly capable, attractive, mature women, which also reflects negative Western societal attitudes about aging women" (119). In contrast with many older men (Perry White, J. Jonah Jameson, Alfred, Lex Luthor, Professor X), women basically all look young, even matriarchs like Wonder Woman's mother Hippolyte. All the heroic women are lovely and young-looking. "In other words, heroes and heroines cannot be old and ugly, because they are good people" (Neumann 121). The same is true for too many of television's heroines.

> Older single professional women are portrayed in a less flattering light. They're either terribly stern and hard-boiled, as with Helen Mirren's detective character on the British import *Prime Suspect* or Star Fleet captain Karthryn Janeway (Kate Mulgrew) on *Star Trek: Voyager,* or a bit too much the meddling old biddy, as with mystery writer and sleuth Jessica Fletcher (Angela Lansbury) on *Murder, She Wrote.* It's a subtle way of showing that smart, independent women wind up with the traits of the traditional old maid [Isaacs 130].

Millennia ago, as stories shifted to depower strong women, the heroic crone was the first to go: "Out of our fear of crones and the specifically female fear of turning into one, out of our dread of death and also out of unholy desires, we create the fairytale witch, who is the opposite of the traditional good woman" (Gould 302). The crone represented the realm of death and

power over it—a terror to some. She became banished to the underworld as only young and middle-aged women remained in the world's male-dominated pantheons.

Thanks to the cultural context, many older women onscreen have ambiguous representation. In *The Seeds of Doom,* Amelia Ducat appears an absent-minded elderly artist who provides a clue and forwards the plot. She lives in a classic cottage with china dogs and collector's plates. However, when she returns later, she subversively uses her "daft old lady" act as a cover, explaining when she's overheard whispering to Sarah Jane, "I'm always talking to myself. It's old age, you know. Happens to us all." It's soon revealed she's doing recon for the government, in a parallel investigation to the Doctor's. "Besides, I have some wartime experience, you know. Oh yes. I was a sergeant in the ATS. Manned an ack-ack gun at Folkestone," she smiles back at head-quarters. However, after this strength, "the show then turns around and demolishes all that by portraying her, in her final scene, as a silly biddy the men can't wait to be rid of. It's almost a perfect allegory for the awesome/hor-rifying seesaw around the portrayal of women in this entire season," explains K. Tempest Bradford in "The Women We Don't See."

Actual witches like Miss Hawthorne embody a similar archetype, com-plicated between power and pointlessness. "Sages have little or no need to control or change the world; they just want to understand it" (Pearson 209). She quests for wisdom and knowledge of the universe. Thus, she is a detective, unraveling the mysteries of the universe. *The Daemons* opens with the frumpy spinster Miss Hawthorne demanding the male authorities listen to her. There's been a murder but it's much more—"The signs are there for all to see! I cast the runes only this morning," she protests to an uninterested audience. Pro-fessor Horner has begun an archeological dig on Devil's Hump, and as she warns, he's "tampering with forces he does not understand." As she finally admits, she's an actual witch, so she knows the devil is coming. She reveals she can raise and lower winds to protect herself.

Feminist interest in neo-pagan and occultist religions grew during the seventies. "Particularly popular in Britain were sects built around the re-invention of Wicca or witchcraft, those that referred back to polytheistic reli-gions associated with Celtic myths and legends, or sects assembled under the sign of exotic Goddesses derived from ancient Egyptian, Roman, Grecian, Indian culture" (Cornea). Archetypes scholar Christine Downing writes that "We are starved for images which recognize the sacredness of the Feminine and the complexity, richness, and nurturing power of female energy" (qtd. in Zweig 190). In an offering to this, the festival of Beltane, with all its magical significance, has arrived. Meanwhile, companion Jo is open to mysticism while the Third Doctor insists there's always a rational explanation. Nonethe-less, he takes Miss Hawthorne's side, showing viewers she has true perception.

As the Doctor reveals, Daemons are actually aliens from the planet Daemos, providing the science behind the all-too-real "devil."

Miss Hawthorne teams up with Sergeant Benton to save the Doctor, though she's also practical. At episode end, the ignorant villagers try burning the Doctor as a witch. Miss Hawthorne helps him pretend to cast spells, tricking the villagers into releasing him. In the story's course, both show off their expertise at stage magic and slight-of-hand. She ends the episode encouraging Benton and the others to join her at the maypole, frivolously celebrating that Beltane has been restored, with the evil banished. Her cleverness has won the day.

With Sarah Jane frequently the only woman in an entire episode, the Sisterhood of Karn stand out. In *The Brain of Morbius*, they create the elixir of life and immortality, making them the guardians of life itself. The sisters, marked with red and gold paint, appear particularly mystical. They circle their leader and gesture ecstatically, channeling power. Their gray-haired leader Marin explains "our senses reach beyond the five planets," stressing her perception. She and her sisters guard the Flame of Life and tell the Fourth Doctor their wisdom is beyond his understanding. As they point out repeatedly, they're the Time Lords' equals and supply them with the elixir as needed.

However, they undercut their stately mission as they lay traps for spaceships like sirens. When they discover their precious flame is going out, they blame the first scapegoat they find—they threaten the Doctor with flame-shaped blades and condemn him to death for defiling their magic. "Has he no fear of the sisterhood? Does he think death a trivial thing?" Marin asks. However, her blame of the heroic Doctor (based on her dreams) casts her as irrational and overly credulous—traditional feminine qualities. She badgers him for a confession and willfully ignores his protestations of innocence. Their repeated messages of sisterhood not only invoke ancient priesthood, but feminism of the time.

> Within this discursive and cultural context it is easy to see how the Sisterhood in the "Morbius" episode might be related in some way to Sarah Jane's "troublesome" feminist views ... this witchy Sisterhood represented an extreme and "dangerous feminism" (read radical feminism) in comparison to Sarah Jane's more liberal leanings ... in the mind of the Doctor, the Sisters are regressive figures who are stuck in the past; they are displaced figurations of a threatening feminism that apparently resists scientific and social progress [Cornea].

Bearing no grudge, the Doctor fixes the flame, emphasizing their helplessness. He insists there's a chemical, scientifically based solution—it turns out there's just soot in the chimney, but it's obvious the women are nearly dead without a man to do the handiwork. He goes on to challenge their unchanging society, pointing out how stagnant they've grown. The episode emphasizes how much he's right. "To be an effective Magician, it is important

to be spiritually, emotionally, and physically linked in to the great web of life. Real power comes paradoxically from recognizing our dependence—on the earth, on other people, and on our spiritual source" (Pearson 202).

On discovering the Doctor is dying, Marin accepts that her time has finally come and gives the last of the elixir to him, choosing self-sacrifice and reaffirming her role as the arbiter of life and death. She fades into the flames, becoming a spiritual protector like Obi-Wan and advancing to the next stage of being. "To the Magician, the sacred is not seen as above us, judging us (as it is from an Ego perspective), but as imminent in ourselves, nature, society, the earth, the cosmos" (Pearson 195). She connects with the magic and the power of the universe itself.

In *Meglos* a few years later, similar priestesses in hot pink square off against the men's leadership and its science. For all of recorded time, the mysterious Dodecahedron has powered their world. The women (led by head priestess Lexa, played by former companion Jacqueline Hill) believe it's a god, the men a device. Of course, the men call the Doctor and believe his rational perspective. Priestess Lexa, however, is skeptical and insists he swear an oath. When she loses track of him, she calls for his arrest. At last, she leads a coup, exiling all disbelievers and attempting to sacrifice the Doctor. She dies saving Romana's life, redeeming herself somewhat, but the show marks her as terribly misguided.

Mrs. Fenella Wibbsey, who stars in three series of audio adventures, is the Fourth Doctor's housekeeper at Nest Cottage in Cromer. In 1932, the Doctor saves her and takes her to Sussex in 2009. She thus makes a highly unusual companion, older, old-fashioned, and displaced in time. Her sensibility makes her a joke—she sells part of the Tardis at a church rummage sale on one adventure. Tracking the part, the Doctor takes Mrs. Wibbsey to Roman times, where she casts herself as the goddess Wibbsentia (*The Relics of Time*). Thus, she gets less of the "wise crone" respect and more of the ridicule.

White-haired Professor Emilia Rumford from *The Stones of Blood* is a strikingly unusual helper in a world of active men and twenty-year-old women. With close-cropped hair and sturdy brown jacket, she's more capable than glamorous. She's an archaeologist, author of *Bronze Age Burials in Gloucestershire*, which the Fourth Doctor calls "The definitive work on the subject." While performing a "topographical, geological, astronomical, archeological" survey of a group of standing stones in Boscombe Moor, Cornwall, with her friend Vivien Fay, the group discover blood spilled. The Doctor goes to meet the druids' leader, de Vries. Meanwhile as Romana remains behind, the two women befriend her, one practical, the other cattier: Vivian complains, "Typical male. Strands you here in the middle of nowhere with two complete strangers while he goes off somewhere enjoying himself," while

Emilia invites her to help with their work. Of course, three women starring (plus De Vries' female helper) makes the episode strikingly feminine. The episode basically begins with a group of druids praying to the Cailleach, the ancient goddess of war. Thus, from the start, the episode salutes the power of the wise crone. Visually portraying an end to the Doctor's power, ravens and a man in a bird suit (Celtic goddess imagery) assist De Vries in sacrificing the Doctor at the stones. Martha, his druid assistant, protests, casting her as a good companion much like the Doctor's many assistants.

Professor Rumford rides up on her bicycle—an unlikely rescuer for the Doctor but one he welcomes. As it turns out, she's kind (she had returned to bring Romana some tea) and clever (she suggests hunting for Romana with a dog, so the Doctor summons K9). He tries explaining Einstein's Special Theory of Relativity to her, but she already knows it. The stout lady also carries a policeman's truncheon to protect herself from muggings. Charging around the countryside on her bicycle, she becomes a figure of agency and empowerment as well as wisdom. She fixes the Doctor's portable hyperspace portal with K-9's help, faces the Ogri, and quibbles with the Doctor. As Tom Baker quipped later:

> I wanted this old lady to be the companion. She would have a stick, because she would have a very bad hip. You could have had great fun with the Doctor saying, "Come on, please, you know, we've got to go fast," and she obviously can't go fast. Now, it strikes me as being in a wonderful surreal area—how fast are the monsters who are following us? They can only move very slowly, and that strikes me as being full of comic possibilities…. See, all television is predictable, isn't it? [Airey and Haldeman].

After the Doctor finds her, he urges Romana to stay with the professor and study her mythological research. Meanwhile, he learns of the wicked Lady Morgana Montcalm, who was "said to have murdered her husband on her wedding night." This, it turns out, is Vivien, who is actually sorceress Morgana le Fay and the Irish goddess Cailleach too. As the Doctor discovers, she's the ancient alien Cessair of Diplos (another name from Irish myth). Cessair was being transported by the alien justice machines called Megara (named for Megaera, one of the Furies who persecuted the guilty). In fact, a long list of goddesses is saluted in the course of the episode as the Doctor only escapes female powers with his female allies.

Another Morgana, this one a fortuneteller in red finery, is an observer to the events of *The Greatest Show in the Galaxy*. She hesitates over the murders they've committed, adding, "Just think of all those tickets we've sold. Does that make you feel good? It wasn't always like this, was it? Not before we came to this dreadful place. We used to have fun. We were free spirits then." However, she does little to intervene, emphasizing her archetype's helplessness. Adding true magic to the story, she and the Ringmaster escape by vanishing.

New Who's older women are mostly leaders like Queen Victoria or Prime

Minister Harriet Jones. One exception is Agatha Christie, the reclusive writer with a stockpile of secrets. Aside from royalty, she's likely the most famous historical woman on the show. Ten and Donna visit her in "The Unicorn and the Wasp," only to be drawn into an actual cozy mystery. While the Doctor smiles about solving a mystery beside Agatha Christie, she shuts him down with a cold, "I'll work with you, gladly, but for the sake of justice, not your own amusement." The Doctor drifts into technobabble, but she retorts, "I think I understood some of those words. Enough to know that you're completely potty." Asked where her husband is, she only responds, with delightfully anachronistic feminism, "Is he needed? Can't a woman make her own way in the world?" While remaining a skeptic of the science fiction involved, she solves the mystery. They discover the alien murderer, but she bravely decoys him away, insisting, "No. No more murder. If my imagination made you kill, then my imagination will find a way to stop you, foul creature." Her heroic sacrifice wipes her mind, but with her doughtyness, she retains enough of the story to write about it.

The West Indian couple Lou and Carmen in "Planet of the Dead" are memorable as more than innocent human civilians—in fact, Carmen is psychic. Each week she wins ten pounds in the lottery, like clockwork. When their bus is pulled through to an alien world, Carmen hears voices and tells the Tenth Doctor they're surrounded by the dead. Of course, the Doctor is the only other one to sense this. He assesses her and decides she has a "low level psychic ability, exacerbated by an alien sun." Carmen warns him about an alien invasion and ends the episodes with prophecies about the Doctor's "song ending" with the arc phrase "He will knock four times." Thus, she offers foreboding and a hint of the future, though she has no alien abilities.

Wilf has a delightful scene in "The End of Time" in which he sneaks out and enlists all the overlooked elderly to scour the city for the Doctor. Flirtatious Minnie "the Menace" calls them "The Silver Cloak." As she explains, "It worked. Because Wilf phoned Netty, who phoned June, and her sister lives opposite Broadfell, and she saw the police box, and her neighbor saw this man heading east." Ordinary people save the day once again. Though the Doctor had been battling the Master in an epic showdown, he's suddenly stuck posing for photos with the older women, who've hijacked the moment, and Minnie even gets in a grab. The Silver Cloak pull him down to earth and direct his actions, suddenly taking charge of the all-powerful hero.

Twelve acquires a rare older companion in the comic *Super Gran*. Gertie actually waits thirty years for the Doctor to reappear, by which point she has a grandchild. At last, however, the careless Doctor returns and carries her off with him and Clara. While this partnership seems unlikely onscreen, the comics have much more flexibility to experiment, even with this one-off companion.

BAD LADIES

Collaborator: Sara Kingdom

Sara Kingdom (Jean Marsh) is generally given the status of companion. She is the first of a new type, appearing in a black catsuit and described as "ruthless, hard, efficient" (*The Daleks' Master Plan*). Her actress smiles, "I spent several episodes in an Avengers-style tweed cat suit, though God knows why the designer thought you should wear tweed in outer-space" (Hutchinson). As a Space Security Service (SSS) agent, she's armed and dangerous ... and determined to defeat the Doctor. Sara Kingdom was the first formidable woman seen on the Tardis. "Terry Nation even intended for Sara Kingdom to spin off into a US TV series featuring an anti–Dalek task force. When that plan fell through, Nation absorbed some of the ideas into *The Daleks' Master Plan* and, sadly, decided to end the character" (Kistler 62).

Despite her strength, her top quality is that she accepts orders unquestioningly:

KARLTON: She actually believed you.
CHEN: Of course.
KARLTON: I thought for a moment you were really going to tell her about the Daleks.
CHEN: Oh, come. We need that taranium back, but we can't allow any more people to know the plan.
KARLTON: I was watching her all the time. She never doubted anything, even momentarily.
CHEN: A good security agent [*The Daleks' Master Plan*].

While obeying orders, she shoots her own brother as he pleads for mercy. When she discovers to her horror that obeying evil orders has caused this and also endangered earth, she switches sides and allies herself with the First Doctor.

Though she has an impressively tough beginning, her "innocent" belief

in what others tell her outlasts her action skills. She's soon reduced to running through the corridors and acting as the Doctor's sounding board. Like every other companion when ordered to remain in the Tardis, Sara chases after the Doctor. She's caught in a Time Destructor field and hyper-aged to the point of death. Steven Taylor manages to save the Doctor, but reports that he didn't even see Sara leave. "She plays a different kind of companion, one more outwardly aggressive and cool than many of the others seen thus far ... however, as the 'bad girl' she could not be allowed to live" (Muir 120). As Jean Marsh notes in her interview: "I had a wonderful death scene, filmed before I did anything else in the story. I was aged to death, which was done really well. I remember a darling old lady playing my final moments, but dressed in this slinky Space Police outfit and looking really good in it!

Villainous collaborator women outnumber the other female archetypes. In the wake of World War II, British writers may have considered this the worst of humanity. Churchill famously said, "An appeaser is one who feeds a crocodile, hoping it will eat him last." Giving bullies what they want never works, and those who did allowed the war to take place. The writers were also reacting to the rise of communism, fearing spies and traitors within their own country. Being raised to niceness and compromise works against women here, emphasizing how they're trained to support powerful men and conform rather than rebelling against injustice.

Kala, with her stately blonde braid and silk gown, aids her male companions rather than acting on her own, though she's soon swept away in a cover-up. They steal one of the keys to the Conscience of Marinus, hoping to sell it. However, when her friend Aydan's part in the plot is revealed, she shoots him so he won't reveal his accomplices. She also kidnaps Susan, preying immorally on both innocents and her allies. Since this was only the fifth story of the show, it emphasized that women could be villainesses, just like capable teachers, and needn't be screamers. In fact, Barbara Wright is the one to confront her. Starting here, *The Keys of Marinus* introduces the collaborators like Sara ... women who serve the male supervillains and soon get their comeuppance.

In *The Crusade*, Fatima, one of the occupants of a harem, betrays Barbara to her lord for a ruby ring. Another occupant of the harem, who protects Barbara, is therefore endangered. However, the other women kill Fatima for her treachery, emphasizing that they choose loyalty and sisterhood over their husband.

Soon after, in *The Dalek Invasion of Earth*, Barbara and local girl Jenny take refuge in a house belonging to two women, a mother and daughter, who trade with the Daleks. In exchange for more food (a bribe commonly offered by Nazis), the pair betray them. The episode, with echoes of Nazism, suggests that collaborators will always rise in times of fascism.

The Space Pirates' Madeleine Issigri is the elegant-looking head of the Issigri Mining Company after her father disappears. Her futuristic silver jumpsuit and sleek hair suggest poise and control. However, when she discovers what her employee is doing, she panics:

> MADELEINE: Well then, just remember I'm still running this operation.
> CAVEN: Are you? I do all the dirty work. The space piracy, the capital larceny...
> MILO: The first-degree homicides!
> CAVEN: Right, Clancey. While all you do is sit there looking pretty and count the money. But that doesn't mean to say you're not guilty.
> MADELEINE: Maybe, but I never agreed to murder.
> CAVEN: Well, you'd better agree to it, because if we don't get rid of these snoops, we'll both end up in a nirvan chamber.
> MADELEINE: I don't want them killed! There must be some other solution.

She turns her back on the criminal activity and gains a bit of complexity, switching from reluctant villain to heroine.

"Women who have been indoctrinated in the prevailing views from the patriarchal culture—for example, that they should be nice and nurturing, obedient, supportive of men, and of service to their husbands—may try to act that way on the surface. But in the hidden recesses of their psyche, the shadow of the Madwoman will be lurking" (Leonard 27). Thus niceness and civilized standards create apologists for supervillains. Meanwhile, criminal women also appear, as, seeking a way to defy the system, many turn vicious.

Jamie rescues Victoria in *The Evil of the Daleks*, but two well-meaning women are aiding in keeping her prisoner. Mollie Dawson, the oblivious maid, hears Victoria's voice and protests that she knows the girl is nearby, but that's about all she contributes. Meanwhile, Ruth Maxtible doesn't realize her father is willingly collaborating with the Daleks, who are controlling her fiancé Arthur. As lady of the house, she's a pacifier, insisting Arthur get along with Jamie and stop bullying the maid. Finally, when Jamie and Arthur duel, she sends Mollie to fetch the Second Doctor, who insists the trio escape the Daleks. Thus, Ruth and Mollie do little to stop Victoria's imprisonment, leaving the Doctor and Jamie to save her.

Janley in *Power of the Daleks* is remarkable as a female supervisor. As the male governor and his aides welcome the Daleks (who chant "I am your servant" until predictably they turn on their masters) she insists her people must accept the Daleks' rise to power. "Good women" like an innocent slaughtered worker and a young mother with a baby are presented as contrast, only heightening her role as the villainess and traitor. Another contrast is Lesterson, a co-worker who proves an out-of-his-head hysteric as he pleads for his people to end their Dalek alliance. His unusual gender role counterpoints hers. As Janley finally realizes the Daleks' cruelty and shoots them, they elim-

inate her in a single wordless blast. "She wasn't as bad as you think," Lesterson offers weakly, though unconvincingly.

In a silvery space tunic, Kaftan the beehived brunette makes a secret bargain with the Cybermen in *Tomb of the Cybermen*. She prides herself on logic, and thus is won over to their perspective. With her knowing smirks and Eastern European accent, she seems a classic villainess. She also literally wears the pants. She works with Eric Klieg, and the pair fund an expedition to Telos to recruit the Cybermen to their cause. Of course, the Cybermen turn on them. Kaftan and Victoria, as the women, wait inside while the men go adventuring. She viciously drugs Victoria and locks the men out to freeze to death. As Kaftan coolly explains, holding a gun on Victoria, "I shall open it when Mister Klieg has completed our plans. Meanwhile, it is better that they remain undisturbed. If you touch those controls, I shall have to kill you." However, Victoria finally gains the upper hand and helps her friends. As the story continues, Klieg and Kaftan begin to resemble the Macbeths, with her egging him on, asking, "You're not scared, are you?" and urging him to take the Cybermen's own weapon and turn it against them. She builds him up but is happy to let him take charge as the woman behind the villain. Of course, the Cyber Controller finally kills her just as a Cyberman beats Klieg to death.

The Third Doctor and Jo discover in *The Mind of Evil* that Professor Emil Keller has discovered a way to extract people's villainy into a storage unit. A female Chinese officer visits UNIT to demand they track down stolen state documents. However, it's soon revealed that she's Keller's assistant (Yates observes that she's "quite a dolly" though she's on the side of villainy). Using the machine's power, she can induce pain just by staring, thanks to a telepathic amplifier connected to the machine. At last, her secret is revealed—she's a pawn in another's plot: The Master has hypnotized her and is forcing her to kill the American delegate, even as she begs him to stop. At last, the Doctor's team discovers she's been serving the Master and stop her. As the Doctor concludes, they should let her go since "she's not a criminal" and "she can't do any more harm now" without the amplifier. As the story's female pawn, Chin Lee goes from dupe to negligible threat as the Doctor and Master return to their usual manly conflict.

Continuing the pattern, Queen Galleia in *The Time Monster* is naïve, accepting the Master as an emissary of the gods thanks to his parlor tricks. She introduces herself proudly as "Queen of Atlantis, daughter of kings and wife of Dalios," emphasizing that she takes her power from men, as well as giving it to the Master. He urges her to ally with him to aid Atlantis, promising it will be restored to its former glory and exalted among the nations of the world. He also hints at a proposal if her husband dies. When he pushes her, however, she resists out of arrogance: As he tells her she must follow orders without question, she retorts, "You mean like a servant girl? And you must

learn, my love, that Galleia is a Queen." When the Master actually kills her husband, she's horrified and protests, "You promised he should not be harmed!" She calls for guards to seize the Master, only for him to fight back and destroy Atlantis itself, serving the queen her just desserts.

Ruth, formerly Lady Cullingford, is a colonist and an environmental activist in *Invasion of the Dinosaurs*. However, she only turns up in part four and comes across as a deluded, gullible idealist: When Sarah Jane says they should get to make decisions for themselves, Ruth replies, "People on Earth were allowed to choose. And see what kind of a world they made. Moral degradation, permissiveness, usury, cheating, lying, cruelty." With this, Ruth decides Sarah needs reeducation, or possibly death so she doesn't cause too much disruption. In a beige tunic with a tight, pinched face, this grandmother-type-turned-vicious is a chilling picture of those who obey authority without questioning it.

Female assistants continue to build up the show's villains. Marn, the cool-toned Gatherer's secretary in *The Sun Makers*, has more than a trace of collaborator. The Gatherer quickly quashes her protests at illegal activity and when he insists the criminals are out to get him, she devoutly responds, "The Company be praised." When the Citizens' Revolution breaks out, Marn turns her coat and offers to join the rebels. Likewise, Madame Lamia aids Count Grendel's evil schemes in *The Androids of Tara,* constructing android doubles of the princess so he can seize power. She's romantically involved with Grendel, though of course, she loves him more than he loves her. At story end, she tries to escape but is accidentally shot and killed by Grendel's guard.

Consuls Katura and Kassia begin *The Keeper of Traken* at Kassia's wedding, as the guests tease her for caring for a statue better than she'll care for her husband. Katura (Margo Van der Burgh, who once played Cameca), quips, "People have begun to think she was married to the statue, all these years she's been tending him." Of course, this stresses her duty as caretaker for the men in her life, though both women are consuls. As the pair lead their community, the Doctor reveals the statue is evil, and it soon betrays Kassia. The force controlling it ignores his promise to protect her husband, and then takes her over entirely. He tortures her, demanding she kill the Doctor. While Katura only protests pointlessly, Kassia becomes the new Keeper, though under the alien influence, which uses her up to the point of death.

Connie Zweig in her archetypes essay discusses society's creation of "ladies": "They shape themselves to cater to the needs of others. Known in Jungian circles as anima women, willingly (though perhaps unknowingly) carry the projections of men, taking on society's stereotypical images of beauty in order to please men and stay connected with them" (183). Too many of the show's women are this kind of enabler, aiding husbands, sons, and monster gods instead of themselves.

In *Black Orchid,* Lady Cranleigh holds a charity ball, dressed as Marie Antoinette. When the Doctor discovers a dead body, she coolly says, "I'm very sorry, Doctor, that you've had this dreadful experience. I wonder, would you be kind enough to help me keep it from my other guests? I wouldn't want to upset them." Her revulsion for bad publicity extends to keeping her scarred, insane son locked upstairs and letting the Fifth Doctor take the blame for the murders. Thus her family loyalty compromises her ethics. Sadly, her lies cause her son's death.

State of Decay has peasants raised to serve the vampires. The peasant mom Marta describes her son's loss philosophically, insisting, like her husband, "It is our place to serve." She's kind and protective of Adric but doesn't speak a word of resistance when the vampires take him. When her own son must go, she isn't even present. In her brown peasant dress and braids she represents one of the ignorant masses, and her husband and son do far more to rebel. Thus even among the peasants, she's uncaring of consequences, willingly complying with the ruling powers.

Another bystander couple reflects them: Arak is a wimp of a man, dominated by his patriotic wife Etta in *Vengeance on Varos.* While he complains about the food and criticizes the governor, she retorts, "I'd like to see how far you get in the Dome of Punishment. You'd not even survive the first distort section." Etta speaks sluggishly and stares constantly at the screen, emphasizing how she's given her mind to the television. As the couple vote for opposite goals, they demonstrate the political fervor and threat of punishment in their dystopia: the governor is tortured for the entertainment of the masses when his measures fail to pass. The other woman of the episode is freedom-fighter Areta. In her olive jumpsuit, she's tough and loyal, not sexualized. When she's informed of her husband Jondar's upcoming execution, she protests that her former friend has turned collaborator, adding, "Varos is what is always was. A prison planet, a colony for the criminally insane. The descendants of the original officers still rule, by fear, with the spectacle of death our only entertainment." She demands the man help save her husband. Though he refuses, the Sixth Doctor and Peri save Jondar and reunite him with his wife. Together, they fix their world and end the tyranny. Meanwhile, Arak and Etta watch television mindlessly, spectators as the heroes fight for their lives. The two couples, set in opposition, emphasize the contrast between those who fight and those who let their world exploit them.

Solow, an older doctor and spy with off-putting eyeshadow, mentally programs a crewmember to destroy the base computers. Her use of hypnosis emphasizes women's wiles being used to twist men's brains and destroy them. She flees to an escape pod, but is electrocuted when she decides to karate kick the alien invaders on her way out (*Warriors of the Deep*). As always, the collaborator's actions condemn her.

Kara, an older factor manager, coldly dismisses her employees and willingly does business with Davros. Thus, from the beginning of *Revelation of the Daleks,* she's marked as a villain:

> KARA: It's all very well to make these demands, but you already take most of the profits my factories make.
> DAVROS [on monitor]: I created the product you manufacture. I have a right to the money.
> KARA: I'm well aware of that, Great Healer. I would willingly sell the bones of Vogel here if it would help your cause.
> VOGEL: And I would give them willingly.
> KARA: You see how devoted we are. But you'd get very little for him, dead or alive, and I would be without a secretary. Good secretaries are very hard to find.

Her purple turban only helps with the image. Of course, even as she works with Davros, she plots to betray him. She hires an assassin, and coldly gives him a bomb that will kill him as well as Davros, neatly tying up loose ends. Fittingly, he's the one to turn on her and kill her.

In an almost entirely white world of actors, the slave handler in *Mindwarp* is played ironically by a Black actress. Her character, Matrona Kani, also assists Crozier, a bio-engineering scientist. Crozier is young and blond, while Matrona dresses in a yellow coat like his, but with exotic alien marks and cone-headed hair. Her pink tunic underneath is rather sexy, feminizing her assistant look. Her name or possibly title clearly comes from "Matron." Towering with authoritative body language, she offers Peri a job like hers, noting, "You were to serve the Mentors and their favored creatures. Now, I control the women servants, and for that I need help. Loyal help." Matrona leads the veiled Peri to Kiv, and holds a flask with a glass straw in it from which he can drink. She may rule the female slaves, but around the men, she's a sycophant. The Sixth Doctor too starts ordering Peri around, demanding she bring him another drink (in a parallel for their real relationship). The Matrona's morality is clearly compromised: Though she looks disturbed, she holds the Doctor down without a word of protest while the others subject him to a "possibly fatal" interrogation.

New Who, written for a new era of gender roles, nonetheless continues the pattern. Yvonne Hartman, in charge of the Torchwood Institute, plans to restore the United Kingdom's vast empire. As happens with most collaborators, she's shocked when the Cybermen take over her staff and upgrade her. As a Cyberman, Yvonne strikes back: she repeats her last words, "I did my duty for queen and country" as her human side reclaims her for a few crucial moments. She succeeds in aiding the Tenth Doctor and Rose in destroying the threat to earth ("Army of Ghosts").

The *Sarah Jane Adventures* story *Death of the Doctor* has Colonel Karim deliver the unfortunate news. She is actually allied with a rogue faction of

the Shansheeths, so they can take her out into the universe and give her grand adventures. "Not as daft as they look, for two batty old pensioners and a bunch of ASBO kids," she smirks when she's found out. Unsympathetically, she adds, "Given the choice between saving the world, or saving the children, the Doctor goes the wrong way." However, the companions' happy memories of adventure save the day, contrasting with the bitter colonel. Of course, she perishes during the episode.

Lucy Saxon, wife of politician Harold Saxon (in fact, the Master) is the ultimate collaborator, fawning over her deranged husband and always appearing at his side in "The Sound of Drums." Their sexy, glamorous, power-seeking relationship inverts Martha and the Tenth Doctor, their enemies. "Lucy stands behind Saxon in a numb, hypnotic state, eyes shining with the intensity of an addict. Saxon is her drug, her martial adornment, and even her weapon. Faithfully, she hangs on his every word, leaning on his chair, physically resting on her husband" (Burke 151).

She wears black and gold, casting her as privileged and polished, rich with a touch of darkness. Her blonde hair is smoothly swept upwards. In the sequel, "Last of the Time Lords," she's physically weakened—loose, duller hair, blackened eye. She sports red nails, lips, and gown as she burns down the world beside her husband, then finally shoots him. "She mostly stands in the Master's shadow, literally behind him, the dutiful wife. Yet, a complex creature, she may have ramifications in the future of the series, and her actions, regardless of how demure, designate her as a baneful, battle-demon in human form" (Burke 148–149).

In fact, the Master returns in "The End of Time, part 1." Lucy reveals she's expected his return, and she hurls a strange potion at him with a defiant "Till death do us part, Harry!" She sacrifices herself to kill him, as she thinks. However, her attempt fails and she dies in vain.

Other collaborators in the episode take her place. The wealthy "king" Joshua Naismith and his daughter Abigail are Black, with white servants and workers fulfilling their every whim in a visual flip like Matrona's. He has created a gate that will rejuvenate all of mankind, while his daughter of course is his eager supporter, smiling that her name means "bringer of joy." Naismith explains, "You've my daughter to thank for this. It's all her idea. She heard rumors of Harold Saxon, his disciples, his return. It's the sort of thing she finds rather thrilling." Both are unaware they're fulfilling the Master's goals, enabling him to take over every human on the planet.

Like Mrs. Saxon, Miss Dexter is a woman devoted to his service. She's a security agent who searches for the Doctor and even arrives at companion Martha Jones's house. In an even more creepy moment, Miss Dexter enlists Francine Jones's help to tap her phone conversations with her daughter in "42." She also arrests Martha's family in "The Sound of Drums" and orders

her guards to open fire on Martha. Thus, she represents all that is evil, even while serving the male force, the Master.

Miss Trefusis serves the Master as well, stealing his ring and then using Lucy to resurrect him. She takes a print of Lucy's lips and smiles: "You were Saxon's wife. You bore his imprint. That's all we needed. The final biometrical signature." She gloats, cult-like, "There are those of us who never lost faith. And in his wisdom, Harold Saxon prepared for this moment. He knew that he might die and he made us ready. Tonight, Mrs. Saxon, he returns" ("The End of Time"). Trefusis "offers herself" in pure devotion. When the Master awakens, he drains her life energy, promptly killing her and her prison staff. In this scene, all the Masters' devotees are female and self-sacrificing, in a disturbing portrayal of gender roles.

Miss Kislet in "The Bells of Saint John" fills the same role, serving the Great Intelligence. She appears to run a company but in fact is stealing minds for the creature to devour. She appears to have no conscience, or nearly none: She decides, "I'm ever so fond of Alexi, but my conscience says we should probably kill him." However, in order to be more reasonable, as she thinks, she postpones his execution until he returns from his vacation. Further, she tells her employee, "If your conscience is bothering you, think of it like this. We're preserving living minds in permanent form in the data cloud. It's like immortality, only fatal." She then plays with her conscience and paranoia settings on her data pad, controlling him from the inside. Miss Kislet spends the episode preying on the much-younger Clara, casting her as the brutal murderous mother. Of course, as she reports to the Great Intelligence, it's revealed that he's using her. When the Doctor defeats Miss Kislet and she admits she's failed, the Great Intelligence tells her unsympathetically, "I have feasted on many minds. I have grown. But now it is time for you to reduce." He discards her as she did to so many. At episode end, she's revealed as another victim when he reverts her to a little girl seeking her mummy and daddy, removing all the wisdom and power he once gave her.

Solana, in "Planet of the Ood," is an apologist for the empire built on slavery after they've colonized an entire culture (though in a moment of visual irony, she's Indian). As the Ood rebel, she tells the guests that all is well and that all the alarms they hear are routine. In her black suit, she appears a polished spokesperson well-versed in denial. In a moment that's all too believable, Solana points out that the people of earth know about the slaves' terrible treatment or at least, "They don't ask. Same thing." The Doctor and Donna try to appeal to her better nature, but fail: When the Doctor urges her to turn on her employers, she bursts out, "They're over here! Guards! They're over here." When the Ood turn violent, she orders the guards to kill them all. After this, it's no great shock when the Ood kill her too.

Auntie in "The Doctor's Wife" resembles a kindly old lady, except that

she's constructed from the parts of others like her husband, Uncle. They sacrifice the Victorian young lady Idris, replacing her soul with that of the Tardis. Auntie and Uncle are in fact presented as puppets of the planet-sized intelligence more than collaborators—a far creepier prospect. As they mouth the words of the planet controlling them, they demonstrate the danger of giving away one's willpower.

In the Twelfth Doctor's "Sleep No More," the Morpheus ad is presented by a video of a perky woman. A similar upbeat female computer insists soldiers sing the Sandman song, adding, "In order to enter rooms, everyone must do the song. It's very amusing." However, both these female voices are spokespeople for the "abomination" that's killing everyone—a creepy juxtaposition. The episode warns of "improvements" to the human condition, while demonizing the spokeswomen who support it.

Margaret Thatcher: Helen A

Possibly the most explicit examples of *Doctor Who* focusing on British politics and society happened during the Sylvester McCoy era. The Seventh Doctor found himself pitted against a number of women who were obviously little more than stand-ins for the Prime Minister Margaret Thatcher—the first woman to hold that important political position. They tended to be older and authoritarian. Stories such as "The Happiness Patrol" (25.2), "Time and the Rani" (24.1), and "Battlefield" (26.1) were specifically written—according to script editor Andrew Cartmel in interviews for the DVD releases—to "bring down" the Thatcher government [Clegg].

In *The Happiness Patrol,* absolute dictator Helen A coos over strawberry desserts and her horrible growling dog. "We're a team, Fifi, you and I. We help each other, and we will make this a happy planet, in spite of all the killjoys and the bunglers that surround us. And if they're miserable, we put them out of their misery. After all, it's for their own good. But first of all, a little harmless revenge," she smiles. In a ludicrous alien look with artificial pink hair, she wears fuchsia with a large A on her arm and dresses her happiness patrols in pink, feminizing them. Thus, she parodies femininity even while dominating her people. Her squads, in short silvery skirts with crazily punked hair, track down killjoys and execute them. As the Seventh Doctor and Ace soon discover, she insists on joy at the point of a soldier's gun. Forbidden crimes include wearing dark clothes, listening to slow music, and reading poems. At last, she confronts the Doctor:

HELEN: I only wanted the best for them.
DOCTOR: The best? Prisons? Death squads? Executions?
HELEN: They only came later. I told them to be happy, but they wouldn't listen. I gave them every chance.

Her philosophy is downright psychotic, and she takes the people's resistance personally, insisting one day, she'll be appreciated. The shadow ruler wants "control for its own sake or for power, status, or personal aggrandizement" (Pearson 187). Certainly, Helen A is a tyrant, enforcing her arbitrary whims. The girls she's trained are killers and fanatics. She lies to them, plotting her escape as the rebellion rises, but assuring them that "Everything's fine." Meanwhile, the Doctor calls on the drones to drop their tools and revolt, a clear reference to industrial disputes of the time like the miners' strike. The Doctor finally wins over everyone—from Helen's patrol girls to her husband (who flees without her).

The character and others like her were politically minded, but the message also comes across as sexist—in Seven's era, strong female leaders were evil and corrupt, often flawed in their thinking. Helen A holds to her philosophy even as the Doctor insists she lacks all compassion (a traditional feminine trait, it should be noted). She instead insists on "control" and "A place where people are strong, where they hold back the tears. A place where people pull themselves together." As she concludes, "I always thought love was overrated."

Just then, in a moment as pathetic as it is laughable, she sees her dog has died and breaks down. The Doctor announces that they've achieved their goal—the dictator need not be battled, as her society will crumble of its own accord, her people turn against her. The message for viewers is clear.

These episodes illustrate what some viewed as the almost fascist nature of the Thatcher years, but all through the personality of the Prime Minister herself instead of her government or the Parliament in general. The stories do highlight social inequality and the problems many saw with Thatcher's government. Taking these stories out of their historical context—a contentious political period, marked by labor and social unrest, led by the first woman to be British Prime Minister—they seem nearly misogynistic, questioning women's fitness to govern. However, in the political context of the 1970s and the 1980s, the program wrestled with British political developments and wasn't rejecting women as unfit to lead a democracy [Clegg].

Female authority is difficult. "If she adopts a vocal, capable attitude, she is deemed too 'masculine' and therefore becomes unattractive to men" (Zweig 184). If she acts feminine, she's criticized for weakness. Balance becomes difficult and perception, everything.

Though Helen A is the most obvious representative, other characters through the show mirror her traits. Continuing the Seventh Doctor era, Lady Peinforte of *Silver Nemesis* sculpts an alien piece of validium into a silver statue of herself—the "nemesis" she wishes to become. This statue, like a wiser form of herself, tells her of Gallifrey and the Doctor. He shoots it into space, but when it comes to earth, she recaptures it. As she gloats, she emphasizes her greed and desire for dominance: "All power, all power past, present

and future, shall be mine. Why, I shall be mistress of all of that is, all that shall be, all that ever was. Yes, all! All!" she chortles. When her male helper urges her to find shelter, she retorts, "How dare you! I shall lead and you follow!" Clearly her leadership is a point of anxiety.

The Doctor orders the Nemesis statue to serve his own patriarchal agenda, repurposing it from the female character, rather like the cyborg archetype. Meanwhile, there's notable resistance to the woman who wants to rule everything. Even Ace calls her an "old bag." In her stark black and white with a mannish stride, Lady Peinforte tries blackmailing the Doctor for his secrets only to be dismissed. Her attempts to be an equal in a man's world crumble, in another lesson for viewers. The statue she's created absorbs her and leaves the planet—even the representation of her stronger self has turned against her. The metaphor is clear; no one will support her.

In Arthurian legend, Morgaine is the villainous mother of Mordred, who brings down Camelot and seals Merlin in a cave. *Battlefield* heralds her return. As Jean Marsh (who also played Sara Kingdom) notes in her interview: "Although I was only in that one, very long story, I always gets lots of fan mail about it. I was so pleased to do another one, playing a wicked queen in the last series." She describes her character as "actually very intelligent and rounded, as characters go."

With scary pointy crown and pointier nails, Morgaine is an older woman, more domineering than attractive in a shiny black witch's robe. A world of spooky, greenish magic gives the setting an air of unreality. She's the ultimate maneater, willing to sacrifice even her son Mordred to achieve her ends. She also preys on screaming young women, harvesting one's mind to learn military secrets. At the same time, she fights in service to a male entity, weakening her authority. Mordred exclaims, "This is no battle. Tis but a ruse, a diversion. My mother hath summoned the Destroyer, the Lord of Darkness, Eater of Worlds." The Seventh Doctor and Morgaine face off. The Doctor is Merlin in her universe, so she battles him for Excalibur with swords, emphasizing her mannishness. She finally plans to unleash a nuclear weapon in her fury. However, the Doctor convinces her this is a dishonorable attack, and she sadly surrenders, accepting her world is gone. This ending proves her weak and fragile on many levels.

"It is said that a woman with a highly developed animus becomes overly aggressive, intellectual, and power-hungry in an effort to end patterns of passivity, dependency, and moodiness" (Zweig 188). A few domineering leaders of other eras fall into this pattern. Megan Jones is a company director in *Fury from the Deep*, showing her strength even in the sixties. "I'm director of the board. I put you in charge of this area and I can just as easily send you back to the rigs," she tells her male subordinate.

In the midst of the mission of *The Ark in Space*, an announcement pops

up on the screens: the Earth High Minister (a woman), inspires the crew with a lovely speech, saying, "You stand now at the dawn of a new age. You will return to an Earth purified by flame, a world that we cannot guess at.... The challenge is vast, the task enormous, but let nothing daunt you." Since the crew is actually fighting an alien organism that's possessing the crew, her speech is painfully out of touch, in what may be a subtle criticism of female leaders. Compounding this, Harry Sullivan bursts out to Sarah, "Well, I bet that did your female chauvinist heart a power of good.... I mean, fancy a member of the fair sex being top of the totem pole." Female leaders are strange enough that all feminists must be assumed to support one.

In *Robot*, Sarah is put in her place by the Manager of the Think Tank:

> SARAH: Hello. You know, it's awfully good of you to allow this visit, Director.
> HILDA: I hadn't expected male chauvinist attitudes from you, Miss Smith.
> SARAH: I'm sorry?
> HILDA: I'm the Director. Hilda Winters. This is Arnold Jellicoe, my assistant.
> SARAH: Oh [*Robot*].

In a black coat with clunky glasses, Hilda Winters indeed seems a dominating figure. Creepily, she demonstrates her robots' nonviolence by ordering them to kill Sarah—a cruel assertion of dominance. Her name may be an homage to Margaret Hilda Thatcher (not appointed leader of the Conservative Party until February 1975, a month after *Robot* aired, but still an up-and-coming politician of the time). Secretly, she's the leader of the Scientific Reform Society, a group that desires rule by the scientific elite. Their illegal coup, using the robot to obtain the nuclear missile codes of all nations for extortion, hints at women illegally rising to positions of power, since the story suggests they cannot be winning elections honestly. She belittles Sarah, the story's other woman, for her femininity:

> Unlike Vira in *The Ark in Space*, who is virtually indistinguishable from her male colleagues—her hair and clothing are identical, her gender is seemingly irrelevant— Hilda Winters does not disguise her femininity, but is not above treating it as a weakness in others. When she denigrates Sarah, she does so by implying that she is sentimental, "the sort of girl who gives motorcars pet names." On the other hand, the Doctor has done just that in recent memory, naming his yellow roadster Bessie—an indication of the delight the show is beginning to take in skewing the gender norms. The problematic nature of a woman wielding power only to misuse it is counterbalanced by the stronger depiction of Sarah throughout the story—female viewers are not asked to choose between the powerful villain and the weak heroine [Welsh].

Enlightenment, written by Barbara Clegg and directed by Fiona Cumming, was the third of three loosely connected serials known as the Black Guardian Trilogy. The female characters here deserve a close look. A tough, dreadlocked destroyer (and thus suiting her name), Captain Wrack is participating in a galactic race. She enters the episode by swishes a cutlass

through the air above Turlough's head. After this, she puts him in irons and smirks, "Have you ever seen a man flogged to death? Or keelhauled? Very painful." She willingly embraces the Black Guardian, using his power to destroy her competition. Formidable as she becomes, she freezes Tegan with a wave of her hand. In classic memorable villain fashion, she gloats at the Fifth Doctor, "You've lost. All that awaits is your ultimate destruction. Bwahahahahahahaha!" The Doctor finally responds to her pirate attitude by hurling her overboard (nonfatal thanks to her powers). Though she works for a male force, she's memorable in her strength.

While Alice Guppy and Emily Holroyd (lovers) work for Torchwood in the Victorian era, Alice coldly executes a blowfish alien and delightedly tortures Jack Harkness on first meeting him. They soon recruit him to their institute in the flashback episode "Fragments." They are also featured in *Torchwood* novels such as *The Baby Farmers* and *Risk Assessment*. With their strength, they emphasize the difficulty of being female leaders in a man's world, but also the heartlessness they've developed for their job.

A century later, Yvonne Hartman (in charge of Torchwood 1), explains their mission: "Anything that comes from the sky we strip it down and we use it for the good of the British Empire." When told there is no British Empire, she replies "not yet," showing her imperialist goals. She uses the Cybermen until, of course, they turn on her. However, repeating her last words, "I did my duty for queen and country," she manages to stop the Cybermen long enough for the Doctor to seal the breach between worlds.

Miss Hartigan, matron of the St. Joseph's Workhouse in "The Next Doctor" is much the same. Her profession of manipulating men has left her with a mind so strong she can overcome Cybermen. She tells the Doctor, "No one's ever been able to change my mind" but adds, "The Cybermen offered me the one thing I wanted. Liberation." She's finally given the power to transcend the limits of a woman in her Victorian world, and she's determined to use it. When she attends a funeral in shocking red, she makes a decidedly rebellious statement, then sends her Cybermen to kill everyone, enslaving a few of the most powerful in a gender flip. She clearly loathes men, with comments like "The CyberKing will rise, indeed. How like a man." Another evil mother, she plots in Dickensian style to make children her new workforce. Of course, she's painfully let down when the Doctor reveals how she's being used.

Hartman and Hartigan are, like Ianto Jones's Cyberwoman, converted by the Cybermen. However, they both resist with a willpower unseen in most of the show's men.

Yvonne Hartman in "Doomsday" is already patriotically pre-programmed ("I did my duty for queen and country!") and is therefore not re-programmable, and Mercy Hartigan (Dervla Kirwan) in "The Next Doctor" shows an emotional strength that exceeds the limits of cyber control.... The women who fail the cyber conversion are

also linked by both sexuality and emotion, which are destructive to technological standardization of the Cybermen [Kydd 199].

The balance also suggests that the women, already Othered, are accustomed to patriarchal control; with this training, the women who have risen to be leaders can fight off conversion.

Other female leaders of New Who are more ambiguous, suggesting a desire to work with female power in a shifting dynamic of control. Harriet Jones is the new show's running joke, as everyone knows who she is. A minor politician, she shines in her first appearance, when the Slitheen infiltrate Downing Street. She clearly represents the backbone of ordinary British folk, rising to heroism when needed. There to defend her constituency, she insists even an alien invasion won't deter her. Jones is the one to order the Doctor to destroy the Slitheen, even at the possible cost of all their lives, and he follows her order. The world is saved, and she goes to brief the press, head held high. She triumphantly becomes Prime Minister by the Tenth Doctor's regeneration.

However, her morality may be slipping. In "The Christmas Invasion," she bravely defends the earth and reasons with murderous aliens. However, the Doctor is horrified when she orders her secret Torchwood project to blast the fleeing aliens out of the sky. She replies calmly, "I'm sorry, Doctor, but you're not here all the time."

He brings her down on the spot with six words: "Don't you think she looks tired?" She apologizes, but it's too late. The Doctor thus destroys her destiny to be Britain's Prime Minister for three terms and bring about a Golden Age (an odd breach of his hands-off ethics). This plot twist is also strange for condemning a moral (and female) leader for uncompromising defense, rather than bloodthirstiness.

In "Journey's End," Harriet Jones, former Prime Minister, serves her country once more. When the world surrenders to the Daleks and all the companions break down in tears, Harriet Jones activates the subwave network. After uniting the companions, she summons the Doctor with it, though this costs her life. She dies threatening the Daleks (who know who she is) with their downfall at the hands of humanity

For the next leader, Davies describes his Chief Constable of the Shadow Proclamation and his struggle to make her stand out: "I've renamed her the Shadow Architect, made her albino and weird (hair scraped back into a black snood, red eyes, solemn, swathed in black robes), and given her a slight mysticism—not hermit-in-a-cave mysticism, just an albino freakiness—so she's sort of interesting now" (Davies and Cook 37). On the show, like the Inquisitor, she's wise and fair but naïve: After the Doctor seeks help from the galaxy's police in "The Stolen Earth," she insists he lead the Shadow Proclamation into war. The Doctor agrees, pops into the Tardis, and vanishes. It's arguable

whether her character mocks female authority or just authority in general, but this becomes one of many less-than-stellar moments for women in charge.

Kate Stewart, the Brigadier's daughter, stars in "The Power of Three" then "Day of the Doctor." In the former, she insists on putting UNIT under scientist control and adds, "UNIT's been adapting. Well, I dragged them along, kicking and screaming, which made it sound like more fun than it actually was." This suggests that she's moved past Harriet Jones's warrior model to protect the world more subtly. In her next appearance, she begins by carrying off the Tardis by helicopter … with Eleven dangling outside! "Kate Lethbridge Stewart, a word to the wise. As I'm sure your father would have told you, I don't like being picked up," he barks.

"That probably sounded better in his head," Clara smiles, jokingly under-cutting the moment ("The Day of the Doctor"). Soon enough, Kate's facing off with her Zygon counterpart and prepared to blow up London to stop the alien shapeshifters. The women sit steel-faced opposite each other. However, the Doctors stop both Kates, lecturing in a way that emphasizes their wisdom and longevity. They insist the human and Zygon Kates create a peace with "the most perfect treaty of all time" since they won't know who is who—once more, the female leaders need the Doctor's intervention to keep them on the path of morality. Both Kates cancel the detonation and do indeed create a perfect treaty. In a happy ending, the Zygons are given a refuge on earth. Though the Doctor places safeguards to protect the planet from Kate in "The Zygon Invasion"/"The Zygon Inversion," he considers her a mostly-altruistic friend and ally.

Kate returns for "Death in Heaven." As the Twelfth Doctor, Missy, and a group of Cybermen face off, she instantly takes charge: "Kate Stewart. Divorcee, mother of two, keen gardener, outstanding bridge player. Also Chief Scientific Officer, Unified Intelligence Taskforce, who currently have you sur-rounded." The moment is delightful as she claims power as a mother, gar-dener, and bridge player as well as military leader. When the Cyberman insists they cannot be stopped, she throws down a battered Mondas Cyberman head, emphasizing her ability to destroy them. She's just as businesslike with the Doctor, as she suddenly sedates him and drags him off to the plane she's had made for the new "President of Earth." As she tells him straightforwardly, "I'm sorry. In the event of an alien incursion on this scale, protocols are in place. Your co-operation is to be ensured and your unreliability assumed. You have a history." In their dynamic, she appoints him to power, but keeps him on a tight leash.

Still the tearjerker moment comes when her father comes to save her as she falls from the plane … his being dead and transformed into a Cyberman won't stop him from rescuing her. This moment is a lovely salute, giving the character a bit more depth. She also has a large arc in the audio adventures,

leading UNIT to defend earth. She first appeared portrayed by Beverley Cress-man in the home-video releases *Downtime* (1995) and *Dæmos Rising* (2004), as she struggles with her estranged father and young son in a pair of spinoff adventures.

Evil Ice Queen: The Rani

Sarah Hellings directed *Mark of the Rani,* last of the classic episodes directed by a woman, while husband-and-wife team Pip and Jane Baker wrote both Rani episodes, along with some of Trial of a Time Lord. Thus, the Time Lady stands out as a female creation as well as superb villainess.

She is cast as the dark side of Ice Queen scientists like Liz Shaw or Romana—an amoral researcher who prizes discovery above the cost to inno-cent lives. In her long dark dress and elaborate braids, she's the tyrant queen, all-powerful and cruel. She alters the biochemistry of other species for her own ends, often enslaving entire worlds to gather subjects. "Like many scientists, I'm afraid the Rani simply sees us as walking heaps of chemicals. There's no place for the soul in her scheme of things," the Sixth Doctor comments (*Mark of the Rani*). The negative aspect of the Sage "has no tolerance for normal human feelings or vulnerabilities" (Pearson 216). She controls information to make it less threatening. While the opposite of com-passionate, the Rani insists she's absent of "idiotic pride," a traditionally mas-culine quality (*Mark of the Rani*). She stands for womanly power, though used immorally.

On the planet Tetrapyriarbus, the Rani collects scientists, including the Sixth Doctor, and melds them into a giant brain, with which she believes she can invent a Time Manipulator. A knowledge-oriented villainess, she attacks his intellect—his prized mind. The Doctor, a force of altruism, attempts to reason with her, telling her the humans deserve compassion. She retorts that they're carnivores, oblivious to the suffering of animals they eat. This argu-ment indicates a cruel fairness. The Rani coldly insists, "Sentiment has noth-ing to do with it. Wasting a resource does. Until this experiment is successfully concluded, I can't be certain that I won't need them as a labor force. Selective retribution will bring any dissidents to heel" (*Time and the Rani*). When the Doctor still protests on ethical grounds, she adds, "Am I expected to abandon my research because of the side effects on inferior species? Are you prepared to abandon walking in case you squash an insect underfoot?" (*Time and the Rani*).

Her work emphasizes the Time Lords' approach to the universe—though she is interfering with many species, the Time Lords simply exile her, leaving her to destroy entire races as she's no longer their problem. As such, she's the

dark side of the Doctor—she interferes through malevolence and scientific inquiry, while he battles for innocent lives.

Like three siblings, the Master, Doctor and Rani offer polarized opposites: altruism, destruction, and amorality, or selflessness, selfishness, and expediency. The Master's talent is hypnotism, and the Rani's contrasts it with invention. "You're obviously a brilliant tactician as well as a brilliant chemist," he tells her (*Mark of the Rani*). Master and Rani end their first episode trapped on her Tardis endlessly squabbling, much like the end of *Star Trek*'s "The Trouble with Tribbles."

It's nice to see a "Time Lady" besides Romana, emphasizing the many roles women can have in the Doctor's universe. "Female villains are a rarity in [classic] *Doctor Who*, so it is with a real sense of pleasure that fans watched the highly competent and threatening renegade Time lady" (Muir 352). Of course, she's beautiful, sexy, and intelligent. Slipping into another (admittedly sexist) woman's role, she beguiles the Doctor, switching faces with Mel in her second adventure. Rani-as-Mel flatters the Seventh Doctor to get his scientific expertise and wipes his brow while he works. As such, she appears the perfect self-effacing assistant. When asked if she thinks herself superior to him, she coos, "Now how could I possibly think that, Doctor?" (*Time and the Rani*).

Of course, in a moment that appears companion-wish fulfillment, she slaps his face and accuses him of hallucinating (while hallucinating, Six slapped Peri in a similar fashion). Eventually the Rani's trick is discovered. She and Mel face off, and unsurprisingly debate ethics. Though Mel insists the Rani shouldn't underestimate the Doctor, and that his compassion strengthens him, the Rani retorts, "Huh. You're as sentimental as he is" (*Time and the Rani*).

She finally proves to have believed her philosophy that people are commodities too well and even imparted it to others—she's betrayed by her slaves, the monstrous Tetraps, who decide to use her brain to power their technology, the same use she had planned for scientific geniuses like the Doctor. She, like so many Who villains, tumbles into her own trap, though she returns for some audio adventures.

Evil tyrants "are selfish, narrow-minded and vindictive—and also usually unimaginative or unintelligent and prone to either indolence and self-indulgence or spartan rigidity and intolerance" (Pearson 187). They lack balance. Each time such a woman (or admittedly a man) battles the Doctor, he emphasizes how their worldview is cruel or unjustified.

Lady Adrasta from *The Creature from the Pit* is a tyrannical ruler of a gynarchy. In her turban with dark robes and off-putting makeup, she resembles the evil queen of Snow White. Though bandits keep attacking, she's determined to maintain control. She sneers, gloats, and emphasizes the danger of a powerful woman. Meanwhile, Madame Korella, the crone who serves her,

parades the Fourth Doctor around in stocks, demonstrating the women's superiority. Harnessing the feminine natural world to augment her monstrosity, Adrasta has plant balls called wolfweeds that can attack on command. She's cast as the monster-queen, attacking the Doctor with the weapons of her femininity.

Camilla in *State of Decay* is a vampire, once navigational officer Lauren MacMillan. After their transformation, the vampire queen and king speak emotionlessly and make large, premeditated gestures. Otherwise they remain as stiff and still as paintings. Caked in alienating makeup, they walk in perfect unison, arms clasped more like matched guards than husband and wife. The lady's majestic dress dips low while her hair gleams artificially stiff and black. Certainly, everything about Camilla marks her as the alien ice queen. Notably, she's stronger than the king, more active, more forceful. The pair finally age and crumble into skeletons, emphasizing, like the Wicked Witch of the West, their inherent lifelessness and stagnation.

Queen Xanxia plays a simple nurse for much of *The Pirate Planet*, manipulating the captain she cares for. However, she's finally revealed as a galactic tyrant determined to preserve her youth forever, much like Camilla. She has also shaped the captain into her cyborg slave. Of course, the Fourth Doctor takes her down, while emphasizing how impossible her plan is—the lifecycle must continue, as the show destroys those who oppose it.

A final intriguing tyrant goes unseen. There's a running joke as the Doctor mentions "The Terrible Zodin" several times as "a woman of rare guile and devilish cunning" (*Attack of the Cybermen*). The Expanded Universe mentions her even more, giving her a background as a clawed sword-swallower at the Grand Festival of Zymymys Midamor and pairing her with Iris Wildthyme. Since she hires an assassin to destroy the earth, she's also a force of great entropy and cruelty. However, her threat remains nebulous as she never appears in the flesh.

The Fool: Missy

"The Fool is the archetype most helpful in dealing with the absurdities of the modern world and with faceless, amorphous modern bureaucracies— places where no one takes personal responsibility, rules are expected to be followed no matter how absurd they might be, and the tables are incredibly stacked against individual effectiveness" (Pearson 223). The Master is a trickster and rule-breaker like the Doctor, one who points out all the flaws in the status quo. He breaks another boundary in the Twelfth Doctor's era when he changes sex … into Missy.

"While never less than a serious threat, the Master's efforts to torment

the Doctor were soon shown to be a battle of wits between two old sparring partners" (Hearn 74). The first Master was the evil-looking Roger Delgado, the "most deadly enemy" of Three, who coveted the Doctor's regenerations. Delgado's character was a calculating Bond villain, but other actors found different angles to explore: the younger John Simm who faced off with Ten was far less stable—mad even, as he turned all of humanity into his subjects, and then remade them in his image. "The Fool tricks us into moving out of a continuing psychological space, but we are then flooded with too much unsorted psyche material. The challenge is either to reconstruct an ego or to go under" (Pearson 226). Confronted by this contrarian, the Tenth Doctor finds creative ways to combat him, even as the Master makes him admit that his beloved Time Lords are wicked and selfish.

Missy (Michelle Gomez) is first hinted at when Clara arrives in "The Bells of Saint John," and she introduces them by giving Clara the Doctor's phone number. After he transforms in "Deep Breath," she posts an ad to reunite them. "There's a woman out there who's very keen that we stay together," he notes.

After the episode's villain, the Half-Face Man, dies, he wakes in a beautiful garden beside a woman in a black Edwardian costume. She tells him, "Hello. I'm Missy. You made it. I hope my boyfriend wasn't too mean to you." She adds that the Doctor is never mean to her "because he loves me so much" ("Deep Breath"). The audience is left to puzzle out which love interest from the past or future Missy may be. Meanwhile, she assures the Half-Face Man he's reached heaven. As with other arcs, she gets in a quick reference in several episodes, welcoming sacrificed characters to Paradise. She also watches Clara on a screen and mutters the ominous words: "Clara ... my Clara.... I have chosen well" ("Flatline"). At last, she settles the mystery, on meeting the Doctor in the Nethersphere, an afterlife of a sort. She tells him, "Oh, you know who I am. I'm Missy.... Short for Mistress. Well, I couldn't very well keep calling myself the Master, now could I?" ("Dark Water").

Missy owns her new femininity. "Tell him the bitch is back," she smirks ("The Witch's Familiar"). She also coos over her Cyberman "children" in "Dark Water." Most of all, of course, she flirts heavily with the Doctor, whom she calls her boyfriend. On their first meeting, she places his hand on her chest and competes with the Doctor's companion. "Oh, Clara, Clara, Clara! You know I should shoot you in a jealous rage. Now, wouldn't that be sexy?" This flip on the Master emphasizes how close and competitive the Doctor-Master relationship has always been. Only Missy's sex change lets her make it overt. Now she considers the Doctor her "boyfriend" in truth, and all the killing just foreplay.

The new character is intriguing, provocative, fun. She owes much to her directors: Rachel Talalay, who directed the cult favorite *Tank Girl,* directed

"Dark Water"/"Death in Heaven," "Heaven Sent"/"Hell Bent," and then the later "World Enough and Time"/"The Doctor Falls." Hettie MacDonald, who had directed "Blink," returned eight years later for "The Magician's Apprentice"/"The Witch's Familiar." Many considered Missy a step forward in the female Doctor question. However, she's less than the protagonist and far less than equal. "Missy challenges and subverts the Doctor's power, but ultimately the Doctor—along with the white male authority he represents—remains in charge" (Nathanael 90).

Of course, she's a horrible parody of femininity as well as the rapacious evil matriarch and seductress in one—preying on the Doctor and killing his human friends. Missy murders the innocent Osgood, babbling insanely and gleefully, "I'm going to kill you in a minute. I'm not even kidding. You're going to be as dead as a fish on a slab any second now, all floppy and making smells. But don't tell the boys. This is our secret girl plan" ("Death in Heaven"). Gothic music plays madly as she kills the other woman, then twirls round and round eagerly.

Her scheme in "Death in Heaven" is another shock—she doesn't wish to rule but to create the largest army ever and then give it to the Doctor. As Victoria Schmidt says of the Seductress, "Very often the Seductive Muse just wants to be recognized for her brain instead of just her looks…. She wants a true soulmate who sees her for who she is." Certainly, Missy wants the Doctor to admire her inside as well as out. With this, Missy creates a monster army for her man … and is dismayed when he rejects her worldview. She insists, insidiously, "I need you to know we're not so different. I need my friend back. Every battle, every war, every invasion. From now on, you decide the outcome."

It appears she has brought the Doctor and Clara together because she wants to engineer a moment where Clara tries to kill Missy—thus forcing the Doctor to do it himself and making him more like his old foe. He refuses the army, but does prepare to execute her, until the Brigadier beats him to the job (or so it appears).

In "The Magician's Apprentice," Clara faces off with Missy one on one and they squabble over the Doctor. Missy of course is terribly possessive:

CLARA: He's not your friend. You keep trying to kill him.
MISSY: He keeps trying to kill me. It's sort of our texting. We've been at it for ages.
CLARA: Mmm. Must be love.
MISSY: Oh, don't be disgusting. We're Time Lords, not animals. Try, nano-brain, to rise above the reproductive frenzy of your noisy little food chain, and contemplate friendship. A friendship older than your civilization, and infinitely more complex.
CLARA: So the Doctor is your bezzy mate and I'm supposed to believe that you've turned good?
MISSY: Good?

She shoots several guards to make her point, until Clara pushes her to prove her devotion to the Doctor and stop. Only this persuades her. When the pair are trapped together on a mission to Skaro, Missy gets to indulge her mad, savage side. She ties Clara up and threatens to hunt her with a pointy stick. Of course, her bluntness is legendary. "Fools have a license to say what other people would be hanged for, to puncture the ruler's ego when the ruler is in danger of hubris, and to generally provide balance to the kingdom by breaking the rules" (Pearson 220). In the course of this, however, Missy reasons that the Doctor has abandoned his determination to survive and insists in her roundabout way that they steel themselves and go rescue him. Still, she continues to bully the weaker girl. When Clara suggests tossing a stone into a Dalek sewer to judge the depth, Missy tosses her. "Every miner needs a canary," she smirks. She also chains Clara to use as bait for the Daleks. All of Missy's actions suggest a complete contempt for Clara's life, yet she partners with her and uses her as a sounding board, in another interesting flip on the Doctor-companion dynamic.

At episode end, she stages her great betrayal of the Doctor. She brings him a Dalek she says has killed Clara—actually a Dalek casing with Clara trapped inside. "Indulge yourself. Go on, kill the Dalek," she smirks. As Schmidt adds of the Femme Fatale, "She never dirties her own hand when she can manipulate a man into doing the dirty work for her." When Clara begs for mercy, the Doctor figures it out. "Missy, run," he tells her succinctly. With her plan found out, Missy turns arrogantly defensive, insisting, "In a way, this is why I gave her to you in the first place. To make you see. The friend inside the enemy, the enemy inside the friend.... Everyone's a bit of both. Everyone's a hybrid" ("The Witch's Familiar"). This heralds the threat against which the Doctor has guarded Gallifrey. It also reiterates her motives from her previous scheme—to make the Doctor's morality slip so he'll be more like her as her perfect partner and mate.

The Doctor spends Series Ten guarding Missy in a vault. Thus, succeeding River, a new perfect mate who's imprisoned eternally returns in a less-than-empowering dynamic. Due to be executed, Missy pleads with the Doctor, "I'll be good, I promise. I'll turn, I'll turn good. Please. Teach me, teach me how to be good" ("Extremis"). He accepts her oath and avoids executing her, but obeys the letter of his vow: He locks her up for a thousand years, though with a piano and takeout food. In one memorable scene, she gives advice in return for bribes like new boots and a pony. The Doctor protests, "Nice people generally don't haggle over the fate of a planet," but she responds that she could've escaped but is still there, "engaged in the process." By her standards, she's helping ("The Lie of the Land"). Indeed, her advice saves everyone. She ends the episode painfully recalling all those she's killed, with the Doctor telling her, "I'm sorry but this is good." It seems she's finally growing beyond her role.

However, in the season finale, "The Doctor Falls," Missy meets her previous incarnation, the John Simm Master—like the older, crueler self she used to be. "Becoming a woman's one thing but have you got ... empathy?" he asks when Missy worries about Bill. Being around him clearly evokes her cruelty, though at times she seems torn. The Doctor has been pulling her towards goodness, but now her old self tugs her back to evil.

In a more disturbing sequence, the Master and Missy flirt, while discussing how wrong their attraction is ("Hold me." "Kiss me." "Make me."). While they're lighthearted scenes, the Master in his sexism appears truly interested, while Missy more goes along with it. Moffat, the writer, comments, "Their flirtation, I'm not sure whether they're just showing off" (Moffat and Talaylay).

While happy to play, Missy still seems torn. Fed the straight line "Knock yourself out," Missy does, and tells the Doctor she's always been on his side, though he's skeptical. When, at a crucial moment, he asks her to stay and save lives, she turns down redemption, taking his hand and adding, sincerely, "Thanks for trying." She has grown through his teaching, but not enough. At story's end, she stabs the Master, adding that she knows the Doctor is right. However, he shoots her in the back, insisting that his gun has destroyed her chance to regenerate. As he slinks off to die and become her, she lies open-eyed on the forest floor, her lesson of goodness learned too late.

The Monster: Miss Quill

On the show *Class,* Miss Quill, the mean teacher introduced as she smashes a kid's cellphone, calls her student April the "answer to are spinsters born or made." Miss Quill's deadpan is mockingly evil. "Don't make me put you in detention, Ram—you won't like it" ("For Tonight We Might Die"). Worst of all, she gives a student a weapon with which to kill alien invaders, even knowing it will destroy him as well. She's completely amoral, though she's presented as more alien than malicious.

Further, she's resisting in all the ways still allowed her. Quill was once an alien freedom fighter, finally conquered and forced to serve as bodyguard to her student Charlie (actually an alien prince). Their world was destroyed, leaving the pair the last survivors. Now she lives with him as a sort of foster parent, fulfilling both the "teacher as villain" and "foster parent as villain" tropes of school stories.

Fictional mothers are expected to sacrifice all for their children, so Quill's apathy and anger cast her as the antagonist ... but also lead viewers to question their biases.

If a mother is less than devoted, she is depicted as putting her children's minds, souls, and very lives at risk. Who but a monster would do such a thing to young innocents? Make-believe mothers out to be reflecting what we now acknowledge real mothers—real women—to be: complex beings with rich inner lives, people capable of a range of behavior from egotism to selfishness, from cowardice to valor. Certainly they should be more than either a June Cleaver or a Mrs. Bates [Isaacs 52].

Likewise, Quill's insistence on the rightness of her cause complicates the show—for losing her rebellion, she is condemned to an eternal servitude she loathes. In episode five, she finds her freedom. The new school governor, brunette Dorothea Ames, wears a ladylike red suit. Quill, the angry warrior with her chin-length blonde cut, sports a sharp-edged black suit, casting them as opposite forces. Ames is an ice queen and collaborator as well as evil headmistress. She tells the teens, "Do you really think the Governors are so cold-blooded? We are academics. We research. We gather knowledge in preparation" ("The Lost"). She awaits an alien arrival (suggested to be the Weeping Angels) and serves obediently, oblivious to human lives. She's also obsessed with the superweapon called the Cabinet of Souls, trying to unlock it by threatening the teen protagonists in the murderous mother archetype. In the end, the angels kill her, even as she pleads, "My belief is pure. I have done everything in the name of the Arrival!" ("The Lost"). Of course, they show no sympathy.

While Ames urges Charlie to save the earth with the cabinet, Quill asserts that she values revenge over her own life. With the aid of the governor, Quill quests through red forests, blue caves, and empty deserts. At last she wins her freedom. She's thus the hero of her own story, granted a magical quest that parallels the teens' adventures. Now freed, she can fight for herself at last.

However, she wakes from her adventure heavily pregnant. She has achieved a new life stage, but her babies will kill her. As she reveals, "This is the traditional end to a Quill life ... we die and our offspring consume us. They take our strength as their first gift, and our last legacy" ("The Lost"). Nonetheless, she begins bonding with the child, feeling it kick and promising, "I will take you into battle. I'll take you to the very end of this world" ("The Lost"). Likewise, when Tanya's mom dies, Quill finds herself hugging the crying teen, finally reaching out to show a little awkward sympathy. While pregnant, she also defeats fearsome Shadow Kin in hand-to-hand combat and then teaches Tanya to fight. She insists her condition hasn't made her soft, just "more ferocious." However, the birth scene waits on a cliffhanger for the show's return.

Of course, most monster matriarchs are villainesses, not antihero protagonists. The suggestively named Miss Foster of "Partners in Crime" provides a benevolent service on paper—raising tiny Adipose babies in a way that lowers

people's fat content. The humans even volunteer after the deceptively honest advertisement that "The fat just walks away." However, when Donna Noble and a client discover what's happening, Miss Foster activates "full partheno-genesis," and the client is converted completely into Adipose, leaving nothing but empty clothing. Miss Foster thus subverts motherhood by murdering young women to serve her alien employers. While the Tenth Doctor pardons the children, he notes that Miss Foster will be forfeit once her task is complete: "Mum and Dad have got the kids now. They don't need the nanny anymore." The aliens who hired her send her plunging to her death, erasing evidence of her crime and destroying the collaborator.

Signora Rosanna Calvierri runs a girls' school in "The Vampires of Venice." She too preys on her charges, training them to be brides to her ten thousand monster-sons. Her fierceness and creative plan to rebirth her people (marrying off her protégés to her sons then sinking Venice in a storm of boiling rain) is striking: "I will bend the heavens to save my race, while you philosophize," she insists. She realizes that she has some of the moral high ground, adding, "Tell me, Doctor. Can your conscience carry the weight of another dead race?" He must admit that her desperation was justified if not her methods. Despite her plotline being driven by her children's welfare, the writers have her throw herself into the canal, where her sons devour her in an image of true monstrosity. Both Miss Foster and the Signora preserve children. Nonetheless, the Doctor takes the side of humanity, insisting that aliens have no right to prey on them. He, the male arbiter of justice, defeats the monster-moms, emphasizing their alien horror over their maternal love.

The Ice Governess, another evil mother, battles the good governess, Victorian Clara in "The Snowmen." As she emerges from the frozen pond in which she died, little Digby reports, "She fell in there, and then it froze. She was in the ice for days and days. I hated her. She was cross all the time." Frannie adds that the governess is stalking her dreams, planning to punish her. When the Ice Governess forms fully, she chants, "The children have been very naughty" and terrorizes them. She finally kills Clara, casting herself as the benevolent mother's mortal foe. Nonetheless, the children's love, inspired by their dying governess, melts the bad one.

Dame Diana Rigg plays Mrs. Winifred Gillyflower in "The Crimson Horror" with her daughter, Rachael Stirling, playing her scarred, rebellious daughter Ada. She runs a factory called Sweetville in which she preserves young couples in eternal stasis, keeping them lifeless and sterile. Obviously, this fulfils the pattern of the evil mother preying on innocents, keeping them safe and pure yet lifeless prisoners. Meanwhile, Mrs. Gillyflower and her real daughter can't stop bickering as Ada, considering herself a monster, bonds with the damaged Eleventh Doctor. In fact, Mrs. Gillyflower is inhabited by a monster-leech, Mr. Sweet, who's encouraging her behavior until Ada smashes

him. Since Mrs. Gillyflower has caused Ada's injuries through her experiments, the two women have irreparably damaged each other. Both are monsters, one on the inside and one on the outside, as they prey on the villagers and their own family.

Like Ada, many series monsters are sisters, children, or damsels. *Planet of the Spiders* presents all its creatures as female—a disturbing image of women as predators. Among them, the queen insists she doesn't want to invade earth—a "foolhardy venture." Still, she arrogantly turns on her allies, displaying a monster's greed and warped morality. Meanwhile, her subjects display the same treachery as they turn on her:

> SPIDER: But it's true. Once more, O Queen, your arrogance has endangered the master plan of the Great One.
> SPIDERS: All praise to the Great One!
> SPIDER: It is not the first mistake the Queen has made.
> QUEEN: Mistake?
> SPIDER 2: Maybe the most noble Queen is growing old?
> SPIDER 3: I think the time has come for a coronation.

Paradise Towers offers sweet old ladies Maddy and Tilda who welcome Mel with cooing voices, untie her, and stuff her with tea and fresh cookies. "She can eat and eat till her heart's content and get nice and plump and healthy," Tilda coos. They are the "Rezzies," residents of the towers, in pink and purple, one in crochet and the other with a frilly apron. Condemning the teenage gangs, they call Mel "a nice, polite, clean, well-spoken girl. Just the sort we like." Thus, they appear mentors, teaching the younger generation values. However, the "two harmless old folks like us," as they call themselves, suddenly turn on Mel. With sweetly menacing dialogue like "In our experience, Mel dear, it is much better not to struggle too much. It only causes needless distress" they tie her up and prepare to eat her. This is suburban horror, with the benevolent grannies revealing themselves as cannibals in a shock for the audience. A similar character, Mrs. Poggit, lives in a retirement home in "Amy's Choice." Her body is taken over by an Eknodine, so she walks to a playground and murders all the children. She also invades Amy and Rory's house wielding an axe. Even their quiet village becomes a place of savagery, down to the once-benevolent elderly.

With a similar creepiness, *The Faceless Ones* has many female characters besides the companion Polly: Samantha Briggs, Jean Rock, Nurse Pinto, and Ann Davidson. Pinto, like the beaming Ann, is a chameleon creature in disguise—when the Second Doctor exposes her, she attempts murder. Combatting these sweet-faced young women, Samantha Briggs teams up with the Doctor to find her brother and other suspiciously vanished people. Jean, the Commandant's secretary at Gatwick Airport, mostly answers phones, though she gains a little independence as she feigns illness to distract the nurse.

Terror of the Zygons similarly shows its nurse Sister Lamont taken over. All these characters add to the horror of having smiling women in traditional service roles controlled by alien monsters and murdering their charges.

On the doomed expedition of "The Waters of Mars," another damsel, Maggie Cain, is quickly infected and put in quarantine. Tragically, her teammates can watch their friend deteriorate, as water pours from her mouth and she creepily comments, "Earth is so much water.... We should like that world." Maggie destroys the base, emphasizing that she's more monster than teammate now. After this, Senior Technician Steffi Ehrlich sobs and shrieks, trapped by the water. Sadly, she watches videos of her little daughter, bidding her farewell as she succumbs to the same affliction.

Still, these aren't all stories of losing autonomy. *The Greatest Show in the Galaxy* introduces Mags the werewolf with punk hair and leopard skirt. Calling her an "unusual specimen," the captain in his safari gear (suggesting a tamer of wild animals of course) fells her with moonlight. He adds, "She can't control herself, of course, and like all her kind she'll destroy whatever comes in her path. Which, I'm afraid, in this case has to be you." On the spot, she turns into a fanged, snarling beast, tongue protruding and eyes glazed over, emphasizing women's monstrousness. Of course, she turns on the Captain and destroys him. Nonetheless, she is presented as benevolent, an abused heroine of the tale. Meanwhile, the hypnotized audience watching her are in reality the gods of Ragnarok, powerful creatures with an insatiable craving for entertainment. Giving the daughter and mother deep voices and vacant stares emphasizes their alien nature as well as their inhuman priorities—they are cast as antifeminine, drawn as they are to bloodsports. Though they appear motionless, they're controlling the story's action.

Ace befriends Phyllis and Jean in *The Curse of Fenric,* giving her a nice moment to bond with other teens. Their guardian, the sharp-faced Miss Hardaker, warns them not to visit Maidens Point: "When you stand on those cliffs, you can hear the terrible lost cries of girls who went to that place with evil in their hearts. Girls who are damned forever." The girls swim there anyway and are turned into Haemovores. Now long-haired seductresses with scary monster fingernails, they beguile a man into the water and kill him. They then murder their guardian. The young women, with rebellious impulses but no power, discover a path to strength and take it, striking out against those who have held them back. With this, they've become a force of power and can fulfil their own agendas, not an alien's.

The creepy landlord of "Knock Knock" has been preserving his terminally ill daughter Eliza in the walls, using space termites. He lures young people into the house, where the walls absorb them to feed her. However, Eliza comes to realize all she's forgotten: the landlord is actually her son, preserving her unnaturally and making her a predatory monster. By casting himself as

her father, he has introduced a domineering dynamic, one she soon outgrows. She tells him, "I did what you told me because I thought you knew best" and the Doctor emphasizes that she needs to take charge, rather than the child who never grew up. A wise and moral woman, Eliza destroys them both. She understands the power of the lifecycle, letting things end instead of preying on innocents like a monster would do. Her sacrifice frees the teens she's devoured and collapses the house that had become their prison.

Rose Tyler, the genuine loving, living human, contrasts herself with Cassandra, who brags she's the last pure human in existence. On seeing this piece of stretched skin (a satire on cosmetic surgery), Rose tells her, "You're not human. You've had it all nipped and tucked and flattened till there's nothing left. Anything human got chucked in the bin. You're just skin, Cassandra. Lipstick and skin" ("The End of the World"). Cassandra, who prides herself on blood purity, is no alien's victim but has remade herself into an unnatural creature. On discovering her machinations have killed people, the Ninth Doctor confronts her, only to see her exert her massive callousness and privilege: "It depends on your definition of people, and that's enough of a technicality to keep your lawyers dizzy for centuries. Take me to court, then, Doctor, and watch me smile and cry and flutter," she smirks. Instead, he calmly lets her die from lack of moisturizing spray.

In her second appearance, in "New Earth," she's created a clone slave named Chip who "worships" her. Wanting still more, Cassandra gleefully takes over Rose's body. However, as the Doctor frees a group of clones, creating a new form of humanity and celebrating their freedom from victimization, Cassandra realizes she's the last gasp of a dead world: "There's no place for Chip and me anymore. You're right, Doctor. It's time to die, and that's good." The Doctor lets her bid her past self goodbye, and then she finally lets go. Fighting the lifecycle through cosmetic surgery and preying on others is the act of a monster, the show insists.

Meanwhile Cassandra comments, "The Sisterhood is up to something. Remember that Old Earth saying, never trust a Nun? Never trust a Nurse. And never trust a cat" ("New Earth"). Matron Casp and the Sisters of Plentitude are villainous cat-women, with their alien faces reflecting their lack of human morality. Though as nurses, viewers expect them to help their patients, they create and infect thousands of suffering human clones. The Doctor ensures the sisters are arrested for their cruelty. By "Gridlock," more reformed cat-women appear, suggesting they've learned their lesson.

Silurian twin sisters Alaya and Restac find themselves in a standoff with mankind when they awaken from hibernation. They too display alien morality, as Alaya rejects an offer of truce. She snarls, "You beg and offer betrayal so early. Why would I want to escape when I can watch you die?" ("Cold Blood"). Restac does not show much concern for her missing sister, until she

finds Alaya has been killed. Angry mother Ambrose Northover has struck her with a Taser, in a moment the audience understands but can't condone. Her father Tony is furious, insisting, "We have to be better than this!" The Doctor echoes him with "there was a chance but you were *so much less* than the best of humanity." Thus the humans parallel the monsters in savagery.

Blon Fel-Fotch Pasameer-Day Slitheen (Annette Badland) appears a proper lady, stockier than typical for television. In fact, she's an alien who's wearing the human skin as a suit. The fact that she needed a larger woman to hide inside, combined with the gassy noises her skin suit makes, provides ongoing low humor. She functions as a repeat Ninth Doctor villain and is a perfect example of the female monster—a killer of the innocent, especially young women. Her upbringing is responsible—she reveals in "Boom Town" that when she was thirteen, her gangster family forced her to kill, otherwise her father would have executed her with Venom grubs. Blon aids in her family's plan to destroy Earth for the mineral profits in "Aliens of London," then transports out, abandoning them. She then becomes Mayor of Cardiff and schemes to destroy it too. When the Doctor captures her, she harnesses her feminine wiles to charm him. However, she isn't seductive but challenging: "I wonder if you could do it? To sit with a creature you're about to kill and take supper. How strong is your stomach?" ("Boom Town"). At the restaurant, she relies on her harmless appearance to beguile him: She poisons his drink and he switches them. Then she leans in and sweetly asks, "Did you know, for example, in extreme cases, when her life is in danger, a female Raxacoricofallapatorian can manufacture a poison dart within her own finger." She points. The dart flies and the Doctor catches it. She starts to breathe poison onto him and the Doctor uses a breath freshener on her. As their standoff continues, he remains resolute. It seems her feminine wiles will get her nothing against the ultimate patriarch. However, the Heart of the Tardis, the benevolent feminine presence, transforms her into an egg, giving her a second chance. The monster is reborn as a young heroine, and the lifecycle can continue.

"Hide" introduces a ghost called "The Wraith of the Lady, the Maiden in the Dark, the Witch of the Well." As Eleven and Clara investigate, they reveal a courageous woman underneath the rumored monster: The ghost is actually one of the first time travelers of the 22nd century, Hila Tacorien, trapped in a pocket universe. Her ancestor, Emma Grayling, finally provides a lifeline, dispelling humans' superstitious fear of her ("Hide"). The story thus emphasizes that boogeymen are sometimes just human projections, demonizing innocents.

In "Human Nature"/"The Family of Blood," the eponymous family plot to devour the Doctor's lives. "Father," "mother," "son," and "daughter," with no other names, are archetypal, though also alien monsters. Even the sweet

little girl holding a red balloon is a homicidal beast. After they murder students and start a small war in the sleepy village, the Tenth Doctor reclaims his powers and decides their punishments. The parents are imprisoned forever, the son trapped as a scarecrow guarding England's fields forever. His tiny sister is treated only a bit more kindly: "He still visits my little sister once a year every year. I wonder if one day he might forgive her, but there she is. Can you see? He trapped her inside a mirror, every mirror. If ever you look at your reflection and see something move behind you, just for a second, that's her. That's always her." There's a hint that the Doctor's waiting for her to rehabilitate, since she's younger and more sympathetic, though he doesn't aid in her education.

The Carrionites of "The Shakespeare Code" represent some of the most stereotypically offensive views of women in the new show. Lilith and her mothers, Mother Doomfinger and Mother Bloodtide, escape to Earth in 1598. The trio try to bring their race to earth, but Ten and Martha stop them, working with Shakespeare who then writes *Macbeth* with its own one-sided monster-witches. Their use instead of fairies emphasizes the stereotype of female power, but also its negative image.

Lilith is young and lovely enough to attempt seducing the Doctor, as she smirks, "Men to Carrionites are nothing but puppets"—the fear of misogynists everywhere. After the Doctor quips of her seduction, "Now, that's one form of magic that's definitely not going to work on me," she finds another victim. When she kisses him, her face changes to one with a hooked nose, deep lines, and pointed teeth, and her voice turns higher. Then she and her mothers devour him. As the evil, ugly witch, she follows problematic fairytale stereotypes.

> While many feel no offense should be taken with Roberts' depiction of Witches, it must be noted that those who do take offense—namely Pagans, Witches, and feminists—have a right to be heard. Witches are one of the last groups it's socially acceptable to persecute and stereotype. Roberts' depiction of Witches is currently part of the "accepted" world view, but is no less offensive than Shylock is to Jews, Uncle Remus is to African-Americans, Tonto is to Native Americans, or Sacha Baron Cohen's Bruno is to Gay men. As a writer, Roberts' should have pushed the boundaries of stereotype a bit more instead of presenting yet another tired view of Witches—and of women [Burke 178].

Beyond the issue of offending modern Pagans, their story presents shallow, evil women with no other side to their personalities—two murderous hags and one seductress who's just as much of a hag underneath.

TOUGH GIRLS

Galactic Orphan: Ace and Lady Me

"I don't believe you've met my young friend Ace, an expert in calorification, incineration, carbonization, and inflammation," the Doctor smiles in *The Happiness Patrol*. Ace, companion from 1987 to the show's cancelation in 1989, is the tough anti-hero companion, as popularized at the time by *Blake 7* and the *Batman* franchise (Britton 122). "I was doing this brill experiment to extract nitroglycerine from gelignite, but I think something must have gone wrong. This time storm blows up from nowhere and whisks me up here," Ace explains in *Dragonfire*, demonstrating why her real name is "Dorothy"—she was carried off by a tornado. Of course, she's a punk rebel. Her actress, Sophie Aldred, notes, "The great thing about Ace is that she's totally blunt.... She's also flawed but people always love a flawed character. And she's vulnerable in her own way as well" (72).

The human teen has already been swept across the galaxy on an alien adventure, so she's far from the wide-eyed damsel stepping into the learned Doctor's time travel machine. Angry and broken, she doesn't hesitate to get in fights … or start them. In her bomber jacket and ponytail, her greatest weapon is her explosives. "Do you feel like arguing with a can of deodorant that registers 9 on the Richter Scale?" she asks provocatively (*Dragonfire*).

Carol Pearson contrasts two types of young heroes, the Innocent and the Orphan. While the Innocent believes people are essentially kind, and tries harder to be perfect and lovable, the Orphan operates from a more traumatized and cynical place. "At some point, Orphans give up on failed authorities and take control of their own lives, and when they do, they become Rebels" (85). "The Orphan as Rebel works for justice and claims solidarity with all other oppressed, wounded, or suffering people" (Pearson 85). With no parents to protect her, Ace makes her own morality.

Orphans are skeptical outsiders who hang back from trusting adults, instead constructing an inner reality based on personal judgment. With this perspective, Ace represents "a deliberate shift away from the unreflective patriarchy" (Britton 118) as the Seventh Doctor became a manipulative "bad father" rather than the all-wise adult. In fact, he begins distributing knowledge in hoarded piece, deliberately keeping important facts back to manipulate Ace in *Ghostlight* and *The Curse of Fenric*. In the latter, he feigns contempt to motivate Ace. "The Seventh Doctor's dissolution of Ace's faith may appear necessary within the context of the scene but is nonetheless remarkably cruel in its execution" (Jones 56). After denouncing her as a "social misfit" and "emotional cripple," he tells her he wouldn't waste his time on her unless he meant to use her somehow, suggesting that in all their travels she has simply been a pawn. "Such remarks naturally render Ace a sobbing wreck" (Jones 56). To the Orphan, trust always leads to betrayal.

Ace is celebrated among the companions, with a backstory equal to the ones in New Who. "The underrated final season became Ace's story, as travels through her own history saw her come to terms with her troubled upbringing and emerge a confident woman" (Martin). She has a romance (*Remembrance of the Daleks*), a childhood (*Ghost Light*), and a dark side (*Survival*). In *The Curse of Fenric,* she confronts her hatred for her mother and dives into the water of Maiden's Point to cathartically cleanse herself of it. Aldred notes that she had thought, "Wow, this is really exciting because Ace is being made to confront some demons here, and she's learning a lot, and she's growing a lot" (69).

In *The Curse of Fenric* she speaks up for the upcoming girl power movement, quipping, "If you want a job done properly, get a girl to do it. Out of the way, boys!" Aldred adds that she received many letters from girls "who were so relieved to see a realistic, strong female character on British TV" (71). She describes her character as "blunt, honest, says exactly what she thinks, and doesn't edit what she's saying." She's also "flawed" "vulnerable" and "troubled" (72).

Ace comes as close to a "real" teen as the series had ever had at that point—her bedroom is strewn with dirty laundry that reflects contemporary fashion choices. She lies about her age, bemoans that her previous school didn't understand that blowing up the art room was an act of creativity, runs about blowing ice dams up with great glee while shouting "Ace!" at their destruction, and insists upon being included in the Doctor's plans—rankling particularly when women are excluded for some reason [Thomas].

The Orphan is a force of self-reliance, for herself and for others. Ace is an extraordinarily athletic and capable companion, as she fires missile launchers at Daleks and beats them up with her baseball bat. She somersaults, tumbles, and kicks. Unlike Leela, Ace insists on dressing as a Victorian man, not

a lady on a trip to the past. She stands up for herself and her desires as more
than the Doctor's pupil. Like Sarah Jane, she's genuinely friends with the Doc-
tor—this means arguing and learning to trust him through difficult times,
not just playing the sounding board. When the Doctor insists Ace answer his
queries (as a teaching style), Ace resists this, saying "I'm asking the questions!"
(*Ghost Light*). She and the Doctor also maintain a delightful understanding:

> DOCTOR: I don't suppose you've completely ignored my instructions and secretly
> prepared any Nitro-9, have you?
> ACE: What if I had?
> DOCTOR: And naturally, you wouldn't do anything so insanely dangerous as to
> carry it around with you, would you?
> ACE: Of course not. I'm a good girl and do what I'm told.
> DOCTOR: Excellent. Blow up that vehicle.

"In Ace's case, a near-pathological restlessness and a propensity for vio-
lence make her a logical long-term companion for the Doctor in ways that
few earlier characters were" (Britton 119). In the novels, Ace continues with
Seven for years and gets to be even more outrageous. Author Lance Parkin
notes in amusement that the novels put in all the hanky-panky the show left
out: "I think, in the course of sixty books, that we managed to deflower every
regular character from the TV series. Apart from K9—and I once proposed
a book where K9 got a robot dog girlfriend. Ironic for a company called Vir-
gin, I know" (Parkin, *The Dying Days*). Eventually, Dorothy McShane (for-
merly known as Ace) arrives for Bernice Summerfield's wedding, riding a
motorcycle rigged to travel through time, and apparently seduces the groom
(Cornell, *Happy Endings*).

Pearson notes that Orphans may wander the world forever, or may turn
savage and become rebels (84). Returning in *Deceit*, Ace is much tougher,
several years older, and more cynical after fighting the Daleks in numerous
battles. Ace has become "Time's Vigilante," righting temporal wrongs with a
vengeance that the Doctor cannot match. In the audio drama *Death Comes
to Time*, Ace reaches a special destiny. The mysterious Casmus trains her
with tests of mind and body, from the Cavern of Infinite Death to the task
of healing a damaged world. At last, she is given her own Tardis and elevated
to the status of Time Lord in an empowering conclusion.

A few other characters share Ace's strength and independence. Natasha,
the daughter in *Revelation of the Daleks* who's willing to risk death to find
her father, is a model of strength and fidelity. On discovering his empty sus-
pended animation chamber, she learns to her horror that he's been trans-
formed into the pulsating flesh of a Dalek. After he tells them about Davros's
scheme to remake the population, he asks his daughter to kill him. Summon-
ing a great deal of inner strength, she does.

In New Who, Nancy is a teen in the London Blitz. She not only takes

care of herself, but has become a guardian to street children. She finally tells the Ninth Doctor her secret—she's an unwed mother whose son Jamie has become a monster. Blending science fiction and catharsis, the Doctor tells Nancy she can save Jamie and all those afflicted in the city by telling the truth and letting the nanobots repair Jamie from her biological template. Thus she saves everyone by embracing her child in a heartfelt moment.

Kar, the young Scottish Keeper of the Gate, is introduced sacrificing to the gods and asking them to protect her family, all killed. However, when Bill surprises her, she chases Bill with weapons bristling as the other girl runs for it. Clearly, Kar is no damsel. Nonetheless, Twelve snarks, "She's not a warrior. She's an embryo. What did you do, throw your action figures at them?" ("The Eaters of Light"). As it turns out, each generation a hero must enter the gate and battle the alien monster there. However, Kar let the beast out, hoping it would slaughter the invading Romans. It did, but turned more deadly as a result. Alone, she falls into despair over her guilt, and the Doctor must push her to act rather than mourn. He compares her, the young leader of her people, with the surviving Romans, underage as well, and tells them all, "Okay, kids, pay attention. She slaughtered your legion. You slaughtered everything that she loves. Now, you all have a choice. You can carry on slaughtering each other till no one is left standing, or you grow the hell up!" Though the Doctor in his role as Earth's protector, tries to make himself the new guardian, Kar and the Romans insist they will sacrifice themselves and share the burden. Thus it becomes a story of accepting duty and becoming adults. For all of eternity, the crows chant her name in a touching memorial.

Ashildr, a young Viking, impresses the Twelfth Doctor with her independence. As often happens, she sacrifices herself and dies bravely ("The Girl Who Died"). Moved by pity, the Doctor plays God. He gives Ashildr alien technology, reviving her but making her immortal. His final gift is a second token, in case she finds someone with whom to share eternity. With this, he leaves without a word of advice.

Catherine Tregenna—who had penned four *Torchwood* scripts—returned to write the emotional sequel, "The Woman Who Lived." Twelve meets Ashildr centuries later—a scarred and callous heroine. As she relates, the human mind cannot bear immortality and more to the point cannot remember all—only her diaries contain the knowledge of what has befallen her. She has renamed herself simply "Me"—a clear analysis of her relationship with the rest of the world—they pass on and only she is left. She has never used the second token, and her life has been filled with loss—of her children so many times she will never have more, of her lovers until she resolves to remain alone.

Devastated from what the Doctor has made her, she begs to travel with him, to have a better existence than being the one immortal person on earth.

"I look up to the sky and wonder what it's like out there. Please, take me with you. All these people here, they're like smoke, they blow away in a moment. You don't know what it's like." The Doctor rather heartlessly refuses her, insisting he needs short-lived, compassionate humans instead. However, he bears responsibility for creating and abandoning the tortured young woman. As he mentions that he meant to warn her about the Black Death but didn't, he's condemned her to a painfully slow path. She in turn is basically wrung dry of feelings. "You'll have to remind me, what's sorrow like? It all just runs out, Doctor. I'm just what's left" ("The Woman Who Lived"). While he protests how de-sensitized she's become, she retorts that he's clearly most frightened that he's caused this. She refuses to be his pawn any longer. As she adds, "So you intend to fix me? Make me feel again, then run away? I don't need your help, Doctor, you need mine. Just this once, you can't run off like you usually do" ("The Woman Who Lived").

With this, she reveals she's been spying on him through the centuries, tied irrevocably to her creator even as, like River or Amy, she waits endlessly for him to return to her. Nonetheless, cool, calculating Ashildr appears quite philosophical about her isolation. She lives in a massive house and plays highway robber for fun. Her outfit is rather boyish, though she wears a gown as she desires.

She makes a deal with an alien to take her off earth, and is willing to sacrifice her devoted servant to make it happen. At episode end, however, she realizes she does care and saves the man she's condemned to death with the spare amulet she's kept all this time. However, she decides, "Someone has to look out for the people you abandon. Who better than me? I'll be the patron saint of the Doctor's leftovers. While you're busy protecting this world, I'll get busy protecting it from you." She thus becomes a savior of people like herself, guardian of a community the Doctor too often forgets. Freed from the responsibility, he only notes that he appreciates it.

She returns as the Mayor of a hidden street in "Face the Raven." Since the creation of Waterloo Station, she's been living invisibly in the city, protecting aliens there from the Doctor and from humanity. They're outsiders as she is, and she only requires they keep the peace and stay hidden. Over time, she's become another Doctor, though flipped along traditional gender lines—she doesn't travel the universe but hides people in a protective refuge. Devoted to her community, she willingly betrays the Doctor to protect it, creating a mystery to entrap him. However, Clara has endangered herself by taking the fatal chronolock from her friend Rigsy to put on herself. Now Mayor Me is helpless to call off the raven, an automated executioner. Apologetically, she can only watch Clara die. The Doctor departs, but warns, "I'll do my best, but I strongly advise you to keep out of my way. You'll find that it's a very small universe when I'm angry with you."

"Hell Bound" leaves her apparently the last person in the universe, sitting and watching the stars go out. At last she is "Me" indeed—completely solitary. As she adds that watching the universe die was beautiful as well as sad, she suddenly harnesses her metaphor to play conscience and tell him that Clara's death was beautiful too, and that the Doctor has no right to take her agency. Throughout her arc, she operates as the Doctor's greatest critic, pointing out all the damage he causes. Like the fabled Wife of Bath, she favors sovereignty above all, reminding the Doctor that he can't, and shouldn't, unmake Clara's choices.

Here at the end of time, the universe has abandoned Me to fend for herself, leaving her a survivor though not a cheerful one. However, after she advises the Doctor and they part ways, she finds herself a new story. She remains on Clara's newly-stolen Tardis, exploring the galaxy. Having taken on the Doctor's companion, she mirrors him—she has grown to understand the price of immortality and the preciousness of humanity as much as he does.

Brash Equal: Donna Noble

Unusually, companion Donna Noble (Catherine Tate) isn't a slender teen in a miniskirt. She's forty, less conventionally beautiful, almost stocky. "Her sexuality, coupled with her adornment, reflect her stage in life—mature well beyond maidenhood. Donna's clothes are adult, exhibiting more color— shades of purple, blue, and deep red with splashes of pink, black, or grey. Her adornments are earthy, spiritual, royal tones" (Burke 170). Nonetheless, jokes keep appearing about her lack of attractiveness: After watching the Doctor's daughter kiss a guard to distract him, Donna says, "Let me distract this one. I have picked up a few womanly wiles over the years."

"Let's save your wiles for later. In case of emergency," the Doctor retorts ("The Doctor's Daughter"). He and Donna have an ongoing joke about how they're *not* a couple, not one bit. "You're not mating with me, sunshine.... I'm not having any of that nonsense. I mean, you're just a long streak of nothing. You know, alien nothing," she says when she agrees to travel with him in "Partners in Crime." This is her second appearance, after what appeared a one-off in "The Runaway Bride." In this episode, he invites her along and to his surprise she refuses. Pamela Achenbach explains in her essay, "Companions Who Weren't": "Neither the Doctor nor Donna was ready for the kind of relationship that would develop between them. The Doctor needed time to mourn the loss of Rose, and Donna needed to recover from the loss of her fiancé, who died on their wedding day. Donna refused the Doctor's offer to take her along because she knew the Doctor was not ready for her,

that he needed time." Instead, she resolves, "I'm not going to temp anymore. I don't know. Travel. See a bit more of planet Earth. Walk in the dust. Just go out there and do something." The Doctor bids her a friendly goodbye. When they meet a year later, however, she refuses to let him get away again, and announces she's coming along.

Davies remarks, "[Donna's] an equal to the Doctor, a friend, a mate, a challenge." (Davies and Cook 197). Lynnette Porter adds, in an essay on New Who companions, "She assumes the role of the Doctor's best friend or big sister—not quite an equal, but a confidante, a sibling playmate, a solid supporter but not always a fan" (255). Emphasizing their playfulness, she calls him "Dumbo" and "Space Man" among other nicknames. The Tenth Doctor and Donna squabble and bicker like adult siblings, though they also have fun together. "The Doctor and Donna are verbose to the point of euphoria and, save for Romana, no other Companion has ever matched his shrewdness. While some Classic Series companions can banter, it's often irresolute and subservient to his dexterity. Rose, River, and Martha are quick with rejoinders, but Donna outshines them all" (Burke 171).

Of course, being friends is its own kind of relationship, no less joyful for its platonic nature. "Friends force us to reconsider our politics, indeed to notice parts of the world that without them we would pass over" (Hunt 262). Indeed, Donna won't let the Doctor get away with anything—not with making her feel bad about sweatshops on earth or about his assumed Time Lord superiority. When he tells her he's in charge, adding, "Tardis, Time Lord, yeah," she retorts, "Donna, human, no. I don't need your permission" ("The Fires of Pompeii").

Thus she resists his notion of superiority as well as his moral dictates: "While the universe needs some kind of a savior, that savior needs to be questioned and challenged" (Deller 247). On their first time travel adventure, she insists, "Listen, I don't know what sort of kids you've been flying round with in outer space, but you're not telling me to shut up. That boy, how old is he, sixteen? And tomorrow he burns to death" ("The Fires of Pompeii"). She calls that his fault, for being there and not interfering. He has the power, therefore, he has the responsibility. At last, she persuades him to save a single family. After he does, the Doctor tells her, "You were right. Sometimes I need someone. Welcome aboard."

"Perhaps the most noble human of all—and given her surname, that's not surprising—is Donna. It's Donna who continually challenges the Doctor's ethics, who's not afraid to tell him he's wrong, and who reminds him and the rest of the universe that humans are just as special as Time Lords" (Deller 245). She takes a similar attitude in "Turn Left"—because she can save the world, she must. Despite Donna's own inner turmoil, Davies explains: "There's an indestructible core to her … she's always determinedly at a right-angle to events" (Davies and Cook 310).

Of all the Davies companions, Donna alone appears as a mother—married and with children. However, they are an illusion of the Library storage system, soon taken away. "Donna suffers the most. Series Four has her lose her life on three separate occasions, lose her husband and children, lose her reality, and lose herself as 'the most important woman in the whole-wide universe'" (Burke 175). For her path to growth, she takes on adult challenges and adult pain.

Of course, she achieves real transcendence in "Journey's End," when she merges with the Doctor and blends his expertise with her own attitude. Immediately she's calling the shots in a way few companions ever achieve, emphasizing that she's more capable than *two* Tenth Doctors as well as a ship of Daleks:

> DONNA: Holding cells deactivated. And seal the Vault. Well, don't just stand there, you skinny boys in suits. Get to work.
>
> …
>
> NEW DOCTOR: What did you do?
> DONNA: Trip switch circuit-breaker in the psychokinetic threshold manipulator.
> NEW DOCTOR: But that's brilliant!
> DONNA: Why did we never think of that?
> DONNA: Because you two were just Time Lords, you dumbos, lacking that little bit of human. That gut instinct that comes hand in hand with Planet Earth. I can think of ideas you two couldn't dream of in a million years. Ah, the universe has been waiting for me.

Afterwards, the information is too much for Donna's mind. Ten removes the memories, as she pleads, "The rest of my life, travelling in the Tardis. The Doctor Donna. No. Oh my god. I can't go back. Don't make me go back." As he erases their adventures, Donna loses agency, far more abandoned than even the companions the Doctor ditches without a goodbye.

In her last appearance, "The End of Time," Donna's mother and grandfather keep her ignorant of the Doctor's return. Her trances and helpful revelations cast her as a tool for the Doctor—especially since she's unaware of them. Her grandfather Wilf pleads for the Doctor to take Donna back, adding, "But don't you see? You know, you need her, Doctor. I mean, look. Wouldn't she make you laugh again? Good old Donna?" Still, the Doctor insists he can't even meet her or she may die. While Rose gets a fairytale ending with a Doctor-clone, and Martha gains strength and empowerment through UNIT, Donna reverts to her old life of "The Runaway Bride"—superficial phone conversations and conventional marriage. Wilf comments, "Yeah, he's sweet enough. He's a bit of a dreamer. Mind you, he's on minimum wage, she's earning tuppence, so all they can afford is a tiny little flat. And then sometimes I see this look on her face, like she's so sad, but she can't remember why." All the Doctor leaves her is a lottery ticket to make her mundane life more comfortable.

The audio adventures of the time reflected Davies' work on the restored television show. This included companion Lucie Miller (Sheridan Smith), a "brash northern lass" introduced in *Blood of the Daleks* (2006). "It's my super-power. I am Sarcasmo, woman of sarcasm. My enemies are struck down by my barbs of steel," she smirks. She pops abruptly onto the Tardis like Donna, and has other things in common with the redheaded temp:

> Both temps, working in dead-end admin jobs. Both mouthy, and quick-witted, and had a tendency to give the Doctor an earful when he was being pompous, or some-times just for standing there. Both were to grow and transcend their original image of themselves, to become absolutely epic characters.... Both of them displayed absolutely no physical attraction to the Doctor—which was a refreshing change from their immediate predecessors! Both were awesome [Roberts, "Lucie"].

Lucie soon reveals she's arrived as part of a Time Lord witness protection program, as she saw something important, but doesn't know what. As it turns out, she was the assistant to Professor Martez, who created a hybrid race of Daleks. Though neither Lucie nor the Eighth Doctor favors a partnership, they discover that even when the adventure has ended, the Time Lords won't let them part. In *Human Resources* (2007) a Time Lord explains that the Celestial Intervention Agency predicted that Lucie would become a dictator who would interfere with mankind's progress, so they pulled her out of time. As it turns out, this is a mistake, and once rectified, she and Eight can continue as chosen partners. She truly stands out for her attitude. Along with sarcasm and boldness, she's sweet and sympathetic, with a genuine enthusiasm for the wonders they encounter. At one point, the Doctor worries he's endangered Lucie, who, as he puts it, is "just a kid."

She in turn replies, "It's one thing after another with you, innit ... and me. What a pair we make, eh? Still, I'm glad I met ya," claiming her own agency beyond his protection (*Horror of Glam Rock*). Tansy Rayner Roberts remarks on the blog *Doctor Her*: "Her chemistry with Paul McGann is electric, you can hear how much the actors enjoy each other's company in the various Extras documentaries that are paired with the episodes, and she brought out something marvelous in his Doctor" ("Lucie"). They're clearly best friends.

As Roberts concludes, "Fierce, brave, strong, loyal, hilarious, implacable, utterly self-reliant, and capable of giving her best Time Lord a good slap around the chops when he deserves it, Lucie Bleedin' Miller deserves her place in the pantheon of Awesome *Doctor Who* Companions" ("Lucie"). Lucie Miller grows up considerably through her four seasons, and makes difficult life decisions. There's a major plot arc in which the Doctor discovers her beloved Aunt Pat is a Zygon and doesn't tell her—when the truth comes out, she feels terribly betrayed and even leaves for a time. Ironically, she answers an advertisement for a time travel companion and finds herself working for the Meddling Monk.

In the two-parter *Lucie Miller/To the Death*, Lucie falls victim to a Dalek plague and is left crippled and blind in one eye. Like Donna, she discovers the adventures can have real-life consequences. At last, she joins Susan and her son Alex in a rebellion, saving the universe. In an epic, unforgettable moment, she perishes, defiantly yelling, "And just in case you wanted to know who it was who blew you to pieces—the name is Lucie Miller. You got that? Lucie Bleedin' Miller!" Of course, this heroism leaves the Doctor despondent. Like Donna, she's truly noble, willingly sacrificing herself to preserve the universe. She's delightfully added to television canon in *Night of the Doctor*.

Feminist: Sarah Jane Smith

After klutzes and screamers, Sarah Jane Smith's arrival in season eleven offered a truly clever companion: a "female lead in the *Doctor Who* series that matches the wit and intelligence of the Doctor" (Winstead 230). However, when she joined to back up the Third Doctor, she didn't stand out. As her actress, Elisabeth Sladen notes in her autobiography, "I was perceived as the latest in a long line of ditzy girls employed to scream 'Doctor!' every five minutes" (99).

Barry Letts observed that he chose Sladen because only she could act frightened and brave at the same time. This allowed her to become a hero and inspire the feminists even while keeping the companion tradition ("Changing Time"). Dicks notes, "One of the perpetual criticisms we got about the female lead, the female heroines, *from* women was that they never did anything except stand around screaming and wait for the Doctor to come and rescue them … they very much wanted a heroine who was stronger" (Tulloch and Alvarado 183). Letts adds, "Speaking personally, I'm very much in favor of women's lib…. So when Sarah Jane Smith came into the program, we were very pleased that it fitted in … with the idea that we wanted a *Doctor Who* assistant who would strongly initiate things" (Tulloch and Alvarado 182).

Instead of traditional background on her character, her history and relationships, Sladen was only told, "We want Sarah to be very much her own person, someone of today, with her own job, always questioning everything" (Sladen 83). On her notes from her script copy, she described her character as "impulsive, ready for anything new, everything very obvious, righteous indignation" (Ginn 243).

She not only fought monsters but kept her job as a reporter for *The Metropolitan* (unlike almost every other companion, who must take some form of sabbatical to accompany the Doctor). Archetypally, the investigator solves crimes and puzzles—a respected profession that gets her public acclaim,

especially in a man's world. Sladen explains, "It was important that my character had a life—and subplots—of her own and wasn't just arm candy. It was imperative not to agree with the male characters out of habit. Decisions had to be questioned—even the Doctor's" (Sladen 165). As she adds, "I needed to shoehorn Sarah Jane into the action as quickly and firmly as possible—and that had to start with the boys of UNIT" (100). She found one way to do that—her lines. "I began to alter the odd word, then sentences, then whole exchanges. I'd never ask, I'd just do it" (110).

Paddy Russell, the first woman director of *Doctor Who,* covered *The Massacre of St Bartholomew's Eve. Invasion of the Dinosaurs, Pyramids of Mars* and *Horror of Fang Rock.* Two of these starred Sarah Jane Smith, and (judging from the *Pyramids of Mars* DVD featurettes) helped Sladen to move Sarah Jane's role in the show beyond "designated screamer and recipient of explanations." Russell gave some of the Doctor's explanatory dialogue to Sarah Jane, helping to shift the companion relationship. Since Russell was "trying to overcompensate for being a woman in a man's world" (Saden 111) she wanted her to fire a rifle in *Pyramids* to prove a woman could do it (Sladen 191).

Though Dicks adds that Sarah Jane "always tended to stand up for herself and go off and do things by herself" the story patterns remained conventional (Tulloch and Alvarado 183). She often required rescuing, and asked constant questions. "Nevertheless, the 'companion questions' raised by Sarah Jane were often inflected by feminist concerns and were not always adequately answered by the Doctor ... a space was made for feminism through this characterization" (Cornea).

An unusually fun companion, Sarah Jane is the first since Barbara to be independent heroine first and stereotype second. Sarah begins the show disguised as her aunt, hard at work as an investigative reporter. As she infiltrates an enemy company, following her own mission rather than the Doctor's, she saves the day rather than screams for help. She rescues the Doctor, despite comments that she shouldn't because she's a girl.

In her first adventure, when she stows away and reaches the Middle Ages, she impresses the locals with her aggression. They make flattering comments like "She has the heart of a lion, sire" and "If I had an army of girls such as you, I might hold this castle forever" (*The Time Warrior*). Even the foreignness of her setting doesn't stop her: "Sarah Jane, having no idea of the times in which she is situated (rather surprising in a woman who is supposed to be an investigative reporter) is able to tell everyone what they should do and should think because she, the young, smart, white English woman says so" (Ginn 244). In the episode, she bosses around armed knights and joins them on a raid, dressed in men's clothes. She drugs the guards and saves the Doctor repeatedly. Finally, in the most blatant moment of feminism, her women's lib speech to the castle cook gleams with forcefulness:

SARAH: I'm not afraid of men. They don't own the world. Why should women always have to cook and carry for them?
MEG: What else should we do?
SARAH: Stand up for ourselves. Tell the men you're tired of working for them like slaves.
MEG: We are slaves.
SARAH: Then you should set yourselves free.... You're still living in the Middle Ages.

While other companions have jobs that correspond with the Doctor's (history expert, science expert) or are untutored teens who drink in his every word, Sarah Jane has a contrasting, even antagonistic profession to his: She insists he set aside his condescending, incomprehensible explanations and answer her directly since she's in the business of discovering the truth. In fact, she insists she has to ask all these questions because it's her job as journalist. When he calls a device his alarm clock in *The Time Warrior*, she retorts that he shouldn't be so patronizing.

As she directs conversations and rejects the Doctor's arrogance, she provides an excellent modern foil for the Doctor's old-fashioned attitudes. "Sarah Jane proved to be a new type of companion for the Third Doctor, one who, although impressed by his brilliance and joie de vivre, nevertheless insisted that he never condescend to her ... she refused to prepare coffee for him, to allow him to protect or coddle her, and to remain on the sidelines when the action commenced" (Ginn 243).

Unlike previous companions' short skirts, "Sarah Jane's costuming (i.e. trouser suits, knickerbockers, waistcoats etc.) indicated a more active and assertive role" (Cornea). With the Fourth Doctor's arrival, Sarah Jane moves from pantsuits to outlandish outfits to suggest the Doctor's influence. She wears a bright yellow rain outfit in *The Sontaran Experiment*. (She was expected to wear a skirt and jumper for shooting, but Sladen suggested the yellow outfit instead and the director agreed.) Thus, she comes across as individualized, not sexualized. She varies her outfits as the show continues—she wears a bathing suit when they expect a beach trip. She wears a bodice in *Planet of Evil* and candy-stripe overalls in *The Hand of Fear*. Sladen adds that after traveling so long with the Doctor "She's totally lost it as far as Earth clothes are concerned" (Sladen 223).

She also tries costumes on occasion: In *The Pyramids of Mars,* Sarah emphasizes the gothic tone with a white lacy gown the Doctor mentions belonged to Victoria (presumably he means the companion, not the queen). Nonetheless, she jumps out of windows and continues to be active while wearing it. While second-wave feminism of the sixties and seventies advocates dressing in more masculine attire, other dress revolutions from earlier and later times suggested the woman dressing however she wished, for comfort

and flexibility, instead of being confined in corsets or acres of petticoats. The Scientific Reform Society of *Robot* denies this right, insisting that Sarah not wear trousers, but instead, as Sarah quips, "I would wear what you thought was good for me. I see. And think what you thought was good for me, too?" As she dresses in androgynous suits, she chooses what makes her feel comfortable and empowered.

The third in their little troop (besides the Brigadier) was Harry Sullivan, rather a caveman of a soldier and surprisingly inept at it. "He quickly became a foil for Sarah, his bumbling stupidity highlighting her bravery and quick thinking. His function as comic relief also indicates on which side of the battle of the sexes the show places itself" (Welsh). He became the clichéd damsel on the adventures. In *Robot,* he's tied up in a closet while the Doctor is menaced by the automaton. In *The Sontaran Experiment,* they both fall into a ditch. "He is outsmarted by not only Sarah, but Hilda Winters and Vira. At one point, he nearly gets eaten by a giant clam—the symbolism speaks for itself" (Welsh).

New producer Philip Hinchcliffe soon steered the show toward a Hammer Horror style. As one might expect for such a gothic genre, many strong women vanished from the show. Bradford explains:

In *Planet of Evil,* the Tardis lands about 30,000 years in the future. A human science expedition has been on the planet for months, and a spaceship manned by humans arrives to check up on them. None of these humans is female. Sarah is the only woman that appears in this story. *Planet of Evil* teaches us that, in the far future, women won't serve on starships and they won't be scientists. Not even a little bit.

Further, all the men in the episode call Sarah "girl" or "the girl." Just after this, she's the only woman in *Pyramids of Mars* and the only one of significance in *The Android Invasion.* Only about thirty percent of Hinchcliffe's sixteen stories pass the Bechdel test (Simon).

At the time, Robert Holmes wrote 18 scripts and edited 21, over a period of five different Doctors. Working with Hinchcliffe, Holmes introduced powerful warrior Leela and delightful K9. He also wrote the first stories to feature Liz, Jo, Sarah Jane and Romana, as well as the Master, thus defining much of the Third and Fourth Doctor eras. Thirty-five percent of the stories he wrote (in this single-companion era, admittedly) pass the Bechdel test, while his script editing numbers come out a fraction worse (Simon). Thus he creates memorable protagonists, but spends little time teaming them up with other women (as was frequent in the First and Second Doctor eras).

Sarah began the buddy pairing of one Doctor and one female companion, rather than a larger group, after Harry stopped traveling with the Fourth Doctor. Their relationship also changed, as Sarah resented the Third Doctor's patriarchal attitude, while the Fourth Doctor, closer to her in age, called her his "best friend" in *Seeds of Doom.* Sarah, complete in herself, can approach

the Doctor from an equal place, unlike so many childlike companions. "A feminist approach to friendship prioritizes quality and not quantity of friends…. Above all, it begins with a friendly relationship with the self" (Hunt 260). The joking relationship was often played up:

DOCTOR: You humans have got such limited little minds. I don't know why I like you so much.
SARAH: Because you have such good taste.
DOCTOR: That's true, that's very true [*Masque of Mandragora*].

As the Doctor grew comfortable in their dynamic, he learned to exploit it and push Sarah's buttons: In *Ark in Space*, Sarah is trapped, and the Doctor begins castigating her, telling her to "stop whining" and adding, "Stupid, foolish girl. We should never have relied on you. I knew you'd let us down." When Sarah succeeds through his reverse psychology, the Doctor confesses he was only "encouraging" her and adds, "You've done marvelously, Sarah. I'm very proud of you."

Season Twelve begins with the Doctor regenerating. Unencumbered, Sarah investigates Think Tank for her own reporting career, not just to stand in for the Doctor. Meanwhile, the Brigadier breaks the Official Secrets Act to confide in Sarah as a Doctor-surrogate because without the Doctor, "there's no one else I can tell." Sarah, a planner, leads a slave rebellion in *Genesis of the Daleks*. She saves the Doctor repeatedly in *Seeds of Doom*. "She was as much of a swashbuckler as any man," Sladen notes (84).

Currents like this ran through Sarah's adventures. For instance, *The Monster of Peladon* ended up being a women's liberation story: The Doctor and Sarah arrive to find Queen Thalira struggling with pushy male counselors and a mystery beast. The Ice Warriors impose martial law on the capital, imprisoning the Queen until she can find a compromise. Finally, the Doctor advises Sarah to make a speech, urging the queen to claim her rights:

SARAH: Women's liberation, your Majesty. On Earth it means well, very briefly, it means that we women don't let men push us around.
THALIRA: It's not like that on Peladon. The ruler is always a man. I was only crowned because my father had no son. It's Ortron who holds the real power.
SARAH: Well, only if you let him. You've just got to stand up for yourself.
THALIRA: It would be different if I was a man. But I'm only a girl.
SARAH: Now just a minute. There's nothing only about being a girl, your Majesty. Never mind why they made you a Queen, the fact is you are the Queen, so just you jolly well let them know it.

However, this became a story of "the conventionally heroic Doctor and his frightened assistant who has to be rescued by monsters" (Tulloch and Alvarado 183) while the producers introduced a modern agenda beneath the crowd-pleasing elements. This feminism subplot is also a little silly, since Sarah Jane and the privileged queen are basically the only females in the

entire episode. Sladen recalls that the "irony of the male writers getting a male character to 'order' a woman to talk about feminism wasn't lost on me" (83).

After accompanying two Doctors from 1973–1976, she finally leaves. The Doctor is summoned home to Gallifrey and knows he can't bring her. Though she protests, he reluctantly takes her home (or so he thinks—he's off by quite a few miles). Sladen and Baker famously wrote their own goodbye, each asking "Don't forget me." Sladen notes, "I was content that Sarah wasn't being married or killed off—the same thing, some might think" (223). Thanks to her popularity, she did return—not once but several times before finally gaining her own spin-off.

After palling with the Third Doctor in the anniversary special *The Five Doctors*, "A Girl's Best Friend" aired in 1981 as the pilot of *K9 and Company*. Sladen notes, "I had to agree that it sounded like a fabulous idea: Sarah Jane striding out into the world, pursuing her journalistic instincts to solve crimes—with her trusty robot dog at her side" (257). The show combined two beloved heroes who emphasized their skill without the Doctor.

In the episode, Sarah Jane visits her Aunt Lavinia, only to find her on tour. Sarah picks up Lavinia's ward, Brendan Richards, and they discover the Doctor has sent them a large crate containing K9. While Brendan plays with the robot dog, Sarah investigates. Flipping gender roles, she establishes she can lead as action hero with a younger male sidekick. In fact, she finally rescues Brendan when Lavinia's gardener and his son treacherously try to sacrifice him. "*K9 and Company* should have been my first leading television role and on paper it had all the potential to be a *Sarah Jane Adventures* for the eighties," Sladen notes sadly (244). However, when new staff took over at BBC1, they rejected it. Despite this setback, the pilot episode blended Sarah's skills with defense of a surrogate child—roles she would resume decades later

Hero Mom: The Sarah Jane Adventures

Sarah Jane wobbles in the 2006 New Who episode "School Reunion"—after adventuring with the Doctor, her life clearly has halted for forty years—she didn't date, marry, or make many friends, as is apparent by her empty house. She has waited, mourning being left behind. She even has the same investigative journalism job she had in the seventies. As she tells the Doctor:

> SARAH: You were my life. You know what the most difficult thing was? Coping with what happens next, or with what doesn't happen next. You took me to the furthest reaches of the galaxy, you showed me supernovas, intergalactic battles,

and then you just dropped me back on Earth. How could anything compare to that?

DOCTOR: All those things you saw, do you want me to apologize for that?

SARAH: No, but we get a taste of that splendor and then we have to go back.

By the end of the episode, she learns to drop her holding pattern. As she notes, "The universe has to move forward. Pain and loss, they define us as much as happiness or love. Whether it's a world, or a relationship, everything has its time. And everything ends."

This encounter launches a new show, *The Sarah Jane Adventures* (2007–2011). Russell T. Davies offered her the program, adding, "Everyone in Cardiff loved you in 'School Reunion'... The world needs more of Sarah Jane" (315). It made an instant splash—one reviewer notes, "SJA is very clearly the most woman-friendly show in the Whoniverse (and indeed, one of the most woman-friendly shows out there)" (Beppie).

On the show, Sarah Jane stars with an extensive backstory: She was brought up by her Aunt Lavinia, "the family genius." As Sarah Jane explains, "She did the best she could, but she was always so busy. Never in one place long enough to lick a stamp." As she adds, unveiling the central mystery of her life, Aunt Lavinia seems to be covering for her parents, who "just upped and left their baby alone. Left me behind" (*The Temptation of Sarah Jane Smith*). She faces moral quandaries usually left to the Doctor as the Trickster tempts her with her parents and her fiancé, but she must allow them all to die to preserve the timeline.

Her sonic lipstick is a matter of debate among feminists: some find it stereotypically feminine, while others applaud it as subversive, reclaiming it as an object of power. "After decades of watching the Doctor get himself out of any writer's cul-de-sac with his handy sonic screwdriver, now Sarah could do the same," Sladen explains (318). Throughout the show, she generally owns her third-wave feminism, wearing a pink dress and watching over a teenage son.

In the first episode, Luke the alien clone springs to life, brilliant but naïve. He soon ropes the neighborhood kids into joining the team, and Sarah Jane becomes surrogate mother for them all. In fact, she's the first "action mom" ever seen in the Whoniverse (aside from Jackie Tyler's rather laughable moments).

While Captain Jack Harkness gets *Torchwood,* the masculine, edgy "adult" show, Sarah Jane babysits children on a chaste, feminized show for young viewers. Nonetheless, she has a strong, commanding presence. The show celebrates girl power with Luke's friends Maria and Rani. "Every episode passes the Bechdel test easily, and it's not just the two 'lead' female characters who talk to each other—they also have conversations with mothers, scientists, antagonists, and other women and girls who exist outside the small circle of main characters" (Beppie).

Many children's shows focus on kids as the action heroes. They have an eccentric magical grownup who is coded as outsider like them, but the kids are definitely the stars. This is Harry Potter with Dumbledore or Hagrid, Buffy the Vampire Slayer with Giles. This time, however, Sarah Jane fights alongside the children. Despite her age, she's firmly in the middle of everything. While she's the "adult," she makes mistakes, as a schemer sweeps her off her feet in her wedding episode, and she greedily accepts a dangerous gift from the Blathereen. In short, like the Doctor, she can fail and learn. Her greatest enemy is Mrs. Wormwood, evil architect of her adoptive child:

> Mrs. Wormwood and the Bane (meaning harmful) create Luke, but they are constructed as the evil side of motherhood. The Bane mother eats the children that can't successfully commit murder and sends others out to do her vile tasks. By episode end, they attempt to control or liquefy all the human race. Sarah Jane battles for the innocent child Luke, her new neighbor Maria, and the humans of earth [Frankel, *Doctor Who and the Hero's Journey*].

Fighting her helps Sarah Jane discover who she wants to be, insisting, "She thinks kidnapping Luke will stop me going after her. If Mrs. Wormwood thinks that, she really doesn't understand motherhood" (*Enemy of the Bane*). Of course, Sarah Jane saves the world and rescues her son, establishing herself as triumphant protector once again. As she proclaims, "Do you hear that, Mrs. Wormwood? Luke is my son because I have cared for him and looked after him. Because I love him. And you don't understand love. People who understand love don't want to crush planets or take over the universe. Those people aren't people at all. They truly are monsters" (*Enemy of the Bane*).

When Luke is poisoned by alien spores, she likewise pushes her action mom approach to its limit. When asked who will be left to protect earth if the aliens kill her, Sarah can only respond, "This time it's about Luke" (*The Gift*). She teleports in, wielding a big gun, and tells the Blathereen, "This is loaded with vinegar. You're going to do exactly as I say, or I'll blast you to oblivion." Escaping her bonds with the sonic lipstick, she teleports out and finally executes the alien criminals.

The Sarah Jane Adventures was nominated for several children's television awards, and won a Royal Television Society 2010 award for Best Children's Drama. The show, already gender-balanced in its heroism, tackles many related issues. The third story, *Eye of the Gorgon,* sensitively explores Alzheimer's and the way older women are marginalized and silenced, while the fourth story, *Warriors of Kudlak,* examines how people construct masculinity in terms of violence and warfare.

While quite popular, the show unfortunately ended with the actress's sudden death. Russell T. Davies, creator of *The Sarah Jane Adventures* said: "I absolutely loved Lis. She was funny and cheeky and clever and just simply wonderful. The universe was lucky to have Sarah Jane Smith; the world was

lucky to have Lis" (McLaughlin). Ideally, the show has broken barriers and proven how popular a sixty-year-old action heroine can be.

A few other stories feature the Hero Mom. Kathleen Dudman in *The Curse of Fenric* is a rare mom with a baby on the show. While a tough radio operator for the British army, she's dealing with 1940s problems, as her boss tells her, "I gave you clear instructions the baby was not to remain in camp." Ace helps her out and finds her a refuge, but Kathleen makes it clear she can care for herself while doing her part in wartime. They drive off to London, delightfully to become Ace's ancestors.

Delta and the Bannermen begins with Queen Delta, last of the Chimerons, bravely shooting aliens to save her friend. Clearly, she's presented as a tough freedom fighter. Fleeing to earth, she finds herself on a nostalgia bus tour with Mel and Seven. Even while Mel suspects her new roommate is in danger, the two have a Bechdel-friendly moment of connection:

DELTA: Thank you.
MEL: What for?
DELTA: For lending me your dress. For making an effort to be kind.
MEL: Oh, I'd help anyone in trouble, if I could.
DELTA: Mel, there's something you should know…

At once, her alien egg starts to hatch. A green face emerges and Delta cradles her rapidly-growing baby girl. Meanwhile, Billy, the mechanic and singer, falls for her. As they have a romantic picnic, her baby makes a beautiful chiming sound—as Delta says, "It's partly a song, and partly a defense mechanism." In fact, as Delta protects the baby, the child grows rapidly and saves them all, emitting a high-pitched scream that blows out windows and damages the attacking Bannermen. Thus, motherhood is not weakening but empowering for mother and child. With Billy accompanying them, the new family launch into the stars to save Delta's people.

"The Doctor Falls" introduces Hazran, a frontier mom who defends her farm against the superior Cybermen. A calico dress, bun, and rifle give a distinctive tough look. Giving her a bit more dimension, she also flirts with Nardole the robot, telling him she'll try anything once. She protects a house of children through the episode, and then finally leads them to a new land of safety, Nardole hilariously by her side.

"The Doctor, the Widow and the Wardrobe," the seventh Christmas special, has Eleven playing the caretaker of a country house—references to Narnia abound as the children Lily and Cyril step through a forbidden portal to a winter wonderland. The Doctor plays up his adoring uncle role, showering the children with treats, including the ultimate bedroom with "A sciencey wiencey workbench. A jungle. A maze. A window disguised as a mirror. A mirror disguised as a window. Selection of torches for midnight feasts and

secret reading. Zen garden, mysterious cupboard, zone of tranquility," and so on.

Their mother Madge soon discovers that the Doctor is responding to her wish—she wants a happy Christmas for her children before telling them their father's plane has been lost. As she explains, "Lily and Cyril's father, my husband, is dead and they don't know yet, because if I tell them now, then Christmas will always be what took their father away from them, and no one should have to live like that. Of course, when the Christmas period is over, I shall. I don't know why I keep shouting at them."

Sympathetically, the Doctor notes this is because "every time you see them happy, you remember how sad they're going to be, and it breaks your heart." Thus, Madge's entire plot involves safeguarding her children's happiness, then literally guarding them as she follows them through the portal. There, she's captured by loggers trying to destroy the sentient trees. Since they refuse to let her go, she suddenly, deliberately breaks down in tears. The men are disarmed completely by this:

> DROXIL: Ma'am, please stop crying. I can't interrogate you while you're crying. This is a military engagement! There's no crying in military engagements. Corporal Ven Garr, are you—
> VEN GARR: I'm fine, sir.
> DROXIL: What is wrong with you?
> VEN GARR: I have mother issues, sir. It's all on file. It won't affect the performance of my duties.
> BILLIS: Er, sir. Er, with regret, I'm going to have to lower my gun.
> DROXIL: Why?
> BILLIS: She is a crying, unarmed female civilian. I'm thinking of the visual.

Their leader lays his gun on the ground, and Madge instantly aims a revolver at them. "Crying's ever so useful, isn't it?" she smiles.

"If you say so. But there's nothing you could say that would convince me you'd ever use that gun."

"Oh really? Well, I'm looking for my children." The men cave.

The trees have captured the children and try to ride Cyril's mind like a lifeboat. When he crumbles, the Doctor volunteers, but to his shock the trees (or rather their wooden queen) name him "weak" as well. They're considering Lily, whom they find more suitable, when suddenly Madge crashes in, driving one of the loggers' giant harvesters. The trees declare her the strongest and the Doctor finally understands. "Think about it. Weak and strong. It's a translation. Translated from the base code of nature itself. You and I, Cyril, we're weak. But she's female. More than female, she's mum. How else does life ever travel? The Mother ship." This doesn't just refer to her biology but her personality, as her husband noted earlier that she'd been "taking home strays as usual"—the way she first met the Doctor.

Madge willingly rescues the forest as well as Eleven and her children—as the Doctor notes, "You've got a whole world inside your head." He can't save them, but tells her she can with her human emotions: "I don't have a home to think of. And between you and me, I'm older than I look and I can't feel the way you do. Not anymore. And you really need to feel it, Madge. Everything about home that you miss until you can't bear it. Until you almost burst." He emphasizes, as he always does, the human wonder and emotion the jaded Time Lord can no longer supply. Only Madge, with her mothering superpower, can save them all. He tells the children, "Your mother is flying a forest through the Time Vortex. Be a little impressed."

The episode concludes with Madge sharing the grim news with her children, only to find that the beacon she created with her flight saved her husband too. "He followed you home. Look what you can do, Mother Christmas," the Doctor smiles. Her love and protection have reunited her family. Madge makes a final gesture and encourages the Doctor to return to his own family, which he does, seeking out Amy and Rory to tell them he's alive and join them for Christmas. This becomes more than a story of the Doctor saving a shattered family—Madge flips the story and brings Eleven back to his own loved ones.

Adventuress: Bernice Summerfield

In Paul Cornell's *Love and War,* one of the Virgin *New Adventures* authorized novels, the beloved companion Benny first appears. In the 26th century, on the planet Heaven, she's leading a team of archeologists. Professor Bernice Summerfield is like an early River Song, with Lara Croft thrown in (though not her ridiculous proportions). In fact, she's generally depicted as slim and brunette in a catsuit. Over thirty, ex-military, and a competent professional, this sassy lass is worshiped on some planets as a minor goddess of inebriation.

Love and War shows Seven and Ace dealing with a religious cult, which is being drawn into a group mind thanks to alien spores. When the Doctor sacrifices Ace's love interest, she leaves in a fit of anger. Bernice, though annoyed with the Doctor's actions, agrees to travel with him for moral guidance. Of course. this demonstrates how she won't blindly support the Doctor, but will continue questioning him.

Bernice's entry into the ranks of companions begins with her warning the Doctor against manipulating her as he had Ace. Bernice, thus, demonstrates an awareness of the Doctor and his actions both within the context of the story as well as within the larger context of illustrating that the changes in the relationship between the Doctor and his companions have continued to evolve beyond the end of the televised series [Gulyas].

Bernice Summerfield grows up in the 25th or 26th century. After her father vanishes and mother dies in the Second Dalek War, Bernice finds herself in foster homes and frequently runs away to hide in the woods. She fakes her archeology credentials for a dig, but is soon offered the chance to earn them for real. (Possibly her chameleon nature and interest in archeology contributed to the later character River Song). Lisa Bowerman, who voiced Bernice in the Big Finish audio dramas and directed two, says of her, "She's resourceful and instinctively brave, but she has weaknesses and a sense of humor" (Bowerman 95).

An expert in Egyptian, Hebrew, French, ancient Greek, modern Greek, Old English, Old Norse and most Martian dialects, she bridges the old world and the new. She values information from the original sources, and thus makes an eager companion. She's the Indiana Jones–style of archeologist, eager to get her hands dirty. "There's very little concession for her being girly—she has human frailties, but is very focused and gets on with things," Bowerman adds (96).

She's also an atheist and vegetarian, disorganized in her personal life. She enjoys Jane Austen and carries a gown around in case she finds a dance. Benny is intuitive, self-taught and fiercely independent. Sometimes cynical, she emphasizes her formidable intelligence. She actively enjoys traveling, making her less of a teen protégé and more of a partner. With all these contradictions and a novel character's inner monologue, she shows more depth than most television heroines.

When the Doctor calls on Benny, he often finds that she's self-reliantly solving the problem already. "I'm isolating the electrics from the fuel supply," she says, "to prevent an explosion. I'll be with you in a moment" (Parkin, *The Dying Days* 10). Throughout her adventures, she saves the universe over and over, bursting paradoxes and restoring earth's past, present, and future. She uses her archaeology skills—as she tells the Doctor, "As you'd know if you'd read my first book.... I made my reputation as part of an expedition excavating the tombs of the Mare Sirenum" (Parkin, *The Dying Days* 17).

In the audio adventure *Silver Lining,* Benny's a celebrity author invited to archeological digs around the galaxy. They all pay her "spectacularly generous fee," and her wide-eyed employer in this story has a stack of books for her to autograph. Meanwhile, she saves the day of course, but also gets in a feminist lecture, telling the Cybermen, "Next time try putting together some cyberwomen. Putting them in charge would do your race a power of good."

When Ace rejoins them, the women work well together, though in *Conundrum,* Benny dreams of how "Ace had tried to kill her—hurled her to the ground, choked the life out of her struggling body—and all the time, the Doctor had just stood calmly by and told her that it was all for the good of the universe and she really shouldn't be fighting it, you know" (24). This

suggests hidden anger and unresolved feelings between companions. Nonetheless, the same book has a delightful scene where the pair go drinking together, recalling the Doctor's past adventures (in, admittedly, a discussion too Doctor-heavy to pass the Bechdel test).

In *Death and Diplomacy,* Benny meets her future husband Jason Kane, a human from 1996 who was stranded in deep space for fifteen years. Kane is a pansexual hero "in many regards a precursor to Jack" (Magnet 160). Though they constantly quarrel, they finally realize they're in love. "Doctor, this is my fiancé. Please don't kill him," she announces hilariously. She weds him in *Happy Endings* and ends her journeys.

The last New Adventure, *The Dying Days* by Lance Parkin, has Bernice meet the newly regenerated Eighth. While she comes to terms with the Doctor's death and her own divorce, she must also help the Brigadier and Bambera defend earth from a Martian invasion. At story end, the Doctor gives Benny his cat Wolsey and takes her to the 26th century so she can accept a professorship at St. Oscar's University on the planet Dellah. He respects her self-determination as well as her desire to improve her career.

Playing with sexist tropes, one humorous moment appears to have the Eighth Doctor suggest Benny use her feminine wiles:

He took his companion to one side. "Couldn't you … persuade him?"
"How?" Bernice scowled.
"Well, you're not a little girl anymore…"
"I beg your pardon?" she snapped, before remembering the urgency of the situation. She bit her lip. "OK."
Bernice leant forward, and flashed her eyes at the proprietor, who dragged himself away from his movie. "I don't have any money, but I think I have something you might find of interest." She lent forward and whispered into his ear, before pulling back. "Do you want that?" Bernice asked softly.
"If you'll do that for me," the fat little man said in all seriousness, "then you can have as much connect time as you want, and free cappuccinos" [Parkin, *The Dying Days*].

As it turns out, she charms his geeky heart with knowledge of the next two *Star Trek* movies. However, she's not desexualized. As the novel ends, Benny does something unheard of and actually seduces the Doctor (admittedly as they're parting ways):

Benny hesitated, looking into those deep blue eyes of his. "Yes. Look, before you leave, there's one thing I have to do. I'd never forgive myself otherwise."
The Doctor looked puzzled. "What would that—"
She grabbed the lapels of his frock coat, kissed him square on the mouth and pushed him down hard onto the bed.

The end is ambiguous as it's cut off—the Doctor might protest and leave … or he might stay. Certainly, it's a brash move from Benny and another similarity to River.

As Virgin lost the *Doctor Who* license, they had Benny travel the universe alone. The *New Adventures*, beginning with *Oh No It Isn't!* continued until 1999, when the Virgin fiction department closed. Benny teams up with Braxiatel, the Doctor's older brother, and becomes the staff archeologist for the Braxiatel Collection. She also becomes a single mother—a progressive step except that the pregnancy occurs when her body is taken over against her will by alien sorceress Avril Fenman. The father, alien Adrian Wall, resembles a sort of eight-foot-tall wolf-ape. Though Jason and Adrian each want to be involved, Benny determines she'll raise her son by herself.

Soon, audio production company Big Finish Productions began issuing full-cast, officially-licensed Bernice Summerfield audio dramas. Eleven seasons (1998–2010) followed. *The New Adventures of Bernice Summerfield* (2014–2016) pair her with the Seventh Doctor. As her stories continue, she transcends the Whoniverse with her own supporting cast and solo adventures, making her far more than a sidekick companion.

Another romantic adventuress appears when Bev Tarrant, unearthing a 42nd century Dalek hibernation unit, meets the Seventh Doctor and Ace in the audio adventure *The Genocide Machine.* An art thief, she encounters the pair again and becomes a companion in *Dust Breeding.* After their travels, she continues stealing and eventually works for Benny. At the Braxiatel Collection, she makes a spectacle of herself, walking around naked when it's hot and kissing Benny in the sexy, sexy episode *Summer of Love.* Like Benny, she throws capricious subversion into the show, acting as she wishes without constraint.

On New Who, there's Robina Redmond, "the absolute hit of the social scene" in "The Unicorn and the Wasp," who carries a small gun in her handbag. As it turns out, she's no lady but the famous jewel thief "The Unicorn," though a red herring in the episode's murder mystery. Throughout the episode, she smiles sweetly and says little, relying on her pretty face and flashy gowns. After revealing her cockney accent, she's quite unapologetic of her shifting roles. At episode end, the Tenth Doctor notes amusedly that she's slipped off to London, never to be seen again.

A similar character is Lady Christina de Souza, the thief in "Planet of the Dead." Stranded on a desert planet, she pops on sunglasses and smiles how she's prepared for anything. She's willing to listen to the more experienced Tenth Doctor though she takes charge. "A good leader utilizes her strength. You seem to be the brainbox. So, start boxing," she tells him. The Doctor calmly agrees. "Yes, ma'am." The pair mirror each other as they each pull out tech—Christina notes that like him, she's "ready for every emergency." She even calls them "two equal mysteries." As they both speak French and parallel as "lady" and "lord," both are struck by the similarities. They both love danger, and the Doctor has to admit that he's been a thief too. However,

offering the same skillset can be a detriment. The Doctor values companions for their youthful energy and compassion, not for the experience and gadgets he already provides.

Though presented as a one-off companion, she lacks the necessary chemistry and moral depth. Iona Sharma explains in her essay on the specials, "Lady Christina is something of a misfire. It's hard to feel much sympathy or commonality with an aristocratic jewel-thief who just steals for the thrill of it. While Donna proves that you can have a beloved companion with a somewhat abrasive personality, Christina doesn't have Donna's warmth or compassion to offset it." She's also opportunistic, stealing alien tech when presented with a chance. As she smirks, "The aristocracy survives for a reason. We're ready for anything." Undermining her toughness, Lady Christina has a girlish squeamishness that can be viewed as stereotypically feminine—she's grossed out by humanoid flies and by dead people because their particles are in her hair.

When they return to earth, she plants a kiss on the Doctor, and, after escaping UNIT, she's eager to come on adventures. Here, however, she hits a snag. Through the course of the episode, she never finds greatness or selflessness. In fact, the Doctor notes the lack of spark and noticeably does not invite her along. When she asks, the music turns dark and he says: "People have travelled with me and I've lost them. Lost them all. Never again." Thus, he continues as the lonely, miserable Doctor mourning his lost companion. Perhaps the "wrong companion" arrives just at the right time—when he isn't prepared to acquire one.

Soldier: Roz Forrester

Roz Forrester from the Virgin New Adventures can trace her ancestry back to Nelson Mandela and wears her ancestral Xhosa dress at a costume party (*Just War*). All this makes her an unusually non–British companion. In fact, Roslyn Sarah Inyathi Forrester is a 30th century police officer, born to a rich family on the moon Io. "She had thrown over the privileges of being born into an ultra-rich, high-level Overcity family to join the Adjudicators" (Stone, *Sky Pirates* 23).

She and her partner Chris Cwej are investigating a murder in the year 2975 when they encounter the Seventh Doctor and Benny (Lane, *Original Sin*). Emphasizing her toughness, Roz killed her former Adjudicator partner, Fenn Martle, when she discovered he had been taking bribes. However, her memories have been manipulated to make her think an alien killed him, heightening her xenophobia. She's a contradiction, a strong, capable cop who's been reprogrammed like a cyborg, another victim of the patriarchy. The Doctor lessens this programming but can't entirely remove it.

With a gun and Adjudicator armor, Roz becomes a tough, savvy companion who can solve crimes beside the Doctor. By showing how much men and women are alike, Roz and Chris help readers embrace the complexity of gender and discover the similarities. They travel with the Doctor for many adventures. They also keep their partner relationship platonic (though they kiss briefly in *The Death of Art*). Of course, they can't go home. As Roz thinks, "The nefarious conspiracy in question had wrecked one glittering career in the Guild of Adjudicators—hers—nipped one career slightly less coruscating in the bud—that of one Christopher Rodonante Cwej, her partner of a matter of days but it seemed longer—and had left half of the 30th century Adjudication Guild busily arranging tragic accidents for either her, or Cwej, or both of them should they ever show their faces again" (Stone, *Sky Pirates* 21). She adds at book's end, "The only so-called 'adventure' I know about is the one that ended with my life and my career in shreds, the memory of the man I loved befouled, half the world I knew reduced to smoking rubble and the strong possibility of Cwej degenerating into a ravenously murderous maniac at any minute" (275–276).

Since she's of African descent, Roz's trip in *Toy Soldiers* to the era of World War I (rather like Martha's on New Who) gives her a barrier of societal racism with which to cope. At the end of *Just War* in World War II, Roz gets engaged to Captain George Reed. Nonetheless, she leaves with the Doctor, emphasizing her independence as George must wait until she returns.

When the Doctor passes through her home in *So Vile a Sin* by Ben Aaronovitch and Kate Orman, Roz joins her sister Leabie's revolution against the Earth Empire. Unfortunately, the Doctor realizes he won't be able to help her as Roz insists on fighting for her people in the front lines. To the Doctor's horror, she dies. This shocks him so much he has a heart attack in one of his hearts. Of course, her death demonstrates agency and selflessness, as well as a connection to family—instead of dying for the Doctor and her fellow companions like so many others, she sacrifices herself for her birth people. Her choices emphasize the desire for freedom, demonstrating the courage and the creativity of the human spirit. She is buried in the Umtata Reclamation Zone in Africa, next to her nephew and niece, wrapped in a prepared animal skin called a kaross. Meanwhile, Leabie becomes the new Empress and vows to fix the corrupt Empire.

More soldier companions frequented the audio adventures—Captain Lysandra Aristedes appears in the standalone Forge novel *Project Valhalla* and the Seventh Doctor audio *Project Destiny*. A high-ranking member of the institution The Forge, she is persuaded to drop her association and ultimately orders its final destruction. The Doctor soon invites her along and adds Private Sally Morgan to the mix. On all their travels, Lysandra's a soldier and remains one, until she finally leaves to fight in another war. She's often

criticized as being unsympathetic by those who expect an ingénue. While Twelve dislikes Danny Pink and harasses him about his military background, this appears to be jealousy for Clara's affection—other incarnations are happy to travel with soldiers, especially those who display some flexibility.

An unusual married companion in eight of the Sixth Doctor's audio adventures, Constance Clarke prefers "Mrs." She's a WREN of the Women's Royal Naval Service during World War II (as she reminds listeners constantly), and on meeting the Doctor, insists on going along and then being returned to her duties after (*Criss-Cross*). She's very loyal to her husband, but her marriage is eventually revealed to be quite complicated. A forceful personality, capable and driven, she has a way of organizing whomever she encounters.

In *Engines of War*, John Hurt's War Doctor recruits Cinder of the planet Moldox. She has been fighting since age seven, when Daleks destroyed her family. The Tardis crash-lands at just the time to save her from a Dalek patrol. The pair work together and discover a Dalek weapons factory where a temporal cannon is being built. Together, they escape and warn the Time Lords of the danger. Of course, this Doctor is a fighter, not an explorer, so he needs a companion who can fight beside him. However, Cinder is shot and killed by a Time Lord assassin, when she takes the shot meant for the Doctor. He buries her by her family and vows to them all, "No more." This scene suggests that Cinder's death prompts the Doctor to decide to use the Moment to destroy both Time Lords and Daleks ("The Day of the Doctor"). She's a fitting companion for the War Doctor but also an impetus through her self-sacrifice, like so many other doomed companions.

Several female soldiers appear in even early *Doctor Who*. In *War Games*, Jamie meets Lady Jennifer Buckingham and learns something about modern gender roles. She's a World War II nurse and ambulance driver, and thus terribly tough. Of course, the young Highlander is uncertain how to respond.

JAMIE: Ah, now, Lady Jennifer, I don't think you should come.
BUCKINGHAM: Because I'm a woman?
JAMIE: No, er, well, in a way, yes.
BUCKINGHAM: That settles it then. I'm certainly coming. You can't go alone.

In the course of the episode, she and Jamie tangle with Civil War soldiers as she attempts to reason with them. Her failures contrast their unreasonableness with her own level-headed attitude as she proves a capable partner.

Brigadier Lethbridge-Stewart's administrative support staff includes Corporal Carol Bell in *The Mind of Evil* and *The Claws of Axos* (1971). Onscreen, she's notable for her bouncy curls, but, like Liz, she's a competent professional and valued staff member. Of course, she has far fewer lines and not much personality to go with them—she answers the phones and makes

the coffee. On the show during that era, military women in both UNIT and the Royal Navy seem strictly limited to taking dictation, operating radios or phones and making hot drinks, admittedly a typical job description that was only slowly changing. In the novels, she appears often among the UNIT staff, with a bit more of a backstory.

Day of the Daleks features Anat, a 22nd century guerrilla fighter who travels back to the 20th on a desperate mission. She's an icy, dark-haired military woman, whose stilted speech contrasts with emotional Jo's. Her origin in the future softens her otherwise radical presence on the front lines. Early on, she apprehends the Third Doctor with the words "So, you are the man. Outwardly so innocent looking but capable of such crimes. Who would ever know?" Though he expresses puzzlement, she arranges his execution. It takes some time for him to persuade her he's not the criminal she wants. At last, she concedes, adding with a touch of fairness, "We are soldiers, not murderers." When the Doctor reveals Anat and her team have created the events they seek to stop, she drops her plan to pursue his. Though strong, she nearly makes the wrong call several times, leaving her more than a little problematic.

Bettan, a Thal woman, seems capably short-haired in military gear. She has a logical exchange with the Fourth Doctor, friendly and helpful, in which he convinces her destroying Davros will save them all. When he asks whether she'll help, she responds with a simple "Yes." The Doctor leaves, and Bettan ducks down as a Dalek passes the top of the trench, silhouetted against the sky. She is the hardened commander willing to destroy their allies to eradicate the Daleks, while Sevrin, who cares for the captured Sarah Jane, pleads for a delay. Bettan and her team set explosives outside Davros's bunker, but finally wait, allowing the Daleks to exterminate Davros instead. Her take-charge attitude leaves her quite memorable, even for a solo appearance. As the Doctor leaves, it's suggested she'll be instrumental in rebuilding her civilization and redefining gender expectations too.

Captain Briggs in Earthshock (1982) is a capable older woman, striding across her ship with the line "Don't call me ma'am on the bridge." She's tough enough she doesn't need the crew to defend her, even when she's interrogating the Fifth Doctor. With short hair and a gray military coat, she looks like she could take on an army all by herself. "This strange, surly old woman makes for a very memorable freighter captain" (Muir 316). Faced with a mutiny, she can only reply dismissively, "Oh, come off it." However, when the rebellious officer turns his back, she gives him a fast karate chop and regains control. Her first officer, Berger, is also a woman, in a rare female team-up. In fact, Earthshock features an enormous host of female characters—without a single damsel or wife. In this, it is strikingly feminist, emphasizing that women may have any role or make up most of the cast. Troopers Mitchell and Snyder act as the armed guard for the expedition, treated no differently from the men.

Meanwhile, Professor Kyle, leading a team of paleontologists and geologists, loses her people to the Cybermen. When they attack again, she bravely gives her life for Tegan.

Resurrection of the Daleks (1984) also has an equal number of female soldiers and scientists. In her white uniform, Doctor Styles cares for the prison inmates, adding, "My only concern is the medical welfare of the crew and the prisoner." She ignores the appalling morale on the ship, with the words "If the Captain doesn't care, why should I?" and insists her goal is simply to get a good reference and leave. Her crisp black and white suit echoes her narrow perspective. As they walk through battle conditions, she constantly complains about thirst. In the end, however, she dies heroically stopping the Daleks. Other female soldiers in the episode include Osborn, a rare Indian woman onscreen. Her elaborate hairdo and flirty manner admittedly "damsel" her a bit. She does her best to fulfil her duty and execute Davros before she is unfortunately killed. Another crewmember, Zena, has a similar role, though neither has much personality as she stands silently in the background. Finally, Professor Laird, a frumpy scientist attached to the British Army's Bomb Disposal Squad, cares for Tegan as her fellow soldiers are replaced by Dalek duplicates. In her large glasses and sloppy coat, she stands out as clever, noting to Tegan that she has drugged the enemy with sleeping powder. The two women team up, opposing the Daleks until Laird too is killed (partly prompting Tegan's quitting her travels at episode end). Establishing gender equality, all the female soldiers, kind or disinterested, do their part and die, just the same as the men.

Threst, who hires male thieves to deal with the Cybermen in *Attack of the Cybermen*, doesn't show gender independence. She and her friends, the rebels, are notably all female, in a script written by a woman, Paula Woolsey. However, one must note that the rebels have no personalities or, in fact, differences. Other episodes do better: *Planet of the Daleks* introduces Rebec, a brave Thal unit leader with plenty of screentime who allies with the Doctor to battle the Daleks. Lieutenant Preston in *Warriors of the Deep* offers a token female among the soldiers, but every line is tied up in her duties. Jill Tarrant, a space marine in *Death to the Daleks,* has little personality but does much more than pour coffee. Likewise, Rega, a rebel in *Planet of the Spiders,* fights in her father's memory and insists, "Better dead than captured."

Katz, another youthful freedom fighter, saves Peri in *Timelash.* As her partner argues for killing her, Katz insists Peri is on their side. However, she soon reveals herself as a true believer, pulling out a locket with a picture of Jo Grant. "This was given to my grandfather by the Doctor. Do you know who she is?" she asks. Katz allies herself with Peri and helps bring down the corrupt system. While a capable warrior, she clearly shares Martha's soft heart for the galaxy's savior.

McLuhan, one of the villain's guards in *Dragonfire*, tells her teammate, "Do me a favor and leave your water pistol at home. If I'm relying on you to cover my back, I want to know that you are carrying enough artillery to blow this ant clean across the space lanes." Her firmness leaves a favorable impression. Despite her robustness, she's suddenly killed, emphasizing that gender is no protection.

Brigadier Winifred Bambera (Angela Bruce), plays UNIT's commanding officer in *Battlefield* (1989). Her presence alongside not just the Seventh Doctor and Ace but also Brigadier Lethbridge-Stewart, UNIT's previous commander, suggests an egalitarian salute from the old ways to the new. Onscreen, she battles hand to hand as well as armed, while her no-nonsense attitude gains her respect. Her using the word "shame" as an expletive is a bit silly, but the show is child-friendly after all. In the same episode, flight Lieutenant Françoise Lavel (Dorota Rae) flies the Brigadier to face Morgaine and Mordred. Morgaine crashes the helicopter and captures Lavel, stealing her memories. Later she kills her senselessly. Once again, female soldiers die in combat and save the day, offering them a spectrum of roles. Bambera returns in the Virgin New Adventures novels, in *Head Games*, *The Dying Days*, *Transit* (promoted to general), *Present Danger*, and *Animal*. She has married Ancelyn, the Arthurian knight from *Battlefield* and had twins with him, but, significantly, maintains her career.

Of course, many soldiers are sacrificed through the show—losing a female one may be more emotional for the audience, but she goes down in memory as having performed her duty. Sally Jacobs, a UNIT technician during "The Christmas Invasion," reports the origin of the Sycorax signal. Like everyone on earth with A-Positive blood, she succumbs to the Sycorax mind control and becomes a hostage for the planet's surrender. For this casting, her gender seems especially sympathy-inducing.

U.S. officer Major Frost is called to 10 Downing Street during the Ninth Doctor episode "Aliens of London" since she is an alien expert. She, like all her colleagues, is suddenly killed by the Slitheen. According to the *Series One Companion*, earlier drafts of the episode's script called her Muriel Frost, a character from the comic strip. In *Doctor Who Magazine*, Frost is a no-nonsense UNIT operative working undercover in *The Mark of Mandragora* (*DWM* #169–#172). She aids Seven and Ace in thwarting an attack from the Mandragora Helix. In *Evening's Empire* (*Doctor Who Holiday Special* 1993), she's promoted from captain to colonel, working beside Seven once more. She branches over to other media as Captain Frost in the audio play *The Fires of Vulcan* (voiced by Karen Henson). Each time, she is efficient and clear-headed, an excellent officer.

Women warriors can do everything men can, with additional barriers to surmount. Thus, they emphasize that concepts of masculinity and femininity

are fluid, changing as society redefines them. UNIT officers make coffee in the seventies, but lead armies in the eighties. Of course, Martha becomes a powerful soldier, one of the three charged with the ultimate doomsday weapon in "Journey's End."

Captain Marion Price, a rather glamorous UNIT officer, assists her commander, Colonel Mace, when Sontarans attack in "The Sontaran Stratagem"/"The Poison Sky." The soldiers fail and the Doctor succeeds (of course). As stirring music sounds, she exuberantly kisses her commanding officer in a heartening moment but one far from professional. Thus this character is more than dual—she's sympathetic but more than a little weakened.

Captain Erisa Magambo of UNIT works with Rose Tyler in the parallel universe of "Turn Left" to restore the correct universe. With competence and technical brilliance, her team constructs a time machine from the Tardis to send Donna back in time. She returns in "Planet of the Dead," charged with rescuing civilians from an alien planet. "Establish an exclusion zone. Any media, move them back. Any trouble, arrest them," Magambo orders smoothly. She's one of the "good UNIT officers" who respects the Doctor, even saluting him over the phone. She coordinates Doctor, scientists, civilians, and alien threat, all while getting in a moment of fangirling (though keeping it professional). However, when faced with a threat to the entire earth, she turns much colder:

> TAYLOR: Done it. Transmit that, and the wormhole should close.
> MAGAMBO: Then do it.
> TAYLOR: Well, after the Doctor's come through, obviously.
> MAGAMBO: I'm sorry. Believe me. That wormhole constitutes a major threat, and I have a duty to every man, woman and child on this planet. It's got to be closed immediately. That's an order.
> TAYLOR: No, no, no, no. No, we can't just abandon him. He's the Doctor. How many times has he saved our lives? I won't let you, ma'am. I simply won't.
> (Captain Magambo points her pistol at Taylor.)
> MAGAMBO: Right now, soldier.

It's arguably the right call for a soldier to make, and the Doctor holds no animosity, though he refuses to help with her paperwork.

Jagganth Daiki-Nagata, played by Elaine Tan, suits up as the feminine but tough leader of a 38th century rescue team, investigating the silence from the Le Verrier space station in "Sleep No More." She tends to call everyone "pet," in a gender hybridization. She mocks people who refuse to use the new Morpheus system—though she's proven to have misplaced her trust in it. Once again, being female gets characters no special claim on making the right call.

Military leaders of Earth's three most powerful armies appear in the Twelfth Doctor's "The Pyramid at the End of the World." The American and

Russian are men; the Chinese is a woman. While all are cautious, the Doctor informs them their actions are endangering the world, with the Doomsday Clock nearly at midnight. Struck by the threat of destruction, Xiaolian is the first to reach out and shake each man's hand: "No. I say, no. Friend, I will not fight you," she insists. When the Russian hesitates, she goads him, asking, "Are we too afraid to disobey?" until he capitulates. Sadly, this fails to prevent the war, but makes an inspiring gesture of peace.

The bravest, Captain Adelaide Brooke, makes a serious impression on the Tenth Doctor in "The Waters of Mars." When he visits (reeling from Donna's loss), he realizes Adelaide is doomed. Trapped with her, however, he comes to admire her. To compensate her for the upcoming loss, he tells her of the future: "Imagine it, Adelaide, if you began a journey that takes the human race all the way out to the stars. It begins with you, and then your granddaughter, you inspire her, so that in thirty years Susie Fontana Brooke is the pilot of the first lightspeed ship to Proxima Centauri." The Doctor breaks his own rules and saves her, but after the commander has heard over and over that her fate can't be changed, she makes the hardest choice of all, killing herself to ensure her granddaughter's future. "I don't care who you are. The Time Lord Victorious is wrong," she tells the Doctor. While all this serves to teach him a lesson, the feisty commander emphasizes moral strength and sacrifice.

Sovereign: Erimem

The concept of the princess may evoke the damsel in distress or spoiled "daddy's girl." However, historical princesses were trained as diplomats and managers of immense estates, leaders who thought of others before themselves.

Erimemushinteperem "Erimem" (Caroline Morris) arrives in the audio drama *The Eye of the Scorpion* (2001), as the seventeen-year-old Egyptian heir in 1400 BC. As controversy rises about a woman inheriting, the Fifth Doctor and Peri show up to save her from assassination. Through the story, the Doctor worries that he knows she never ruled, and Erimem too feels her destiny is elsewhere.

On the adventure, the Doctor is poisoned, leaving Peri and Erimem to team up and investigate together, a lively pairing stressing they're more than the Doctor's assistants. The princess grows up with a heavy weight and describes her "burden of duty" to Peri: "I could learn to like walking through the market like a normal person," she adds wistfully, before she finally gets the chance. At the same time, she has her ruthless side: "Discover what you can about this scum and then throw him in the Nile—let the crocodiles have

him!" she decrees. She leads her army, wielding her powerful war bow. With this, she emphasizes she was born to lead, though she finally steps away.

Saddened by the number of men who have died on her word, the Pharaoh refuses her throne. "I don't feel like celebrating a battle that cost untold lives," she adds. Peri suggests that they take Erimem with them, and the Doctor agrees, adding he knows many professors that will help her continue her studies—unusually, Erimem will be fulfilling her educational goals, not just adventuring. "I can study and learn," she says, voice alight with eagerness. She gets her cat and away they go.

While Katarina came from about as far back, she was woefully uneducated and considered the Doctor a god. Erimem, by contrast, has an excellent education and is schooled in rationality (to the standards of her time, admittedly). She perceives the Doctor is a scientist with amazing technology. As she adds, "I believe in *real* things. I have heard of men who study the stars and say that we travel around the sun, not it 'round us ... one of these men even claims that the world is round like a ball.... There are other men who study plants or animals or rivers, or make extraordinary devices out of wood and metals. You are like them."

When they tour the Tardis for a short adventure in "No Place like Home," she's never seen ice but she reacts to the world around her with practicality, not naive wonder. "Was that an answer or were you just showing that you know some big words?" she asks. Erimem even points out that she's lost a home like the Doctor has. She's the one to discover their antagonist ... a Gallifreyan mouse. Her cat helps deal with the problem.

Erimem and Peri team up for many adventures, offering a delightful female-female dynamic. *The Veiled Leopard* has them gushing about the party they'll attend and the dresses they'll wear to it, amid jokes about "Pharaoh finishing school," Egyptian makeup, and painful high heels. Thus their pairing allows both to indulge in a girlier side. Erimem's charisma and negotiating skills follow her, emphasizing that an educated companion can be a decided asset. In Paris 1926, she inspires and leads the French forces against the English. She also finds herself matching wits with Queen Anne of France and Empress Fausta, as their peer. All this shows her as an effective, practical companion with a skillset the ingenues rarely offer. At last, she accepts the king's marriage proposal in *The Bride of Peladon* and settles down to rule, reclaiming her destiny at last.

If the original show had few women, it had even fewer female leaders, though a few notable ones shine, starting with the Old Mother in *An Unearthly Child.* She resists letting the Doctor bring fire to her tribe, insisting, "It is better that we live as we have always done." She also undercuts the eager young warrior, noting that he wants tools "So that everyone would bow to you as they did to him." She's a perceptive, wise matriarch from the very first

episode. Wise rulers do not "make decisions simply on the basis of our egos or whims," something the old mother clearly knows (Pearson 184).

A few other royal figures appear, like Lady Joanna, sister of Richard the Lionheart in *The Crusades*. Barbara impersonates her, while Vicki dresses as a boy. Lady Joanna forgives her the deception and graciously takes her under her protection. Though a princess, she's also treated as a pawn as she complains, "I am my brother's favorite, yet now I find I am excluded from his confidence. I sense he's made a plan of which I am a part." Joining this boy's club, the Doctor insists he can't confide in her, adding, "I have no desire to upset the king." Thus he preserves himself and the timeline but treats her with the same disregard. To Joanna's horror, she's to be negotiated away in marriage. She refuses, asserting, "This unconsulted partner has no wish to marry. I am no sack of flour to be given in exchange." Further, she insists she'll take her case to the Pope, adding, "You are here to fight these dogs, defeat them. Marry me to them and you make a pact with the Devil. Force me to it and I'll turn the world we know into your enemy." Thus even in the early historical adventure, she's a bit of a firebrand.

Cassandra, the High Priestess of Troy and the daughter of the king, is often presented as a raving madwoman. However, *The Myth Makers* shows her with stately dignity. With long sleeves and a bob haircut, she's more authoritative than sexy. Famously, she has premonitions of the future. She also bosses around the men with an ice queen's demeanor. Of course, the audience is aware that her paranoia is correct as she suspects there are passengers in the Tardis and warns of the Trojan Horse: "Fool! One soldier could unbar the gate and so admit an army. It's exactly the sort of scheme Odysseus would think of." Cassandra also cruelly accuses Vicki of practicing witchcraft and decides to destroy the Tardis, saying: "Bring branches, fire and sacrificial oil. We'll make of it an offering to the gods of Troy. And if there be someone within, so much the greater gift." She's ruthless and calculating rather than feeble and mad.

The empress of the court of Kublai Khan in *Marco Polo* is another formidable force. She disapproves of the Khan's penchant for gambling, so Kublai cautions the Doctor to put away their game when she approaches. Of course, this still casts women as the power that spoil men's fun—the obstructionist rather than equal partner.

Catherine de Medici is Queen Mother of France during the events of *The Massacre of St Bartholomew's Eve*. Though she has few lines, her strength matches her historical counterpart's. When her son blusters, "Yes, I am the King, and to be obeyed! Now keep out of my sight unless you care to end your days in a convent," she retorts, "Summon your guards, have me arrested. But you had better have a good reason for the council and for the people."

Eleanor, the wife of Lord Edward of Wessex in *The Time Warrior*, likewise

can only act through her male counterpart. "But for how long, Edward? How long are we to tolerate this upstart, this insolent usurper as our neighbor? He robs, he pillages, he murders. He flouts your authority every day, the authority which comes from the King," she presses. Eventually he comes around to her view. She allies herself with the Doctor, who gives her the mission of making an herbal brew, using women's skills along with force of arms.

The more modern Lady Isobel MacLeish fits well among these women. Though a hostage, she quickly grows beyond expectations. When werewolves imprison her people in "Tooth and Claw," she raises the spirits of her staff and fulfills all of a lady's classic duties in times of peril. She leads her maids and cook in gathering mistletoe. "My husband's up there, and if there's any chance he's still alive, then by God, I'll assist him," she exclaims.

Tom Baker's Doctor returns to Peladon to find Queen Thalira ruling. Her short dark golden hair, soft voice, and wide open eyes make her seem quite youthful. Giant purple robes only add to the look. She's idealistic and devoted to her father's legacy, explaining, "It was my father's dream to see Peladon a civilized planet, a full member of the Federation. He signed the treaty. We must honor it."

"Rulers understand duty and what royalty is expected to do, and they do not fight it" (Pearson 186). Thalira is kind but led astray by an evil advisor, Lord Ortron, who tells her, "You see, your Majesty, already the rebellion has begun. This is what comes of softness with the common people." In her gentleness and willingness to listen to bad counsel, she's cast as a weak ruler. She doesn't believe Ortron, but admits she lacks the power to oppose him.

Though she calls herself "a Queen who is looked upon as little more than a child," Thalira finally rallies and defies Ortron, though he's already put the Doctor and Sarah Jane to the "test" of being eaten by a monster. When they survive, the queen uses the fact to her political advantage. Still, she believes in her own weakness, a fact that encourages Sarah Jane to get on her soapbox and lecture her on women's lib.

As the episode continues, Thalira protects Sarah Jane, while Ortron decides, "Since she is only a female, her activities are of little importance." When the queen's advisors invite aliens in to enslave her people and steal their resources, Thalira escapes and joins them in the mines. One of her evil advisors holds a gun to her head, using her as more of a prop than a person. After this, another kidnaps her. Still, she manages her own escapes and continues to fight for her people's freedom, establishing herself as brave queen and worthy ruler. While she's too eager to let male advisors direct her, she deserves some credit for ruling a planet where they say of Sarah Jane "I addressed your master" and "she's of no importance." On earth, most female rulers have struggled with this additional burden, establishing them as truly great when they can transcend it.

With bright yellow and green hair, Mena of *The Leisure Hive* certainly appears an aristocrat. When her husband the chairman dies, she takes over, and asks the Doctor and Romana to save her people from radiation damage. She's a bit of an idealist, and insists on justice, though she condemns the Doctor unfairly. When backed into a corner, she proposes mass suicide, certainly not in the best interests of her people. "The Ruler does not so much create a life as maintain and govern it. All good monarchs or political leaders identify with the good of their collective, and balance personal desires and aspirations with other people's needs" (Pearson 185). Thus, she is misguided and despairing in her approach. Meanwhile, her son Pangol reveals that he's *not* her biological child but a clone and turns against her, saying, "With Mena's death, the future arrives. The Children of the Generator will rise to claim their inheritance." Her control over her family is as precarious as her control over government. As Pangol announces her death and his new leadership, however, she drags herself upright. The Doctor successfully rejuvenates her and Pangol. As she comes out, young, vibrant, and holding her baby son, she resolves, "This time I must try to bring him up properly, but there's work to do first. We must contact the Foamasi and avert this war." With the Doctor's aid, she becomes the leader she wishes.

> *The Mysterious Planet* brings us Joan Sims as Katryca—the casting of a comic actor in a dramatic role is always a risk, but she acquits herself with great aplomb. Katryca fascinates me—the red-haired warrior queen is the kind of role which would normally be totally sexualized, with a glamorous siren poured into bronze D-cups and a tiny skirt. Instead, we get a robust older peasant woman with a huge voice and a powerful sense of self, who makes a credible leader [Roberts, "Ultimate Sixth"].

Upon finding Peri, Katryca is kind but autocratic, noting, "Not many girls join the Free, Peri. I shall provide some excellent husbands for you" but adding, "Such women as we have must be shared" and "Put her with the other prisoners." This woman's treating a woman as a commodity suggests her obedience to patriarchal structure and its dictates. She also turns on the Doctor when he tries to help, because she insists star-travelling is forbidden. As leader of a group of feral humans, she comprehends little about technology, insisting spaceships are only recorded in her world's folklore. Like the Sisterhood of Karn, speaking with male travelers reveals her helplessness to work with even her own planet's creations as she speaks of gods and legends. Sabalom Glitz, the wily space traveler, must correct her, telling her she's not suffering from the gods' anger but from a malfunctioning navigational beacon. He is quick to take advantage. However, she rejects his advice (correctly discerning his greed) and confiscates his powerful-looking guns, wielding them herself.

Glitz responds by calling her an "old hag," emphasizing his misogyny. She in turn silences him and decides to burn Glitz alive to propitiate the gods. Her ambition takes over when she insists on claiming the false god's

castle, adding, "In the tribe of the Free we had no need of the Immortal. We shall live as we always lived, except now, the Immortal's secrets shall be ours." Her characterization thus suggests a warrior like Queen Boadicea. Nonetheless, the false god strikes her down, leaving the wiser male Doctor to save her tribe from her own foolishness. "The Ruler archetype typically forces a confrontation with power and with the limits of one's power" (Pearson 186). She fails in the task, and nearly takes her people with her into death.

Where would the show be without the British queens? As all of London prepares for Queen Elizabeth II's coronation in 1953, Ten uses this as an opportunity to teach about gender roles:

> DOCTOR: Hold on a minute. You've got hands, Mister Connolly. Two big hands. So why is that your wife's job?
> EDDIE: Well, it's housework, innit?
> DOCTOR: And that's a woman's job?
> EDDIE : Of course it is.
> DOCTOR: Mister Connolly, what gender is the Queen?
> EDDIE : She's a female.
> DOCTOR: And are you suggesting the Queen does the housework?
> EDDIE : No. Not at all.
> DOCTOR: Then get busy ["The Idiots Lantern"].

Other references to Elizabeth II are rare, but since she obviously has reigned over the show's entire run, a few humorous references nod to her being in office. She invites the Fourth Doctor to dine at Buckingham Palace in *Robot,* but he flees. She almost bumps into Seven at Windsor Castle as she walks her pet corgis in *Silver Nemesis.* Finally, in "Tooth and Claw," Rose speculates that the entire royal family are werewolves.

"Voyage of the Damned" reveals that the citizens of London have grown to expect disasters on Christmas. However, the Queen remains in residence "in defiance of extraterrestrial attack." The crashing space Titanic heads toward the palace, as the Doctor radios her, "Listen to me. Security code seven seven one. Now get out of there!" A scene briefly flashes of a woman in a fluffy pink dressing gown running down a red carpeted corridor, accompanied by a footman carrying a corgi. As it happens, the Titanic misses the Palace by inches and flies up into the sky. After him, the Queen cries, "Thank you, Doctor. Thank you. Happy Christmas!" This is a contemporary link, made silly by the constant threat to London. Her presence remains a staple of the show, but one only lightly referenced.

While the Doctor mentions having attended Queen Victoria's coronation and she appears in the Past Doctor Adventures novels *Empire of Death* and *Imperial Moon,* she only arrives in person for New Who. The formidable older queen intimidates Rose in "Tooth and Claw," relating stoically, "I'm quite used to staring down the barrel of a gun." The Doctor mentions she's

had six attempts on her life. She also has her gloomy side, noting, "That's the charm of a ghost story, isn't it? Not the scares and chills, that's just for children, but the hope of some contact with the great beyond." In the end, the Doctor comforts her with the knowledge that her husband's wisdom has saved her. The queen knights Rose and Ten, and then firmly banishes them, adding, "I don't know what you are, the two of you, or where you're from, but I know that you consort with stars and magic and think it fun. But your world is steeped in terror and blasphemy and death, and I will not allow it." She creates the Torchwood Institute, a shadowy Series Two nemesis, to protect England. Clearly, she doesn't find the Doctor's antics amusing.

Far in the future, Liz Ten lurks in an obscure corner of her own palace in "The Beast Below." She wanders the corridors masked and denies the realities of her own kingdom, even as Eleven and Amy uncover them. "Liz Ten, in the future, is trapped in an endless cycle of forgetting as the star whale carries her people to safety. Her society cannot change, as she remains passive and mind-wiped, unable to take action" (Frankel, *Doctor Who and the Hero's Journey*). Unlike Victoria, she only waits for intervention. Like her, she needs a solution from outside to save her people. Rosanne Welch notes in "When White Boys Write Black: Race and Class in the Davies and Moffat Eras": "Liz Ten stands as an example that all his characters of color are Talented Tenth 2 types, coming from the upper classes and the world of higher education, but oddly two-dimensional in that they operate solely as stepping stones to the Doctor's stories. They are never shown to grow or change or have lives outside of their usefulness to the Doctor" (Welch 70).

At the same time, she's a Black queen of Britain, armed with deadly weapons, making the only hard choice she can. Bound by duty, Liz Ten can't free the star whale on which they travel without destroying her people, but her morality pains her. Over and over she solves the mystery but is forced to forget and compromise. She defends her people as well as she can, and eagerly accepts a better solution. It is the strong, assertive Amy who intervenes, freeing the whale and ending the cycle

A delightful historic queen appears in Nefertiti, who stars in "Dinosaurs on a Spaceship" as one of Eleven's alternate companions (a concept that demands an entire show in itself). She dismisses the hunter Riddell's refusal to take orders from women, retorting, "Then learn. Any man who speaks to me that way, I execute." Meanwhile, Riddell is something of a caveman, introducing fun with gender dynamics. He tells Nefertiti: "Egyptian Queen or not, I shall put you across my knee and spank you." As she threatens him with death, he retorts with an appreciative, "They certainly bred firecrackers in your time." Meanwhile, Amy groans as she feels the sparks coming off the pair, despite Riddell's superiority.

Solomon, who is running the ship of dinosaurs, is another misogynist.

He insists on taking Nefertiti with him to sell to a collector. To the Doctor's horror, she sacrifices herself for him to aid the others, adding, "Let me make my choice." She thus demonstrates a queen's selflessness as well as a companion's. Solomon smirks, "My bounty increases. And what an extraordinary bounty you are." However, when Solomon holds her as hostage, she kicks away his crutch and he falls over. She grabs it and puts the point at his throat. "I am not your possession now, nor will I ever be. Now, stay there." She defends her gender and takes down the men, emphasizing her historic toughness.

Iraxxa, the green-scaled, fanged Empress of Mars, rises from a long hibernation to find herself surrounded by Victorian soldiers. Startled, she kills one instantly. Thus her power and volatility both define her. As the Twelfth Doctor struggles to help humans and Ice Warriors negotiate, Iraxxa abruptly asks companion Bill for advice, adding, "We are both surrounded by noisy males. I would value your opinion" ("Empress of Mars"). However, despite Bill and the Doctor's pleas, she only agrees to kill the soldiers mercifully. Clearly, her alien sympathy has limits. At last, when the regiment leader offers his own life, while pleading for his companions and his planet, she relents, vowing he will die with honor "…But not today. In battle, soldier. To die in battle is the way of the warrior. Pledge your allegiance to me and my world, and I will ensure you have the opportunity." This he does, allying the two species at last as she demonstrates respect for her counterpart's strength. Meanwhile, the Doctor contacts other alien races who can guide Iraxxa into modern times, where it's implied she will lead her people with justice. The final "God save the queen" carved on the surface of Mars functions as a salute to Victoria and to Iraxxa as well.

OUTSIDERS

The Alien: Destrii and Izzy

"Where two sexes co-exist in an unequal power dynamic, the female is coded as Other, as dangerous, as confusing, as abject, as threatening, and the male cannot help but bring this to her attention over and over again by reiterating her disturbing difference" (Dunn 113). Alien women doubly fulfill the concepts of othering, helping modern philosophers explore how humans treat those who are different and how they face the differences inside themselves.

Izzy Sinclair is a seventeen-year-old fan of science fiction, including *Star Trek, The X-Files, Star Wars, Alien, The Day the Earth Stood Still, Battlestar Galactica, Wonder Woman, Wallace and Gromit, Tomb Raider, 2001: A Space Odyssey,* Terry Pratchett novels, and so forth (though she spends more time quoting them gratuitously than using the tropes to save the day). With this, she begins more as the perfect geek girlfriend and repository of knowledge than a problem solver. She's already a man's image of a woman rather than a genuine person.

With blonde streaks framing her short brown hair, Izzy is introduced in *Endgame,* which ran in issues #244–#247 of *Doctor Who Magazine,* written by Alan Barnes and drawn by Martin Geraghty. Izzy knows nothing of her parents, so she tells herself she's a lost alien princess. Choosing to call herself Izzy S (for "Izzy Somebody") from then on, she marks herself as "other" from the start. In her first adventure, the Celestial Toymaker transforms everyone except Izzy and her UFO-chasing friend Max into dolls, literally objectifying her still further. The Toymaker then emphasizes her status as pawn by forcing the Eighth Doctor to play a deadly game of hangman ... with Izzy on the gallows. The Doctor saves the town, and then invites the vivacious, trusting teen to travel with him. Despite, or perhaps because of her lack of agency, Izzy is

the Doctor's most frequent comics companion, appearing in nearly all his stories between 1996 and 2003.

Ophidius by Scott Gray and Martin Geraghty introduces her most famous arc—which ran for 197 pages and two years. The Tardis is swallowed by the giant serpent-shaped bio-mechanical spaceship Ophidius, suggesting a true descent into the belly of the whale—the innermost part of the soul. The sharp-toothed snarling red monster represents all that the self has repressed, coming into conscious life. There, Izzy and the Doctor encounter a friendly fish-woman named Primatrix Destriianatos or Destrii, with blue scales, claws, tentacles, and green hair. While extremely agile, with remarkable combat abilities, she's also selfishly amoral and quick to violence. Just eighteen, Destrii makes a perfect friend for Izzy, as she adores Earth television like *Wonder Woman, Bonanza, Lost in Space, The Avengers* and *Star Trek*. The Doctor leaves the two to bond while he explores—indeed, Destrii is charming and outgoing, even outrageous and sexy in her purple bikini-get-up. An alien warrior princess, she's all Izzy once dreamed of becoming. However, Destrii has an agenda. Secretly on the run, she tricks Izzy into swapping bodies with Ophidian tech, telling her only that it will let her contact the Doctor telepathically. When the aliens controlling the ship attack, Destrii, in Izzy's body, kills them. The Doctor demands Destrii switch bodies back. However, the mate of the alien she killed suddenly vaporizes her in turn, leaving Izzy trapped in the fish body. Izzy has, ironically, gotten her dearest wish.

"Beautiful Freak" examines the effect of the bodyswap. Izzy is devastated, as she lies curled in bed, loathing her new self. Psychologically, it's an adolescent's journey through body transformation with all the unsightliness that holds. Her body is far more sexualized now, but she rages at the Doctor for calling her new self an "opportunity," screaming (as teens do to well-meaning adults) "You haven't got a clue!" As the story later reveals, the change is also a metaphor for an isolated young woman, afraid of her sexuality and seeking comfort in fantasy. Izzy lashes out at the Doctor, but begins to suffocate, since her new body needs to be submerged in water periodically. Izzy can't even swim, and the Doctor insists she accept her new self, finally dunking her in the Tardis swimming pool in a type of baptism, while confiding in her about the disassociation of his own regenerations. Able to breathe again, Izzy breaks down in tears. The Doctor cradles her and tells her, "No, Izzy, no.... You don't want to die.... And you'll never be ugly."

The Doctor's companions are generally young, attractive, and human—the comics allow more freedom of special effects as they tackle the metaphor of feeling an outcast. Being an alien suggests being an outsider, but this transformation emphasizes being strange to oneself. There's Izzy's body horror and also amoral Destrii's completely alien perspective as she appreciates earth stories but misses their deeper lessons. In much of men's literature, the woman

appears as mysterious figure of nature and magic, unknowable. Of course, having the already-objectified heroine take the alien role emphasizes women as "other,"—fortunately, the authors of the comics make it a deep, sensitive exploration.

Though Izzy hesitates to leave the Tardis in her new form, she finally ventures out in the next adventure, claiming her new body and taking back control of her life. They visit Mexico during the Day of the Dead, so the locals are wearing masks and accept her, restoring her confidence. Next comes a water world, where Izzy's new body gives her superpowers far beyond the human range. Just as she's coming to value her new skills, Destrii's past catches up with her: Operatives of Destrii's mother, the Matriax Scalamanthia of the planet Oblivion, drag her home. She demands her "daughter" prepare for her wedding by fighting a deadly duel against the Lady Tetronnia for the right to marry her future husband.

Searching for Izzy, the Doctor discovers that Destrii is still alive—her body has been stored instead of disintegrated. He carries Destrii to Oblivion to switch them back. In the combat arena, Izzy finally meets Destrii again, and can settle the war she's been having with her own self. Izzy loses the fight and Tetronnia prepares to slay her when Destrii stabs Tetronnia in the back. Consumed with rage, Izzy almost kills the deceitful body thief (thus destroying her own hated body). However, Destrii and Izzy share thoughts, and Izzy sees Destrii's childhood suffering to toughen her. In turn, Destrii discovers that finding she was adopted made Izzy withdraw emotionally. Her schoolmates thought of her as a "freak" so she bottled up the knowledge that she's actually a lesbian. "I hide from myself. I dream of escape," she thinks (Gray, *Oblivion*). Thus, her soul and body journey have brought her revelations. Meanwhile, though Destrii too dreamed of escape, seeing Izzy's misery makes her value the home she fled. Both women find an inner acceptance through this sympathy. Looking at her old body, Izzy hears it say, "Yes, it's me. And you've missed me so much ... haven't you? But now I'm back. Everything will be as it was and all the pain can go away.... Just look in my eyes and take my hand, Izzy, and then we'll be together again." She reaches out and accepts the old self she once loathed.

Destrii refuses the marriage awaiting her, and the Matriax beats her until, pushed beyond tolerance, Destrii kills her mother. Destrii offers herself to the Horde, her family's subjects, for punishment. However, the Horde appoint her their new leader. As they recreate her as a psychic energy generator, filled with the power of ten billion telepaths, she prepares to destroy her world. In this tenuous moment, Izzy reminds her of her desire to be free. Destrii chooses the life of an adventurer over a queen, and pours the energy into her uncle's chronon capsule prototype, empowering it and reverting to her amphibian form. The two amoral aliens fly off to explore time and space,

paralleling the Doctor and his companions. Clearly, Destrii's new understanding of free will helps her choose a better life.

Meanwhile, Izzy kisses Fey, claiming her sexuality and attaining the status of the first unambiguously LGBT companion, significantly before Jack Harkness. Having accepted herself, she returns to Stockbridge to reconcile with her parents. As she lightly tells them she had a "pretty busy" day, she has in fact found her place in the world.

Destrii and the Doctor reunite when he discovers her lionlike uncle Jodafra has been aiding Custer to destroy the Sioux. When he cages their children to feed a Windigo, Destrii rejects his horrific plan. Jodafra attacks Destrii, and the Doctor carries her off as new companion (Gray, *Bad Blood*). In the following *Sins of the Father*, Destrii gets a holographic envelope, which ironically lets her disguise as human despite her true alien self. With this, her character continues to slip through boundaries and infiltrate man's world, even while exploring the limits of the status quo.

Olla the "Heat Vampire," a Seventh Doctor comics companion, is actually a Dreilyn, shunned by the community, so she grows up in nomadic poverty (Furman, *Redemption!*). Fleeing her warlord consort, she finds herself on a planet that's becoming an icy wasteland. When the Doctor arrives, she attacks him, desperate for his warmth. Later, she uses her heat powers to kill Ice Warriors in close quarters. Using the cool morality of her species, she must choose between companion Frobisher and rebels in danger ... she makes the harder choice, though Frobisher escapes. Her brutal side is apparent here. When her husband finds them and demands Olla, she decides to kill them both and escape. At this, the Doctor hands her over for a trial, imposing his own morality on the outsider. Clearly, his tolerance for alien perspectives has firm borders.

Attack of the Cybermen introduces the Cryons, a rare all-female species in science fiction television. They appear very alien indeed, with whitish crystalline skin, overlong fingers, and strange gestures. Peri looks especially creeped out as they move these fingers over her while they speak. Of course, casting women as aliens (especially aliens who are traditionally feminine peacemakers and negotiators) stresses their othering. Even with her elongated, strangely modulated speech, their leader Flast is kind and a bit funny. She's also determined, telling the Sixth Doctor, "I hate the Cybermen more than you could ever know, and if I could do anything to frustrate or obstruct their course, I certainly would." She calmly sacrifices herself to bring down the Cybermen and save a people not her own. Her dispassion, like her appearance, is distancing, but portrayed as completely valiant.

Madame Vastra (Neve McIntosh) is one of New Who's most delightful characters. A Silurian dinosaur woman, she prowls Victorian London solving crimes. Not only does Vastra catch Jack the Ripper, she eats him. Doctor

Simeon tells her, "Doctor Doyle is almost certainly basing his fantastical tales on your own exploits. With a few choice alterations, of course. I doubt the readers of *The Strand* magazine would accept that the great detective is, in reality a woman" ("The Snowmen"). He also notices her romance with Jenny Flint (Catrin Stewart) and mentions her "suspiciously intimate companion."

Vastra retorts, oblivious to Victorian mores, "I resent your implication of impropriety. We are married." As an outspoken female dinosaur detective married to her human housemaid, she eagerly breaks every rule of her restrictive society.

Vastra takes command of the battle at Demon's Run and realizes first who Melody Pond is. In "A Good Man Goes to War" she's so compelling not just because of her intelligence, but because she's the only character who chides the Doctor as an equal. She smiles sadly and says of Amy's mysterious baby, "Only you would ignore the instincts of a mother." This is something only a woman would observe and thus something the Doctor has missed. In this moment, Vastra establishes herself as the show's wise matriarch—a rarely seen archetype. This episode marks her first appearance, along with Jenny's. After, the Sontaran Strax lacks a place to go, and Vastra makes him an offer in an internet minisode. With her penetrating observation, she points out how isolated and othered all three of them are on earth: "Jenny here has been ostracized by her family because of, well, let's just say preferences in companionship. I'm the last of my kind as you are the only one of yours. A Sontaran who fought bravely in the best of causes." Strax refuses, then hesitates.

STRAX: Although. This planet of which you speak, London, what do you do there?
JENNY: Solve crimes.
VASTRA: Protect the Empire.
JENNY: There's quite a lot of running.
VASTRA: Some spectacular dresses.
JENNY: And an awful lot of fun.
STRAX: I suppose I could make a preliminary reconnaissance of this London place. It may need to be assessed for military protection.
VASTRA: That's the spirit.
STRAX: Thank you for the opportunity. I look forward to obliterating you both in the name of the Sontaran Empire. I'm not an expert on alien species, but you're both women ones, aren't you?
VASTRA: It has been noted.
STRAX: Don't you need a man one?
VASTRA AND JENNY: No.
STRAX: Am I the man one?
VASTRA AND JENNY: No.
STRAX: So, dresses, then ... ["The Battle of Demons Run—Two Days Later"].

Of course, this scene stresses their independence—Vastra and Jenny can have marvelous, empowered adventures, even in elaborate gowns and without a

"man one." Strax joins their alternative family, reveling in his own alien appearance and eagerness to fight. Despite his differences, he too finds a home in London. Delightfully, they always appear mid-adventure, emphasizing how independent they are of the Doctor.

The Paternoster Gang, as they're known, next appear with a far sadder Doctor, who's sulking in the clouds. "The Eleventh Doctor isn't shy about seeking help from characters he already knows. When he retires from active duty in 'The Snowmen,' it is his 'family'—Madame Vastra, Jenny, and Strax— who worry about him" (Hearn 305). However, Vastra notices he always finds a reason to defend humanity again: "You can't help yourself. It's the same story every time. And it always begins with the same two words." These of course, are "Doctor Who?" Of course, she's right.

"The Name of the Doctor" has Detective Vastra uncovering a secret— the Doctor's grave. When the Doctor hears the Whisper Men have kidnapped her, he heads for Trenzalore, knowing it means his doom. "I have to save Vastra and Strax. Jenny too, if it's still possible. They, they cared for me during the dark times. Never questioned me, never judged me, they were just kind. I owe them. I have a duty." This may be duty, but his description of them suggests great friendship. Jenny dies (temporarily) and as history is rewritten, Strax attacks Vastra. This splits up the gang along their weak points—Strax's aggression and Jenny's heart. Nonetheless, Clara's selflessness restores them along with saving her beloved Doctor.

When Eleven changes into Twelve, the Paternoster Gang provide support once more. They round up Doctor, Tardis, and Clara, and Vastra tries reassuring the Doctor, even assuming a Scottish accent so she'll sound normal to him. Once again, her penetrating wisdom has her making the perfect call: She tells him to project an image of sleep into her mind, but bounces it back onto him. Smiling, she remarks, "I love monkeys. They're so funny." When Jenny demands a clarification, Vastra specifies that the monkeys, in particular, are men ("Deep Breath"). She also counsels Clara on accepting the Doctor's new face, bringing in her usual wisdom and perception to emphasize how the young, handsome Eleven was an illusion that Clara must learn to see past.

At the same time, the episode gets silly as Vastra has Jenny pose in her corset while she arranges newspaper clippings. When Clara enters, Vastra asks her to undress and pose too ... at one point, Jenny must remind Vastra they're married. Jenny's also irritated at acting as the maid, even in private. Still, as she tells Clara. "I don't like her, ma'am. I love her. And as to different? Well, she's a lizard." She can accept her wife's changes philosophically, even as she, a Victorian white woman, is happy to ally herself to the ultimate Other. At episode end, their romance merges with the plot as they must hold their breaths. "Be brave, my love. I can store oxygen in my lungs. Share with me,"

Vastra says and kisses her. They continue through the show as perfect examples of unconventional love who nonetheless make it work, emphasizing how they can save the day by working around the Victorian patriarchal structure.

Cyborg: Compassion and Feyde

Compassion (or Laura Tobin) appears in *Interference: Book One* by Lawrence Miles. Though she resembles Nicole Kidman in military gear with a British accent, or at least, "a version of Nicole Kidman that had gained several pounds and lost all her sense of fashion," she's formidable (86). She hails from a people known as the Remote, splintered from the time travelling voodoo cult Faction Paradox. They teach a philosophy devoid of ethics, so Compassion insists selling weapons is no worse than selling matches or engines, since they can be put to any use. "That's why my people are stronger than yours. We don't try to make things make sense. We don't need morality. We just listen to what the transmissions tell us," she adds (82). Sam calls her "TV Zombie" though Laura's actually joined with the larger consciousness by her earpiece (82). Once she becomes a companion, the Eighth Doctor tells her to abandon it, but she won't. Since it sends signals to her brainstem, after some time on the Tardis, it begins restructuring her malleable DNA.

Laura, though abrasive and arrogant, takes her name from her ironic quip that "compassion" is her middle name. In fact, she is cold, analytical and pragmatic, self-interested to the point of being immoral. In Cornell's *The Shadows of Avalon*, the Doctor drops her on earth with an instruction list including "make friends" and "fall in love" in a rather paternal attempt to help her grow (25). However, this book marks a turning point, as Fitz wonders that Compassion is becoming "a real, emotional, complicated person" (132). Feeling urges building inside her, Compassion describes the change that's coming as "terrible and wonderful at the same time" (171). As she adds, "It's going to tear me inside out, I'm going to die" (171).

As it happens, the earpiece signals are turning her into a living Tardis. As an extraordinary prototype, Compassion soon becomes the prey of greedy Time Lords. President Romana coldly orders "You're our property now. We'll take you back to Gallifrey and mate you with another capsule. I'm sorry, I really am. I'm aware the process won't be pleasant but none of us have any option" (253). Organizing the rape of a companion emphasizes how Romana has chosen expediency and power over the rights of the individual or fondness for the Doctor.

Described by Donna Jeanne Haraway, author of *Simians, Cyborgs and Women: The Reinvention of Nature,* as "trickster figures that might turn a stacked deck into a potent set of wild cards for refiguring possible worlds,"

the cyborg shatters boundaries (66). Thus the female cyborg especially represents "transgressed boundaries, potent fusions, and dangerous possibilities" (Haraway 154). With their own Tardis lost, the Doctor and his companion Fitz flee the Time Lords by traveling in *Compassion*. However, his decision to fit her with a Randomizer against her will is another moment of authoritarian cruelty, compounded with invasive surgery that threatens her body and autonomy.

Created women appear throughout fiction, most often created by the patriarchy. They become a metaphor for the men in power reconstructing women to fit their own models, in a story of exploitation and sometimes rebellion against their conditioning. "The cyborg, definitely not the one in control of the state, is an operator of the state: If the computer was represented as able to overrule human will, the threat of the cyborg is that it can obey orders" (Kakoudaki 170). The Cybermen fit this pattern, as do the Cylons, Borg, Technomages, and other characters in science fiction. All suggest humanity's unease with an increasingly technological world.

As Tardis, she's also a motherly figure, protecting her friends within her. This transformation signals her compliance with gender norms. "Their exaggerated gender is what makes cyborgs matter, and is the reason contemporary feminist discourses have appropriated and proliferated cyborg femininities" (Kakoudaki 166). Since the human character was acerbic and selfish, this transformation could be viewed as "fixing" her.

At the same time, her compliance is subverted: Within Compassion, Fitz and the Doctor are disturbed when the console room appears deep in a forest, "We're beyond the civilized self," the Doctor decides, "in the places of nature and emotion" (Cornell, *Shadows of Avalon* 261). This alien feminine realm frightens him, even as it suggests Compassion's despair and deterioration. "The cyborg is a condensed image of both imagination and material reality," here more than in other scenes (Haraway 150).

In *The Ancestor Cell* by Peter Anghelides and Stephen Cole, the Doctor battles Grandfather Paradox, head of the Faction Paradox. The only way he can see to defeat them is to use the energy holding the Tardis together to destroy them and Gallifrey itself. This act ends the conflict but leaves the Doctor amnesiac. Rescuing him, Compassion drops him on his beloved earth with his embryonic Tardis, so he can recover in safety. In a caring gesture, she drops Fitz a century ahead with a pile of banknotes and a note with the Doctor's next appearance. She also warns him, "Don't let the Doctor completely screw up your life," suggesting the effect the oblivious Time Lord has had on her (Brake, *Escape Velocity* 24). She kisses him, and Fitz thinks, "That's the first time I've ever been kissed by a space-time machine" in a quite objectifying moment (24). She flies off, the ultimate adventurer, and is never seen again. Cyborg theory considers how women can liberate themselves through

technology, a path Compassion certainly claims. Transforming helps her break society's chains forever.

Another companion has just as colorful a backstory. In the *Doctor Who Magazine* comics of 1997, Fey Truscott-Sade, a thirties undercover agent for the British government and Katharine Hepburn lookalike, joins the Eighth Doctor. Fey is a tough-minded character, whose masculine clothing and fondness for companion Izzy made many fans detect an unspoken homosexuality. Nonetheless, she's notably feminine rather than butch. In 1939, Fey saves the Doctor and flies him to Gallifrey in the Tardis so he can heal from a deadly disease. His mind is placed in the Matrix, where Shayde, an artificial being, manages to save him. At last, Fey merges with a dying Shayde to save the day, creating a new self with a merged consciousness. This double self, "Feyde," has Shayde's powers, including space and time travel, phasing, and psychic bullets. Troubled by the new existence, Feyde returns to earth (Gray, et. al, *Wormwood*). There she battles Nazis, while maintaining a quarrelsome relationship with Shayde, whose adherence to time law she resents. Of course, Shayde is a timeless being with a duty to preserve the pattern of history, while Fey is aghast by the horrors of World War II and desperate to intervene by assassinating Hitler. The one-part "Me and My Shadow" follows their quarrels as Fey argues with the amorphous image in a mirror, and he reminds her, "Your passions will be your undoing, Fey. You must obtain a wider perspective" (Gray, et. al, *Wormwood*). The cyborg often represents androgyny—rejecting binary splits to wield powers of both genders. "The cyborgs populating feminist science fiction make very problematic the statuses of man or woman, human, artefact, member of a race, individual entity, or body" (Haraway 178). Cyborgs demonstrate the myriad of sides people possess and the struggle to incorporate new abilities and perspectives into consciousness.

Eldrad, a monster broken and scattered across the galaxy, reconstitutes on earth as a metallic female humanoid. She reads the Fourth Doctor's mind and asks him to take her home. There, however, Eldrad returns to male form and reveals a planet-destroying aggression, planning to be a tellingly gender-specific "king" and "god." To protect Earth, the Doctor and Sarah dump him in a lava pit. Sarah Jane notes, "I quite liked *her*, but I couldn't stand *him*," suggesting women are more sympathetic and inherently kinder than their male counterparts. Nonetheless, both heroes reject the gender-flipping cyborg rather than redeeming him/her (*The Hand of Fear*).

Med-tech Vira from *The Ark in Space* comes from an era so futuristic that she acts robotic—especially jarring in a capable (though unsympathetic) heroine. As she wakes from stasis, she injects herself with the proper medicines, but when asked to treat Sarah Jane, asks, "Is she of value?" Finally agreeing to treat her, she adds coldly, "She will either survive or die. The action of the antiprotonic is not predictable." Vira's devoted to her ark mission

and to their commander. When she discovers he's been taken over by an alien parasite, however, she takes command, regretfully noting, "Noah and I were pair-bonded for the new life." This lack of compassion for her fiancé is, again, machinelike, though it frees her from the traditional role of hysterical loved one so commonly assigned to the show's fiancées.

Cassandra and Agella are Movellan soldiers on Skaro, women working beside the men and under a male captain. When asked why Cassandra has suddenly turned on the Fourth Doctor, he replies, "I'm not sure she was ever *for* me" (*Destiny of the Daleks*). He opens her uniform to reveal circuitry and adds, "Just as I thought. Just another race of robots, no better than the Daleks." He insists their robot-versus-robot war cannot succeed. The Movellans' cold-heartedness is soon apparent as Agella insists, "The Dalek fleet will be wiped from the heavens and nothing will stand in our way of the conquest of the galaxy." Still, Agella considers unnecessary killing a waste and chooses not to arm a bomb called the Nova Device, which would have killed Romana as well. Thus, she shows mercy, however logically. Despite this, the Doctor and the other prisoners disable the robots, emphasizing their lack of worth. This question of the robot's ensoulment is a staple of science fiction, though here answered quite callously. Making them female reflects the questions about women's personhood throughout history, again with a worrying answer.

Chessene of the Franzine Grig interacts with Two and Six in *The Two Doctors*. "She's another hyper-intelligent, elegant, mature, driven woman who, despite all the problematic talk about 'savages,' knows what she wants and will stop at nothing to get it" (Roberts, "The Ultimate Sixth"). Born a massive grey instinctual species, she's experimented on by the bio-geneticist Dastari and becomes a humanlike telepath. Dastari, possessively, considers her his greatest work. Meanwhile, she ruthlessly quests for a time machine, killing Sontarans when they're no longer useful, then plotting to turn the Doctor into her own species. Dastari tries to destroy his own creation and Chessene turns on her creator and kills him. When she tries to escape, she's killed in an explosion. This story emphasizes her remaking by the villain and her desperation for escape.

In *The Almost People*, the miners create gangers (short for doppelganger) who have their memories and personalities but can be discarded at will. The miner Jennifer tells the story of a stronger version of herself who rescued her when she was lost on the moor. This emphasizes her fragility ... in fact, Jennifer dies of exposure, as might have happened on the moor, allowing "strong Jennifer," her Ganger double, to take over. Sacrificing the weak one to remake her as strong suggests an improvement, one of many moral lines that blur through the episode.

Doctor Who's showrunner Steven Moffat has commented that "if there are villains in this story, the villains are the humans who have been maltreating this slave class."

> This much is explicit. The interesting thing is that the underclass here represent a near-perfect mirror of the superstructure.... That identicality exposes the perennial and paradoxical moral identicality of the oppressed and the oppressors; that is, the oppressed and their oppressors are morally identical in themselves [Charles, "Allegory" 168].

The Eleventh Doctor emphasizes the falsity of dehumanization by trading places with his counterpart, finally advising some of the gangers to permanently replace the dead humans and provide their families with loved ones. At last the show emphasizes that duplicates are not just "almost," but "people."

Comedian Bethany Black in "Sleep No More" (2015) is the first transgender actress on the show. However, giving her this part seems a bad metaphor. In fact, she plays a grunt called 474, artificially bred in hatcheries with cloned muscles, low intelligence and brute force. 474 seems attracted to a male teammate, Chopra, who pushes away her hand and complains about 474's broken syntax—another mark of alienness. He calls her "it" and proposes sending her to rescue a "real" teammate, adding, "Why not? That's what it's for." Down to her name, 474 is dehumanized, and finally dies protecting Chopra, in a disturbing message once more about the relative worth of people and nonpeople.

Evil robot women appear in "Bad Wolf," running various game shows on the Game Station satellite. Zu-Zana (a pun on host Susannah Constantine) and Trine-E are the robot hosts of the 2,001st century version of *What Not to Wear*. First, they try to find the right outfit for Captain Jack Harkness (removing his clothes, which amuses him and provides the audience with eye-candy). Then Zu-Zana's arms transform into a pair of scissors and a saw and they try to remove his head. As they attack, the sweet hostesses are reenvisioned as murderous, soulless robots. "Precisely because of their destabilizing potential, the popular representations of cyborgs are sentimental, existential, sexualized, and fetishized in alarming ways" (Kakoudaki 166). As actual blocky plastic robots, they dehumanize female game show hosts, presenting these villainesses as actual pieces of technology. Anne Droid, who kills contestants in *The Weakest Link,* fills the same role, apparently killing the weaker Rose. Meanwhile, Jack responds by blasting their robotic heads off, emphasizing his manly power.

On *Torchwood* as well, "Women are continually presented as physically Other and sexually rapacious, or invaded by the Other (usually an alien or alien technology), making them abject and disturbing to the 'normal,' 'healthy' male onlooker" (Dunn 114). Lisa, Ianto's girlfriend on *Torchwood*, is frozen halfway through her cyberman conversion. He hides her in the basement like a guilty secret, until she turns violent. When Lisa surveys herself, she recognizes her grotesqueness: "I am disgusting.... I am wrong." In fact,

she's fetishized in a metal bikini with lots of skin apparent. Jack brutally destroys her, coating her in barbeque sauce for the pterodactyl to devour. Though Ianto is devastated, Jack uses her as a prop to make his point, insisting, "You brought this down on us. You hid her. You hid yourself from us. Now it's time for you to stand as part of the team.... You execute her or I'll execute you both." With this, her presence becomes a loyalty test, even as she must be sacrificed. She steals the body of a young blonde delivery girl, grotesquely suturing her brain into the other woman's head. (This image of the African-British outsider trying to remake herself as a blonde is problematic on deeper thematic levels of course). However, the inhuman monster cannot survive: Jack and the others kill her, removing the disruptive female presence from Ianto's life. The female cyborg is a chilling monster, a woman whose lack of empathy sets it against the macho heroes.

Eleven is thrilled in "The Doctor's Wife," when his Tardis is downloaded into a human woman. They joke and work as a team, even as she displays an alien understanding of the human experience, biting him and running through conversations in reverse. Eleven's flirty, fast banter with her mirrors another encounter in the following year. In the Asylum of the Daleks, Eleven encounters Oswin Oswald, a clever hacker and entertainment officer who cheekily teases the Doctor. However, as he completes his mission, he discovers why she's such an excellent hacker—she's actually been converted into a Dalek. Both women are hybrids, a spaceship's soul in a woman and a woman's soul in a Dalek casing. "Oswin, much like her malformed soufflés, is ultimately 'too beautiful too live,' her genius IQ and quirky personality constrained by her conversion into a Dalek, albeit one who continues to protest its humanity. The Dalek is, of course, an image which has long been associated with disability in *Doctor Who* lore" (McMahon-Coleman). Their creator Davros famously fashioned the Daleks after his own life-support system, and the Daleks too need exoskeletons to survive. However, Oswin insists at episode end that she is human—clearly refusing to let the disability that her condition symbolizes win.

All these madwomen are coded as "Other"—incomprehensible and alien. Continuing the sexy madwoman archetype seen in both these women and in River Song, the 50th Anniversary special introduces The Moment, a Time Lord weapon "so powerful, the operating system became sentient. According to legend, it developed a conscience." Apparently, the Doctor is the only one brave enough to use "a weapon of ultimate mass destruction when it can stand in judgment on you."

The War Doctor activates the weapon and a ragged, mocking young woman (recognized by fans as Billie Piper) appears in his head. She smirks: "I chose this face and form especially for you. It's from your past. Or possibly your future. I always get those two mixed up.... I think I'm called Rose Tyler."

No. Yes. No, sorry, no, no, in this form, I'm called Bad Wolf" ("The Day of the Doctor"). As a hallucination, she's his conscience, Beatrice guiding Dante through Hell. She's a melding of girl and supergoddess, person and device, heart and brain. "The physical casing of the bomb with its big, red, Tudor Rose-shaped button is the 'body' of the Moment and Rose's image is its consciousness or 'mind.' They are both The Moment" (Nathanael 89).

The War Doctor willingly accepts the consequences of his act as the Moment acts as a sounding board, like most companions. Though she's a superweapon, she eyes him with endless sympathy, emphasizing that she wants to help him. She warns him that his ending the war this way will destroy him. "If you do this, if you kill them all, then that's the consequence. You live. Gallifrey. You're going to burn it, and all those Daleks with it, but all those children too.... One day you will count them. One terrible night. Do you want to see what that will turn you into? Come on, aren't you curious?"

To aid him she opens "windows" to his future, so he can see what detonating the device will make him. In fact, doing so doesn't just test his resolve but makes it possible for Ten and Eleven to aid him. She then shows them all a vision of the Time War, spelling out clues until they understand how to preserve Gallifrey like a painting. At this, she beams. It seems she doesn't just judge those who use doomsday weapons but finds alternate solutions. In companion fashion, "It is her interrogation of the right use of power which results in influencing the Doctor's actions" (Nathanael 85).

Having Bad Wolf specifically as companion gives the War Doctor a more powerful, intimidating, and divinely wise companion than Rose—Bad Wolf can travel dimensions and destroy all the Daleks with a thought. More importantly, she's life incarnate and thus the automatic enemy of mass murder. She thus makes the perfect companion for the warrior.

Perceptive Minority: Bill and Anji

New Who Series Ten begins with the Twelfth Doctor as a St. Luke's University professor … grounded on earth for the first time since his third incarnation. His 2017 companion, Bill Potts (Pearl Mackie), is apparently named for William Hartnell, and her episode one crush, Heather, is named for Hartnell's wife. The male name is a striking flip—an homage to a man but perhaps a signal that she'll be undefinable and more hero than companion. A teen orphan who's African-British and lesbian, Bill is set in several uncommon boxes.

Still, the most important one may be unofficial student. Though Peri and Martha attend college and med school respectively, they take a break to run off with the Doctor. Bill, however, clings to her job and housemates in

Bristol, where the Doctor now teaches full-time. This works well as a dynamic added to Doctor-companion. "Their relationship is that of mentor and mentored—the inspiring older professor and the promising young student. It's affectionate, respectful, grandfatherly. And suddenly he's kind and empathetic, he treats her as an equal and accepts he has things to learn from her too ... they're just really good for each other," Rosie Fletcher of *Digital Spy* explains in her review of Bill's first episode. As one of the few nonstudents on campus, she's another minority—she sits in on lectures since she can't afford the fees. Nonetheless, this allows her to see education with a delight the jaded, grade-obsessed students miss.

Teen fans found her incredibly relatable and authentic. Her sexuality appears as she dates other young women with a charmingly tentative insecurity. When in danger, she looks panicked but fights through her fear. "She gets things wrong, she has a temper. I thought, 'I know her. I could play her,'" Mackie says (Jeffries). She has a casual, contemporary look with denim jackets, tank tops, dresses, and a huge afro with big bows. "Cool without being hipster-quirky, sexy without being a stereotype, she's tall, strong, self-possessed, with great comic timing but also able to bring a level of pathos and emotion to her very first ep that almost dragged a tear out of us" (Fletcher).

Serving dinner at the canteen emphasizes her realistic responsibilities and the compromises she'll make for her education. In fact, this is why the Doctor calls her into his office for their first episode together:

DOCTOR: Er, you're not a student at this university.
BILL: Nah, I work in the canteen.
DOCTOR: Yeah, but you come to my lectures.
BILL: No, I don't. I never do that.
DOCTOR: I've seen you.
BILL: Love your lectures. They're totally awesome.
DOCTOR: Why'd you come to my lectures when you're not a student?
BILL: Okay, so my first day here, in the canteen, I was on chips. There was this girl. Student. Beautiful. Like a model, only with talking and thinking. She looked at you and you perved. Every time, automatic, like physics. Eye contact, perversion. So I gave her extra chips. Every time, extra chips. Like a reward for all the perversion. Every day, got myself on chips, rewarded her. Then finally, finally, she looked at me, like she'd noticed, actually noticed, all the extra chips. Do you know what I realized? She was fat. I'd fatted her. But that's life, innit? Beauty or chips. I like chips. So did she. So that's okay.
DOCTOR: And how does that in any way explain why you keep coming to my lectures?
BILL: Yeah, it doesn't really, does it? I was hoping something would develop. What's that? A police telephone box? ["The Pilot"]

Twelve adds that he's especially noticed her because when she doesn't understand something, she smiles—she actually craves the unknown. With

her curiosity, eagerness to learn, and vivaciousness, their dynamic takes off. They joke and tease. "She's funny and geeky and vulnerable. There's a goofiness to her and a big heart," Mackie says (Jeffries). Being stranded on earth lets her attend school, date, and have fun with friends, while the Doctor tries out responsibility. In another hilariously relatable scene, Bill finds a cheap house to share with her friends and the embarrassing Doctor (introduced as her grandpa even as he pleads for "father" instead) insists on sticking around, even starting a dance party, so he can watch over her. In another, he snarks of Bill's generation, "Emojis. Wearable communications. We're in the utopia of vacuous teens" ("Smile").

Beyond this relationship, they share Christmas, and the Doctor arranges pictures of her long-dead mother. Further, he asks friendly questions about how her dates have gone, introducing grandfatherly support in contrast to his paternal jealousy of Clara's boyfriend. Exceeding her predecessor, Bill proves she can befriend the Tardis, saying, "So the Tardis has dresses and likes a bit of trouble? Yeah, I think I'm low-key in love with her" ("Thin Ice"). Most delightfully, she appears the first companion who's actually read science fiction and thus works as an audience stand-in as well as a believable figure. After Bill references Netflix, the Doctor comments, "So, you meet a girl with a discolored iris and your first thought is she might have a lizard in her brain? I can see I'm going to have to up my game" ("The Pilot").

Meanwhile, making her an unofficial student leaves her less dependent on the Doctor for grades or approval. "Bill is not defined by her relationship to the Doctor, he is not the all-seeing, all-knowing superhero to her simpering helper—she's a cool girl with her own desires, agenda, wisdom and moral compass" (Fletcher). Emphasizing that he isn't her boss, but the reverse, the Doctor tells her in "Thin Ice": "Your people, your planet. I serve at the pleasure of the human race, and right now, that's you. Give me an order." Thus, he emphasizes after decades of authoritative behavior that he no longer wants to take charge, even over young female companions.

Bill's minority categories give the writers a chance to repair some of Who's great criticisms. Twelve begins to wipe her mind in "The Pilot," but when she protests losing the amazing experience, he relents. Clara's theme even plays here, echoing the previous mindwipes she and Donna underwent. Though a lesbian, Bill doesn't use her wiles to seduce everyone like Jack, or constantly babble about dating. Her sexuality is only one small aspect. Fixing one Martha problem unequivocally, she makes it clear she and the Doctor won't ever happen. When asked, Mackie notes, "There is some sort of similarity between me and Freema, but Bill is very different from Martha" (Jeffries).

Fixing another Martha problem, writer Sarah Dollard (of "Face the Raven") sends Bill back to when "slavery's totally still a thing" ("Thin Ice").

Instead of leaving her worried about the danger, Twelve advises her to dress like a wealthy lady—a tactic that mostly succeeds. Lord Sutcliffe offers a racist slur, and Twelve responds by punching him in the face. While Ten lets students bully Martha at the turn of the century, and ignores his own white privilege to take her around Shakespeare's day, Twelve (or the writers) seems to have learned from fans' criticism. When they meet a blue person in "Oxygen," the show gets in a little more humor through flipping:

> BILL: Wha! Sorry, I wasn't expecting. Hello.
> DAHH-REN: Great. We rescued a racist.
> BILL: What? Excuse me?
> ...
> BILL: Sorry. It's just I haven't seen many, well, any of your people.... Look, for the record, I'm not prejudiced. I'm usually on the receiving end.
> DAHH-REN: Oh? Why?
> BILL: What, you really don't know?

However, critic Saffron Alexander protests in "Why the 'Space Racist' Trope Is Bad for Women of Color" that this is problematic. She points out that all the Doctor's companions react to aliens with surprise "So why is it that Bill is the only companion branded a racist for her reaction to seeing an alien with entirely blue skin?" Alexander lists other shows like *Voltron: Legendary Defender*, in which the Black-coded heroine is condemned for similar comments and concludes, "When I see characters like Bill and Allura being branded as "racist" for actions their white counterparts are never chastised for, it feels like these creators are laughing at us—like they're sneering at me and every other Black person out there who so desperately want to see ourselves reflected in our favorite shows and characters, saying 'See, you'd be racist, too, if given the chance.'" Flipping Bill in this way shows a disturbing twist on inclusivity.

In a similar joke further in the season, Bill struggles to tell several Romans that she only dates women, adding, "This is probably just a really difficult idea." To her surprise, the Romans find her "narrow-minded" as one puts it. As he adds, "I'm just ordinary. You know, I like men and women." Thus Bill finds herself in societies that broaden the meaning of normal, emphasizing that twenty-first century Britain isn't the only barometer.

As she questions her assumptions, she also challenges the Doctor. Bringing her youthful perspective, Bill asks how many he's killed and protests how he can get over the deaths of innocents so quickly. As he evades, she stands her ground, pushing with "That's not what I asked!" over and over until he replies. Her shock emphasizes how jaded the Doctor as well as viewers soon become to horror and shakes up the narrative. "Interracial friendships, as well as cross-class friendships, and friendships between people of widely varying ages are a promising part of a political solution to a world perched

dangerously on the brink of the most unfriendly act of all, war," Mary E. Hunt explains in her archetypes study (262). In this model, Bill and the Doctor, perhaps more separated by race, class, age, nationality, species, and orientation than any previous pairing, show viewers how to form connections and point out areas for growth.

Midyear, alien monks invade the earth, offering to save everyone from a deadly bacterial outbreak. However, they require consent from someone acting out of pure love. While the leaders and generals of earth have agendas, Bill cares only for the Doctor, and consents on his behalf. As she tells him desperately, "Doctor. This planet needs you, so I'm making an executive decision. I'm keeping you alive" ("The Pyramid at the End of the World"). She trades her entire world for his life. The next episode deals with the repercussions as Bill is one of the few self-aware enough to resist their new alien overlords. She reaches the Doctor's office to rescue him, but on finding he's complying willingly, she snatches a guard's gun. While previously she trusted the Doctor to save the world she endangered, this time she realizes she can't anymore, crying, "If you help the Monks then nothing will ever stop them and they'll be here forever" ("The Lie of the Land"). Amid stirring music, she shoots him repeatedly—a first for a companion!

Of course, it's a ruse after all, down to loading the gun with blanks. However, as the outside critic, rather than fawning discipline, Bill emphasizes that she needs the Doctor to save earth, not that she'll blindly obey him. Further, the story makes her as powerful as he is, or more. When the Doctor's formidable mind can't overpower the alien machine, he slumps to the ground, weakened. She ties him up while he's unconscious. Standing over him, the stronger Bill bids him a sad goodbye and sets off to sacrifice herself to stop the Monks. She plugs herself into their mind control machine. However, the love she bears for her idealized mother resists it. The Doctor calls it "One pure uncorrupted irresistible image. An isolated subroutine in a living mind. Perfect. Untouchable." Once more, the analytical Doctor fails but a companion's love saves the earth.

In "World Enough and Time," Bill is brutalized beyond any other companion. First, someone literally blows a giant hole in her body. Staring in shock, she dies. Restored to life, Bill spends ten years waiting in a grim hospital, scrubbing floors in loneliness, only to be converted into a Cyberman two hours before the Doctor arrives. "I waited," she repeats over and over, crying.

In Bill's final episode, "The Doctor Falls," she's still a Cyberman. Rachel Talalay, director of both episodes, and Steven Moffat, the writer, certainly put the heroine through the wringer. As Missy puts it, Bill is "Dead, dismembered, fed through a grinder and doomed to spend an eternal afterlife as a biomechanical psycho-zombie." The Master is even crueler, calling her "Robo-

Mop," asking her for "old bras" and shrugging that he "might as well rile a fridge." In fact, though most Cybermen have emotions blocked, Bill spends the episode sobbing, discovering the Doctor can't fix her and volunteering to die rather than be taken over. Increasing the tragedy, the episode shows her looking like Bill, as she perceives herself, so the audience can see her expressive face. Moffat explains, "Bill feels like Bill so in her head … she's still that" (Moffat and Talalay). He compares filming to *Quantum Leap*, in which the character always sees himself as the same actor.

Of course, only the audience and Bill see her this way. Everyone else reacts with hate and fear; her allies cringe from her and even shoot her. Sadly, she can only say "I understand" as she knows she's become a killer machine. In this sequence, the racism trope has been actualized—everyone around her sees her as a monster, while Bill (as well as the audience) still sees the sweet, life-affirming girl. Restricted by her cyber-face from even showing her terrible pain, this racism metaphor compounds the episode's horrors. Even Martha, who was treated as a servant, wasn't reviled as a creature.

Bill's keeping her self for the entire episode is striking for a Cyberman. As the Doctor explains, she's learned to hold onto her identity while living under the Monks and she's exceptional. When the Doctor stays behind to fight and die, she does the same, sacrificing herself as several converted Cybermen do and holding onto the last of humanity to save innocents. However, she survives the battle as the Doctor does not, and falls to her knees, completely hopeless.

In an ambiguous sequence, she either dies or attains a new state of being and goes off with her adored pilot, Heather, from her first episode. Moffat insists Bill isn't dead because it's a "big-hearted optimistic show that believes in kindness and love and that wisdom will triumph in the end" (Moffat and Talalay). He explains, "She *nearly* dies and she becomes something else." Bill, killed and then converted against her will, is now suddenly saved by an omnipotent power. It's rather a random miracle, from someone with whom she didn't even have a first date, but a kinder resolution to give her love and a galaxy to explore, sending her off more like the Doctor's daughter than one of the hasty marriage companions. Moffat adds that he pictures her flying off with Heather forever, but adds that she could come back if she wants. Critics found this ending abrupt, especially since Bill and the pilot's connection didn't seem strong enough to sustain all season. As Heather even offers to restore her human body, it's a miracle indeed … though perhaps one that this sweetest of all companions has earned through the previous episode's terrible purgatory.

Fellow students Shireen, Felicity, Pavel, and Harry join Bill as housemates in "Knock Knock." A modern college group with one Indian and one Asian, they emphasize diversity even as they criticize Bill's taste in music. All

the students are terrified when they move into a haunted house that absorbs them into the walls. Felicity, especially, has claustrophobia, symbolizing additional vulnerability. As they panic, they all suggest Bill's easily-wounded side. Of course, the Doctor, playing Bill's grandfather and their communal protector, manages to save them all.

In the comics, Gabby Gonzalez travels with Ten after Donna leaves. This Mexican-American companion works at her father's restaurant in New York while attending night school for accounting. Attacked by Cerebravores on Day of the Dead, a holiday of weakened boundaries and deep mysticism, she helps the Tenth Doctor defeat them and he finally invites her along (*Revolutions of Terror*). Gabby actually has supernatural powers that manifest through her art. Images appear in her notebook without her drawing them, and butterfly images swirl around her. This can all be viewed as the artist's power made manifest. The Doctor validates her sensitivity, commending the telepathy that's othered her and teaching her to wield her gifts. As she draws and journals for the readers, she's their eyes. Granted, the images also suggest woman as magical mystery whose powers work outside her control, a more problematic gender trope that marks her as uniquely other. Nonetheless, she finds her own companion. Cindy Wu, a social sciences student, soon joins her. In fact, Cindy ardently defends her best friend, inviting herself along to protect her, while hilariously calling the Doctor "buster" and "dude."

The Eighth Doctor first meets Anji Kapoor in the novel *Escape Velocity* by Colin Brake, just after Compassion has departed. "A slight scowl on her coffee-colored skin gave her a petulant, spoiled-child look, but now a warm smile turned on a hundred-watt lamp behind her eyes, which both illuminated and animated her face" (Brake, *Escape Velocity* 8). She's traveled through Europe and America but "What she really wanted, she had decided recently, was to go somewhere further afield, somewhere truly different in every way. Somewhere really *alien*" (11). With these thoughts, she's primed to be a companion. By book's end, she's taken down an alien with her rape defense class moves and broadcast over the alien ship that she's taken it over in a colossal bluff. "Fortune favors the bold," she smirks (237). To top it off, Anji finds herself blowing up ships in a space battle. As she watches the destruction she's caused, she quickly wipes her tears away "before either of the men could notice" and keeps her tough image intact (244).

After, she becomes the first Indian companion, intelligent and relentless but down-to-earth. She's always been the skeptic with no patience for science fiction. What she believes in are numbers. Working as a futures trader, she explains, "It's all a question of keeping on top of the data and extrapolating trends. A bit like playing a hundred games of chess at the same time. I love it" (55).

Like Bill, she's a mass of contradictions, a young woman who doesn't fit.

She left home at only 17, stifled by her family's antiquated attitudes towards women. She's also turned her back on religion. Thus, she's an outsider among her own family and culture, and a minority in the world of others. The cyborg's split perspective, according to Haraway, provides her with deeper insights than a human's by looking from new angles outside of just one species positioning (4). While Anji is literally human, she's culturally straddling different worlds. However, while Bill uses her contradictions to reach out, Anji often fails. The novel *Hope* emphasizes how badly she fits in, even on the Tardis: "In the time she had been with the Doctor, Anji had never quite managed to understand his relationship with the Tardis. The Tardis was a machine, and yet the relationship was very personal" (13). As the book adds:

> Anji watched him muttering to himself as he operated the Tardis controls, talking to the machine as if engaged in a motivational exercise rather than a technical operation. What was he thinking? Anji knew by now that she couldn't second guess, she simply wasn't the right species to read the Doctor's body language or relate to his mindset [13].

The stories inconsistently portray her as either Indian or Pakistani. Despite this bit of wobbly characterization, she's meant to be an audience identification figure; a contemporary, middle-class Briton. Thus, there's a twist, as the companion who feels out of place in Britain and among her family becomes the relatable contemporary audience link to the Doctor's world. For instance, she decides the Doctor's disregard for money—which she's devoted her life to—is "incomprehensibly alien" (Brake, *Escape Velocity* 104).

The Year of Intelligent Tigers emphasizes, not Anji's outsider status, but the Doctor's alienness. When he sides with the enemy and steps over the body of a dead human, she is utterly appalled. "Don't give me that! It's not good enough! You can't put on the sad face—oh I'm so sorry—after the fact! You had your chance to be human and you stepped right past it!" She is struck by his inhumanity, while she bubbles with vulnerable emotions like guilt and discomfort—at one point, she even has the very dark thought of being glad the Doctor has lost a friend too. Her distrust of the Doctor gives her unusual depth and strength of mind, casting her as a more analytical version of Tegan or Bill. With no one being absolutely right, the book offers moral complexity. At story's end, Anji decides the Doctor and Fitz have become her brothers … truly irritating family.

Anji leaves the Tardis when she becomes the legal guardian of Chloe, a young, time-sensitive girl. She returns to her old job and uses some of the knowledge of future trends to make a tidy profit in futures contracts. She also keeps in touch with the next companion, Trix, who continues to feed Anji stock tips in exchange for a cut of the action. She doesn't become a former companion obsessing over what she's lost, but one who can use the

knowledge practically. With this, Anji finds a life outside the Tardis but drops in occasionally—another boundary she defies. "Much like Martha Jones or Captain Jack Harkness, these companions develop a life outside of the Doctor. Apart from the recurring presence of UNIT personnel during the early 1970s, this 'occasional companion' status was a novelty when the *New Adventures* attempted it" (Gulyas).

The Shadow-Self: Gwen, Suzie and the Mara

When Ace and her friends capture the exotic cheetah person Karra in *Survival,* the Seventh Doctor calls her "dangerously attractive." The music surrounding the solitary cheetah is alluring, even romantic as Ace stares into the animal's eyes. She feels excited, like she "could run forever." Ace is discovering her buried wildness, a power she longs to explore. As Karra urges Ace, "Come hunting, sister," acknowledging their shared wildness, Ace succumbs and runs off with her. Many have observed a current of lesbian subtext. Whether or not Ace is falling for the other woman, she's undoubtedly falling for the emerging savagery within herself. This moment transforms the heroine, teaching her about the dark power from within she's never experienced. Stories like this represent a confrontation with the shadow—all the aspects the conscious self has rejected. As Ace bares her teeth and snarls, the Doctor cautions her that if she stays she'll never regain her human side. At last, he guides back to her original self and Ace sorrowfully walks away.

Shadow-moments like this follow other heroines in the show, especially for the more developed characters. "Even if a woman fits a culturally desired feminine image and is happy with her life in a traditional role, parts of herself that she has denied eventually will cry out to be seen and heard, and she will feel the urge to change. Ignoring these vital parts of herself, her various desires or needs, can make a woman act or feel crazy" (Leonard 4). However, embracing this madness is the path to self-actualization.

Gwen Cooper is a capable cop, not a fake kissogram cop like Amy. She has the traditional companion traits—intuition, curiosity, an unwillingness to stay behind. She's also in a stable, loving relationship, something unusual in the Whoniverse. When she discovers the secret agency Torchwood is callously experimenting on murder victims, she protests. Gwen may be the outsider, but she's the one with heart, while those on the team seem to have left their morals behind. By the first episode's end, Jack sees her point of view and invites her to join. Gwen is the viewpoint character like Rose—the ordinary human who guides viewers into the alien world. Jack tells her, "Do one thing for me. Don't let the job consume you. You have a life. Perspective. We need that" ("Day One").

On her first adventure, she faces down Suzie Costello, whom she realizes is committing the murders. She's been mesmerized by the power of the resurrection glove. Though Suzie dies in episode one, and Gwen replaces her, her presence echoes. She returns in "They Keep Killing Suzie," and the two women cheerfully compare working experiences, finding a moment of camaraderie and understanding as they agree it's both "the best job" and "the worst." Suzie observes that Gwen has replaced her completely, creating a parallel between characters. They mirror with their long dark hair, sitting opposite in contrasting red and blue. "Gwen and Suzie, like Harry and Voldemort, Arthur and Mordred, Lyra and Mrs. Coulter, and so many other hero-villain pairs, are inextricably linked. Though Suzie is draining Gwen of life, the invasion goes in both directions: Gwen invades Suzie at the episode's start, walking through all that remains of her, in the form of stored possessions" (Frankel, "Gwen's Evil Stepmother" 96–97).

However, Suzie is draining Gwen's energy to sustain herself. This "signals the repetition of this process of replacement by one's double. As Gwen's body is slowly subjected to the same wound suffered by Suzie the similarities between the two women could not be more apparent" (Rawcliffe 108). Further, Gwen's empathy and guilt is tying her to Suzie, even as Suzie's rapacious greed to live sets them in opposition—the light side and the dark. "By deliberately pairing these two female characters' bodies as not able to co-exist with one another, Torchwood appears to be fostering a narrative environment whereby Gwen must constantly be placed in competition, not merely with other female characters but with herself" (Rawcliffe 108). Suzie represents the evil impulse from deep within, the desire to do harm. This stronger, murderous copy slowly sucks Gwen's life away, until heroic Jack rescues her.

While *Doctor Who* began as a children's show and managed to keep hanky-panky out of the Tardis for decades, *Torchwood* battles aliens with nothing taboo. In fact, most of the characters have sex with one another in their first two years, and add plenty of R-rated alien encounters.

Her first day on the job, Gwen accidentally releases a creature. "This alien, released by Gwen from its formless, imprisoning meteor, reflects a feminine side of her, slighted, ignored, and vicious, longing to escape" (Frankel, "Gwen's Evil Stepmother" 92). Since the alien feeds on "orgasmic energy," Carys (a young woman taken over by the amorphous cloud) frantically has sex with strangers, who dissolve into dust at the moment of climax. She begs the Torchwood team, "Please, get it out of me," emphasizing her unwillingness. Her bodily invasion clearly suggests rape, powerfully evoked by a naked Carys crying in the shower. At the same time, her alien incarnation is powerful, choosing an ex-boyfriend to seduce and kill. Proper, well-meaning Gwen must save Carys, even while tapping into this new sensuality. She volunteers her own body as host. "While this is, on the surface, a selfless gesture

to save Carys, Gwen is also offering the alien a chance to consume her, to unleash this lost feminine presence and eroticism within herself" (Frankel, "Gwen's Evil Stepmother" 92). She resolves the story having sampled an inverse self, wild and sensual instead of buttoned up.

In "Greeks Bearing Gifts," Toshiko's lover Mary is revealed to be an alien. Her light-filled encounter with Tosh is beautiful, but subverted in body horror: "Mary penetrates the bodies of her human victims to pluck out their hearts, and even the pendant she gives Toshiko allows Toshiko to perceive the thoughts of others, an act Toshiko characterizes as an 'invasion'" (Cheyne 47). As such, her grasp and even Tosh's new mental powers become a rape metaphor, one that makes Tosh "feel dirty and ashamed." This shadow self makes her confront her suppressed feelings and gives her frightening power over her teammates—a heady dip into her shadow side that Tosh finally rejects. These sexualized aliens emphasize the repression of ordinary society, with the *Torchwood* characters exploring their buried fantasies like the Hyde springing from beneath their Jekylls.

Gwen's wedding is memorable because she faces down a brutal matriarch for more shadow work. In "Something Borrowed," instantly pregnant, she insists on going through with the ceremony before dealing with the literal alien invasion of her body. Her enemy is the mother shapeshifter seeking the child she's implanted in Gwen.

> She is in a place that she has not been invited to be in, she is highly sexualized, she is violent and murderous, and when she is wounded, her blood is black and more so than red blood would be. Despite this, her motive is her maternal instinct, and she uses that knowledge throughout her quest, taking Gwen's mother hostage in an effort to blackmail Gwen and the team, and telling her, "The bond between mother and child is a wonderful thing" [Dunn 117].

The conflict externalizes Gwen's uncertainty about motherhood but also lets her learn from the monster matriarch, one experienced and powerful in skills she will need to progress after her marriage. By the evens of *Miracle Day*, she's battling invaders with a baby in her arms, emphasizing her savage mom power, blending the bright world and the dark.

Back on the main show, Panna the female shaman rules the Kinda. Karuna is her beautiful apprentice, busy reminding her mentor that men aren't meant to wield power. While the story explores colonialism, it also works as a metaphor for the gender divide. Tegan submits to the male mastermind, Dukkha, and she's taken over by the female trickster, the Mara. Her symbol of snake markings echoes back to ancient mythology as well as the Biblical fall. Mara (a demon in Buddhist mythology) was thus written as a shadow for characters—all their unexpressed attitudes and desires. In *Kinda*, Tegan falls asleep under some windchimes and is transported onto another plane where she's split in half and left to argue about which half is real.

TEGAN: Come on, what are you thinking?
TEGAN 2: Don't you know?
TEGAN: Maybe I do.
TEGAN 2: After all, apparently you'll have been thinking it too, won't you.
TEGAN: But I asked first.
TEGAN 2: So did I.

She returns from this dream-quest inhabited by the greedy, angry Mara. Immediately, she starts enslaving the men around her. She tells a local, "With my help, you could launch an attack, destroy the people who've held your brother prisoner. Yes, you're right. The people in the dome are evil. With my help, Aris, you could become all-powerful. I am the Mara." This demon is "quite mischievous and sexy—quite flirty and lascivious" according to writer Christopher Bailey (qtd. in Tulloch and Alvarado 274). This is Tegan, exploring the dark side she's always rejected in herself and discovering life as a bad girl. When the Doctor snaps her out of it, she's reluctant to tell of her adventure, since it made her feel so powerful and liberated.

Snakedance, the sequel to *Kinda* (directed by Fiona Cumming) sees Tegan having nightmares about the Mara—this monster is coming for her once more. "I'm still possessed, aren't I, Doctor? The Mara from the world of the Kinda is still inside my head somewhere, isn't it," she realizes. The Mara invites Tegan to borrow her dark strength, adding, "You're divided against yourself. A stranger in your own mind. You are pathetic. Look at me! I can make up your mind." Using the snake mark that's appeared on her again, Tegan enters the Mara's chamber, and then explores the mysterious market, a live snake coiling around her.

The Doctor protests, "The Mara is feeding off the fear and panic." Using her own self-possession and will, Tegan reaches inside herself to find stillness. This time, she controls the dark power instead of letting it rule her. As she ends the episode, all she can manage is "The feelings of hate and rage. It was terrible. I wanted to destroy everything." The Doctor assures her it's over, but this darkness lurks inside everyone's dreams, even without a monster to channel it. More doubles appear for similar confrontations in *Black Orchid, The Androids of Tara, Time and the Rani, The Massacre,* and *Enemy of the World.* Each gives the gentler heroine a chance to experience the strength of her alter-ego.

Ghost Light is a gothic story, with a classic *Jane Eyre* housekeeper. Further, her name, Mrs. Grose, directly references Henry James' *Turn of The Screw.* As she warns Ace, who's trying to be the detective, not the damsel, "No one in their right mind stays in this house after dark." The creepy maids silently point hand guns at the Doctor's head, to his shock. In Jungian terms, everyone is enacting their shadow side—all that "nice women" repress—all the Jekylls have become Hydes.

While the female gothic adventure involves the heroine solving the mystery and facing her fears, the male gothic has sacrificed maidens shrieking in nightgowns. Gwendoline, the story's loyal ward, takes the latter role as she insists naively, "But Uncle Josiah is a good man, and a great naturalist too. You'll see when you meet him." Plucky Ace tries to liberate her, even to the point of dressing them both in men's attire. Meanwhile, Mrs. Pritchard, the restrictive lady of the house, quells Gwendoline's confusion with "Your mother would be ashamed if she could hear you. Sitting there dressed like a music hall trollop. It's this Doctor, filling your head with his ideas." She also grabs Ace by the hair. When the resident mad scientist cuts up a maid "to see how it works," Prichard helpfully disposes of her. There's also a hunter who has decided, in this realm of killers and victims, that Queen Victoria would make the ultimate prey. As Gwendoline turns on Ace with the words "Come on, Ace. I don't want to hurt you. It'll, it'll be painless" all turns monstrous. Each character is complicit here, with domesticity subverted into horrors.

Meanwhile, Control, the madwoman locked in an attic, adds a monster to the mix. Enslaved perpetually, she craves freedom and also a chance to grow into a lady. "Because these are the two things her oppression denied her. She was not free to achieve self-actualization, and she was certainly not permitted to attain to what she believed was the highest standard of existence: British gentry" (de Kauwe 153). While all the humans find their buried savagery, Control craves civility, her own unexplored side.

As it turns out, the house is actually Ace's childhood dark side, all she's buried within herself: "It was full of evil and hate left by him. So I burnt the house down. I had to," she confesses at last. By dragging her though these horrors, the Doctor helps her reintegrate with the monstrousness she's pushed into her subconscious and out of sight.

Decades later, the Empress of the Racnoss, a giant spiderlike creature, dominates Donna Noble's place of work. She is the successful mother who, like a truly creepy fairy godmother, grows obsessed with Donna's wedding. She dangles Donna and her fiancé over a gaping hole. "My golden couple, together at last. Your awful wedded life. Tell me, do you want to be released?" ("The Runaway Bride"). She directs a wedding ceremony, forcing them both to say "I do." As they speak, she prepares the couple to become food for her children. However, when Lance pleads that she kill Donna, not him, the Empress seems enraged at his lack of fidelity, again suggesting she's living vicariously. "Oh, my funny little Lance! But you are quite impolite to your lady friend. The Empress does not approve." She releases him, and he tumbles to his death. Thus as an embodiment of the wedding, she seems a bridezilla, with the threat of total domination and life-sucking children engulfing the groom's life. Donna, confronting this side, chooses to move on, now that her

symbolic dark side has disposed of her uncaring fiancé. Having learned her lesson, she grows, becoming a brave companion instead of self-absorbed housewife.

Madame Kovarian is the villainess of Series Six, a strange eyepatched figure spying on Amy's adventures, intruding on her very consciousness. It's soon revealed that Amy has been her prisoner for most of the year. She's the ultimate killer mother, preying on Amy to steal her Time Lord baby.

> Madame Kovarian rules her particular sphere. She's unintimidated by the Doctor and even outwits him. She kidnaps pregnant Amy and steals baby Melody, raising her as a murderous psychopath. Amy loses the chance to raise her child, and must content herself with occasional visits from the unknowable adult time traveler her child becomes. Further, Madame Kovarian makes Amy infertile (it's likely this was deliberate, as a part Time Lord child is powerful, and Kovarian thus controls the only one) [Frankel, *Doctor Who and the Hero's Journey*].

Finally, Amy and Kovarian get their ultimate showdown in the mixed-up world of "The Wedding of River Song." Now far harder as a soldier in an eyepatch of her own, Amy has absorbed all the qualities of her great nemesis. Savagely, she tells Kovarian: "You took my baby from me and hurt her. And now she's all grown up and she's fine, but I'll never see my baby again." Though Kovarian protests that companions don't kill, Amy retorts that the Doctor isn't watching and adds, "River Song didn't get it all from you, sweetie." With this, Amy channels the darkness Kovarian has evoked in her through their many encounters. She reattaches Kovarian's eye drive, torturing her to death at the hands of the Silence.

Only later, as her old self in the real world, can Amy feel the guilt. She tells River, "I killed someone. Madame Kovarian, in cold blood.... I can remember it, so it happened, so I did it. What does that make me now?" ("The Wedding of River Song"). Her shadow descent, as traditionally happens, has left her severely unsettled.

RELATIONSHIPS

Companions' Mothers: Jackie, Francine, Sylvia

Rose is more than the Ninth Doctor's heart—she's also the first companion to involve him in her family life. After miscalculating by a year, he's confronted with Jackie Tyler's anguish over her daughter's disappearance. She slaps him, and he remarks to Rose, "Nine hundred years of time and space, and I've never been slapped by someone's mother" ("Aliens of London"). While surrounded by Rose's chattering, shouting family, the Doctor finds himself watching a spacecraft land on TV, observing from the same playing field as everyone else. He's no longer above humanity but part of them, and it's all thanks to Jackie.

Meanwhile, Jackie remains rather oblivious. "Rose's mother, Jackie Tyler, is painted as a stereotypical working class house frau, more concerned with local gossip and sexual conquests than the apparent crash landing of an alien ship in the Thames" (Larsen 123). Shortly after, Jackie and Mickey burst into the Tardis, and he's embroiled in a messy emotional squabble he's battled so hard to avoid. As Nine drags Rose off again, Jackie confronts him directly: "Just answer me this. Is my daughter safe.... Will she always be safe? Can you promise me that?" ("World War Three"). Caught off-guard, the Doctor responds that he can't, and, plagued with guilt, he delays saving the entire planet. His indifference hides a deep layer of concern as a parent finally holds him accountable. He asks whether Rose will pacify her mother by staying home. "I don't know. I can't do that to her again, though," Rose tells him sadly. Thus Rose "plays parent to her rather 'wild' mum, Jackie" and puts her interests first (Winstead 232). The seemingly unattached companion has a dependent.

All the Doctor can reply is "Well, she's not coming with us" ("Aliens of London"). In fact, Jackie becomes a companion in the Series Two and Four finales as she first infiltrates Torchwood pretending to be Rose, then returns

182

from parallel earth with a massive gun, determined not to let her daughter go adventuring without her. Thus she becomes the first parent (on television at least) to accompany a companion. In the first two years, Jackie has no family but Rose, leaving her more versatile as well as more invested. Rose finds her a husband in her alt-world father whom she befriends on one of her adventures. Thus through her two years with the Doctor, Rose is more than participating in her family life—she's repairing it.

When he regenerates into Ten, there's another hilarious domestic scene as Jackie dresses him in her boyfriend's pajamas and bathrobe and manages to stabilize him with a thermos of tea. As Jackie helps out, always bumbling, she remains fun and goofy, balancing the Doctor and Rose's determination with frivolousness but standing up when it counts. Though the comic relief, she's a fierce fighter when cornered, and even rents a massive truck and winch to pry open the Tardis, supplying cleverness and insight when Rose needs a helping hand.

Mickey has his own odyssey in the parallel world of "Rise of the Cybermen"/"Age of Steel" Rose reveals, "Mickey's mum just couldn't cope. His dad hung around for a while, but then he just sort of wandered off. He was brought up by his gran. She was such a great woman. God, she used to slap him! And then she died. She tripped and fell down the stairs. It's about five years ago now. I was still in school." Mickey has run off without explanation, and during the conversation, Rose and the Doctor both realize they have taken him for granted. In fact, Mickey discovers his gran is alive here. In this new world, he can fix his mistakes:

RITA ANNE: It's been days and days! I keep hearing all these stories. People disappearing off the streets. There's nothing official on the download but there're all these rumors, and, and whispers. I thought that God had disappeared you!
MICKEY: That carpet on the stairs, I told you to get it fixed. You're going to fall and break your neck.
RITA ANNE: Well, you get it fixed for me.
MICKEY: I should have done way back. I guess I'm just kind of useless.
RITA ANNE: Now, I never said that.
MICKEY: I am, though. And I'm sorry, Gran. I'm so sorry.
RITA ANNE: Don't talk like that. Do you know what you need? A nice sit down and a cup of tea. You got time?
MICKEY: For you, I've got all the time in the world.

When his counterpart Ricky is killed, Mickey chooses to stay with his gran and take advantage of the second chance. Only after she dies of natural causes does he return to his friends and resume the fight. This storyline provides an exit, but also emphasizes the tie of love and guilt family brings—Mickey gives up the Tardis, Rose, and his own reality, all to care for the woman who brought him up.

In "Doomsday," Rose chooses the opposite—abandoning Jackie to stay with the Doctor. Here, her romantic love and craving for adventure outweigh her family bonds, to her mother's horror. However, Rose is swept into the parallel world beyond her control. Ambivalently, Rose settles into domesticity with her rebuilt nuclear family—a modern reimagining of the instant marriage departure. (In fact, Rose stresses to the Doctor that her mother is the pregnant one, not her). Soon Jackie has a baby boy, Tony (though she adds that she chose not to name him "Doctor"). Rose returns for Series Four's great Davies reunion, but the Doctor drops her back with her family … and gives her a copy of himself to raise. "You made me better. Now you can do the same for him," he insists. Thus, he is joining her family rather than tearing her from it—a Doctor permanently domesticated at last.

The "real" Doctor flies away. However, Martha's, Donna's, Amy's, Rory's, and Clara's families all weigh in as the show continues—the Doctor's dodging of family drama has ended.

Martha Jones begins her first episode entangled in family drama—her sister Tish calls to tell her, "It's a nightmare, because Dad won't listen, and I'm telling you, Mum is going mental. Swear to God, Martha, this is epic. You've got to get in there and stop him" ("Smith and Jones"). Moments later, her brother Leo calls to protest his twenty-first birthday party, and just as Martha starts answering, her mother calls to object to her ex-husband bringing his girlfriend. Then her father calls in too. Hilariously, all expect her to fix the situation. Martha "serves as a mediator between her divorced, bickering parents. In the role of mediator, she effectively becomes parent to her siblings and to her parents" (Winstead 232). Clearly Martha is drowning in relations. They offer an anchor, a reason to return to normal life instead of adventuring forever.

Her family, like Rose's, continue featuring in the story, as Tish's PR job brings Martha a science fiction mystery in "The Lazarus Experiment." Finally, the Master imprisons them, demeaning them as his cleaning staff, since he can't reach Martha herself. This emphasizes the pain and vulnerability of companions' families—trapped on earth unable to flee. At the end of the adventure, Martha tells Ten that she's come to understand the value of home and family after their adventures: "Spent all these years training to be a doctor. Now I've got people to look after. They saw half the planet slaughtered and they're devastated. I can't leave them" ("The Last of the Time Lords"). Thus, she ends their travels together to comfort them.

There's a touching moment a full year later, when Martha dons experimental transport gear. She flits out of New York only to find herself on the floor of her mother's house. "Maybe Indigo tapped into my mind, because I ended up in the one place that I wanted to be."

Her mother tearfully responds, "You came home. At the end of the world,

you came back to me." Martha continues saving the world, even appearing on *Torchwood*, but it's clear she and her family all stay in touch.

Donna Noble, the next companion, has two parents—the supportive dreamer Wilf (Grandfather) and the angry nagging Sylvia (Mother). Though Wilf has faith in both his granddaughter and the Doctor, Sylvia, "joined a long line of mothers that don't get the Doctor," as Donna's actress notes ("Send in the Clones"). Further, Sylvia becomes the internalized voice within Donna calling her stupid and worthless, the one she battles until she becomes strong and self-directed. Cruelly, Sylvia declares that her daughter skipped out on her wedding for the attention and that she wants a London job so she can snag a man. "Partners in Crime" shows Sylvia's barbed nastiness toward Donna, motivating her to escape mundane life. By "Turn Left," Sylvia's disapproval contributes to the destruction of the entire planet. "I suppose I've always been a disappointment," Donna says, and her mother agrees. Of course, Rose appears to her and tells her she matters. When Donna insists she's "nothing special" and "a temp," Rose responds, "Donna Noble, you're the most important woman in the whole of creation." Rose adds that the Doctor brings out people's self-confidence, explaining, "He thought you were brilliant.... It just took the Doctor to show you that, simply by being with him. He did the same to me. To everyone he touches."

"You're special," the half-human version of the Doctor tells her in "Journey's End." With his knowledge of Donna's thoughts, he adds, "But you really don't believe that, do you?" When they part, he talks with Sylvia and tries to improve the family dynamic, telling her, "I just want you to know there are worlds out there, safe in the sky because of her. That there are people living in the light, and singing songs of Donna Noble, a thousand million light years away." When Sylvia acknowledges that Donna is the most important woman in the universe to her, the Doctor retorts, "Then maybe you should tell her that once in a while" ("Journey's End"). While Sylvia never warms to the Doctor, it can be hoped she becomes kinder to her daughter.

Donna doesn't have a sister, but she has something of a nosy neighbor. Nerys, an attractive blonde with an ugly sneer, attends both of Donna Noble's weddings. Though she appears a frenemy, she fits well as adjunct to Donna's critical mother. There's also some bad Bechdel Test here, suggesting all fictional women must hate each other. In "The Runaway Bride," her first episode, Donna assumes that Nerys is the one to pop her onto the Tardis and when she reaches her reception, she's annoyed to find Nerys moving in on Lance Bennett. In "The Doctor's Daughter," Donna mentions that Nerys got pregnant with twins using a turkey baster, contrasting the other woman's fulfilled life to her own empty one. There's still growth, as Nerys complains about her dress at the second wedding, but seems a bit friendlier.

In the far-different Moffat era, Amy and Rory have little family—Amy

grows up with a disapproving aunt (unseen) and no parents in sight until she recreates them. Mom and Dad feature in only her wedding episode in which they're idyllic and somewhat flat. Unlike Rose's or Martha's mothers, Amy's parents offer little incentive to stay on earth. She and Rory unhesitatingly abandon their old life … an issue only addressed in their final few episodes, when Rory's father protests that they should choose. Unlike Rose, when Amy and Rory are banished forever, they leave their families behind. A touching cut scene, available online, has Amy and Rory's foster child, now all grown, come to Rory's father and offer knowledge of their life together.

Clara Oswald's mom, Ellie, is likewise a flimsy presence in the show. She's more inspiration than active parent, as she died many years before. However, Clara keeps the leaf that prompted her parents' meeting, her mother's book *101 Places to See,* and her mother's expressions about how a soufflé exists in the recipe—component ingredients rather than the finished dish. All these become plot points, giving the dead mother an unusually strong echo through Clara's first year on the show. In "The Rings of Akhaten," a memory of her tells Clara, "It doesn't matter where you are, in the jungle or the desert or on the moon. However lost you may feel, you'll never really be lost. Not really. Because I will always be here, and I will always come and find you. Every single time. Every single time." Nonetheless, like the princesses' mothers in Disney, she's only a ghost, motivating Clara but only through memory. "Her mother is her fantastical hero; a 'great woman' whose philosophy lay in baking and whose infinite legacy her daughter now carries. Clara's past is colored with a sentimentality and wistful reminiscence far removed from the cold reality of tragic loss and of a young woman desperate for control where she has none," Ruth Long explains in "Clara Oswald: A Study of the Impossible Girl."

Clara does get a delightfully embarrassing scene when she drags the Doctor home for Christmas dinner, where he plays her boyfriend for her grandmother and father. Unfortunately, he's forgotten that only Clara can see his projected clothes—to her family, he's naked. ("He's Swedish," Clara babbles.) Hilariously, Gran seems to appreciate the view and is eager to play Twister ("The Time of the Doctor").

Like Clara's mother, Bill's is an inspiring memory. Her first episode has the Twelfth Doctor generously arranging photos of her. However, these prove a plot point midway through the year. When alien monks rewrite history in "The Lie of the Land," Bill keeps herself grounded in reality by imagining she's talking with her long-dead mother from the pictures, and thus she narrates the episode. She bravely plugs herself into the Monks' mental broadcast system, and the Doctor realizes the untainted memory of her mother is strong enough to reclaim the world.

Without a birth mother around, Bill's foster mother, Moira, delightfully

defends her charge. When Bill says she's found a tutor, she asks, "Am I going to have to break every bone in his body?" With an independence shared with Jackie, she dates, emphasizing that she has a life beyond her child. She also provides a loving home for Bill, even as the teen branches out with dating and finding a new place to live. However, Bill has failed to come out to her, a lingering source of tension between the two. Moira gives her two £10 notes as a Christmas present (Bill got her a fancy scarf, which she claims the cash will just about cover) and shows little interest in Bill's excellent grades, suggesting she's rather oblivious to Bill's life.

Most often in Classic Who, the mothers and wives are just window-dressing, clichés with no color or personalities. Mrs. Farrell, the two-dimensional wife of a murdered man in *Terror of the Autons,* has little personality to offer. Mrs. Ollis in *The Three Doctors* has a similar role, as does Meg, the wife in *Spearhead from Space.* Mrs. Smith, landlady in *Remembrance of the Daleks,* does even less. *Planet of the Spiders* has Neska—a mother who spends all her time worrying about her family: "My husband has been taken from me, must I lose my sons as well? I've carried you to the fields at my breast, I've dried your eyes, I've laughed with you through the short years of your boyhood. Now you're a man. Must you leave me alone to mourn?" These women are placeholder "wives" with nothing more to offer. Martha Tyler of *Image of the Fendahl* is the stock "village wise woman," though she's lively and fun. In a humorous moment, Four and Leela kneel on either side, waiting patiently for her to wake.

In *Snakedance,* Lady Tanha provides the exposition through an apparent interest in tradition. She explains, "Life under the Mara must have been gruesome in the extreme," but adds, "It's the root of our culture. The Legend of the Return." She has something of a Roman matron look, all in pink. Between her lines and her fussing over her son (who has a plot, though she does not), she has plenty of screentime but little change.

Miss Jackson works in a control center in *The Hand of Fear,* another pro with no personality. Angela Clifford is a stereotypical air hostess in *Time Flight* while Naia is the standard "oppressed peasant" in *Underworld.* Crane, the nurse in *The Curse of Fenric,* mostly offers clichés like "A little less excitement please, Doctor Judson. Remember your blood pressure." In *The King's Demons,* Lady Isabella spends most of the story locked in a dungeon as a hostage to her husband's good behavior. Keara, Adric's acquaintance in *Full Circle,* is a token female friend, no more. The scripts call for a damsel or helper, but not much of a person.

In *The Greatest Show in the Galaxy,* the judgmental stallholder is a parody of a proper British housewife, sneering at the circus and adding, "Every one of them who's up to no good goes there. We locals wouldn't touch it with a barge pole." Ace and Seven unwillingly buy her horrible fruit and eat it all

so, as the Doctor explains, "We must try and convince her we're nice, clean-living people who eat up all our fresh fruit and pay our way."

Even the final classic show episode, *Survival,* introduces a classic mother calling her son in for supper and a prim middle-aged lady in suit and horn-rimmed spectacles scolding, "Wretched cats! Get out of my garden!! Go on, out! Out! Shoo! Shoo!" Both represent the voice of normalcy, housewives in blissful suburbia, unaware of what's invading.

Family Unit: Nyssa and Tegan

> Tegan is twenty-one, an attractive and intelligent Australian trainee air stewardess, whose brash confidence in her own abilities actually conceals inner insecurity, a state of affairs that becomes clear in moments of stress. On her way to her first real flight she accidentally blunders into the Tardis and thus finds herself being inadvertently abducted by the Doctor. Characteristically her inner bewilderment at the new situation in which she finds herself causes her to assume an attitude of overweening self-assertion, and she begins to take charge of the Doctor and Adric ["*Doctor Who*—The Eighties" 13].

"I'd always wanted to play Lucy in Charlie Brown," Janet Fielding explained, so she decided that her character would be "an Australian Lucy" ("Girls! Girls! Girls! The 1980s"). Tegan echoes Sarah Jane "like her an aggressive, impulsive 'professional'" (Tulloch 218). Fielding adds, "Tegan is young, bright, brash and assertive and she's not at all afraid of putting the Doctor in his place. She tends to charge in without thinking at times, but deep down she's a very caring person" (Haining 202). Like Barbara, Tegan is around thirty—unusual among many young companions.

Unlike Adric and Nyssa, she's the earth companion with a modern woman's take on their adventures. In *Enlightenment,* the Eternals (one in particular) are attracted to Tegan because of the passionate energy of her mind. She's heroic, vowing to free the Frontios colonists and hurling knives to defend the Doctor (*The King's Demons*). Fielding distinguished herself by creating some of her dialogue to afford Tegan more onscreen agency. "I can remember having fights with John about the way the girls were treated," she recalls, describing for example a scene in *The Five Doctors*: "As originally written, the girls went off to make the tea.... I got it changed so that Mark [Strickson] also went off to make tea with the girls" ("Girls! Girls! Girls! The 1980s").

Nonetheless, Tegan's stewardess outfit was replaced by something tighter. "Companion Tegan Jovanka spent much of the 20th season in a white tank top and shorts. The costume gave the impression that gravity would eventually win out" (Leitch). Sometimes she had brightly colored tops with expressive swirls, but others, constricting ballgowns. Of the beige "boob-tube"

ensemble from season twenty (which resembled pajamas more than clothes), Fielding commented: "I had that unspeakable costume that John designed. It was neither warm nor sexy nor interesting nor flattering. I cannot find a good word to say about this costume" ("Girls! Girls! Girls!: The 1980s").

She hides insecurity behind snark and bravado, though some find her abrasive. It should be noted that Tegan (unusually for companions) has family—Aunt Vanessa helps her crush the Bechdel test in *Logopolis* with their feminist exchange.

> VANESSA: Oh, please, dear, do let's get a man from the garage.
> TEGAN: No way. The stories I've heard about the way they exploit helpless women. You want the job done well, you do it yourself, that's what Dad used to say.
> VANESSA: Perhaps some knight errant will stop for us.
> TEGAN: You have to learn to fend for yourself in the outback, you know.
> VANESSA: Your father's farm is hardly the outback, my dear, and neither is this. You know, I can see a garage not even a quarter of a mile away.
> TEGAN: Industry and application, Aunt Vanessa. Air stewardesses are supposed to be resourceful [*Logopolis*].

Tegan's aunt dies because of the Doctor's actions, but she stays with him nonetheless. She spends nearly all their travels complaining and demanding to go home. As such, she's one of the most miserable companions. Her actress's frustration with how Tegan is written as anti-feminist backlash shines through until she finally quits in a huff in *Resurrection of the Daleks*. It's not integrated well into the plot—she "simply has a temper tantrum and says she has seen too much violence" (Muir 339). Its jarring rawness is somewhat realistic— she has no fairytale end but simply gets fed up.

Introduced around the same time as Tegan is teen genius Nyssa. A scientist, she builds several useful devices. While Tegan asks the uncomprehending questions, Nyssa speaks the Doctor's language. Nyssa is one of the few companions who can fly the Tardis and solve problems on her own. Most importantly, she's not one of the screamers. In a raucous, argumentative Tardis, she is often the calming voice of reason. Nyssa "was introduced to us both as an alien aristocrat and a brilliant scientist specializing in bioelectronics," explains Francesca Coppa in "Girl Genius: Nyssa of Traken" (63). Sarah Sutton, her actress, says: "Nyssa is very technical and she's very bright and she's adventurous…" (Tulloch 222). The character comes from a world where intellectuals such as herself are the rulers. Thus, even in lovely clothes and a tiara, she's a true scientist and role model for teens. She's introduced in *The Keeper of Traken* as the Consul's beautiful and pacifist daughter. The Master has taken over her father's body, and Nyssa joins the Doctor hoping to rescue him.

The Doctor is very protective of Nyssa—she has nowhere to return to, and the Master has destroyed her family. With her modest dress and obedient

attitude, she's presented as quite youthful. However, this characterization leaves her vulnerable. In *Logopolis*, Nyssa naively believes the Master is her father and obeys his commands. He gives her a bracelet which he can use to control her behavior, making her choke their teen companion Adric.

Coppa reflects that, as one of two female companions, Nyssa's more individualized than the "token girl" (63–65). She's also not the token alien, teen, or genius, as Adric fulfills all these roles. Thus she's welcome to grow beyond stereotype into person, becoming tough enough to stand up to the Gallifreyan High Council in *Arc of Infinity*.

They are a family: teen Nyssa and Adric as the obedient children, leaving forceful Tegan as the mother. Nathan-Turner describes Tegan as "nice figure, nice legs, who appeals to the men" compared with Adric and Nyssa, teens who "are there for audience identification—the younger audience" (Tulloch and Alvarado 207). The dynamic is highly apparent in *Earthshock*—after the Doctor and Adric quarrel, Tegan follows the Doctor when he storms out, while Nyssa promises Adric she'll intercede on his behalf. Tegan behaves like a real person, crying at her aunt's death and staying with the Doctor because he's her ticket home. As the Master and Doctor engage in tech talk, she insists on including herself. Nyssa, by contrast, is the perfect sidekick, absent of will, useful only as a sounding board. When she discovers the Master has destroyed not only her family but her world, her voice barely escapes a monotone. As a good companion, she stays with Adric and does as she's told.

Still, they all work together as a team. In *Castrovala*, the Doctor is incapacitated by his regeneration and Adric is kidnapped. Tegan and Nyssa fly the Tardis, build a Zero Cabinet, carry the Doctor to safety for miles and climb a cliff, saving him with their heroism. The women also have fun together, a dynamic especially rare on the show: In *Black Orchid*, Tegan is the vivacious life of the party as she dances the Charleston in pink and green gauze, while Nyssa shows off a mischievous side when she trades costumes with her double.

The two women also polarize: Nyssa is highborn, exotic, alien—Tegan is none of these things. Nyssa is sweet, Tegan excitable. Their exits reflect their characters: On the leper planet of the Lazars, Nyssa contracts their disease and finally stays behind to nurse them. "Gratifyingly, Nyssa's decision to become the Florence Nightingale of the Terminus Stations seems very right, very true, to this quiet, understated character" (Muir 325). In Big Finish, their friendship flips their family roles as only time travel can—Nyssa has lived fifty years, while only a few weeks have passed for Tegan. They're still a family, but get to experiment with new roles.

Producer John Nathan-Turner started with Tom Baker's final season. He put his own stamp on the show with splashy newspaper ads ... many of which sexualized new companions Tegan and Nyssa with pouting, glamorous

poses. Under his reign, the Fifth Doctor is often blithely antifeminist and condescending. Nathan-Turner soon kicked out Nyssa the genius and added Peri in her bikini. At the same time, more episodes of the Fifth Doctor's were directed by women than any others (Coppa 64). The partnership of two female companions reflects this. Thanks to the multiple companions and more women on the alien planets, Nathan-Turner's fifty stories earned a Bechdel success rate of 78 percent (Simon).

Controlling Caregiver: Clara Oswald

Oswin Oswald's description of herself, "Is there a word for total scream- ing genius that sounds modest and a tiny bit sexy?" is met with "They call me the Doctor" ("Asylum of the Daleks"). Thus even before she's revealed as a copy of Clara, they're parallel. In the Asylum of the Daleks, Oswin and Eleven quip at lightspeed, keeping a running banter as they try to rescue each other, only to discover Oswin is already dead.

In Victorian England, another copy of Clara and the Doctor parallel again as each fights for control. "No, I do the hand-grabbing. That's my job. That's always me!" the Doctor insists ("The Snowmen"). They begin with her demanding his help and with him withdrawing from the world and refusing to give it. Madame Vastra guards the gate with a verbal test for Clara. When she passes it with the perfectly-chosen word "Pond," she intrigues the Doctor. As they run around together, his fascination only grows.

DOCTOR: Oi, I told you to stay in there.
CLARA: Oh, I didn't listen.
DOCTOR: You do that a lot.
CLARA: It's why you like me.
DOCTOR: Who said I like you?
(Clara kisses the Doctor.)
CLARA: I think you just did.
DOCTOR: You kissed me.
CLARA: You blushed. And we just. Shut up ['The Snowmen'].

Clara begins as the stand-out catering officer and clever governess, and thus is quite a puzzle for the Doctor as he discovers the modern girl. She however shuts the door in his face and tells him to get lost. Only when he saves her life do they start to bond. As he often does with new companions, he confounds her, saves her life, tells her to run, and pulls her into the Tardis. She resists in hilarious fashion, protesting his dragging her into "a snogging booth" and adding, "There is such a thing as too keen" ("The Bells of Saint John").

After the shock about his time machine, Clara uses her own clever

insight to help save the day—another staple of new companions. The story follows the usual pattern until he makes his compelling offer at the end. However, she rejects him, asking incredulously, "Is this actually what you do? Do you just crook your finger and people just jump in your snog box and fly away?" She challenges him "ask me tomorrow."

In the words of Jenna Coleman, "He offered her all of time and space and she said 'Come back tomorrow'"; this Clara isn't instantly willing (Long, "Impossible Girl"). By flatly refusing his offer, she stands out from the other companions. No companion has been a stay-at-home mother (or father for that matter)—and Amy has only moments with her baby before losing her to the paradoxes of time travel. Clara, however, takes her child-raising seriously and commutes, traveling with the Doctor but keeping her job. Later she's seen juggling both at Coal Hill School, where she's a full-time teacher who can even manage dating. She's absolutely a control freak, suggesting her parents' deaths left her desperate to take hold of her life.

> It's evidenced in ways both major and minor. She'll only travel with the Doctor on a Wednesday; keeping to a strict schedule and ensuring that it never interferes with the rest of her life and responsibilities. She relishes the idea of being "the boss" ("Yep, that's me"); thriving in positions of authority, which she actively asserts over the Doctor on several occasions ("Pop off and get us a coffee"). Note that across the episodes Clara continuously tries to get her own way, and more often than not, succeeds at it ("Listen you lot. Listen! Help him change the future. Do it!") [Long, "Impossible Girl"].

She bakes her mother's soufflé over and over until she finally "gets it right" and invents a boyfriend rather than admitting she doesn't have one. She'll use a time machine to cook a turkey rather than serve something else. Clara is eager to travel, kind but arrogant. In fact, "assurance in herself and personal insecurity are not mutually exclusive…. Clara hides her fear and uncertainty, which in turn is what drives her. Now, who else does that remind you of?" (Long, "Impossible Mirror"). Her showrunner and scriptwriter Steven Moffat notes:

> When I first wrote Clara, I thought, "Oh, this is fun. If the Doctor were a young woman living in contemporary Britain, it'd be a bit like her." Clever and presentable and funny but also thinking when is something interesting going to happen? The interesting thing between the Doctor and Clara is she can sort of play the same game he does. She can absolutely do that, she's terribly clever, she's got a wayward ego…. I think for the first time, the Doctor's traveling with someone who's a bit of a loony like him, and that's quite fun [Long, "Impossible Mirror"].

Clara has never been conventional: she prefers the company of lonely Time Lords to other children in playgrounds, she hangs up posters of Roman philosophers and spends time as a nanny instead of doing "young things with young people." The Doctor meets her in modern Chiswick, but only after encountering two other incarnations.

She's automatically a nurturer, seen caring for the little Queen of Years in her second episode, "The Rings of Akhaten." She talks Merry through her stage fright and tells her, "I used to be terrified of getting lost. Used to have nightmares about it. And then I got lost. Blackpool beach, Bank holiday Monday, about ten billion people. I was about six. My worst nightmare come true." As she adds, there was a happy ending. The Healer/Caregiver archetype acts from its own wounds, understanding pain as she relieves it in others. Here, Clara uses just this childhood trauma to heal Merry's.

Everywhere she goes, her caregiver role directs her behavior. "The Caregiver creates community by helping people feel that they belong and are valued and cared for, and by encouraging nurturing relationships between and among individuals and constituencies. Caregivers create atmospheres and environments in which people feel safe and at home" (Pearson 109).

When the local god (another great patriarch) tries to devour Merry, Clara and the Doctor both insist on protecting her. Clara, remembering the Doctor's words that "We don't walk away," drives up on a space-moped to offer the fattened creature a single gift: "The most important leaf in human history." It led her parents to meet and represents all her mother wished to do. Clara and Merry's gentle wisdom have ended the god's devouring more than the Doctor's brave self-sacrifice could. Nonetheless, her skills and interests are traditionally feminine, and her care for children is the most prominent of these. She's flirty, intuitive, clever, and feisty, but all these qualities resemble the traditional list for companions.

With little family to ground her, she's one of the traditional companions who's happy to set aside most of her life for the Doctor's whims. She doesn't particularly grow and change, and her most effective moments appear pleading with others to do things—for instance, in "Day of the Doctor," Clara counsels the three Doctors not to destroy everyone in the Time War, She tells them, "Be a Doctor. You told me the name you chose was a promise." Aside from the unreal Moment, she is the only companion of the episode, supporting all three Doctors and urging them to show compassion.

Clara has a more interesting time trying to get along with the Tardis. Her problem here likely comes from her lack of control—the machine with a mind knows more than she does and directs where they go. Riding inside it, Clara feels helpless. Sensing this, the Doctor gives her a flying lesson, but disaster strikes in "Journey to the Centre of the Tardis." However, as Clara makes her way through the damaged ship, the Tardis leaves her messages and locks out a creature that's chasing her. Grateful, Clara kisses the console. At last, they've made their peace.

She's more protective of the Doctor than other companions, an instinct that seems to come from her teacher status. "Whether she's challenging ancient gods with nothing but a leaf, volunteering to negotiate with vengeful

warriors, chasing ghosts through a haunted house, leading soldiers or saving worlds; this Clara is brave, confident and self-assured in the face of danger" (Long, "Impossible Girl"). As Long adds, "'The Name of the Doctor' is her ultimate fulfillment: worthy of a storybook hero." She can save the Doctor a million times across a million lives, every one of which is heroic.

At the same time, the plot arc of the "Impossible Girl" casts Clara as a puzzle to be solved. As a victim of circumstances with no idea what secrets she's hiding, she loses much agency. Moffat admits, "One of the difficulties with her 'impossible girl' story was that she wasn't actually a participant in it, because she didn't actually know about the mystery" (Asher-Perrin, "Moffat"). On Trenzalore, Clara remembers the Doctor's words from "Journey to the Centre of the Tardis"—he met her as an entertainment officer and a barmaid, but she had no idea why. When the Great Intelligence enters the Doctor's timestream to destroy him at every point, she guards and protects her friend. River warns her she'll be torn into pieces, with nothing remaining of her but faint echoes. Clara replies, "But they'll be real enough to save him. It's like my mum said. The soufflé isn't the soufflé, the soufflé is the recipe" ("The Name of the Doctor").

She dives in and meets many versions of the Doctor, aiding him over and over. In this historic scattering, she has all the knowledge and power he lacks, letting her achieve ultimate control. This is also an act of selfless heroism, scattering herself to pieces to protect her hero. The Doctor saves her in turn and the mystery is solved. This apotheosis matches the teacher archetype well: "The myth of the Caregiver is the story of the transformative quality of giving and even, at times, of sacrifice. It is about knowing we are loved and cared for in the universe, and second about coming to share in the universal responsibility to care and give, not just benefiting from the tree but also becoming it" (Pearson 109). This becomes her moment of transcendence.

Continuing to grow in awareness and ability, Clara can close the Tardis with a snap of her fingers by the fiftieth anniversary. There's a joke when the three Doctors, complimenting themselves on their cleverness, work together to unlock the door, only to discover Clara has opened it from the outside.

After the Doctor changes, Twelve relies on Clara with true devotion—perhaps beyond Eleven's. With his arrival, Clara finds new opportunities to grow and excel. "It's fair to say that Clara is a better match for Capaldi's version of the character—she was always so sharp and quippy against Smith's relative softness" (Asher-Perrin, "Moffat"). Working with the more acerbic and protective Twelve, Clara gains strength herself. "Challenged by her best friend's new and unpredictable persona, it is here that the carefully maintained presence of Clara Oswald begins to slip in earnest: revealing the 'bossy control freak' underneath" (Long, "Impossible Mirror"). When they meet in

a café in "Deep Breath," each calls the other an "egomaniac needy game-player." She's become a Doctor in training.

Still, she keeps her links to normality, especially by dating fellow teacher Danny Pink. The new Doctor doesn't just babysit and take phone messages but actively interferes. He wants to whisk her away on a moment's notice, he wants her to take sides, and he especially wants to judge her boyfriend and decide whether he measures up. Her compulsive lying damages her relationship with Danny. In "The Caretaker," Danny learns the truth and immediately assumes that like the Doctor, Clara is an alien ("You're a space woman, you said you were from Blackpool"). She has clearly picked up enough Doctor-like determination to appear that way. As the episode ends, Danny compares Clara's reflexes to his own as a soldier: "I saw you tonight, you did exactly what he told you. You weren't even scared ... and you should have been." Already she's becoming desensitized to danger. Coleman comments, "They've become adrenaline junkies. Especially Clara. She doesn't fear her own mortality in the same way anymore, so with that reckless abandon comes quite a lot of danger. Especially when you have two similar minds without the person to say, 'You guys...'" (Staskiewicz).

Bidding goodbye to Danny after his sudden death devastates the heroine. First she battles his death, hurling the Doctor's Tardis keys into a volcano to extort him into saving her love. She and the Doctor squabble over who can take charge here and even who is the biggest control freak.

> CLARA: I know what you're doing. You're trying to take control.
> DOCTOR: I am in control. Throw away the key. Do as you are told.
> CLARA: No!
> DOCTOR: Well, either you do as you're told or stop threatening me. There really isn't a third option here.
> CLARA: Do you know what, Doctor? When it comes to taking control, you really are out of your depth ["Dark Water"].

She throws all the remaining keys bar one into the lava, but the Doctor reveals it was a hallucination. He cares for her in this moment, sympathetically reminding her some things can't be changed. "The powerful, sometimes brutal, sense of honesty and passion is coupled with the gentle, always embodied sense of nurture and care that friends provide for one another" (Hunt 260). However, he embarks with her on an epic quest to hell itself: He plugs her into the Tardis, letting Clara's longing and love steer them to the Nethersphere, where they struggle to rescue Danny. At last, however, Clara must let Danny sacrifice himself for the planet. Determinedly, she pulls the trigger herself, shutting down Danny's emotions. Still in love with her, he leads the other Cybermen in defending earth and their still-living loved ones. The Doctor gives him a single chance at resurrection, but Danny nobly uses it to

save the boy he once killed. Clara accepts the death of her love, and finds closure in "Last Christmas."

Clara, like River Song, Sara Kingdom, Katarina, and Adric, dies. In companion style, she sacrifices herself for an innocent in Sarah Dollard's poignant script, "Face the Raven." Rigsy, her friend who has a wife and child, also has a number counting down to his death on the back of his neck. She takes it for herself. However, as Clara admits, she's convinced she can weasel her way out of the sacrifice with cleverness—after the Doctor's example, she's sure she's too wily to die. "I wasn't sacrificing anything. It was strategy. Backup plan, to buy us more time." However, she finally realizes the great rule she didn't account for: Someone has to die, and the death can be transferred, but not canceled.

With her options, gone, she faces death bravely like Danny did. She admits the Doctor's influence has made her reckless: "Maybe this is what I wanted. Maybe this is it. Maybe this is why I kept running. Maybe this is why I kept taking all those stupid risks. Kept pushing it." As she adds when the Doctor blames himself, "Why shouldn't I be so reckless? You're reckless all the bloody time. Why can't I be like you?" On the verge of death, she orders him to continue healing and not to take revenge. This emphasizes her power in their relationship as well as her understanding of him. She faces her death, saying "Let me be brave," and she is.

After Adric's death, the Doctor and his surviving companions are downcast. When he loses Amy, the Eleventh Doctor turns dark and isolates himself. After Clara's death, the Doctor uses her as a mental prop, casting the silent, back-turned figure as his "audience" to whom he can tell his story of survival. She wordlessly writes advice on a chalkboard, like his own mind prompting him. The actress's visible silence emphasizes that she's not real—the Doctor's damsel, not a person in her own right. Continuing his own heroism in "Heaven Sent," the Doctor withstands four and a half billion years of torture to reclaim her. Their bond, while not romantic, is deeper than the Doctor's with most companions. He breaks all the rules of time and space, reaching Gallifrey in "Hell Bent" and taking over the planet just to save her.

The episode's end parallels the Tenth Doctor's treatment of Donna, though with intriguing flips. Many loathed Donna's lack of agency, as the Doctor stripped her of her powers and erased all her memories and amazing character growth, all for her own good. This time, he Clara he cannot live with the pain of losing her (another emphasis on their bond, as he survived the loss of his Gallifreyan family, his entire world, the Ponds, and his wife River—bearing the memories each time.) He offers to wipe her memories, but when she refuses in horror, this time he listens and is convinced. She contends that she never wanted to be kept safe and adds, "These have been

the best years of my life, and they are mine. Tomorrow is promised to no one, Doctor, but I insist upon my past. I am entitled to that. It's mine."

The Doctor realizes she's right, as always. He chooses to wipe his own memories of her, losing his own growth and lessons learned with her (a significant loss indeed, as she is the only companion in show canon to have appeared to every Doctor thanks to "The Name of the Doctor"). She doesn't protest—though if she dies and he forgets her, many of her exploits will be well lost. As their time together ends, he places both their fingers on the button, emphasizing their shared agency—either she will die and he will forget her, or she will survive, protected by her lack of memories on earth, and he will fly away, watching from a distance as he does with other abandoned companions.

In fact, he forgets her. They have yet another touching goodbye as he wanders into a diner (actually their stolen Tardis) and chats with the waitress—Clara in her last alter ego. She guides him through the story of their last adventure, noting how much he must have loved Clara and saying her own silent goodbye. After he leaves, the Tardis offers him an image of painted flowers and a portrait of her, offering its own salute to the companion it admired.

Clara meanwhile, pops into her own Tardis (now accidentally stuck in diner mode with sixties white circles within). Lady Me assures her the Time Lords can restore her destined death, and Clara sets off … but to take "the long way round." Reversing the Doctor's dynamic, she has a same sex immortal companion. Though with only a single heartbeat of life, she embodies enjoying the brief span that remains. With the Doctor unaware she's gallivanting around the galaxy, her ending parallels Jenny the "Doctor's Daughter"—free to have adventures or even return for a sequel, as unencumbered as the Doctor himself. In both cases, the women know the Doctor is out there, but he doesn't know the reverse—the women thus reclaim the agency here in the story's final twist.

Other teachers and caregivers after stalwart Barbara don't fare so well in the show: schoolteacher Jane Hampden in *The Awakening* is like the nagging voice of concern and propriety as she worries that reenactors will get people hurt. Of course, Sir George, in charge of it all, counters with patronizing entitlement: "Why, Miss Hampden, you of all people, our school teacher, should appreciate the value of reenacting actual events. It's a living history" and "So there's been a little damage. That's the way people used to behave in those days. It's a game. You must expect high spirits." From the first, her protests sound painfully overcautious. Of course, her belief turns out to be true—the townsfolk appoint Tegan their Queen of the May and try to burn her alive. Despite her start as a complainer oblivious to local mythology, Jane heroically aids the Doctor and helps rescue Tegan from her fate.

The nurse Norna in *Frontios* folds clothes and hands around soap, though when she's asked, she offers scientific advice. She also wears a military uniform, making her seem less "damseled." She helps Turlough and Tegan, and when she's tied up, frees herself with a knife. In the end, she's a helpful temporary ally.

Governesses can be problematic when all their motivation goes to their charges. *Mawdryn Undead* introduces a classic matron with little personality fussing over the new companion-to-be Turlough at his boys' school, one of the stand-in background women of the series. An older Indian housekeeper, Miss Chandrakala bullies the household staff and insists everything runs smoothly. She has worked for Lady Eddison for many years. However, the pair keep secret that she had an illegitimate alien child. That boy murders her, leaving her mumbling as she dies, "Poor little child." Clearly, for the ultimate governess, her sympathy is stronger than her self-preservation ("The Unicorn and the Wasp").

In "World Enough and Time," a creepy nurse converts people to Cybermen. She's a bully, telling Bill, "Everyone here works for me. There's a floor out there needs cleaning." While she harasses Bill, her new male friend is more like a protector. However, this protector beguiles her into the surgery room and finally reveals himself to be the Master. Thus Bill is sacrificed, friendless in the evil medical lab, with nurse and kindly mentor both turning on her.

Molly O'Sullivan, a Voluntary Aid Detachment Nurse's Aide (don't call her Nurse or Sister), is the first Irish companion, traveling with the Eighth Doctor in the Big Finish adventures. A loyal chambermaid, she follows her mistress Kitty to the Great War. She's known for punching people who tease her, though she's also steadfast and moral. Upon teaming up with the Doctor and flying off in his "Tardy Box," she's perfectly willing to challenge him—even to befriend a planet of apparently benevolent Daleks! However, she presents her own challenge when her first reaction to his ship is a bewildered "...I've been here before." She has perfect knowledge of how to fly, finally explained by her childhood kidnapping by renegade Time Lord Kotris. He's filled her with retrogenitor particles through which he can watch her while he sends her to spy on Time Lords. This ploy objectifies her, and she responds by considering suicide, but the Doctor talks her down. At the same time, it enhances her healing powers to the point of superheroism. When they erase Kotris from history, thus saving her beloved Kitty, Molly realizes she can return home and care for her best friend, which does. In the final *Dark Eyes* story, she sacrifices herself to defeat the universe's villains, taking a stand against evil but also, like Clara, protecting loved ones with her life.

Liv Chenka, a medical technician, accompanies the Seventh and Eighth Doctors on audio adventures. It's actually the Tardis who suggests they come

along; however, the Doctor replies, "Another time perhaps, but not now" (*Black and White*). Finally meeting up with Eight, Liv compassionately provides aid wherever she sees suffering. However, she serves the Dalek invaders in *Dark Eyes: The Traitor,* since the Daleks have decided allowing a hospital will give the people a little futile hope. Liv insists the Doctor should protect the greatest number of people, letting millions of hostages die to stop the Daleks from destroying billions. The Doctor, of course, refuses to play the numbers game. A few episodes later, she joins as companion, only to reveal she's dying from the Dalek adventure, and is being controlled as well. She tries suicide, but of course, the Doctor saves her once again. By needing so much care, she in fact subverts the powerful role of healer into a damsel. Nonetheless, Liv's role is often to keep the other female companion, whether Molly or Helen Sinclair, in one piece.

Time Lady: Romana

While some viewers are disappointed at the lack of a female Doctor, there have been female Time Lords, most memorably the Fourth Doctor's companion.

The first Time Lady seen on the show (aside from Susan, whose species is never absolutely established) is Rodan, the controller on Gallifrey during the Fourth Doctor's presidency in *The Invasion of Time*. On meeting Leela, she complains, "Do you know, I've passed the Seventh Grade and I'm nothing more than a glorified traffic guard?" When Leela tries to enlist her help, Rodan falls back on duty and her beloved "reason," protesting, "But that would be against every law of Gallifrey. Oh no, I could never interfere, only observe" (*The Invasion of Time*).

Still, when the president demands surrender and the Doctor proposes they fight, Rodan takes the latter course. She helps Leela organize the resistance and battles Vardans and Sontarans. She's a practical soldier, but her high-collared pink gown casts her as terribly feminized, even laughable. When they hike across sand dunes, she longs to give up, but the stronger, more determined Leela won't allow it. An encampment of desert folk smirk, "You wouldn't last three days out here" as Rodan bursts into exaggerated tears and admits she hasn't considered food or shelter. As it happens, she's never eaten real fruit or meat or ventured outside. Repelled, she tells Leela, "It's frightening…. It's all so … natural." Presta, one of the capable desert people, contrasts sharply in her tough furs, though she lacks dialogue. She helps the balance the imagery, but it's the young crying woman in pink who emphasizes the sheltered uselessness of the aristocracy.

The Doctor has Rodan save the day but under his direction and even

hypnosis as she applies Quasitronics, the "simple field study exercise" she discounts as useless, and builds a De-Mat gun. She appears a model for Romana, who arrives in the next episode—in fact, there were rumors Rodan's actress had been offered the part, but was unavailable.

The Graham Williams era brought in a frivolous, comical K9 questing with Romana for the Key to Time, with a Bechdel success of about 70 percent (Simon). As Season Sixteen begins, Lady Romanadvoratrelundar arrives as Four's "assistant" quite against his will. As he protests, "In my experience, assistants mean trouble. I have to protect them and show them and teach them and couldn't I just, couldn't I just manage with K9?" (*The Ribos Operation*). While fans were divided on her likability, many saw her as a perfect reflection: In "What Would Romana Do?" Lara J. Scott notes, "Romana is the Doctor with tits. There's not really any getting round that. She's arrogant, witty, occasionally smug, hyper-educated, privileged, curious, compassionate, brave and more than slightly posh."

When Romana first appears, the camera pans up her silver boots and low cut slinky white gown. She's tall and statuesque, with an intricate tiara in her dark hair. A short time later, she teases the Doctor for being old as she brushes her luxuriant curls and he sulks. In her feather-collared white fur coat, she glides about like a movie star. She maintains her girlish side, attempting to wear four-inch purple platform heels in *The Stones of Blood,* as the Doctor complains. Despite her glamour, she's also an intellectual. The Doctor's attempts to condescend to her and ask her to make the tea lead to her responding with her own condescension.

> ROMANA: Very exciting, isn't it?
> DOCTOR: Yes, I suppose it must be for someone as young and inexperienced as you are.
> ROMANA: I may be inexperienced, but I did graduate from the Academy with a triple first.
> DOCTOR: I suppose you think we should be impressed by that, too?
> ROMANA: Well, it's better than scraping through with fifty-one percent at the second attempt.
> DOCTOR: That information is confidential! That President [*The Ribos Operation*].

Despite his orders, Romana subverts him at every opportunity. She also diagnoses his behavior as deriving from "a massive compensation syndrome" and considers writing her thesis on the fact. She invents a key tracker that the Doctor admits is "very clever," though she punches a hole in his beloved Tardis to make it. While she agrees with everything he says, her praise is often sarcastic. Clearly, she's trying to break free from her companion part.

Women's changing roles in the sixties and seventies appeared in "the repeated figuration of powerful feminine archetypes like the hag, the witch, the female warrior, and the ice goddess" (Cornea). Williams argued that after

the instinctual warrior Leela, "the only remaining stereotype" was the "Ice Queen," so that's who he created (Tulloch and Alvarado 213).

> Whereas the swarthy and primitive Leela was coded as exotic and foreign, Romana is the picture of civilized, white womanhood, writ large. Cold, rational and emotionally distant, she takes on the role of the archetypal "Ice Goddess," only here these characteristics are associated less with essential and mystical female powers than with a reasoned and scientific approach to the world. The "restoration of balance" arc seems to speak directly to the state of the nation at the end of the 1970s and the commanding figure of Romana can clearly be read in alignment with Margaret Thatcher's rise to power during this period [Cornea].

As the archetype of "the father's daughter," cool intellect prized above softer qualities, Romana echoes the goddess Athena. "Athena predisposes woman to form mentor relationships with strong men who share with her mutual interests and similar ways of looking at things." (Bolen 81). Passion, fear, and other strong emotions are rejected as useless. "In the midst of emotional turmoil or hard infighting, she remains impervious to feeling as she observes, labels, and analyzes what is going on and decides what she will do next" (Bolen 83). Romana makes a loyal "right-hand woman," challenging Four on occasion but basically obedient. The Athena figure thus often defends patriarchal values, as Romana follows all the White Guardian's dictates—the Doctor is the one to rebel.

On their first adventure in *The Ribos Operation*, she diminishes from her impressive entrance to a more traditional role: a monster threatens to eat her, so she clings to the Doctor and cries for help. "I never imagined. Are there many creatures like that in other worlds?" she babbles. Nonetheless, she springs back, keeping her confidence if not as much dignity as her mentor. In her second episode, Romana is busy usurping the Doctor's role: she flies the Tardis, "by the book" instead of his experienced approach. She steals the jelly babies from his pocket and offers them around. Arrested, she coolly sends K9 to the Doctor for help, even while threatened at gunpoint. When the pirate planet's inhabitants ignore the Doctor, he gets another comeuppance. "Suggest you allow mistress to make contact," K9 chirps, adding (admittedly in a dismissal of her cleverness and tact) "She is prettier than you, Master" (*The Pirate Planet*).

Onscreen, the Doctor mostly has human companions, but Romana and K9 function as the too-literal aliens on occasion:

> DOCTOR: Anyone for tennis?
> ROMANA: Tennis?
> DOCTOR: Yes, it's an English expression. It means, is anyone coming outdoors to get soaked?
> ROMANA: Oh.
> …

ROMANA: K9, what is tennis?
K9: Real, lawn or table, mistress?
ROMANA: Never mind. Forget it.
K9: Forget. Erase memory banks concerning tennis. Memory erased [*The Stones of Blood*].

Romana's seasons "offer an unusual opportunity to see the Doctor inter-acting with a character who shared his background and abilities, but whose goals and experiences are not necessarily congruent with his (Barr). The only reason he gets to be in charge is her youth—she's "nearly 140" to the Doctor's 700-plus. His knowledge from experience rather than books appears con-stantly, as he challenges her to break the rules. This aids in giving her growth as she questions the Time Lords' dictates. "When she first arrives onboard the Tardis in *The Ribos Operation,* she appears to be a much more traditional Time Lord than the Doctor—but by the end of her tenure on the Tardis, the Doctor's influence has allowed her to become her own Romana" (Scott).

John Nathan-Turner though, felt that her intelligence put her character at a disadvantage. "This array of characters possessed such wide-reaching and all-encompassing knowledge and intelligence, we felt the 'baddies' of the stories were complete idiots, or at least they should pack up the minute the Tardis crew reveal themselves" (*The Companions* 33). Teamed up with K9, Romana and the Doctor seemed over-powered. This especially bothered some of the less-progressive viewers. "Unfortunately, many *Doctor Who* viewers found Mary Tamm too aggressive as Romana. They were not yet ready for a companion of her stature" (Muir 270). The Doctor himself is terribly stuck up, particularly the Third. He's excused for being a Time Lord—he actually does know more than everyone else. However, when a Time Lady (his protégé in some ways, and yet biologically his equal) arrives, she is dismissed for showing the same arrogance.

Graham Williams chose to replace Romana because of the actress's "wanting to be liked." With Romana II's arrival, "It didn't seem to make much sense in doing another Ice Goddess. The companion is a storytelling device," he explains (214). As the next season begins, Romana regenerates into the form (i.e. actress) of Princess Astra of Atrios, the final key to time in *The Armageddon Factor.* Regenerating as the helpless princess who was literally transformed into an object emphasizes that she will be more pawn and less controller of events in the future. Romana is cheated in another way—the Doctor regenerates when he dies stopping the Master or saving his compan-ions. His execution at the hands of the Time Lords is filled with pathos. Romana by contrast changes faces as if changing a dress—as a fashion state-ment. (The books add another dimension, explaining that she is infected and another force is taking over her personality.) As Romana jokingly models different bodies for the Doctor, this "suggests the Doctor sees Romana's body

as an object or commodity that can (and should) be easily exchanged for another, more pleasing one" (Schuster and Powers 59). He approves or condemns them based on how they appeal to *him*. First, he complains at her copying Princess Astra's body, then rejects a strange blue form. When she becomes a voluptuous brunette in belly dancer gear, he responds with a disgusted "No, thank you!" He calls a looming goddess "too tall," and insists, "What you want is something warm and sensible. Something that will wear well. Something with a bit of style and, well, style. You know." When she walks in dressed just like the Doctor, complete with scarf and hat, he replies, "Good heavens, that's exactly right. Ha! I never realized you had such a sense of style" (*Destiny of the Daleks*).

The actress, Lalla Ward remarks that her character dressed as the Fourth Doctor to appeal to his ego (the Doctor's, not Tom Baker's, she added specifically). Later she wore a prettier version of the Doctor's ensemble with a silky scarf. She saw her character stopping by "flea markets and second-hand shops" to pick up clothing pieces that appealed ("Lalla Ward interviewed by Gary Russell."). The new incarnation is more Bohemian than glamorous: She wears sensible boots and far more pants than skirts. Ward explains, "My Romana was a contrast to the first one because it was felt the Doctor got on better with someone who didn't seem stuck up" (Haining 102). She's described as "a small, laughing, effervescent figure," more of a traditional companion than her previous incarnation (Haining 102). On her first adventure, Romana II screams hysterically upon meeting the Daleks, in contrast with the Doctor, who hurls his hat over a Dalek eyestalk, pats Davros's head affectionately, and otherwise makes it clear the Daleks are no threat.

Nonetheless, their friendly team-up gained a new appreciation much later—"With the revival of *Doctor Who* in 2005, Season Seventeen found a new, largely female audience who felt little if any connection with the fandom debates of yore," modern critic Liz Barr writes. Lalla Ward married Tom Baker for sixteen months, explaining in a later interview that they were both too committed to their careers (Haining 102). This real-life romance echoes the show romance many fans detected between the characters, as the characters debated temporal physics in a Parisian café or went punting on the river. "Season Seventeen is their honeymoon period, with moments of pure joy slipping in between the interstellar wars, genocides and overdue Gallifreyan library books" (Barr). In *Nightmare of Eden*, they finish each other's sentences and, clutching hands, leap together into an unknown virtual world. "You're a very beautiful woman, probably," he tells her in *City of Death*.

Season Seventeen contains a series of love stories, conventional (Della and Stott in *Nightmare of Eden*, Seth and Teka in *The Horns of Nimon*) and decidedly otherwise (the Count and Countess Scarlioni). For the Doctor and Romana, it's the middle chapter of their story, the year in which they're in sync with each other and the

universe. Season Eighteen will bring entropy, separation, regeneration and Adric, but for five (and a half) stories, we have the pleasure of silly, clever, flawed adventures, and two leads who are utterly content to be together [Barr].

Romana II begins using her technical knowledge in practical ways—she constructs a better screwdriver than the Doctor's, which he keeps borrowing, and she builds time travel devices in Paris and on Argolis. She's highly capable, rebuilding a machine in three minutes in *Nightmare of Eden.*

Ward comments that she never felt she got the girly roles: "They didn't dare tie me up; they just fired me" (Jameson, et al.). When Nathan-Turner took over, he scrapped the team-up of the Doctor, Romana II and K-9, since he saw no reason for these overeducated companions to need anything (217). He likewise destroyed the sonic screwdriver, which he considered too powerful.

Having grown to the Doctor's way of thinking on noninterference, Romana II chooses to stay in E-Space, outside normal reality, and keeps K9. "She has broken the cardinal rule of Gallifrey. She has become involved, and in a pretty permanent sort of way. I think that you and I should let a few oceans flow under a few bridges before we head back home," the Doctor tells Adric (*Logopolis*). In the books, Romana returns and is elected President of Gallifrey. Louise Jameson (Leela) and Lalla Ward go on to do audio adventures ... even a series of team-ups. The two women get a long-term friendship in the audio adventures, which focus on them rather than their individual roles as the Doctor's assistants. After the first, Lalla Ward recalls saying, "If I could do more things with Louise Jameson, that would be very good." Lalla and Louise even swap characters in one adventure (a plot twist proposed by the actresses). Thus they grow and change, but mostly after leaving their companion roles behind.

Other Time Ladies, often cool and aristocratic, make distinct impressions. These are the characters who are the Doctor's equals, or sometimes superiors. "Over ten percent of the Gallifreyan population was female, but no more than a dozen of the thousands of Time Lords were women," the novels relate (*The Infinity Doctors* 47). This explains why there are no female characters in *The Deadly Assassin* and very few seen on patriarchal Gallifrey at all.

The blonde-curled heavily lipsticked Chancellor Thalia (Elspet Gray) sits on the High Council in *Arc of Infinity* and gives a few lines on time travel, thanks to her expertise. Though a token female presence, she shares her colleagues' uniform expediency, telling Nyssa, "What would you have us do? Spare the Doctor and condemn untold billions to destruction? That is the choice we face here."

Since Elspet Gray was unavailable, Flavia (Dinah Sheridan) took her place as High Chancellor in *The Five Doctors*. She has the same blonde curls

and a similar personality. Along with the Lord President and Castellan, she bribes the Master to aid the Doctor in saving Gallifrey. When corruption appears within their ranks, Flavia is revealed as the only one acting in good faith. The Doctor convinces her to trust him, and she helps investigate the president. In admittedly something of a gender cliché, the woman is good and the male leader treacherous. The episode features the High Council giving Flavia the authority to make the Doctor President. Her command that he resume his post is logical, but also naïve (another gender-specific cliché) as the trickster Doctor evades her commands, telling her, "Very well, Chancellor Flavia. You will return to Gallifrey immediately and summon the High Council. You have full deputy powers until I return. I shall travel in my Tardis." Of course, he fails to arrive.

The novels have other presidents appropriate the role, so that they can persecute the Doctor during the "Trial of a Time Lord" arc. Flavia continues to watch over Gallifrey in a few novels. Still, her television appearance cements her role as a goodhearted leader completely unable to control the renegade Doctor.

In "Trial of a Time Lord," the Sixth Doctor is tried by a stern, high-collared woman in an elaborate gown. With her hair hidden under the Time Lord hat, the Inquisitor (Lynda Bellingham) is rather androgynous. "Bellingham takes absolute control as the Inquisitor from the first few minutes of the story, in a role where she could have been nothing more than a talking head. She sits between the dynamic, accusatory Valeyard (Michael Jayston) and the outraged, huffy sixth Doctor like a cool-headed Hermione constantly keeping the peace between Harry and Snape," explains Tansy Rayner Roberts in her essay on the Sixth Doctor.

The Inquisitor appears rigidly fair, even sympathetic when she judges the Doctor—of course, judges establish their morality through impartiality and wise compassion. Those who manipulate the system like the Valeyard are the enemy. At the same time, the character is clearly a product of the patriarchy, to the point where she tells the Doctor, "It has long been accepted that the Matrix is the repository of all knowledge." He must point out the insular nature of such an arrogant remark (*The Mysterious Planet*). Like Thalia, she's an arrogant, self-deluding Time Lord, with the hero Doctor puncturing her blindness. In the end, the Doctor respects her rulings, and suggests she run for president of Gallifrey. Her presence emphasizes that Time Ladies are equal to Time Lords, and she provides a grave contrast to flighty Peri and Mel. In Big Finish adventures, she's given a name, Darkel, and more of an agenda, as she opposes all of President Romana's reforms and rejects off-worlder immigration. Eventually, she challenges her for the presidency.

In BBC Books' the Eighth Doctor Adventures, Miranda is an adopted

daughter and companion. Her name suggests the heroine of *The Tempest*, raised by an aging grandfather far from her inheritance. In *Father Time* by Lance Parkin, the amnesiac Eighth Doctor meets the little girl and discovers she has two hearts. There's even a "Miranda. Miranda Who?" quip (109). The Doctor determines she's the Last One, the final child of a corrupt futuristic empire. Her father, the Emperor, is a Time Lord "a war criminal, a man who'd destroyed whole planets" who may even be the Doctor himself (191).

When Miranda's "parents" (actually a bodyguard and nurse from the Imperial Palace) are killed, Eight raises Miranda until she's sixteen. She finds herself intellectually curious about sex, though she has a powerful control over her body's autonomous systems. When he kisses a young man, she feels nothing except a sense of power over him. Thus, like other Time Ladies, she has an icy coolness and detachment from the human world. Attacked by rebels, she flees to the future as supreme ruler of the universe, insisting that she will end the monarchy and create a universe of freedom. In *Miranda*, a six-issue limited series from Comeuppance Comics, she leads an army and survives numerous assassination attempts. Like Romana and a few others, she grows to heroism through the Doctor's example.

She returns in the novel *Sometime Never...* by Justin Richards, older and with a daughter named Zezanne. At the end, Octan of the Council of Eight (determined to erase the Doctor's companions from history) prepares to shoot Miranda with his Vortex Gun, condemning her to eternity in the Time Vortex. The Doctor capitulates, but Miranda determinedly sacrifices herself, smashing her own hourglass and aging to death instantly. Meanwhile, Zezanne and her new grandfather, presumably another incarnation of the Doctor, depart, finally arriving in a London junkyard in the year 1963.

In New Who, the Time Lords have vanished from existence. Nonetheless, a few return. The Visionary, with her henna tattoos and scraggly hair is cast as a classic trope—the madwoman who can see the future. She gives Rassilon the clues he needs to bring the Time Lords back from their Time Lock. However, all her speech is emotional, maddened riddles as she cries, "Ending, burning, falling. All of it falling. The black and pitch and screaming fire, so burning" ("The End of Time: Part Two"). If she is a typical Time Lady (and few are seen in the episode), she's a force of weakened feminine stereotype. One of the president's female counselors protests all the suffering and proposes they let the Time War end with their deaths. However, the president shoots her callously, caring nothing for the cost of his own life.

Other Time Ladies strike closer to home. A mysterious older woman in a white suit appears several times to Wilf, warning him how to save the Tenth Doctor. When Wilf repeatedly asks who the woman is, she gives various non-responses: "Tell the Doctor nothing of this. His life could still be saved, so long as you tell him nothing" and "I was lost, so very long ago" ("The End

of Time, part 1"). At episode end, the Doctor sees the woman, in red this time, and he looks at her sorrowfully. Like his guardian angel, she meaningfully glances at an alternate target he can shoot to banish them all. Another temptation, whom the Doctor sacrifices to save the earth, she ends the story trapped behind the Time Lock. When Wilf asks the Doctor who she is, once again, the Doctor remains silent.

Speculation runs rampant among fans—is she the Doctor's first wife (Susan's grandmother)? Romana? The Doctor's mother? Grown-up Susan? According to fan rumors on the web, the actress was *told* she was playing the Doctor's mother, but with nothing directly said, this could certainly change. She acts more like a mother or guardian angel than a companion, watching over the Doctor and protecting him from afar.

Likewise, the woman who takes Twelve in and feeds him in "Hell Bound" certainly *could* be his mother as she has kept everything in order "for the boys" (implying a brother?) and is terribly startled to see him. They stare at each other for a moment, and she simply warns him, "They'll kill you." He encounters her in the barn of "Listen," his childhood retreat. He addresses her fondly, but not by name or relationship. Complicating matters, Lady Me guesses the Doctor's mother was human, explaining, "By your own reasoning, why couldn't the Hybrid be half Time Lord, half human? Tell me, Doctor, I've always wondered. You're a Time Lord, you're a high-born Gallifreyan. Why is it you spend so much time on Earth?"—something that confirms the Eighth Doctor's quip in the rather experimental movie, something which fans had basically written off as a lie or misdirection.

The novels, particularly *Unnatural History* and *Cold Fusion*, have suggested that the Doctor's father is called Ulysses and his mother is Penelope. "The man was powerfully built with rugged features, a weathered face with dark eyes; the woman was a redhead, a little plump" (*The Infinity Doctors* 17). Thus, the human Victorian inventor Penelope Gate of *The Room With No Doors* by Kate Orman may be her—she comes from 1883 and has invented a time machine, much like the original concept of the First Doctor. In the novel, she makes many joking references to the First Doctor's adventures, suggesting she was keeping a close eye on him then:

"Imagine paying Shakespeare a visit—"
"Been there."
"Or Marco Polo."
"Done that."
"Or Richard the Lionheart."
"Bought the postcard" [53–54].

She's playful and mysterious, emphasizing that side of the Time Lady repertoire.

Ohila (Clare Higgens) of the Sisterhood of Karn makes a mentor and

formidable modern figure. She appears in the minisode "The Night of the Doctor" in which the Eighth Doctor transforms into the War Doctor and sets up the Fiftieth Anniversary special. In prehistory, wise crones midwived men into life, but also through the final passage into death. Ohila offers this ancient wisdom here to emphasize that with a trained guide, the change needn't be random. She also galvanizes the Doctor to enter the war and end it before all of reality is destroyed. Ohila brings him the dead body of the young woman he was killed trying to save, emphasizing that through his inaction, innocents are dying.

> DOCTOR: She wanted to see the universe.
> OHILA: She didn't miss much. It's very nearly over.
> DOCTOR: I could have saved her. I could have got her off, but she wouldn't listen.
> OHILA: Then she was wiser than you. She understood there was no escaping the Time War. You are a part of this, Doctor, whether you like it or not.
> DOCTOR: I would rather die.
> OHILA: You're dead already. How many more will you let join you? If she could speak, what would she say?
> DOCTOR: To me? Nothing. I'm a Time Lord. Everything she despised.
> OHILA: She would beg your help, as we beg your help now. The universe stands on the brink. Will you let it fall?

She's an enabling force, persuading him to do what he knows he must and giving him the power to save the universe. At the same time, this is a deep encounter with the mystic priestess who "changes life's meaning and direction. She initiates a new relationship to Self, to Other, and to the Divine" (Zweig 191). Using this power, Ohila can rejuvenate the lost masculine force in the Doctor, giving it a path and direction.

In "The Magician's Apprentice," she continues her role as oracle and mentor by advising the Doctor not to fulfil Davros's dying wish. He entrusts her with his will and then goes willingly to his death. As he tells her, "Look after the universe for me. I've put a lot of work into it." All this shows a fundamental amount of confidence in the mentor who remade him. She's unassailable to their enemies, warning coldly, "We are the Sisterhood of Karn. If you do not leave our world immediately, we will take your skin."

She returns in "Hell Bent," to encounter misogyny (most likely) as President Rassilon tells her, "The Sisterhood of Karn has no business in this chamber, or on this planet." She retorts, amusedly, that with the Doctor's return, she's come to see the fireworks. Rassilon is the force of supreme patriarchal power, while she represents the feminine mystical, the "sisterhood," hidden on a distant planet with knowledge the mainstream Time Lords lack. As she criticizes, she undermines the great authority with her cleverness. The Doctor fires the President and takes his place. As he impotently shouts, "I am Rassilon the redeemer! Rassilon, the resurrected! Gallifrey is mine!" he is removed.

However, as the wider, more understanding counselor, Ohila too is ignored and sidelined. As she screams for the Doctor to "Get out of that Tardis and face me, boy!" he defiantly flies away, ignoring her warnings that he is defying time itself by saving Clara. He carries Clara off to the end of the universe, trying to resurrect her, but she finally convinces him that all things must die. Ohila was right, but he was too stubborn to acknowledge it.

Trickster-Seductress: River, Trix and Iris

River meets Ten (and the audience) in Series Four's "Silence in the Library"/"Forest of the Dead." Central to her character, beyond expertise and power, is her foreknowledge of the Doctor's entire life, none of which she's willing to reveal.

Shrouded in smoke following the flash-explosion that opens the Library, River Song is exceptional. Her face illuminated with silver light, she appears in a white spacesuit. Leader of the expedition, Captain of her crew, and Professor of Archaeology, River is of elevated status. Having come from her ship, she has obviously traveled in space and, being an archaeologist, she has also traveled over land. Her bearing is dignified, proving even nobler than whining Mr. Lux, patrician spokesman for his family's corporation. Her familiar, intimate posture with the Doctor—her greeting, "Hello Sweetie"—tells us we've not met with her like before [Burke 157].

She sacrifices herself for him and dies (or rather, her soul is preserved, but nothing more), leaving a tantalizing mystery awaiting him in the future. After this, she begins a long, complex arc that defines the Eleventh Doctor's story. The hero often falls for the shapeshifter, whose many forms echo the shifting moods of a relationship. This archetype brings uncertainty and tension into a story, especially the romantic arc. Shapeshifters represent the tug between trust and mistrust because they are literally two-faced. Faced with one, the hero must decide whether to commit to her or pull back. The Doctor protests: "Doctor Song, just one thing. Who are you? You're someone from my future. Getting that. But who? Okay. Why are you in prison? Who did you kill, hmm? Now, I love a bad girl, me, but trust you? Seriously?" ("The Impossible Astronaut"). She even celebrates her mysteriousness, smirking that he can trust her "but where's the fun in that?" ("Flesh and Stone"). Further, in her first few episodes she comes from the Doctor's future, controlling their encounters. She's a mystery, but one on her own terms, who teases him with the "spoilers" she can't reveal. The shapeshifter also offers esoteric knowledge and exotic skills. Thus, the perfect mate for Eleven has knowledge he lacks and commands every situation. She's tough and powerful in a way he isn't, but also surpasses him in charm and allure.

When Eleven meets River in Series Five, she's heavily made up, with

curled hair and a low-cut evening dress. She even fluffs it before catapulting into space and landing atop the Doctor. Only after does she turn all business and put on military camouflage ("The Time of Angels"). Tom Powers explains in "A Muted Melody: The (Dis)Empowerment of River Song":

> She uses hallucinogenic lipstick on a Byzantium soldier to make the seduced man believe he is standing in a beautiful outdoors setting. As River confidently walks toward the ship's room holding the Home Box (the futuristic equivalent of an airplane's black box), a close-up shot of her high-heeled red shoes is offered to viewers followed by close-up shots showing her holding a gun in her right hand and a purse in her left, which symbolize her complementary masculine-feminine traits.

With all this, she presents herself as alluring femme fatale. There are also a number of cleavage shots for the male gaze. At the same time, River subverts the helpless screaming companion image, teasing, "Don't worry, I'm quite the screamer. Now there's a spoiler for you" ("The Impossible Astronaut"). She knows more about time and the Tardis than the Doctor does and can take care of herself. She even refuses to be a companion, preferring to summon the Doctor when she needs him. He accepts her decision, but hopefully adds, "Call me" in "Day of the Moon."

She also uses the High Gallifreyan stately language subversively, to write "Hello Sweetie" on the Home Box. "River's good-humoredly emasculating application of their ancient language with her flirty, feminine salutation destabilizes any reverential feelings the Doctor may possess for his ancestors" (Powers). In her next appearance, she's masquerading as Cleopatra. To lure the Doctor close, River carves her catchphrase into the ancient diamond cliffs of Planet One, the oldest planet in the universe. Apparently, it's now "the very first words in recorded history" ("The Pandorica Opens") "River's mastery of a language known only to the Doctor combined with her intimate knowledge of his penchant for rescuing damsels-in-distress thus works as the means for her to once more achieve a position of Mastery over the Time Lord" (Powers). Like Ohila, she's seized patriarchal powers and reimagined them for her own goals.

She point-blank shoots a Dalek in "The Big Bang" and, in "Day of the Moon," she offers a cascading array of firepower. She often functions as the Doctor's muscle, sporting greater masculine gifts than his, alongside her feminist allure. Because she helps out, with devastating strength, the Doctor can let her take command.

However, the subplot where she was conditioned from babyhood to be a weapon to kill the Doctor weakens her: Kimberley McMahon-Coleman explains in her essay on disability: "The idea that the feisty, independent, resourceful archaeologist River Song is progressively reduced to a caricature of a femme fatale whose very raison d'etre is to seduce and kill the Doctor is one that is disappointing to many viewers of the show."

Series Six focuses on companion Amy's pregnancy, then their quest to find her stolen child. Through this and beyond, the Doctor battles the mastermind manipulating River's life but soon becomes her new controller. Even as she fights off her childhood conditioning, she devotes her life to him. She even studies archeology just because, as she puts it, "Well, to be perfectly honest, Professor, I'm looking for a good man" ("Let's Kill Hitler").

"Let's Kill Hitler" reveals where River (or rather Melody Pond as she was named) has been—hanging out with her young parents as a dreamy teen obsessed with the Doctor, and thus far from the independent professor she'll become. She throws a delightful trickster wrench into the episode as she hijacks the Tardis, quipping, "You've got a time machine, I've got a gun. What the hell. Let's kill Hitler." She directs the scene that follows, sending entire buildings of Germans into vapors:

> OFFICER: What are you doing here?
> RIVER: Well, I was on my way to this gay Gypsy Bar-Mitzvah for the disabled, when I thought gosh, the Third Reich's a bit rubbish. I think I'll kill the Fuhrer. Who's with me?
> OFFICER: Shoot her.
> (Rory watches as the soldiers fire lots of bullets.)
> RORY: No!
> RIVER: Tip for you all. Never shoot a girl while she's regenerating.
> (River blasts them with her golden energy then takes their weapons.)
> RIVER: Ah! Now, that hit the spot. Thanks, boys. Call me.

She also poisons the Doctor with a femme fatale's trick—lipstick. The Doctor calls her "My bespoke psychopath" and River responds, "I'm all yours, sweetie." Here (in her first meeting with the Doctor from her perspective) she emphasizes her ambivalent agendas of love and murder. Alternately flirting and shooting, her sudden regeneration symbolizes her emotional volatility. Amy remarks, "One minute she's going to marry you and then she's going to kill you."

The poisoned Doctor replies, "Ah well, she's been brainwashed. It all makes sense to her. Plus, she is a woman. Oh, shut up. I'm dying" ("Let's Kill Hitler"). As he succumbs, he pleads with her over and over to become River, something she finally does. By episode's end, she capitulates and gives up all her regenerations (and thus her own unique powers) to save him. With this, she "serves as Moffat's fantasy of the perfect woman who will sacrifice everything for her man" (Powers). Combining this with her regeneration, with which she was "focusing on a dress size," weighing herself, and going shopping, the episode weakens her along gender lines. Since their timelines run opposite each other, the Doctor gives her a diary and abandons her, to Amy's displeasure: as she protests, "she's River and she's our daughter," the Doctor only responds, "Amy, I know. But we have to let her make her own way now." Though his actions may be altruistic, they're cold and heavy-handed.

Condemning River's thinking with her heart in "The Wedding of River Song," the Doctor reveals that, by trying to avoid murdering him, she has foolishly destroyed all of space and time. Now he, the man, must put it right. She admits she would sacrifice billions of lives to save his own, a price he usually rejects even for his companions' lives. More significant is the message she sends out "everywhere" when the Doctor is condemned to die: "To the future and the past, the beginning and the end of everything. The Doctor is dying. Please, please help.... The sky is full of a million, million voices saying yes, of course we'll help" ("The Wedding of River Song").

Though he publicly retorts "You embarrass me," he's touched at her devotion as she begs the universe to intercede for him. Continuing the episode, he initiates the wedding and returns them to his preordained death scene (though protecting himself this time), taking charge of the story, fixing their relationship and her mistakes. In fact, the Doctor conducts their wedding dismissively without explaining his actions to his new family:

> DOCTOR: River, take one end of this [his bow tie]. Wrap it around your hand, and hold it out to me.
> RIVER: What am I doing?
> DOCTOR: As you're told. Now, we're in the middle of a combat zone, so we'll have to do the quick version. Captain Williams, say I consent and gladly give.
> RORY: To what?
> DOCTOR: Just say it. Please ["The Wedding of River Song"].

After he fakes his own death and vanishes, he allows River to be imprisoned for life in the Stormcage Containment Facility to cover for him. She accepts this readily. True, he sneaks her out for dates and adventures, but only with him. She is not allowed a life of her own, only to remain safely locked away until called for. In other scenes, she seems resigned to their one-sided relationship: "When one's in love with an ageless god who insists on the face of a twelve-year-old, one does one's best to hide the damage." She adds to Amy, "Never let him see the damage. And never, ever let him see you age. He doesn't like endings" ("The Angels Take Manhattan").

Despite her resignation at seeming perfect for her husband, she's quite strong in "The Angels Take Manhattan," as an independent noir detective symbolically shaping her own world through the novel she writes and facing harder struggles than the Doctor does. She's also been freed from prison. River refuses to be a companion in the strict everyday sense, telling the Doctor after her parents' loss that she'll travel with him "Anywhere and anytime ... but not all the time." Perhaps she senses that to retain her total mystery and allure she must pop in and out of the Doctor's life provocatively instead of letting him watch her brush her teeth.

However, when she loses Amy and Rory, the Doctor deals with his own grief, then adds, "River, they were your parents. I'm sorry, I didn't think."

Her dismissive comment that the loss of her parents "doesn't matter" reveals much: "Her words reveal a conflicted inner truth. What she may actually be saying is that her true emotions toward this situation cannot matter as she must subsume her feelings of grief in order to remain strong enough to comfort the child-like Doctor" (Powers). His narcissism extends to her very life—with years to consider how to save River Song, his best idea is to record her thought patterns and transfer them temporarily into the library to exist in a limbolike database until her pattern degrades. Once again, she's trapped in a prison.

After this event in her timeline, Clara and River meet in a dream conference in "The Name of the Doctor." There, they reveal that Eleven never told Clara about her and never visited the saved copy of River as "He doesn't like endings." On Trenzalore, she guides Clara and Eleven like a guardian angel, another idealized feminine figure. The Doctor appears oblivious to her advice, but when she pleads, he suddenly acknowledges her.

> DOCTOR: You are always here to me. And I always listen, and I can always see you.
> RIVER: Then why didn't you speak to me?
> DOCTOR: Because I thought it would hurt too much.
> RIVER: I believe I could have coped.
> DOCTOR: No, I thought it would hurt me. And I was right.

With this, he makes another scene all about himself. River, meanwhile, urges him to say goodbye and he does, though she leaves him (characteristically) with a final puzzle: "Oh, there's one more thing.... I was mentally linked with Clara. If she's really dead, then how can I still be here?" She doesn't answer the riddle, only departing with "Spoilers. Goodbye, sweetie" ("The Name of the Doctor").

After this death scene, she returns (out of order) in "The Husbands of River Song" to interact with the new Doctor. Twelve recognizes her, though she can't say the same and assumes he's the medical doctor she's ordered. In this goofy episode with plenty of slapstick, the Doctor is aghast that she's married King Hydroflax, a disembodied head. As she coos, "My one true love. The only husband I will ever have," he can't stop fidgeting. In this final River episode (to date), he and the audience finally see River unsupervised and discover she actually finds romance and adventures without him. When she describes the Doctor as "terribly useful" rather than "someone special," he discovers more truth than he's prepared to handle. Meanwhile, River asserts her superiority: "What's that face? Are you thinking? Stop it. You're a man, it looks weird." She even adds, "You know who you remind me of? My second wife." Handsome stud Ramone shows up and River kisses him, mentioning that they're married though she wiped it from his memory, emphasizing her power over him and every other man around. "Well, you were being annoying," she concludes. The Doctor is truly disgusted.

Though her violent agenda seems far from the Doctor's, she's stealing a prized diamond (her real motivation) from an immoral murderer and she's invented a sonic trowel—she's still following in his footsteps. She also has a spray that creates different evening gown looks for a rather girly gadget—an asset as she switches from archeology to fine dining. In a fun gender-flip, she's given the Doctor the codename Damsel in Distress. "Apparently, he needs a lot of rescuing," Ramone concludes. When their enemies demand to know where the Doctor is, River protests that she doesn't know and that she'll make terrible bait as the Doctor isn't in love with her. A mental scan proves she truly believes this. She admits she's "the woman who loves the Doctor" but adds, "Whoever said he loved me back? He's the Doctor. He doesn't go around falling in love with people. And if you think he's anything that small or that ordinary, then you haven't the first idea of what you're dealing with." As she confesses, both angry and resigned, "When you love the Doctor, it's like loving the stars themselves. You don't expect a sunset to admire you back. And if I happen to find myself in danger, let me tell you, the Doctor is not stupid enough, or sentimental enough, and he is certainly not in love enough to find himself standing in it with me!" She makes a good point—she has waited in prison for years while the Doctor swings by when he chooses. While her life has been tied to his from birth, he's had decades of adventures without her. Of course, Twelve, trapped beside her, smiles and she finally realizes who he is. After a moment of teasing ("Hello, Sweetie"), they break into a coordinated escape, reaching for and finding their perfect teamwork. As they run, there's still time for a bit more goading.

> DOCTOR: So, King Hydroflax?
> RIVER: Oh, how many times? I married the diamond.
> DOCTOR: So you say.
> RIVER: Elizabeth the First.
> DOCTOR: Ramone.
> RIVER: Marilyn Monroe.
> DOCTOR: Stephen Fry.
> RIVER: Cleopatra!
> DOCTOR: Same thing.

Bantering, the pair reveal that they each have had romantic indiscretions and will have to live with the time-traveling vagaries of their marriage.

Showing jealousy for the diamond as well, the Doctor trades it away, encouraging a local man to turn it in for the reward and construct a dazzling restaurant. On Christmas Day, River awakens to find all ready for her—a romantic moment but another of the Doctor taking charge. They have their final date at the Singing Towers of Darillium, and the Doctor gives her a Christmas present—her own sonic screwdriver. With all his elaborate arrangements (done without confiding in her directly), she still understands

her death is approaching. Meanwhile, the Doctor shows that she matters to him, describing the towers as a metaphor for himself and his love for her: "They've been there for millions of years, through storms and floods and wars and time.... All anyone will ever tell you is that when the wind stands fair and the night is perfect, when you least expect it but always when you need it the most, there is a song." Thus, he shows he cares in his own way, even with their painful imbalance.

Another interesting character is Tasha Lem, who may even be River in some form. She appears between "The Name of the Doctor" and "The Husbands of River Song" to narrate "The Time of the Doctor," demonstrating her agency. As the Mother Superious of the Papal Mainframe, she rules the Church of the Silence that once brainwashed River (making this quite circular if it is her). Upon meeting, Eleven bows, then they instantly start flirting:

TASHA: Hey, babes.
DOCTOR: Loving the frock.
TASHA: Is that a new body? Give us a twirl.
DOCTOR: Tash, this old thing? Please, I've been rocking it for centuries.
TASHA: Nice though. Tight.

Uncharacteristically, he asks Clara for some alone time with Tasha. When he is drawn by a message from Gallifrey, Tasha she forbids him to let his people return to the universe and directs all the galaxy's villains: angels, Cybermen, Daleks, and so on to begin the Siege of Trenzalore, the Doctor's destined final battle. However, the Doctor returns to find the Daleks have killed Tasha, replacing her with a Dalek puppet of herself. Instantly turning to manipulation for her own good, he goads her with jealousy for Clara to make her reclaim herself from Dalek control. She slaps him. He kisses her. When she returns to herself, she tells him to run, and he replies, "Listen to me. You have been fighting the psychopath inside you all your life. Shut up and win. That is an order, Tasha Lem."

This line strongly suggests she's River, though she might just be a similar character. Like River on several occasions, Tasha sacrifices herself, adding, "None of this was for you, you fatuous egotist. It was for the peace. Fly away, Doctor!" Later, she comes for Clara in the Tardis, to bring her to the Doctor. She tells her, "Flying the Tardis was always easy. It was flying the Doctor I never quite mastered" (another suggestion that she's River). As she concludes, "He shouldn't die alone. Go to him." The Doctor's emotional well-being is her central focus. Of course, Clara saves the day, making Tasha the Doctor's rescuer during her final appearance.

Beatrix MacMillan appears in the Eighth Doctor Adventures novels, with a name likely referencing Tricia McMillan from *The Hitchhiker's Guide to the Galaxy*. The Eighth Doctor first meets her in *Time Zero*, and she stows

away until he discovers her in *Timeless* and she goes on to become a companion. She's a streetwise trickster and con artist, funny and blunt: "Never mind," she says in a particularly tense moment to Guy in *Timeless,* "Your underwear was dirty anyway, right?" She rejects the traditional ingénue's sweetness, instead stealing and treating life as a challenge. It's clear she comes aboard for the business opportunities all of time and space can offer. "Beware of obsession, Trix. It isn't something you have, it's something that has hold of you!" warns the Doctor in *Emotional Chemistry.* Once again, he must police the overemotional trickster.

In *The Gallifrey Chronicles,* the police identify her as "Patricia Joanne Pullman," murderer of Anthony Charles Macmillan. This may be her real identity, but she's also gone by The Grand Duchess, Crystal Devine, Tee-Ex, Natasha, Susan Canonshire, Ms. Atherton, Nat, Mac, Tricia MacAlister, and so on, leaving her the mystery woman in truth. She uses lies and retellings as her tools: On one adventure, Trix meets the famed princes in the Tower and tells them a rewritten Cinderella starring two boys. Continuing to bend reality as she likes, she convinces an obnoxious lord to meet for an assignation, but only so she can use the pass he gives her to sneak out (Richards, *Sometime Never...*).

She ends the Eighth Doctor Adventures by beginning a romantic relationship with fellow companion Fitz Kreiner. In *To the Slaughter,* he tells her, "Trix, you're hard, devious, manipulative and you're always trying it on. But at least with you I always know where I am." Later, she adds: "Well, it kind of snuck up on me. And him, I think. We were, er, workmates. He was honest. What you see is what you get with Fitz. No matter what was happening he was ... well he was Fitz. I trusted him with my life, so often it felt like the most natural thing in the world. He didn't play games, no hidden agendas or emotional baggage" (*The Gallifrey Chronicles*). Clearly, the eternal trickster values the straight shooter, and the pair fall into a trusting relationship—something of an echo of the Doctor and River.

Hilariously, the Eighth Doctor holds auditions for a companion in *Situation Vacant* (in a parallel to the actors' real lives). "Traveler in time and space seeks male or female companion with good sense of humor for adventures in the Fourth and Fifth Dimensions. No experience necessary. No time wasters, no space wasters please." Starting off, out-of-work aging actress Tamsin Drew (Niky Wardley) gets the job (though she auditions while playing someone else of course). He's struck by her total boredom and ennui—basically the opposite of his usual criteria. Clearly, she's a shapeshifter, like many trickster characters. Of course, the trickster is never completely trustworthy ... and may not be entirely altruistic. She calls him out, protesting, "Oh great! Everybody's dead, but that's okay. The Doctor's got a clear conscience!" In a surprise twist during their travels, Tamsin tells the Doctor she's sick of his

self-absorbed adventuring and leaves with the Meddling Monk instead. She and the Monk set off to find "some old friends who also have a score to settle with the Doctor" to "combine their talents" (*The Resurrection of Mars*). In the two-parter *Lucie Miller/To the Death,* Tamsin realizes the amoral Monk has misled her and is exploiting innocents for his own gain. She returns to the Doctor to help stop him. However, the Daleks suddenly kill her, leaving the audience reeling. While an entertaining character, she thus has a truly memorable impact on the series.

In the novels and audiobooks, Iris Wildthyme is a flirtatious renegade Gallifreyan. She describes herself as a "transtemporal righter-of-wrongs, wronger-of-rights, meddler, artist, writer, glamourpuss, occasional Time's champion, and very old flame of the Doctor" (*The Blue Angel*). Meanwhile the Third Doctor calls her an old, dear friend but also "an oafish clodhopping harridan" (*Verdigris*).

Her first three regenerations look strikingly like celebrities Edith Sitwell, Shirley Bassey and Beryl Reid, respectively (women who strongly resemble William Hartnell, Patrick Troughton and Jon Pertwee). She is apparently outside the Time Lord elite and calls Time Lords "your own people" not "our own people" (*Verdigris*). "Her mother had vanished when Iris was quite small, into the dawn with a man who was a great deal older, an offworlder" (*Scarlet Empress* 63–64). Thus, Iris may be half-human like the Doctor is rumored to be in the film.

She's a consummate liar, whose stories are all quite suspect. She tells the Doctor she's from the Obverse (an alternate universe) in *The Blue Angel* but may be lying. She claims many of the Doctor's adventures for herself, as she either tells tall tales or hints that her life has paralleled his: "After all I've survived! Giant Spiders on Metebelis Three, the Cybermen tombs of Telos, the Drashigs in feeding frenzy on their fetid swamp world" (*Scarlet Empress* 32). As she adds: "Seven of me were taken to the Death Zone on Gallifrey. Someone had reactivated the Games they used to play there. Each of my selves, present, past and future, was given a relevant companion and playmate, and we were forced to battle our separate, and then collective ways, past Ice Warriors, Ogrons, Sea Devils, Zarbi, Mechanoids and Quarks, to get to the Dark Tower. Good job we only got rubbishy monsters to battle, eh?" (*Scarlet Empress* 59).

Iris' Tardis is, she claims, an experimental one, left to die on the mountains of Gallifrey by the Time Lords (*Veridgris*). Its chameleon circuit is broken and it resembles a beaten-down, cluttered double-decker no. 22 to Putney Common bus. Ironically, it's smaller on the inside. Paul Magrs crafts Iris Wildthyme as a sort of "anti–Doctor" who drinks heavily, smokes, and generally kidnaps her companions. Her companions are more provocative, including Jenny Winterleaf, the "butch dyke traffic warden" who "got the

runs" as they went through the vortex, and Tom, the African-British gay man who worries he's destined to impregnate his own mother. There's even a Big Finish series (2005–2013) in which Iris travels with Panda, a sentient stuffed bear who likes pretty girls, alcohol and a good book.

Iris first appears in the BBC Short Trip "Old Flames." This time she resembles Beryl Reid with frizzy lilac hair, sensible boots, and a silver cardigan. The Fourth Doctor and Sarah Jane attend a ball only to discover Iris, who remarks she's "an old flame of the Doctor's" (19). He notes "their paths had crossed on only a few occasions in the past" (18). Sarah Jane meets her companion Turner, who's hoping to marry the young lady of the house. However, Lady Huntingdon and her daughter are shape-shifting cat aliens who turn against them. The Doctor traps her in a pocket dimension and the two time travelers depart with their companions.

When Iris arrives, she disrupts everything around her, a plot emphasized by her alt-world adventures and constantly-changing appearance. In *The Scarlet Empress,* the Eighth Doctor and Sam arrive on the planet of Hyspero, where stories have power and magic is real. Sam runs across the bus, and, in companion fashion, she climbs aboard to discover a bound and gagged alligator man named Gila who insists he's been abducted by a madwoman. This is Iris who's busy fending off Gila's attack dogs. By story's end she's forced to regenerate.

The Blue Angels takes place in another wacky alt-universe, with the Eighth Doctor living in a ramshackle house with Fitz and Compassion. Now Iris resembles Jane Fonda from *Barbarella,* with cascades of blonde hair and a hot pink blaster. With a pink and purple catsuit and yellow plastic boots, she's striking. She also kisses Fitz with plenty of tongue and warns him, "Don't tell the Doctor." *Mad Dogs and Englishmen* is a similar alt-universe romp. A fantasy book's story has been altered, leading to civil war on the planet of the poodles, unless the Eighth Doctor and a time travelling Noël Coward can fix everything. Fitz, in 1960 Las Vegas, finds himself desperately drawn to Brenda Soobie, the "Scots Caribbean songstress" who sings the Beatles' "Hey Jude" before it's been written. This, as it turns out, is Iris in disguise. The poodles, meanwhile, call her "the evil one in the wonderbra and sensible shoes."

Iris as Gracie Fields (but with a drinking problem) appears in Big Finish's *Excelis Dawns, The Plague Herds of Excelis* and *The Wormery.* This time around she has a less abrasive, less controversial personality. She's played by Katy Manning (Jo Grant), who poses for her on the covers. "I love putting Iris and Jo together" she says.

In the *Excelis* arc, the Fifth Doctor lands in a village on the slopes of Mount Excelis on the planet Artaris. There, Iris is bragging about her adventures to a group of nuns at a convent, only to join the Doctor. They seek a mysterious relic possessed by a group of forest zombies, who have been using

it in order to attain immortality. As it's finally revealed, it's actually a gold lamé handbag Iris lost. However, it contains a glimpse into Artaris' heaven and hell and the souls of all of its dead. Iris purchased it on Hyspero and accidentally left it on Artaris "years ago" when she was "young and drunk." (The horrified Doctor demands, "You had no idea your handbag contained all of heaven and hell?" She retorts, "I only wore it for show!") In the fourth part, Iris returns for her handbag and hangs out with Benny in a local bar. Iris finally remembers the truth; the Relic is an organic bomb, and the people of Excelis are its fuse. The pair battle together to save the locals, working as a hero team in a delightful combination of clever assertiveness.

In Big Finish's *The Wormery*, Iris meets the Sixth Doctor in the exclusive club Bianca's, and notes that she doesn't like this look on him. She challenges the Doctor, pointing out that he inherently does believe in his "right to interfere" if not his "right to rule." Wearing a long leopard-skin coat, she staggers about, making drunken threats for the story's beginning. Her scenes with Colin Baker are fun in their flirtatiousness ("Rest your head on my bosom"; "Of course I'm drunk! I'm always drunk!"; "Iris! Stop singing! You'll destroy us all!"). He also suggests a team-up that she views as a marriage proposal. Nonetheless, she has a carefree attitude, noting, "In my experience the world is always ready to unravel ... and that is where you always find the cabarets ... singing into the darkness!" She explains, "I am always serious about what I do, though not always about the way I do it." Getting into the fun, Six announces her as "That slinkiest trans-temporal adventuress of them all" while setting her up to sing onstage. Bianca's is a hideaway for radicals and intellectuals, but as the pair discover, the owner Bianca is Iris's equivalent of the Valeyard, trying to steal her regenerations. Of course, the Doctor helps her win the day once again. Like the other tricksters, Iris adds fun, flirtatiousness, and uncertainty to the series, shaking up the Doctor's adventures.

Love Interests: Grace and the Tardis

Since the Doctor has a granddaughter, Susan, he logically had a wife (most likely). In "Hell Bent," Twelve mentions he stole the President of Gallifrey's daughter, but this may be an unrelated quip. Either way, Lance Parkin's novels *Cold Fusion* and *The Infinity Doctors* (written for the show's 35th anniversary), tell a bit about the Doctor's original wife.

The Doctor keeps a painting of her in his quarters on Gallifrey of a woman holding a scroll with the words "Death is but a door." Behind her is a memorial room with thousands of burning candles. Called Patience (or at least so-named by Tegan), Patience was one of the last Womb-born Gallifreyans (as opposed to a regenerated one). She was the Doctor's nursemaid

and teacher from birth. "She'd been his tutor, his friend, his first love, his wife, the mother of his children" (*The Infinity Doctors* 259). In this novel, Patience is "A beautiful lady with short black hair and a straight golden gown" (17). Patience apparently is not a Time Lady (*Cold Fusion* 108) but the Doctor whisks her off planet in a Tardis (*Cold Fusion* 96). She is apparently "immortal barring accidents" and lives to be two million years old. In *Cold Fusion,* he finds her again, triggering flashbacks of their life together that he's forgotten. As the book closes, she vanishes, but apparently Omega (his own shadow self) carries her into the Zone of Singularity where she remains as a temptation for the Doctor. The Doctor is willing to imperil history and even stab his companion to reach her. However, her appearances even in the larger canon are rare and nebulous.

The show offers a few additional romantic encounters. When the First Doctor meets the Aztecs, he becomes close with Cameca, their wisewoman. When he prepares chocolate for her, she unfortunately interprets it as a marriage proposal and accepts. The Doctor tells her only, "You're a very fine woman, Cameca, and you'll always be very, very dear to me," but he does not invite her to join them, and she's left sadly in the past. Nonetheless, she distracts a guard and helps them to free Susan and escape. He bids her goodbye with the words, "That was a very brave thing for you to do, Cameca, but you can't stay here."

"I'd hoped I might stay by your side. Then think of me. Think of me," she responds sadly and gives him a gem as a memento. The Doctor's relationship with Cameca "is treated in a mature and respectful fashion," however firmly he rejects it (Muir 90).

Thanks to a firm policy of "no hanky-panky in the Tardis," he goes through the next few decades as asexual, with very few women so much as making a pass at him. All this continues until the 1996 film with its introduction of Daphne Ashbrook as Doctor Grace Holloway.

Many celebrated that the movie's companion would be a capable doctor. The other companion, an Asian teen, also pushed inclusivity forward. However, lovestruck Grace, like Martha Jones, has a moony emotional quality that eclipses much of her apparent capability.

Rather than a professional lab coat, Doctor "Amazing Grace" Holloway as her colleagues call her, appears in a teal ballgown with cleavage showing. As she rushes to the ER, she squabbles with her boyfriend over the phone and dons scrubs over her gown, blending the professional and the personal—male characters are rarely seen having relationship issues while prepping for surgery. She tells a colleague that Brian won't leave her—in fact, he leaves before she gets home.

In this and other matters, Grace lacks perception and compassion, which becomes much more problematic as she goes to work on her patient. No

doubt she's heard delirium before, but she in fact kills the Seventh Doctor, because she ignores the x-ray evidence and the Doctor's pleas:

> DOCTOR: Whatever you're about to do, stop.
> GRACE: Mister Smith, you're going to be all right.
> DOCTOR: No. I am not human. I am not like you.
> …
> GRACE: Try not to speak, Mister Smith. We've already taken out all the bullets, and now we're going to listen to your heart, find out why it's so wild, and then I'm going to fix it. You'll be fine. Okay, he's under.

In front of the hospital's sponsors (another display of professional incompetence, this time more public) she fumbles the Doctor's heart probe and he dies.

Afterwards, she deals with a condescending boss who ignores her opinions, much as she ignored the Doctor's. While she protests that he really did have two hearts, Doctor Swift burns the x-rays and insists, "A man died last night because you lost your way."

The movie was "a co-American production, and that meant sex; not only McGann, with his angelic good looks, but Daphne Ashbrook with her large, well-displayed breasts—a second Peri, only with a medical degree" (Rose 46). The Doctor finally experienced a kiss onscreen, and the era of "no fooling around in the Tardis" ended. Eighth Doctor Paul McGann himself was torn over the kiss, adding that he kept it reasonably close-lipped and chaste. "The Doctor has always been a very child-like character. If they had asked me to do a bedroom scene, I would have said no. What would be the point?" (qtd. in Hearn 234).

Grace becomes a pawn between Doctor and Master as the Master fills her with his presence, and then kisses her to remove it. Nonetheless, she helps the Doctor defeat the Master at last. She displays scientific knowledge, not just of medicine, but also the Tardis's capability of interdimensional transference. Later, she successfully jumpstarts the Tardis console and time rotor. When the Doctor responds to her "Thank you, Doctor" with "No, no. Thank *you*, Doctor," he's acknowledging her as his equal, the woman who evaded death and restarted the world.

When the Doctor invites her along, she retorts, "You come with me." The startled Doctor admits it's "tempting." However, neither is prepared to pay the price. "When love captures us, we are no longer free to attend to only our own desires and wishes. Instead, we make choices based as much on the good of what and whom we love" (Pearson 153). She chooses career over relationship, and their team-up dissolves, even as Eight becomes a long-lived adventurer in audio, comics, and novels. If the movie had kicked off a revival of the show, this Doctor likely would have had romantic adventures, either with Doctor Grace or with new heroines each week (or both!). It had nine

million viewers in the UK, 8 million in the U.S. (Muir 411). Nonetheless, a decade would pass before the show rebooted.

After Grace's relationship kiss, the New Who Doctors kiss other companions: Jack kisses him and Rose on the edge of death. The Tenth Doctor gets a great deal of action: Rose-as-Cassandra kisses him and the newly regenerated Doctor notes, "I've still got it!" Rose kisses and hugs him on other occasions, and even her mother covers him in excited kisses to the Doctor's dismay. He kisses Martha on their first adventure (and adds that it means nothing—it's a genetic trick). Madame de Pompadour, Astrid Peth, and Joan Redfern kiss him as well. In a more hilarious moment, Donna kisses him on the Agatha Christie adventure when he says he needs "a shock." Amy kisses Eleven and wants much more. It's no wonder that the War Doctor jokes about how much of this is going on in the future.

Matron Joan Redfern, who works at a boys' school in 2013, falls for Ten when he becomes human in "Human Nature"/"The Family of Blood" and it's mutual—clearly giving up his Time Lord burdens means he feels free to give his heart. When, after several months, the Doctor discovers who he is, he wants to stay human. It's Joan who must be the brave one.

> JOAN: If I could do this instead of you, then I would. I'd hoped. But my hopes aren't important.
> DOCTOR: He won't love you.
> JOAN: If he's not you, then I don't want him to. I had one husband, and he died. I never thought, ever again. And then you were so...
> DOCTOR: And it was real. I wasn't. I really thought...

For a moment, he clasps her hands and they live an entire imaginary life together: wedding, children, aging, death. Then he resolutely opens the watch and returns to his old self. After, a disconcerted Joan asks him, "Could you change back?" The Doctor tells her candidly that he could but won't. He doesn't seem to realize what a slap it is that he invites her along as a potential lover, but not an actual one. This will be painful to Martha, who loves him, as well. Joan asks him if he endangered her students with his Time Lord adventures and upon having this confirmed, refuses to travel with him. The Doctor accepts this, though he visits Joan's descendent just before his death and asks if she was happy. Eleven tells Jo that during this companion tour he visited all the companions he could (though offscreen). "But the last time I was dying, I looked back on all of you. Every single one. And I was so proud" (*Death of the Doctor*). Apparently, Joan's descendent rates a place among them.

Jeanne-Antoinette Poisson (1721–1764), often known as Reinette or Madame de Pompadour, was the celebrated mistress of King Louis XV of France. The Doctor encounters her at many life stages in the beloved episode "The Girl in the Fireplace." She displays a startling mental acuity, reading the

Doctor's mind as he reads hers (as she notes, "a door once opened may be stepped through in either direction"). She is also famously the one to intuit his loneliness in a way companions generally don't, and insists that he must have a chance to "dance" (as this word is used as a sexual metaphor in the Davies era, fans are curious what exactly Reinette and the Doctor do off-screen). She's a muse of a sort, offering a comfort and wisdom he never antic-ipated. She also gives him a rare kiss as she finds him fascinating, as a man, not just a Time Lord. "Her sense of wonder is solely for the Doctor rather than the adventure, although she is not quick to shy away from danger" (Achenbach). She faces down the clockwork droids with desperate courage, and displays a faith in the Doctor only rivaled by Martha. As his guardian angel once again, she helps him return home through her cleverness in safe-guarding the gateway. He invites her to be a companion. However, he lets her down (in an oddly foolish moment) by delaying his return until she dies.

There are quicker references to romance, as the Eighth Doctor notes that he knew Madame Curie "intimately," and Eleven encounters famous spy Mata Hari, who undresses in front of him while he's roasting Jammy Dodgers (*Pond Life*). There's also a throwaway line in "A Christmas Carol" about mar-rying Marilyn Monroe and one in "The Husbands of River Song" about mar-rying Cleopatra. Likely the most intriguing for fans was a series of gags about Ten and Queen Elizabeth I. In "The Shakespeare Code," she recognizes him and immediately orders her guards to kill him. In "The End of Time, part 1," he tells Ood Sigma that he has married "Good Queen Bess" and made her lose one of her epithets. However, Ten changes into Eleven, and it seems nothing will be resolved, until the crossover episode "The Day of the Doc-tor."

A flashback takes the audience to Ten and the queen picnicking in 1562. Suddenly, he proposes, just to prove she's really a shapeshifting Zygon. In fact, it's the horse. Upon discovering this, Ten blurts, "I'm going to be King." As they run, he adds, "Oh, good work, Doctor. Nice one. The Virgin Queen? So much for history."

In the episode, Queen Elizabeth is shrewd and quite physically capable, stabbing her enemies with a hidden knife. As she explains, fully collected, "My twin is dead in the forest. I am accustomed to taking precautions. These Zygon creatures never even considered that it was me who survived rather than their own commander. The arrogance that typifies their kind." When Clara asks, she specifies that she doesn't mean Zygons but men.

"Elizabeth I demonstrates that she can be as equally formidable as her foes by killing her Zygon duplicate and impersonating him, ultimately pro-tecting England and ridding it of the Zygon threat at the end of her timeline" (Nathanael 89). They hurry off to save the world, yet the queen adds, "But first, my love, you have a promise to keep." She and Ten actually go through

with the ceremony, and then the Doctor promises to be "right back" and flies off in the Tardis. This might explain why the elderly queen is so enraged in "The Shakespeare Code." It's a silly adventure, but Elizabeth makes an assertive show of her power before becoming one more of Ten's abandoned love interests. History's powerful queen nonetheless appears naïve in romance, allowing the Doctor to trick and abandon her.

Certainly, the Doctor's true relationship over the fifty-plus year series is the Tardis, often presented as a sentient confidante. "The Tardis is more than a machine. It's like a person. It needs coaxing, persuading, encouraging" he insists (*The Five Doctors*). As early as the first season's *The Edge of Destruction*, the Tardis attempts to warn the Doctor that they've accidently entered a proto-solar system with atoms forming around them. Later, it also warns of danger with the Cloister Bell. The Tardis represents home and safety for the travelers, but also actively protects them. It actually aids in the regeneration process (*The Power of the Daleks, Castrovalva*) and can hear when people talk about it. Thus, the Doctor calls her "Old girl" and "Sexy." It creates cricketing clothes for Five in *Castrovalva,* as well as a wheelchair, suggesting caring.

Early on, the Doctor complains, "I have no control over where I land. Neither can I choose the period in which I land in" (*The Smugglers*). This serves as a device to keep Ian and Barbara or Ben and Polly trapped on the ship, hoping it will return to their time. It also suggests the Tardis is making the choices, indicating a personality, not just a broken machine. The later Doctors, by contrast, dial up an exact time and place and head straight there, though the Tardis sometimes diverts for distress calls. Tardis and Doctor are presented as learning together, discovering how to fly and negotiating where to go. "The Tardis and I are getting rather better at these short hops," the Doctor notes in *Logopolis*. Neil Gaiman explains, "The Tardis doesn't ever take the Doctor to a boring place where nothing's ever happened or is going to happen: it always dumps him somewhere at the right place or the right time for a story to happen. And given that most of the time he's not doing it, obviously she is." The Tardis certainly has opinions and reactions: Just as Four insists he understands the Tardis perfectly and further, is "in complete and constant control of her," they get thrown sideways (*Image of the Fendahl*).

In 2011, showrunner Steven Moffat liked the idea of featuring the Tardis as a woman, believing this to be the "ultimate love story" for the Doctor ("Bigger on the Inside"). Fantasy author Neil Gaiman created a beloved script, which won a Ray Bradbury Award and Hugo Award. Explaining the title "The Doctor's Wife," Gaiman writes, "This was a story about someone who was married to his ship, and someone who was his wife and mother and girlfriend and best friend all in one, the only person who would always be there for him on all his adventures…"

A planet that eats Tardises downloads the soul of the Doctor's Tardis into a woman called Idris. For the first time, the pair can converse. As the Tardis embodied, Idris gets details out of order, bites the Doctor, and communicates erratically. The Doctor struggles to adjust. "The objectification of the Tardis when it is still the Tardis, that is, an actual object, is perfectly understandable; that the Doctor's suddenly human 'wife' is reduced to being 'Sexy' and having a limited lifespan, less so" (McMahon-Coleman). She is referred to as the "mad, bitey lady" who is "doolalley," while she warns that her human casing "may blow" at any time. Moffat meanwhile described Idris as "sexy plus motherly plus utterly mad plus serene" ("Bigger on the Inside"). Nonetheless, they share a great deal of affection:

> IDRIS: Yes, that's me. A Type Forty Tardis. I was already a museum piece when you were young, and the first time you touched my console you said...
> DOCTOR: I said you were the most beautiful thing I had ever known.
> IDRIS: And then you stole me. And I stole you.
> DOCTOR: I borrowed you.
> IDRIS: Borrowing implies the intention to return the thing that was taken. What makes you think I would ever give you back?
> DOCTOR: You're the Tardis?
> IDRIS: Yes.
> DOCTOR: My Tardis?
> IDRIS: My Doctor ["The Doctor's Wife"].

The Tardis's concept of ownership, that she has been the one directing the adventures, and that she owns him, is a delightful flip on the relationship. The Doctor, meanwhile, is entranced by this perfect companion. Amy even gets in a quip about "Did you wish really hard?" The Doctor dismisses this, but as he and the Tardis banter, it becomes clear she really is his ideal mate. All good things end and Idris's body fails, though her soul returns to where it's always been.

After this episode, the Tardis's personality is played up even more. The Moment asks in "The Day of the Doctor": "Why did you park so far away? Didn't you want her to see it?" In "Hide," it picks a fight with Clara, one that continues through an entire year of Tardis-Clara spats. Clara insists it's an appliance, but as the Doctor soothes the offended Tardis, Clara complains, "You're like one of those guys who can't go out with a girl unless his mother approves" ("Journey to the Centre of the Tardis"). The Doctor doesn't argue. Through the episode, Clara explores the craft and slowly learns more about herself and the Doctor, even as the Tardis comes to respect her and finally gives her the Big Friendly Button that can save them all. Thus the ship establishes herself as companion, far more than machine.

CONCLUSION: THE FEMALE DOCTOR QUESTION

"Legs! I've still got legs!! Good. Arms, hands. Ooh, fingers. Lots of fingers. Ears? Yes. Eyes: two. Nose ... eh, I've had worse. Chin—blimey! Hair.... I'm a girl! No! No! I'm not a girl! And still not ginger!" ("The End of Time, Part 2"). Here, Matt Smith emphasizes that he *could* have regenerated into a girl, though he didn't. Moffat threw in more teases, from Eleven mentioning on *The Sarah Jane Adventures* that he could change race or gender to the teasingly-named "The Doctor's Wife" where he describes the gender-switching Corsair. Clearly a female Doctor was established in the show as *possible*.

Many women cosplay the Doctor, clearly aspiring to be more than a companion. This is the center of the debate—whether women can be super-heroes, Ghostbusters, Doctors, or merely the screaming damsels in the short skirts. "Certainly if ever the producers of *Doctor Who* experiment with alternative casting, that moment would be a notable indicator of a shift in Western attitudes about power, and who is perceived as capable of wielding it" (Nathanael 90). One critic protests: "After all, why haven't we had a female Doctor or a Doctor of color? Is it because s/he would lose all that power associated with being a white man? Does he need the power to strut through Earth history and the rest of the universe without a worry, the power to command and control, even if he doesn't use it? Are we fans as attracted to the Doctor's power as his companions are?" (Stoker).

Noncanon stories have tackled the issue more directly: Joanna Lumley played a Time Lady in the television parody *The Curse of the Fatal Death* by Steven Moffat (1999). In this, she was a spoof herself with a plunging neckline, overly sexualized. As she probes her breasts for the "on switch" to her "beam locators," the camera zooms in on them exaggeratedly. The Doctor ends the episode speculating about dirty uses for the sonic screwdriver and flirting

with the Master, frightening all fanboys off the female Doctor question. In 2003, Arabella Weir became the first full-adventure female Doctor in *Unbound*. This fan film Doctor works in Sainsbury's, on Earth, and gets drunk most nights with friends. Enemy Time Lords Toby Longworth and David Tennant (yes, really) visit Earth to hunt her down in this lighthearted adventure. The fact that she became female by committing suicide is a darker current, turning the Doctor into something of a self-hating woman drinking heavily each night, drowning in an identity crisis. In fact, she's desperate to reclaim her heroic "Doctor" self, even as she continues to hide. "I know the Time Lords won't be able to find me. The trouble is, if I carry on like this, neither will I," she decides.

Over the years, different actors and showrunners weighed in: When Tom Baker announced he was moving on, he stirred up the press conference when he added, "I wish the new Doctor, *whoever he or she is* the very best of luck" (Haining 163). John Leeson (K9) reveals Muriel Margolese was Baker's choice (Jameson, et al.). The show's creator Sydney Newman actually suggested in 1986 that the network spice things up with a female Doctor and cast Dawn French, Frances de la Tour, or Joanna Lumley (Torpey). Of course, they went a different way, with children's entertainer Sylvester McCoy. Russell T. Davies, who revived the show, comments:

> While I think kids will not have a problem with [a female Doctor], I think fathers will have a problem with it because they will then imagine they will have to describe sex changes to their children. I think fathers can describe sex changes to their children and I think they should and it's part of the world, but I think it would simply introduce genitalia into family viewing. You're not talking about actresses or style, you're talking about genitalia, and a lot of parents would get embarrassed [Dowell].

Louise Jameson (Leela) replies: "Yes of course it's time for the Doctor to be a woman and in fact I think she should be a Black, redheaded lesbian" (Jameson, et al.). Some creators are more excited about diversity here than others.

Meanwhile, in 2004, Moffat said that a female *Doctor Who* is "not impossible," and that the best person would play the part, no matter the gender (Torpey). When Matt Smith moved on much later, he cast Peter Capaldi, though there was pressure at the time to change up the gender at last. Instead, Moffat threw in a twist with Missy, the gender-flipped Master. "Some of us can afford the upgrade," she quips ("The Witch's Familiar"). At the time of writing, fans are gushing throughout social media about Jodie Whittaker's coming transformation into the Thirteenth Doctor. However she turns out, the Doctor and his or *her* show will continue pushing boundaries of both representation and gender. The Master smirks in "The Doctor Falls," surrounded by action women, female companion and female incarnation of himself, "Is the future gonna be all girl?"

The Twelfth Doctor replies, "We can only hope." Indeed, we can.

Appendix:
Doctors and Companions

The Doctor (s)

1. William Hartnell 1963–1966
2. Patrick Troughton 1966–1969
3. Jon Pertwee 1970–1974
4. Tom Baker 1974–1981
5. Peter Davison 1981–1984
6. Colin Baker 1984–1986
7. Sylvester McCoy 1987–1989
8. Paul McGann (1996 movie + audio productions)
9. Christopher Eccleston 2005
10. David Tennant 2005–2009
11. Matt Smith 2010–2013
?. John Hurt 2013
12. Peter Capaldi 2014–2017

Principal Companions

Carole Ann Ford as Susan Foreman 1963–1964
Jacqueline Hill as Barbara Wright 1963–1965
William Russell as Ian Chesterton 1963–1965
Maureen O'Brien as Vicki 1965
Adrienne Hill as Katarina 1965
Jean Marsh as Sara Kingdom 1965
Peter Purves as Steven Taylor 1965–1966
Jackie Lane as Dodo (Dorothea) Chaplet 1966
Anneka Wills as Polly 1966–1967
Michael Craze as Ben Jackson 1966–1967
Fraser Hines as Jamie McCrimmon 1966–1969
Deborah Watling as Victoria Waterfield 1967–1968
Wendy Padbury as Zoe Heriot 1968–1969
Caroline John as Liz Shaw 1970
Katy Manning as Jo Grant 1971–1973
Elisabeth Sladen as Sarah Jane Smith 1973–1976
Ian Marter as Surgeon Lt Harry Sullivan, RN 1974–1975
Louise Jameson as Leela 1977–1978
Mary Tamm as Romana 1978
Lalla Ward as Romana 1979–1981
Matthew Waterhouse as Adric 1980–1982
Sarah Sutton as Nyssa 1981–1983
Janet Fielding as Tegan Jovanka 1981–1984
Mark Strickson as Turlough 1983–1984
Nicola Bryant as Peri Brown 1984–1986
Bonnie Langford as Melanie Bush 1986–1987
Sophie Aldred as Ace 1987–1989

Daphne Ashbrook as Doctor Grace
 Holloway 1996
Billie Piper as Rose Tyler 2005–2006
Bruno Langley as Adam Mitchell
 2005
John Barrowman as Jack Harkness
 2005
Noel Clarke as Mickey Smith 2006
Freema Ageyman as Martha Jones
 2007
Catherine Tate as Donna Noble 2008
Karen Gillan as Amy Pond 2010–2012
Arthur Darvill as Rory Williams
 2010–2012
Alex Kingston as River Song 2010–
 2013
Jenna-Louise Coleman as
 Clara/Oswin Oswald 2012–2015
Pearl Mackie as Bill Potts 2017–2017

Torchwood 2006–2011

John Barrowman as Jack Harkness
Eve Myles as Gwen Cooper
Gareth David-Lloyd as Ianto Jones
Burn Gorman as Owen Harper
Naoko Mori as Toshiko Sato
Kai Owen as Rhys Williams

The Sarah Jane Adventures 2007–2011

Elisabeth Sladen as Sarah Jane Smith
Tommy Knight as Luke Smith
Yasmin Paige as Maria Jackson
Daniel Anthony as Clyde Langer
Alexander Armstrong as Mister
 Smith
Anjli Mohindra as Rani Chandra

K9 2009–2010

K9 Mark 2 John Leeson
Keegan Joyce as Starkey
Philippa Coulthard as Jorjie Turner
Daniel Webber as Darius Pike
Robert Moloney as Professor Alistair
 Gryffen

Class 2016

Katherine Kelly as Miss Quill
Greg Austin as Charlie
Fady Elsayed as Ram
Sophie Hopkins as April
Vivian Oparah as Tanya

WORKS CITED

Primary Sources

Shows

Baker, Bob, and Paul Tams, creators. *K9*. Network Ten/Disney, 2009–2010.
Davies, Russell T, creator. *The Sarah Jane Adventures*. BBC, 2007–2011.
_____. *Torchwood*. BBC, 2006–2011.
Ness, Patrick, creator. *Class*. BBC, 2016.
Newman, Sydney, and Verity Lambert, creators. *Doctor Who*. BBC, 1963–present.

Novels

Aaronovitch, Ben, and Kate Orman. *So Vile a Sin*. Virgin, 1997.
Blum, Jonathan, and Kate Orman. *Unnatural History*. BBC Books, 1999.
Brake, Colin. *Escape Velocity*. BBC Books, 2001.
Clapham, Mark. *Hope*, BBC Books, 2002.
Cole, Stephen. *Timeless*. BBC Books, 2003.
Cornell, Paul. *Death and Diplomacy*. Virgin Publishing, 1996.
_____. *Happy Endings*. Virgin Publishing, 1996.
_____. *Love and War*. Virgin Publishing, 1992.
_____. *The Shadows of Avalon*. BBC, 2000.
Dicks, Terrence. *The Eight Doctors*. BBC Books, 1997.
Ebbs, Paul. *The Book of the Still*. BBC Books, 2002.
Lyons, Steve. *Conundrum*. Virgin, 1994.
Magrs, Paul. *Mad Dogs and Englishmen*. BBC, 2002.
_____. *The Scarlet Empress*. BBC, 1998.
_____. *Verdigris*. BBC, 2000.
Magrs, Paul, and Jeremy Hoad. *The Blue Angel*. BBC, 1999.
Miles, Lawrence. *Alien Bodies*. Virgin, 1997.
_____. *Interference Part One*. BBC, 1999.
_____. *Interference Part Two*. BBC, 1999.
Orman, Kate. *The Room with No Doors* Virgin Publishing, 1997.
_____. *The Year of Intelligent Tigers*. BBC Books, 2001.
Parkin, Lance. *Cold Fusion*. Virgin, 1996.
_____. *The Dying Days*. BBC, 1997.
_____. *Father Time*. BBC Books, 2001.

_____. *The Gallifrey Chronicles.* BBC Books, 2005.

_____. *The Infinity Doctors.* BBC, 1998.

_____. *Just War.* BBC, 1996.

Platt, Marc. *Lungbarrow.* Virgin, 1997.

Richards, Justin. *Sometime Never...* BBC Books, 2004.

Russell, Gary. *Placebo Effect.* BBC Books, 1998.

Stone, Dave. *Sky Pirates.* Virgin, 1995.

Audio Dramas

Blood of the Daleks. the Eighth Doctor Adventures, written by Steve Lyons, directed by Nicholas Briggs. Big Finish, 2006–2007.

The Company of Friends. Big Finish Main Range, written by Lance Parkin, Stephen Cole, Alan Barnes, and Jonathan Morris, directed by Nicholas Briggs. Big Finish, 2009.

An Earthly Child, Specials, written by Marc Platt, directed by Nicholas Briggs. Big Finish, 2009.

Excelis Dawns. Excelis, written by Paul Magrs, directed by Gary Russell. Big Finish, 2002.

The Eye of the Scorpion, Big Finish Main Range, written by Iain McLaughlin, directed by Gary Russell. Big Finish, 2001.

Gallifrey Series One: The Inquiry. Gallifrey, written by Justin Richards, directed by Gary Russell. Big Finish, 2005.

Gallifrey Series One: Weapon of Choice. Gallifrey, written by Alan Barnes, directed by Gary Russell. Big Finish, 2004.

Gallifrey Series Two: Lies. Gallifrey, written by Gary Russell, directed by Gary Russell. Big Finish, 2005.

The Girl Who Never Was. Big Finish Main Range, written by Alan Barnes, directed by Barnaby Edwards. Big Finish, 2007.

The Great War, Dark Eyes, written by Nicholas Briggs, directed by Nicholas Briggs. Big Finish, 2012.

The Horror of Glam Rock. the Eighth Doctor Adventures, written by Paul Magrs, directed by Barnaby Edwards. Big Finish, 2007.

Human Resources. the Eighth Doctor Adventures, written by Eddie Robson, directed by Nicholas Briggs. Big Finish, 2007.

Lucie Miller/To the Death. The Eighth Doctor Adventures, written by Nicholas Briggs, directed by Nicholas Briggs. Big Finish, 2011.

The Marian Conspiracy, Big Finish Main Range, written by Jaqueline Rayer, directed by Gary Russell. Big Finish, 2000.

The Neverwhen, the War Doctor, written by Matt Fitton, directed by Nicholas Briggs. Big Finish, 2016.

No Place Like Home, Specials, written by Iain McLaughlin, directed by Gary Russell. Big Finish, 2003.

The Plague Herds of Excelis. Bernice Summerfield, written by Stephen Cole, directed by John Ainsworth. Big Finish, 2002.

The Resurrection of Mars, the Eighth Doctor Adventures, written by Jonathan Morris, directed by Barnaby Edwards. Big Finish, 2010.

Silver Lining. Doctor Who Magazine releases, written by Colin Brake, directed by Gary Russell. Big Finish, 2004.

Situation Vacant. the Eighth Doctor Adventures, written by Eddie Robson, directed by Nicholas Briggs. Big Finish, 2010.

Storm Warning. Big Finish Main Range, written by Alan Barnes, directed by Gary Russell. Big Finish, 2005.

The Thousand Worlds, the War Doctor, written by Nicholas Briggs, directed by Nicholas Briggs. Big Finish, 2015.

The Traitor, Dark Eyes 2, written by Nicholas Briggs, directed by Nicholas Briggs. Big Finish, 2014.

The Veiled Leopard, Doctor Who Magazine releases, written by Iain McLaughlin and Claire Bartlett. Big Finish, 2006.

The Wormery, Big Finish Main Range, written by Stephen Cole and Paul Magrs, directed by Gary Russell. Big Finish, 2003.

Comics

Abadzis, Nick (w), and Elena Casagrande (a). *Doctor Who: The Tenth Doctor Vol 1: Revolutions of Terror*, Titan Comics, 2015.

Barnes, Alan (w), and Martin Geraghty (a). *Endgame*. *DWM* #244–#247. *Doctor Who Graphic Novel #4: Endgame*. Panini Comics, 2005.

Barnes, Alan (w), and Martin Geraghty and Robin Smith (a). *Tooth and Claw*, *DWM* #257–#260, *Doctor Who Graphic Novel #4: Endgame*. Panini Comics, 2005.

Ewing, Al, Rob Williams (w), and Simon Fraser (a). *After Life*. Titan Comics, 2014.

Furman, Simon (w), Kev Hopgood, and Tim Perkins (a). "Redemption!" *DWM* #134, Mar 1988.

Gray, Scott (w), and John Ross (a). "Me and My Shadow," *DWM* #318, 26 June 2002. *Doctor Who Graphic Novel #6: Oblivion*. Panini Comics, 2006.

_____. *Sins of the Father*. *DWM* #343–345, 26 May 2004–21 July 2004. *Doctor Who Graphic Novel #7: The Flood*. Panini Comics, 2007.

Gray, Scott (w), and Martin Geraghty (a). *Bad Blood*, *DWM* #338–342, 7 January 2004–28 April 2004. *Doctor Who Graphic Novel #7: The Flood*. Panini Comics, 2007.

_____. *Beautiful Freak*, *DWM* #30–43, May 2001. *Doctor Who Graphic Novel #4: Endgame*. Panini Comics, 2005.

_____. *Oblivion*, *DWM* #323–#328, 13 November 2002–2 April 2003. *Doctor Who Graphic Novel #6: Oblivion*. Panini Comics, 2006.

Gray, Scott (w), and Martin Geraghty and Robin Smith (a). *Ophidius*, *DWM* #300–#303, 7 February 2001–2 May 2001. *Doctor Who Graphic Novel #6: Oblivion*. Panini Comics, 2006.

_____. *Wormwood*, *DWM* #266–#271, Marvel Comics UK, 1998. *Doctor Who Graphic Novel #4: Endgame*. Panini Comics, 2005.

Russell, Gary (w), and Lee Sullivan (a). *Dreadnaught*. *Radio Times BBC Magazine*, 1 June–9 August 1996. http://web.archive.org/web/20070927194254/http://www.cuttingsarchive.org.uk/comics/1990s.htm.

Wright, Mark (w), and Mike Collins (a). "The Pestilent Heart." *Doctor Who Magazine* #501, Aug. 2016.

Secondary Sources

Achenbach, Pamela. "Companions Who Weren't: The Pompadour and the Pauper." Leitch and Ginn, pp. 123–134.

Airey, Jean. "Colin Baker: Gallifrey Vice?" *Starlog* 115, Dec 1987, p. 46.

Airey, Jean, and Laurie Haldeman. "Tom Baker—The Curious Heart of Doctor Who." *Starlog* 115, Dec 1987, p. 47.

Akers, Laura Geuy. "Empathy, Ethics, and Wonder." Lewis, Courtland and Smithka, pp. 145–156.

Aldred, Sophie. "An Interview with Sophie Aldred." Thomas and O'Shea, pp. 68–73.

Alexander, Saffron. "Why the 'Space Racist' Trope Is Bad for Women of Color." *The Mary Sue*, 27 June 2017. https://www.themarysue.com/space-racist-trope-needs-to-go-away.

Asher-Perrin, Emily. "Moffat Admits Clara Oswald Was 'Not a Participant' in Her Own

Story Until Season 8 of *Doctor Who.*" *Tor.Com,* 18 Sept 2014. http://www.tor.com/2014/09/18/moffat-admits-clara-was-not-a-participant-in-her-own-story-until-season-8-of-doctor-who.

_____. "No Room for Old-Fashioned Cats: Davies Era Who and Interracial Romance." Orthia, pp. 63–66.

Barr, Liz. "Nimons Are Forever." Stanish and Myles.

Belam, Martin, ed. *Who's Who? The Resurrection of the Doctor.* Guardian Books, 2011. Kindle Edition.

"Bigger on the Inside." *Doctor Who Confidential.* Series 6. Episode 4. 14 May 2011. BBC. BBC Three.

Bolen, Jean Shinoda. *Goddesses in Everywoman.* Quill, 2004.

Bowerman, Lisa. "The Digging Chick." Thomas and O'Shea, pp. 94–97.

Bradford, K. Tempest "The Women We Don't See." Stanish and Myles.

Britton, Piers D. *Tardisbound.* I.B. Tauris, 2011.

Burdge, Anthony. *The Mythological Dimensions of Doctor Who.* MythInk Books. Kindle Edition.

Burke, Jessica. "Doctor Who and the Valkyrie Tradition, Part 2: Goddesses, Battle-Demons, Witches, & Wives" Burdge, pp. 140–182.

Butler, David, ed. *Time and Relative Dissertations in Space: Critical Perspectives on Doctor Who.* University of Manchester Press, 2007.

"Caroline John." *Doctor Who Interviews,* 27 Sept. 2009. http://drwhointerviews.word press.com/category/caroline-john.

"Changing Time: Living and Leaving Doctor Who." *The Hand of Fear.* BBC Home Entertainment, 2006. DVD special feature.

Charles, Alec. "The Allegory of Allegory: Race, Racism and the Summer of 2011." Orthia, pp. 161–179.

_____. "War Without End? Utopia, the Family, and the Post–9/11 World in Russell T. Davies's *Doctor Who.*" *Science Fiction Studies,* vol. 35, 2008, pp. 450–465.

Cheyne, Ria. "Touching the Other: Alien Contact and Transgressive Touch." Ireland, Palumbo and Sullivan, pp. 43–52.

Clegg, Mindy. "The Doctor Has His Day? *Doctor Who* and the Constraints of the American Cultural Cold War." *New Worlds, Terrifying Monsters, Impossible Things: Exploring the Contents and Contexts of Doctor Who.* PopMatters, 2016.

Coppa, Francesca. "Girl Genius: Nyssa of Traken." Thomas and O'Shea, pp. 62–67.

Cornea, Christine. "British Science Fiction Television in the Discursive Context of Second Wave Feminism," *Genders,* vol. 54, Summer 2011. http://www.colorado.edu/gendersarchive1998-2013/2011/08/01/british-science-fiction-television-discursive-context-second-wave-feminism.

David-Lloyd, Gareth, Naoko Mori, and Scott Handcock. "Making Torchwood." Gallifrey One: 28 Years Later. 16–19 February 2017. Marriott Los Angeles Airport, Los Angeles, CA. Conference Panel.

Davies, Russell T and Benjamin Cook. *Doctor Who: The Writer's Tale.* BBC Books, 2008.

de Kauwe, Vanessa. "Through Coloured Eyes: An Alternative Viewing of Postcolonial Transition." Orthia, pp. 141–159.

Deller, Ruth. "What the World Needs Is … a Doctor." Lewis, Courtland and Smithka pp. 239–247.

Dodson, Linnea. "Conscious Colour-Blindness, Unconscious Racism in Doctor Who Companions." Orthia, pp. 29–34.

Dowell, Ben. "Russell T Davies to Step Down as *Doctor Who* 'Show-Runner.'" *The Guardian,* 7 July 2008.

Downing, Christine, ed. *Mirrors of the Self.* Jeremy P. Tarcher, 1991.

Dunn, Carrie. "The Alien Woman: Othering and the Oriental." Ireland, Palumbo and Sullivan, pp. 113–120.

Fisher, India. "An Interview with India Fisher." Thomas and O'Shea, pp. 51–54.

Fletcher, Rosie. "Why Pearl Mackie's Bill Might Just Be the Best *Doctor Who* Companion Yet." *Digital Spy,* 5 April 2017. http://www.digitalspy.com/tv/doctor-who/feature/ a825262/pearl-mackie-doctor-who-bill-companion.

Frankel, Valerie Estelle. *Doctor Who and the Hero's Journey.* Thought Catalog, 2013.

_____. "Gwen's Evil Stepmother: Concerning Gloves and Magic Slippers." Ireland, Palumbo and Sullivan, pp. 90–101.

Gaiman, Neil. "A Fairly Humongous Doctor Who Q&A Mostly." *Neil Gaiman's Journal,* 9 June 2011. http://journal.neilgaiman.com/2011/06/fairly-humongous-doctor-who-q-mostly.html.

Ginn, Sherry. "Spoiled for Another Life: Sarah Jane Smith's Adventures with and Without Doctor Who." Leitch, pp. 242–252.

"Girls! Girls! Girls! The 1980s." *Doctor Who: Paradise Towers.* BBC Home Entertainment, 2011. DVD special feature.

Gould, Joan. *Spinning Straw into Gold.* Random House, 2005.

Green, Melody. "'It Turns Out They Died for Nothing': Doctor Who and the Idea of Sacrificial Death." Burdge, pp. 105–119.

Gulyas, Aaron John. "When No One Can Hear You Scream: Doctor Who Companions on the Printed Page." Leitch and Ginn, pp. 135–140.

Haining, Peter. *Doctor Who, a Celebration: Two Decades Through Time and Space.* Carol Pub Group, 1983.

Haraway, Donna Jeanne. *Simians, Cyborgs and Women: The Reinvention of Nature.* Free Association, 1991.

Hattenstone, Simon. "Take a Girl Like You" *The Guardian,* 16 December 2006. Belam.

Hearn, Marcus. *Doctor Who: The Vault.* Harper Design, 2013.

Hoskin, Dave. "The New Man: The Regeneration of *Doctor Who*." *Metro* no. 169, 2011, p. 130. MasterFILE Complete. Web.

Howe, David J, Mark Stammers, and Stephen James Walker. *Doctor Who—The Eighties.* Virgin Publishing, 1997.

Hunt, Mary E. "The Friend." Downing, pp. 259–264.

Hutchinson, Diana. "Curse of Dr Who." *Daily Mail,* 20 June 1997, p. 22.

Ingram, Tony. "Doctor Who: A Companion Piece—Half a Century of the Time Lord's Comic Strip Fellow Travellers." *Broken Frontier,* 21 Apr 2017. http://www.broken frontier.com/frobisher-doctor-who-companions-kroton-destrii-olla.

Ireland, Andrew, Donald E. Palumbo, and C.W. Sullivan III, eds. *Illuminating Torchwood: Essays on Narrative, Character and Sexuality in the BBC Series.* McFarland, 2012.

Isaacs, Susan. *Brave Dames and Wimpettes: What Women Are Really Doing on Page and Screen.* Ballantine, 1999.

Jameson, Louise, Lalla Ward, Gary Russell, and John Leeson. "The Gallifrey Chronicles." Gallifrey One: 28 Years Later. 16–19 February 2017. Marriott Los Angeles Airport, Los Angeles, CA. Conference Panel.

"Jacqueline Hill." *Doctor Who Interviews,* 1984. http://drwhointerviews.wordpress.com/ 2009/09/25/jacqueline-hill-1984.

"Jean Marsh." *Doctor Who Interviews,* 13 Oct. 2009. https://drwhointerviews.wordpress. com/2009/10/13/jean-marsh-1990.http://www.digitalspy.com/tv/doctor-who/ feature/a825262/pearl-mackie-doctor-who-bill-companion/.

Jeffries, Stuart. "Doctor Who's New Companion Pearl Mackie: 'I Have No Time-Travelling Experience!'" *The Guardian,* 5 Oct 2016. https://www.theguardian.com/ tv-and-radio/2016/oct/05/doctor-who-pearl-mackie-new-series-companion-inter view.

Jones, Tim. "Breaking the Faiths in 'The Curse of Fenric' and 'The God Complex.'" *Time and Relative Dimensions in Faith: Religion and Doctor Who*, edited by Andrew Crome and James McGrath. Darton, Longman and Todd Ltd, 2013, pp. 45–59.

Jusino, Teresa. "Moffat's Women: Amy and Her Skirt." Torwww, 21 March 2011. http://www.tor.com/blogs/2011/03/moffats-women-amy-and-her-skirt.

Kakoudaki, Despina. "Pinup and Cyborg: Exaggerated Gender and Artificial Intelligence." *Future Females, the Next Generation*, edited by Marleen S. Barr. Rowman and Littlefield, 2000, pp. 165–195.

Kang, Helen. "Adventures in Ocean-Crossing, Margin-Skating, and Feminist-Engagement with *Doctor Who*." Thomas and O'Shea, pp. 38–45.

Kistler, Alan. *Doctor Who: A History*. Lyons Press, 2013.

Kydd, Elispeth. "Cyberwomen and Sleepers: Rereading the Mulatta Cyborg and the Black Woman's Body." Ireland, Palumbo and Sullivan, pp. 191–202.

"Lalla Ward Interviewed by Gary Russell." Gallifrey One: 28 Years Later. 16–19 February 2017. Marriott Los Angeles Airport, Los Angeles, CA. Conference Interview.

Larsen, Kristine. "Doctor Who and the Valkyrie Tradition Part 1: The Valiant Child and the Bad Wolf." Burdge, pp. 120–139.

Leitch, Gillian I. "With Whom He Travels: The Companions of the Doctor." Leitch and Ginn, pp. 9–25.

Leitch, Gillian I., ed. *Doctor Who in Time and Space: Essays on Themes, Characters, History and Fandom, 1963–2012*. McFarland, 2013.

Leitch, Gillian I., and Sherry Ginn, eds. *Who Travels with the Doctor? Essays on the Companions of Doctor Who*. McFarland, 2016.

Leonard, Linda Schierse. *Meeting the Madwoman: Empowering the Feminine Spirit*. Bantam, 1994.

Lewis, Courtland, and Paula Smithka. "We've Been Abducted by the Doctor, and We Love It!" Lewis and Smithka, pp. ix–xviii.

Lewis, Courtland, and Paula Smithka, eds. *Doctor Who and Philosophy: Bigger on the Inside*. Open Court, 2010.

Long, Ruth. "Clara Oswald: A Study of the Impossible Girl." *Doctor Who TV*, November 26, 2015. http://www.doctorwhotv.co.uk/clara-oswald-a-study-of-the-impossible-girl-78428.htm.

_____. "Clara Oswald: A Study of the Impossible Mirror." *Doctor Who TV*, December 17, 2015. http://www.doctorwhotv.co.uk/clara-oswald-a-study-of-the-impossible-mirror-78978.htm.

"Louise Jameson Interview." Gallifrey One: 28 Years Later. 16–19 February 2017. Marriott Los Angeles Airport, Los Angeles, CA. Conference Interview.

Magnet, Shoshana, and Robert Smith. "Two Steps Forward, One Step Back: Have We Really Come That Far?" Thomas and O'Shea, pp. 154–163.

Manning, Katy, Anneke Wills, Frazer Hines, Peter Purves, Prentis Hancock and Michael Troughton. "Days Gone By." Gallifrey One: 28 Years Later. 16–19 February 2017. Marriott Los Angeles Airport, Los Angeles, CA. Conference Panel.

Martin, Daniel. "Doctor Who: The Five Best and Worst Companions." *The Guardian*, 28 Mar 2007. http://www.theguardian.com/culture/tvandradioblog/2007/mar/28/doctorwhothefivebestandw.

McLaughlin, Helene. "RIP Elisabeth Sladen, a Timeless Companion." *Wired*, 20 April 2011. http://www.wired.com/geekmom/2011/04/rip-elisabeth-sladen-a-timeless-companion.

McMahon-Coleman, Kimberley. "'The Battle-Scarred, the Insane, the Ones Even You Can't Control': Disability and the Female Bodies of the Doctor's Companions." Leitch and Ginn, pp. 37–51.

Moffat, Steven, and Rachel Talalay. "The Aftershow—Doctor Who: The Fan Show." *YouTube*, 1 Jul 2017. https://www.youtube.com/watch?v=Ac7pl1lI8FU.

Muir, John Kenneth. *A Critical History of Doctor Who on Television.* McFarland, 1999.

Murray, Andy. "The Talons of Robert Holmes." Butler, pp. 217–232.

Nathanael, Tanja. "Rose Is England: Nationhood, British Invasion Anxiety and Why the Doctor Will (Almost) Always Rescue His Companions." Leitch and Ginn, pp. 79–90.

Newman, Kim. *Doctor Who.* British Film Institute, 2005.

Orthia, Lindy, ed. *Doctor Who and Race.* Intellect, 2013. ProQuest ebrary. Web. 8 March 2017.

"Out of Time." *Doctor Who Confidential.* Series 5. Episode 13. 26 June 2010. BBC. BBC Three.

Pearson, Carol S. *Awakening the Heroes Within.* HarperCollins, 1991.

Pool, Hannah. "Freema Agyeman: Question Time." *The Guardian,* 29 March 2007. Belam.

Porter, Lynnette. "Chasing Amy: The Evolution of the Doctor's Female Companion in the New Who." Leitch, pp. 253–268.

Powers, Tom. "A Muted Melody: The (Dis)Empowerment of River Song." Leitch and Ginn, pp. 106–122.

Rawcliffe, Daniel J. "Transgressive Torch Bearers: Who Carries the Confines of Gothic Aesthetics?" Ireland, Palumbo and Sullivan, pp. 102–112.

Roberts, Tansy Rayner. "Big Finish Originals: Lucie Bleedin' Miller." *Doctor Her,* 20 February 2012. http://doctorher.com/?p=91.

_____. "The Ultimate Sixth." Stanish and Myles.

Rose, Lloyd. "What's a Girl to Do." Thomas and O'Shea, pp. 46–50.

Sarkeesian, Anita. "Damsel in Distress (Part 1) Tropes Vs Women." *Feminist Frequency,* 7 Mar 2013. http://feministfrequency.com/2013/03/07/damsel-in-distress-part-1.

Schmidt, Victoria. *45 Master Characters.* Writer's Digest Books, 2007.

Schuster, Marc, and Tom Powers. *The Greatest Show in the Galaxy: The Discerning Fan's Guide to Doctor Who.* McFarland, 2007.

Scott, Lara J. "What Would Romana Do?" Stanish and Myles.

"Send in the Clones." *Doctor Who Confidential.* Series 4. Episode 4. 26 Apr 2008. BBC. BBC Three.

Simon. "How Sexist Is *Doctor Who?*–50 Years of Sexism in Statistics." *Simon's Incoherent Blog,* 22 Aug 2014. https://blog.incoherent.net/2014/08/22/how-sexist-is-doctor-who50-years-of-sexism-in-statistics/.

Sladen, Elisabeth. *Elisabeth Sladen: The Autobiography.* Aurum Entertainment, 2011.

Smelik, Anneke. "And the Mirror Cracked: On Metaphors of Violence and Resistance." *And the Mirror Cracked: Feminist Cinema and Film Theory.* Palgrave MacMillan, 1998, pp. 90–122.

Sharma, Iona. "All the Way Out to the Stars." Stanish and Myles.

Stanish, Deborah, and L.M. Myles, eds. *Chicks Unravel Time: Women Journey Through Every Season of Doctor Who.* Mad Norwegian Press, 2012. Kindle Edition.

Staskiewicz, Keith, Kyle Anderson, and Dalton Ross. "Doctor Who." *Entertainment Weekly,* vol. 1381/1382, 2015, pp. 140. *MasterFILE Premier.* Web. 25 Dec. 2016.

Stoker, Courtney. "Maids and Masters: The Distribution of Power in Doctor Who Series Three." Stanish and Myles.

Stuller, Jennifer. *Ink-Stained Amazons and Cinematic Warriors: Superwomen in Modern Mythology.* I.B. Tauris, 2010.

Thomas, Lynne M. "Build High for Happiness!" Stanish and Myles.

Thomas, Lynne M., and Tara O'Shea, eds. *Chicks Dig Time Lords.* Mad Norwegian Press, 2010.

Torpey, J.C. "A Female Doctor Who? Fifth Doctor Peter Davison Says 'No,' Producer Steve Moffat Says 'Yes.'" *The Inquisitr News.* 29 January 2015. Web. http://www.

inquisitr.com/1796462/a-female-doctor-who-fifth-doctor-peter-davison-says-no-producer-steve-moffat-and-show-creator-say-yes.

Tulloch, John, and Manuel Alvarado. *Doctor Who: The Unfolding Text.* Saint Martins, 1983.

Turner, John Nathan. *The Companions.* Random House, 1986.

"Viewers Think New Doctor Who Is 'Too Sexy.'" *The Daily Telegraph,* 5 April 2010. http://www.telegraph.co.uk/culture/tvandradio/doctor-who/7554825/Viewers-think-new-Doctor-Who-is-too-sexy.html.

Waltonen, Karma. "Religion in Doctor Who: Cult Ethics." *Time and Relative Dimensions in Faith: Religion and Doctor Who.* Edited by Andrew Crome and James McGrath. Darton, Longman and Todd Ltd, 2013, pp. 145–160.

Welch, Rosanne. "When White Boys Write Black: Race and Class in the Davies and Moffat Eras." Orthia, pp. 67–71.

Winstead, Antoinette F. "*Doctor Who*'s Women and His Little Blue Box: Time Travel as a Heroic Journey of Self-Discovery for Rose Tyler, Martha Jones and Donna Noble." Leitch, pp. 227–241.

Zweig, Connie. "The Conscious Feminine: Birth of a New Archetype." Downing, pp. 183–191.

INDEX

Ace 1, 23, 24, 34, 46, 97, 99, 114, 118–120, 135–138, 140, 146, 176, 179, 180, 187
action 1, 13, 16, 47, 58, 70, 76, 89, 114, 128, 129, 132–135, 154
Adrasta 105–106
Adric 1, 57, 93, 187, 188, 190, 196, 204
"Age of Steel" 57, 59, 183
agency 2, 8, 10, 15, 16, 19, 39, 57, 59, 67–69, 86, 123, 125, 126, 142, 156, 188, 194, 196, 197, 215
Aldred, Sophie 118–119
"Aliens of London" 60, 116, 146
"The Almost People" 165
"Amy's Choice" 64, 66, 68, 113
The Ancestor Cell 163
The Android Invasion 130
The Androids of Tara 47, 92, 179
"The Angels Take Manhattan" 212
Anji Kapoor 168, 174–176
April MacLean 19, 22, 62, 110
Arabella Weir 227
The Arc of Infinity 190, 204
The Ark 3, 12
The Ark in Space 99, 100, 131, 164
The Armageddon Factor 47, 202
"Army of Ghosts" 94
Ashbrook, Daphne 220–221
Ashildr see Lady Me
Asian 34, 50, 78, 173, 220
assassin 45, 94, 106, 143
Astra 47, 202, 203
Astrid Peth 30, 50, 56–58, 222
"Asylum of the Daleks" 63, 69, 167, 191
Attack of the Cybermen 3, 106, 145, 159
The Awakening 197
The Aztecs 80, 220

baby 21, 22, 24, 62, 69, 90, 133, 135, 152, 160, 178, 181, 184, 192
"Bad Night" 64
"Bad Wolf" 52, 57, 59, 66, 166, 168
Baker, Colin 44, 46, 81, 219

Baker, Jane 104
Baker, Tom 151, 190, 203, 227
banter 53, 124, 167, 191, 225
Barbara Wright 2, 3, 7–10, 14, 16, 68, 79–81, 89, 128, 150, 188, 197, 224
Battlefield 34, 97, 99, 146
BBC Books 2, 205
"The Beast Below" 154
"Beautiful Freak" 157
Bechdel test 2, 7, 13, 15, 22, 27, 31, 49, 66, 73, 130, 133, 135, 139, 185, 189, 191, 200
"The Bells of Saint John" 96, 107, 191
Ben Jackson 9, 13, 14, 70, 142, 224
Bernice Summerfield 120, 137–141, 219
Bev Tarrant 140
"The Big Bang" 210
Big Finish 2, 41, 45, 53, 138, 140, 190, 198, 205, 218, 219
bikini 43, 157, 167, 191
Bill Potts 168–174, 198
Bill's mother 186
"Birth of a Renegade" 6
black characters 17, 25, 35, 39, 50, 55, 93, 94, 95, 100, 101, 122, 154, 166–168, 171, 179, 190, 199, 218, 227
Black Guardian trilogy 100, 101
Black Orchid 17, 93, 179, 190
"Blink" 18, 37, 108
The Blue Angel 217
"Boom Town" 116
Bowerman, Lisa 138
boyfriend 9, 17, 50, 52, 64, 67, 107, 170, 177, 183, 186, 192, 195, 220
The Brain of Morbius 84
Braxiatel 140
Brigadier Lethbridge-Stewart 1, 28, 32, 34, 70, 74–76, 103, 108, 130, 131, 139, 143, 146
Brigadier Winifred Bambera 146
Briggs, Nicholas 113, 144
Bryant, Nicola 43, 44
Bryant, Peter 15

Capaldi, Peter 194, 227
Captain Jack Harkness 39, 51, 52, 66, 70, 133, 166, 176
Caretaker 25, 195
Carnival of Monsters 29–30
Castrovalva 3, 224
cat-women 115
The Caves of Androzani 44
The Celestial Toymaker 12
Chantho 31, 57
Charley Pollard 48, 50, 53–55
The Chase 10
chauvinist 100
The Children of Earth 60
Christina de Souza 140
"A Christmas Carol" 61, 223
"The Christmas Invasion" 60, 102, 146
Cinder 143
City of Death 33, 203
Clara Oswald 5, 23, 25, 26, 31, 57, 66, 67, 87, 96, 103, 107–109, 112, 116, 122, 123, 143, 161, 170, 184, 186, 191–198, 209, 213, 215, 223, 225
Clara Oswin Oswald 23, 25, 112
Clara's grandmother 186
Class 19, 22, 62, 110, 111
The Claws of Axos 27, 143
cleavage 71, 210, 220, 221, 226
Clegg, Barbara 2, 3, 97, 98, 100
Cleopatra 210, 214, 223
Clyde Langer 20
Coal Hill School 25, 39, 192
"Cold Blood" 77, 115
Cold Fusion 6, 207, 219, 220
Coleman, Jenna 49, 66, 69, 167, 192, 195, 210, 225
colonialism 178
The Colony in Space 76
comics 2, 23, 24, 25, 34, 35, 41, 55, 58, 60, 73, 74, 76, 86, 87, 130, 146, 152, 157, 158, 159, 164, 174, 183, 221
The Company of Friends 41
Compassion 162–164, 174
Constance Clarke 143
Cornell, Paul 120, 137, 162, 163
costumes 17, 43, 66, 107, 129, 141, 188, 189, 190
The Creature from the Pit 105
"The Crimson Horror" 112–113
C'rizz 54
The Crusade 16, 89, 150
Cumming, Fiona 3, 179
The Curse of Fenric 114, 119, 135, 187
"The Curse of the Black Spot" 67
The Curse of the Fatal Death 226
Cwej 141, 142
Cyberwoman 101, 166, 167
cyborg 56, 99, 106, 141, 163–168, 175

The Daemons 28, 83, 84
"Dalek" (episode) 51

The Dalek Invasion of Earth 8, 16, 89
The Daleks (serial) 7, 16, 80
"Daleks in Manhattan" 49
The Daleks' Master Plan 11, 88
damsel 16, 17, 27, 31, 34, 47, 48, 49, 52, 58, 59, 77, 114, 118, 121, 130, 144, 145, 148, 179, 187, 196, 199
Danny Pink 143, 195
Dark Eyes 199
"Dark Water" 107, 108, 195
dating 19, 170, 187, 192, 195
Davies, Russell T. 2, 3, 18, 33, 39, 49, 50, 52, 53, 67, 70, 102, 124–126, 133, 134, 154, 184, 223, 227
Davies, Sharon 23
Davison, Peter 3, 18
Davros 33, 57, 94, 120, 144, 145, 167, 203, 208
Day of the Daleks 28, 144
"The Day of the Doctor" 103, 143, 193, 208, 225
"Day of the Moon" 210
The Deadly Assassin 204
Death and Diplomacy 139
"Death in Heaven" 42, 103, 108
Death of the Doctor 14, 29, 94, 222
Death to the Daleks 145
"Deep Breath" 107, 161, 195
Delta and the Bannermen 135, 228
Destiny of the Daleks 165, 203
Destrii 156–159
Dicks, Terrance 27, 40, 127, 128
"Dinosaurs on a Spaceship" 67, 154
diversity 23, 173, 227
"The Doctor Dances" 121
"The Doctor Falls" 24, 108, 110, 135, 172, 227
"The Doctor, the Widow and the Wardrobe" 24, 135–137
Doctor Who (movie) 34, 41, 207, 220, 221
Doctor Who and the Silurians 32, 75
Doctor Who Magazine 2, 41, 146, 156
"The Doctor's Daughter" 18, 39, 49, 61, 123, 173, 185, 197
Doctor's first wife 219–220
Doctor's mother 207
"The Doctor's Wife" (episode) 97, 224, 225
Dodo Chaplet 9–14
Dollard, Sarah 170, 196
The Dominators 17, 74
Donna Noble 39, 43, 49, 50, 57, 60, 61, 66, 75, 87, 96, 112, 123–127, 141, 147, 148, 170, 174, 180, 184, 185, 196, 222
Doomsday 52, 101, 184
Dragonfire 23, 33, 46, 118, 146
The Dying Days 120, 138, 139, 146

An Earthly Child 9
Earthshock 144, 190
Eccleston, Christopher 49, 51, 66
The Edge of Destruction 80, 224
ego 81, 85, 107, 109, 179, 192, 197, 203
The Eight Doctors 39–40

Eighth Doctor 26, 34, 35, 39–41, 50, 53, 62, 108, 126, 139, 140, 143, 156, 157, 162, 174, 199, 205–208, 215–218, 221, 223
Eighth Doctor Adventures 215–216
Eleventh Doctor 31, 42, 48, 55, 63–69, 103, 112, 116, 127, 135, 137, 140, 154, 161, 166–168, 191, 194, 196, 209, 213, 215, 222, 223, 226
Elizabeth I 81, 214, 223, 224
Elizabeth II 153
Elizabeth Ten 66, 154
Ellie Oswald 186
Emma Peel 73
"Empress of Mars" 155
"The End of the World" 57, 58, 115, 184
The End of Time 31, 39, 87, 95, 96, 123, 125, 206, 223, 226
The Enemy of the World 30, 179
Enlightenment 3, 100, 188
Erimem 45, 148, 149
Escape Velocity 163, 174, 175
e-Space 204
Evelyn Smythe 81–82
The Evil of the Daleks 26, 90
"Evolution of the Daleks" 49
Excelis 218
The Eye of the Scorpion 148

Face of Boe 57
"Face the Raven" 57, 122, 196
The Faceless Ones 14, 113
Faction Paradox 162–163
fainting 15
fairytale 5, 45, 52, 64, 69, 82, 117, 125, 189
faith 6, 8, 9, 33, 38, 42, 68, 96, 119, 185, 205, 223
"The Family of Blood" 116, 222
Father Time 206
"Fear Her" 24
female gaze 66
femininity 8, 9, 14, 15, 18, 22, 26, 51–53, 70, 71, 75, 84, 86, 97, 98, 100, 106–108, 116, 133, 139, 141, 146, 147, 159, 163, 164, 176, 178, 193, 200, 206, 208, 210, 213
feminism 1, 2, 15, 27, 29, 34, 62, 65, 70, 71, 74, 79, 84, 87, 128, 129, 131–133, 138, 144, 163, 164, 189
femme fatale 109, 210, 211
Fey 159, 164
Feyde 162, 164
Fielding, Janet 188–189
Fifth Doctor 1, 17, 18, 73, 93, 101, 144, 191, 218, 224
"The Fires of Pompeii" 60, 124
First Doctor 13, 14, 25, 130, 207
Fitz Kreiner 40, 162, 163, 175, 216, 218
The Five Doctors 132, 188, 204, 224
"Flatline" 107
Flavia 204–205
"Flesh and Stone" 67, 209
Ford, Carole Ann 5, 6, 80
"Forest of the Dead" 57, 209

"42" 37, 50, 60, 95
Fourth Doctor 1, 42, 72, 73, 85, 106, 129, 130, 144, 153, 164, 165, 187, 199, 201, 218, 224
"Fragments" 101
Francine Jones 184
freedom 16, 22, 58, 71, 93, 110, 111, 115, 135, 142, 145, 151, 157, 180, 206
fridging 58, 60
Frontier in Space 28, 29
Frontios 188, 198
Fury from the Deep 15, 17

Gabby Gonzalez 174
Gallifrey 6, 40, 41, 72, 73, 98, 109, 132, 162–164, 168, 196, 199, 204, 205, 208, 215, 217, 219
The Gallifrey Chronicles 41, 216
Gardner, Julie 2, 49
gender flip 34, 101, 164, 214, 227
gender roles 77, 80, 94, 96, 143, 153
genocide 52
Ghost Light 119, 120, 179
Ghost Machine 49
Gillan, Karen 64, 65, 68
"The Girl in the Fireplace" 222
"The Girl Who Died" 121
The Girl Who Never Was 54
"The Girl Who Waited" 66, 67
"The God Complex" 63
"A Good Man Goes to War" 69, 160
"Good Night" 64
Grace Holloway 219–222
The Great Intelligence 96, 194
The Greatest Show in the Galaxy 17, 86, 114, 187
The Green Death 28–29
"Gridlock" 36, 38, 50, 57, 115
Gwen Cooper 79, 176, 177, 178
gynarchy 105

The Hand of Fear 129, 164, 187
The Happiness Patrol 97, 118
Happy Endings 120, 139
harem 16, 45, 89
Harriet Jones 57, 87, 102, 103
Harry Sullivan 70, 100, 130, 134, 177, 205
Hartnell, William 168, 217
Heather McCrimmon 35
"Heaven Sent" 108, 196
Helen A 97–98
Helen Sinclair 199
"Hell Bent" 108, 196, 208, 219
Hellings, Sarah 104
"Hide" 31, 116, 225
hierarchy 51
The Highlanders 16
Hill, Jacqueline 79, 80, 85
Hinchcliffe, Philip 130
historical 1, 41, 81, 87, 98, 148, 150
Holmes, Robert 75, 130
The Horns of Nimon 33, 203

The Horror of Fang Rock 31, 71, 128
The Horror of Glam Rock 126
"Human Nature" 37, 116, 222
"The Hungry Earth" 77
Hurt, John 143
husband 8, 10, 16, 17, 33, 50, 56, 61, 62, 64, 68, 69, 81, 86, 87, 89, 91–95, 98, 104, 106, 125, 136, 139, 143, 151–154, 158, 159, 183, 184, 187, 212, 213, 222
"The Husbands of River Song" 213, 215

Ian Chesterton 7, 10, 66, 70, 80
Ianto Jones 101, 166, 167
The Ice Warriors 15, 76
Image of the Fendahl 71, 77, 187, 224
"The Impossible Astronaut" 64, 209, 210
Impossible Girl 67, 186, 192, 194
"In the Forest of the Night" 26
Indian 20, 24, 78, 83, 87, 96, 145, 173, 174, 175, 198
Inferno 32, 75, 76
The Infinity Doctors 204, 207, 219, 220
Inquisitor 2, 205
Interference 40, 162
interracial couples 50
intuitive 49, 138, 193
Invasion of the Dinosaurs 92, 128
The Invasion of Time 72, 199
The Invisible Enemy 72
Iris Wildthyme 106, 170, 217–219
Izzy Sinclair 23, 156–159, 164

Jackie Tyler 11, 59, 133, 182–184, 187
Jameson, Louise 71–73, 82, 204, 227
Jamie McCrimmon 9, 14–17, 25, 30, 35, 66, 73–75, 90, 143
Jane Austen 138
Jane Grey 62
Jenny Flint 160–161
Jo Grant 10, 26–32, 68, 75, 77, 83, 91, 130, 144, 145, 218, 222
John, Caroline 75–76
John and Gillian 25
Jorjie Turner 19–22
"Journey to the Centre of the Tardis" 193, 225
"Journey's End" 52, 57, 59, 102, 125, 147, 185
Just War 141–142

K 9, 120, 132, 200, 201, 204
K-9 (show), 21–22
K9 and Company, 132
Katarina 9, 11–13, 57, 149, 196
Kate Lethbridge-Stewart 2, 40–43, 75, 82, 103, 104, 142, 207
The Keeper of Traken 26, 92, 189
The Key to Time 47, 200
The Keys of Marinus 16, 80, 89
"Kill the Moon" 26
Kinda 178
The King's Demons 187–188

kiss 41, 54, 57, 67, 123, 139, 141, 142, 163, 191, 221–223
kissogram 65, 176
"Knock Knock" 114, 173
The Krotons 17, 74

Lady Me 121–123, 197, 207
Lambert, Verity 2, 79
Langford, Bonnie 45
"Last Christmas" 78, 196
"The Last of the Time Lords" 9, 95, 184
Lavinia (aunt of Sarah Jane) 132–133
"The Lazarus Experiment" 36, 184
Leela 31, 66, 70–73, 119, 130, 187, 199, 201, 204, 227
legs 65, 190, 226
The Leisure Hive 152
lesbian 79, 158, 159, 161, 168, 170, 176, 227
"Let's Kill Hitler" 64, 67, 69, 211
Letts, Barry 27, 76, 127
"The Lie of the Land" 109, 172, 186
"Listen" 207
Liv Chenka 198, 199
Liz Shaw 26, 73, 75, 104
Lloyd, Innes 13
"The Lodger" 19, 66
Logopolis 77, 189, 190, 204, 224
"Love and Monsters" 57, 60
Love and War 137
love triangle 22, 66
Lucie Miller 9, 126, 127, 217
Luke (Sarah Jane's son) 133–134
Lungbarrow 6, 73
Lysandra Aristedes 142

MacDonald, Hettie 108
macho 66, 167
Mackie, Pearl 168–170
Mad Dogs and Englishmen 218
Madame de Pompadour 50, 56, 68, 222, 223
Madame Kovarian 181
"The Magician's Apprentice" 108, 208
Magrs, Paul 217
male gaze 19, 43, 51, 66, 210
Manning, Katy 27, 218
Mara 176–179, 187
Marco Polo 16, 150, 207
Maria Jackson 19, 20, 133
The Marian Conspiracy 81
Marilyn Monroe 214, 223
The Mark of the Rani 44, 104, 105
marriage 8, 9, 15, 16, 23, 26, 33–35, 39, 68, 72, 79, 125, 132, 143, 149, 150, 158, 173, 178, 211, 214, 218, 219
Marsh, Jean 88, 89, 99
Martha Jones 31, 35–41, 48–50, 54, 60, 67, 86, 95, 96, 117, 124, 125, 142, 145, 147, 168, 170–173, 176, 184–187, 220, 222, 223
Mary Shelley 41
masculinity 26, 51, 70, 71, 98, 129, 133, 164, 208, 210

The Masque of Mandragora 131
The Massacre 26, 179
The Massacre of St. Bartholomew's Eve 3, 11, 128, 150
The Master 9, 11, 27–33, 37, 42, 60, 67, 87, 88, 91, 92, 95, 96, 105–107, 110, 130, 172, 184, 189, 190, 198, 202, 205, 221, 227
matriarch 108, 149, 160, 178
Matrona 94–95
Mawdryn Undead 198
McCoy, Sylvester 97, 227
McGann, Paul 9, 126, 221
"Me and My Shadow" 164
The Meddling Monk 126, 217
Meglos 77, 85
Melanie Bush 45, 82, 105, 135
Melody Pond 160, 211
mentor 21, 65, 169, 178, 198, 201, 207, 208
Mickey Smith 39, 50, 52, 68, 182, 183
"Midnight" 49, 57, 61
Mila 54
The Mind of Evil 29, 91, 143
The Mind Robber 74
Mindwarp 44, 94
miniskirt 1, 10, 15, 28, 43, 50, 65, 66, 75, 129
minisode 65, 66, 160, 208
misogyny 152, 208
Miss Hartigan 48, 101
Missy 42, 66, 67, 103, 106–110, 172, 227
Moffat, Steven 3, 18, 64–68, 110, 154, 165, 172, 173, 185, 192, 194, 211, 224–227
Molly O'Sullivan 198–199
The Moment 167–168
The Monster of Peladon 131, 151
The Moonbase 14
Morgaine 34, 99, 146
Mori, Naoko 78–79
Morshead, Catherine 66
mother 5, 6, 17, 21, 22–24, 31, 33, 43, 52, 55, 62, 69, 78, 82, 89, 90, 92, 96, 99, 101, 103, 111, 112, 114, 116, 119, 125, 133–140, 150, 158, 160, 170, 172, 178, 180–193, 207, 217, 218, 220, 222, 224, 225
movie *see Doctor Who* (movie); Eighth Doctor
Mrs. Wormwood 21, 134
Munro, Rona 3, 24
muse 223
The Mutants 28
The Mysterious Planet 152, 205
The Myth Makers 10, 150

"The Name of the Doctor" 5, 161, 194, 197, 213, 215
Nardole 24, 135
Nation, Terry 7, 88
Nefertiti 154–155
"New Earth" 36, 115
Newman, Sydney 44, 79, 227
"The Next Doctor" 47, 48, 101
"The Night of the Doctor" 62, 127, 208

"Nightmare in Silver" 25
Nightmare of Eden 31, 203, 204
Ninth Doctor 49, 51, 52, 58, 59, 66, 116, 121, 182
Nurse Redfern 37, 222

objectification 61, 225
Ohila 63, 207–210
Ophidius 157
Orman, Kate 2, 40, 142, 207
Osterhagen Key 39
Oswin Oswald 63, 167, 191
"Oxygen" 171

Padbury, Wendy 73
"The Pandorica Opens" 210
Paradise Towers 46, 73, 113
Parkin, Lance 120, 138, 139, 206, 219
"The Parting of the Ways" 52, 57, 59, 228
"Partners in Crime" 111, 123, 185
passive 9, 33, 53, 154
Past Doctor Adventures 153
patriarchy 26, 32, 43, 58, 90, 99, 102, 119, 130, 141, 152, 162, 163, 201, 204, 205, 208, 210
patronizing 12, 32, 129
Peri Brown 1, 43–46, 66, 68, 82, 93, 94, 105, 145, 148, 149, 152, 159, 168, 191, 205, 221
Pertwee, Jon 15, 27, 75, 76, 217
Pete Tyler 59
Petronella Osgood 42, 43, 63, 108
"The Pilot" 62
Piper, Billie 48, 49, 167
The Pirate Planet 106, 201
Placebo Effect 35
Planet of Evil 129–130
Planet of Fire 3, 26, 43
Planet of the Daleks 29, 145
Planet of the Dead 55, 87, 140, 147
"Planet of the Ood" 96
Planet of the Spiders 113, 145, 187
platonic 54, 124, 142
"The Poison Sky" 39, 49, 57, 66, 147
Polly Wright 9, 13–17, 30, 68, 113, 224
Pond, Amy 9, 10, 64, 67, 78
"Pond Life" 223
Power of the Daleks 90, 224
"The Power of Three" 103
pregnant 23, 62, 69, 111, 140, 178, 181, 184, 211
prince 8, 9, 110
Pygmalion 51, 71
"The Pyramid at the End of the World" 78, 147, 172
Pyramids of Mars 128–130
Pythia 6

Quill 23, 62, 110, 111

racism 16, 34, 37, 43, 171
Radio Times 34
The Rani 2, 104, 105
Rani Chandra 20, 21, 62, 133

rape 162, 174, 177, 178
Rassilon 6, 208
Raynor, Helen 66
Remembrance of the Daleks 34, 119, 187
representation 72, 76, 78, 83, 99, 227
The Rescue 10
Resurrection of the Daleks 145, 189
Revelation of the Daleks 94, 120
The Ribos Operation 200, 201, 202
"The Rings of Akhaten" 25, 186, 193
"Rise of the Cybermen" 183
River Song 21, 23, 54–57, 66–69, 109, 122, 124, 137, 138, 139, 167, 181, 194, 196, 203, 209–216, 223
Robot (serial) 100, 130
robots 56, 66, 100, 165, 166
The Robots of Death 72
Romana 31, 33, 43, 46, 47, 54, 73, 75, 85, 86, 104, 105, 124, 130, 152, 162, 165, 200–207
romance 28, 32, 50, 51, 53, 68, 77, 79, 119, 135, 140, 160, 161, 176, 184, 196, 203, 209, 213, 214, 216, 220–224
The Romans 10
Rory Williams 64–69, 113, 137, 184–186, 211, 212
Rose Tyler 24, 36, 39, 43, 49–60, 67, 68, 94, 115, 123–125, 147, 153, 154, 166–168, 176, 182–186, 221, 222
Rosita 48
Roz Forrester 141–142
"The Runaway Bride" 123, 125, 180, 185
Russell, Gary 2, 35
Russell, Paddy 3, 128

Sabalom Glitz 46, 152
sacrifice 11, 47, 48, 57, 60–63, 71, 81, 85, 87, 99, 110, 115, 121, 122, 132, 143, 148, 172, 193–196, 211, 212
Sally Morgan 142
Sally Sparrow 18, 50
Sam Jones 39, 40, 50, 162
Sara Kingdom 88, 89, 99, 196
The Sarah Jane Adventures 19, 21, 29, 39, 49, 60, 62, 94, 132–134, 226
Sarah Jane Smith 1, 14, 19–21, 29, 39, 40, 49, 60, 75, 79, 83, 84, 92, 94, 120, 127–134, 144, 151, 164, 188, 218, 226
"The Satan Pit" 51, 228
savage 45, 71, 72, 109, 120, 178
The Savages 13
The Scarlet Empress 217, 218
"School Reunion" 52, 132, 133
Scottish 64, 67, 121, 161
screaming 1, 9, 10, 14, 15, 26, 29, 46, 72, 77, 99, 103, 127, 157, 180, 206, 210, 226
The Sea Devils 30, 217
Second Doctor 14, 15, 27, 30, 73, 75, 77, 90, 113, 130, 138
Secrets of the Stars 60
The Seeds of Death 76
The Seeds of Doom 83, 130, 131

sensitive 58, 71, 158, 175
Seventh Doctor 1, 46, 97–99, 105, 119, 120, 137, 140–142, 146, 153, 159, 176, 187, 221
sex appeal 1, 7
sexism 16, 29, 33, 43, 50, 65, 98, 105, 139
sexuality 5, 102, 123, 157, 159, 166, 169, 170
sexualized 93, 129, 152, 157, 166, 178, 190, 226
Shada 33
Shadow Architect 102
The Shadows of Avalon 162–163
"The Shakespeare Code" 117, 223, 224
Shayde 164
shorts 188
sidekicks 7, 30, 34
"Silence in the Library" 24, 60, 209
Silver Nemesis 98, 153
sister 22, 42, 87, 115, 117, 124, 142, 150, 176, 184, 185
Sisterhood of Karn 6, 63, 84, 207, 208
Sixth Doctor 1, 18, 43, 46, 54, 81, 82, 93, 94, 104, 143, 159, 165, 205, 219
skirt *see* miniskirt
Sky 21
Sladen, Elisabeth 21, 79, 127–133
slavery 96, 170
"Sleep No More" 97, 147, 166
Slitheen 21, 60, 102, 116, 146
Smith, Julia 3
Smith, Matt 226–227
"Smith and Jones" 184
The Smugglers 3, 9, 14, 224
Snakedance 3, 179, 187
"The Snowmen" 25, 112, 160, 161, 191
So Vile a Sin 142
"Something Borrowed" 178
Sometime Never... 6, 41, 206, 216
sonic lipstick 133–134
sonic screwdriver 26, 133, 204, 214, 226
The Sontaran Experiment 129–130
"The Sontaran Stratagem" 39, 49, 66
"The Sound of Drums" 38, 95
The Space Museum 10
The Space Pirates 15, 90
Spearhead from Space 75, 187
Ssard 35
Stacy Townsend 34, 35
State of Decay 93, 106
stereotype 1, 26, 78, 92, 117, 128, 169, 182, 187, 190, 201, 206
Steven Taylor 9, 11, 12, 70, 89
"The Stolen Earth" 102
The Stones of Blood 85, 200
Storm Warning 41
Strax 160–161
The Sun Makers 71, 73, 92
Survival 3, 23, 24, 119, 176, 188
Susan Foreman 5–13, 16, 25, 68, 79, 80, 89, 127, 199, 207, 216, 219, 220
Sutton, Sarah 32, 189
Suzie Costello 177
Sylvia Noble 182, 185

Talalay, Rachel 107, 172, 173
The Talons of Wang-Chiang 72
Tamsin Drew 216–217
Tanya Adeola 22, 23, 62, 77, 111
Tasha Lem 63, 215
Tate, Catherine 123
Tegan Jovanka 15, 101, 145, 175–179, 188–190, 197, 198, 219
Tegan's aunt 189
The Temptation of Sarah Jane Smith 20, 133
Tennant, David 66, 227
Tenth Doctor 5, 21, 35, 51–56, 66, 87, 94, 95, 102, 107, 112, 117, 124, 125, 140, 148, 153, 168, 174, 184, 196, 209, 222, 223
The Tenth Planet 14
Terror of the Autons 29, 76, 187
Terror of the Vervoids 30, 77
Terror of the Zygons 114
Thatcher, Margaret 97, 98, 100, 201
"They Keep Killing Suzie" 177
"Thin Ice" 23
Third Doctor 28, 30, 32, 75, 83, 91, 127, 129–132, 144, 217
The Three Doctors 187
Time and the Rani 46, 97, 104, 105, 179
The Time Monster 27, 32, 91
"The Time of Angels" 210
"The Time of the Doctor" 215, 228
The Time Warrior 27, 128, 129, 150
Timelash 17, 145
Time's Crucible 6
Tish Jones 184
"To the Last Man" 49
Tomb of the Cybermen 15, 91
"Tooth and Claw" 57, 151, 153
Torchwood (show) 39, 49, 50, 60, 66, 78, 101, 121, 133, 166, 176–178, 182, 185
Torchwood (Victorian) 101, 154
Torchwood One 94, 101, 102
Toshiko Sato 50, 78, 178
"A Town Called Mercy" 69
transgender 166
Tregenna, Catherine 121
The Trial of a Time Lord 45, 104, 205
Trix MacMillan 215–216
Troughton, Alice 49
Troughton, Patrick 49, 217
Turlough 1, 70, 101, 198
"Turn Left" 50, 124, 147, 185
Turner, John Nathan 22, 43, 190, 191, 202, 204
Twelfth Doctor 21, 23, 24, 42, 62, 64, 67, 73, 78, 87, 97, 103, 106, 121, 131, 143, 147, 155, 161, 168, 169, 170, 171, 186, 194, 207, 212–214, 219, 227
The Twin Dilemma 44
The Two Doctors 17, 165

The Underwater Menace 3, 14, 17, 30
Underworld 71, 73, 187

An Unearthly Child 79, 149
"The Unicorn and the Wasp" 61, 87, 140, 198
UNIT 27, 28, 29, 39, 42, 55, 75, 91, 103, 104, 125, 128, 141, 144–147, 176
Unnatural History 40, 207
"The Unquiet Dead" 59
Ursula Blake 57, 60
"Utopia" 31, 38, 57

Valeyard 205, 219
"The Vampires of Venice" 48, 68, 112
Vastra 159–162, 191
The Veiled Leopard 149
Vengeance on Varos 93
Verdigris 217
Vicki Pallister 9–11, 150
Victoria (queen) 86, 153–155, 180
Victoria Waterfield 9, 13–15, 30, 68, 70, 90, 91, 129, 154
Victorian 14, 47, 72, 97, 101, 119, 155, 159–162, 191, 207
Virgin Publishing 2, 40, 137, 140, 141, 146
The Visitation 17
"Voyage of the Damned" 50, 56, 153
vulnerable 25, 39, 42, 60, 65, 82, 118, 119, 170, 175, 190

War Doctor 143, 167, 168, 208, 222
The War Games 143
The War Machines 13–14
Ward, Lalla 203–204
Warriors of the Deep 93, 145
"The Waters of Mars" 114, 148
Weapon of Choice 73
The Web of Fear 15, 76
wedding 21, 35, 65–69, 86, 120, 123, 134, 158, 178, 180, 181, 185, 186, 212, 222
"The Wedding of River Song" 181
Weeping Angels 18, 111, 215
The Wheel in Space 77
white privilege 37, 171
wife 5, 6, 24, 29, 31, 34, 47, 49, 64, 69, 91, 93, 95, 96, 104, 106, 144, 150, 153, 161, 167, 168, 187, 196, 207, 213, 219, 224–226
Wilfred Mott 82, 87, 125, 185, 206, 207
Williams, Graham 1, 200, 202
"The Witch's Familiar" 107, 108, 109, 227
"The Woman Who Lived" 121, 122
women's liberation 131
Woolsey, Paula 3, 145
"World Enough and Time" 108, 172, 198
The Wormery 218–219

The Year of Intelligent Tigers 175

Zoe Heriot 9, 73, 74
"The Zygon Invasion"/"The Zygon Inversion" 42, 103